Cinematic Cairo

Cinematic

EGYPTIAN URBAN MODERNITY FROM REEL TO REAL

Cairo

Edited by

Nezar AlSayyad and Heba Safey Eldeen

First published in 2022 by
The American University in Cairo Press
113 Sharia Kasr el Aini, Cairo, Egypt
One Rockefeller Plaza, 10th Floor, New York, NY 10020
www.aucpress.com

Copyright © 2022 by The American University in Cairo Press

All rights reserved. No part of this publication may be reproduced, stored in a retrieval system, or transmitted in any form or by any means, electronic, mechanical, photocopying, recording, or otherwise, without the prior written permission of the publisher.

ISBN 978 1 649 03133 4

Library of Congress Cataloging-in-Publication Data

Names: AlSayyad, Nezar, editor. | Safey Eldeen, Heba, 1970- editor.
Title: Cinematic Cairo : Egyptian urban modernity from reel to real /edited by Nezar AlSayyad and
 Heba Safey Eldeen.
Identifiers: LCCN 2021016953 | ISBN 9781649031334 (hardback)
Subjects: LCSH: Motion pictures--Egypt--History. | Urbanization--Egypt--Cairo. | Cairo (Egypt)--In
 motion pictures. | Cairo (Egypt)--Civilization. | Cairo (Egypt)—Social conditions.
Classification: LCC PN1995.9.E32 C56 2021 | DDC 791.430962--dc23

1 2 3 4 5 26 25 24 23 22

Designed by Adam el-Sehemy

Contents

Acknowledgments	vii
Volume Editors	ix
List of Contributors	xi
List of Illustrations	xv
List of Films Discussed	xix
Cinematic Cairo and the Discourse on Egyptian Urban Modernity: A Prologue *Nezar AlSayyad*	xxi

PART I: Cinematic Cairo, 1930 to the present

Chapter 1: Bourgeois Cairo, 1930: Cinematic Representations of Modernity of Place in the Middle-class City 3
Ameer Abdurrahman Saad

Chapter 2: Naguib Mahfouz's Cinematic Cairo: Depictions of Urban Transformations in Twentieth-century Egypt 25
Nezar AlSayyad and Mohammad Salama

Chapter 3: Bridge as Border and Connector: Class and Social Relations in Cinematic Cairo, 1940s–50s 43
Nezar AlSayyad and Doaa Al Amir

Chapter 4: Cinematic Cairo of the United Arab Republic, 1958–62 63
Kinda AlSamara

Chapter 5: Kafkaesque Modernity: Cairo in the 1980s and the Middle-class Housing Crisis 81
Ahmed Hamdy AbdelAzim

Chapter 6: Escaping Cairo: Bureaucratic Modernity in the Cinematic Portrayal of the City in the 1980s 99
Tayseer Khairy

Chapter 7: Cairo beyond the Windshield: From the Modernity of
Realism to Surrealistic Postmodernity, 1980s–90s 119
Mariam S. Marei

PART II: Themes in the Transformation of Cinematic Cairo

Chapter 8: Transformations in the Cinematic Space of a Cairo
Suburb in the Late Twentieth Century 139
Farah K. Gendy

Chapter 9: From *Hara* to *'Imara*: Social Transformations
in Cinematic Cairo 161
Mirette Aziz

Chapter 10: Cairo's Cinematic Coffeehouses: Modernity, Urbanity,
and the Changing Image of an Institution 181
Khaled Adham

Chapter 11: Gendered Modernity: On the Changing Role of Women
in Modern Cinematic Cairo, 1950s–2000s 201
Nour Adel Sobhi

Chapter 12: Religious Tolerance in the Cairo of the Movies,
1950s–2000s 225
Hala A. Hassanien

Chapter 13: The City of a Thousand Minarets and a Million Satellite
Dishes: The Dilemma of Islam and Modernity in Cinematic Cairo 249
Muhammad Emad Feteha

Chapter 14: Women's Right to the City: Cinematic Representation
of Cairene Urban Poverty 269
Heba Safey Eldeen and Sherien Soliman

Acknowledgments

The editors would like to acknowledge a few individuals and institutions whose efforts contributed to the making of this volume. The House of Egyptian Architecture (HEA) in Cairo hosted several meetings of the Cinematic Cairo Working Group. The Department of Architecture at the American University in Cairo offered to host the Cinematic Cairo Symposium, which had to be postponed due to the COVID-19 pandemic crisis. The International Association for the Study of Traditional Environments in Berkeley, CA (IASTE) provided some logistical support. We would like to thank Hala Hassanien who helped with arranging some of the early group meetings in Cairo, and we are very grateful for the work of Soad Kahlil who edited all of the chapters produced by the Cairo participants. We also acknowledge Nadia Naqib, our commissioning editor, who adopted the project when it was only an idea and saw its development at AUC Press. We would like to thank Nour Bahgat, editorial assistant, and Laura Gribbon, managing editor, for handling the manuscript at the Press. We are grateful to all of the individual filmmakers and/or owner institutions who granted permission to publish some of the visual material included in the book.

Volume editors

Nezar AlSayyad is distinguished emeritus professor of architecture, planning, urban design, and urban history at the University of California, Berkeley, where he also served for two decades as chair of the Center for Middle Eastern Studies (CMES). He is founder and past president of the International Association for the Study of Traditional Environments (IASTE) and editor of *Traditional Dwellings and Settlements Review* (TDSR). He has also produced and directed two public-television video documentaries and has authored and edited numerous books, including several that have been translated to other languages, among them *Traditions* (2014); *Cairo: Histories of a City* (2011); *The Fundamentalist City?* (2010); *Cinematic Urbanism* (2006); *Making Cairo Medieval* (2005); *The End of Tradition* (2004); *Urban Informality* (2002); *Muslim Europe or Euro-Islam* (2001); *Hybrid Urbanism* (2001); *Consuming Tradition, Manufacturing Heritage* (2000); *Forms and Dominance* (1992); *Cities and Caliphs* (1991); and *Dwellings, Settlements and Tradition* (1989). His most recent book is *Nile: Urban Histories on the Banks of a River* (2020).

Heba Safey Eldeen received an MSc (2000) and a PhD (2004) from the Faculty of Fine Arts, Helwan University, Egypt. She is a professor of architecture and urban design at Misr International University (MIU), Cairo, and an adjunct professor at the American University in Cairo (AUC). She currently serves as director of the House of Egyptian Architecture (HEA), under the Cultural Development Fund of the Egyptian Ministry of Culture. She is also director of the Architecture and Children Work Program of the International Union of Architects (UIA), and a member of the Architecture Committee of the Supreme Council for Culture. She has presented, published, and exhibited more than fifty studies on environmental behavior, urban sociology, architectural education, and urban education for children and youth, internationally and nationally.

List of Contributors

Ahmed Hamdy AbdelAzim is a PhD candidate in the Art History Department at the University of Wisconsin-Madison, where he works on contemporary Middle Eastern and Islamic architecture. He holds master's degrees in both Islamic art and anthropology from the American University in Cairo.

Khaled Adham is an associate professor of architecture and urban planning, who is currently a research affiliate at the Leibniz-Zentrum Moderner Orient in Berlin. His publications are focused on the impact of late capitalism on the architectural and urban transformations of Cairo.

Doaa AlAmir is a teaching assistant in the Department of Architecture, Faculty of Engineering, at Sixth of October University. She holds a BSc in architecture from Sixth of October University and a Certificate of Project Management from the American University in Cairo and an MSc in urban design at Cairo University, investigating the transformation of new districts in the city in the past three decades.

Kinda AlSamara is a specialist in Arabic literature with extensive experience in teaching Arabic in multiple settings, most recently serving as a lecturer and the Unit Chair of Arabic in the Faculty of Art and Education at Deakin University in Melbourne. She holds a PhD from the University of Melbourne, an MPhil from Adelaide University, and an MA in journalism from the University of Lebanon. She is a regular columnist in the Australian and international media and writes for the Australian Arabic-language daily *El-Telegraph*.

Mirette Aziz is a teaching assistant in the Faculty of Architecture at Misr International University (MIU). She is currently completing her MSc in architecture at the Arab Academy for Science, Technology in Cairo. As an architect, she is involved in the design activities for the Architecture and Children Work Program.

Muhammad Emad Feteha is the assistant curator of the Regional Architecture Collections in the American University in Cairo (AUC). He holds a BSc in Architectural Engineering from Misr International University (MIU) and an MA in Islamic Art and Architecture from AUC, where he is also finishing an MA in Philosophy. Feteha is the founder of *MimarCast*, a podcast in which he interviews distinguished architectural scholars. From 2018–19, Feteha was an Andrew W. Mellon Post–MA fellow at the AUC HUSS-Lab, during which he researched the intersections between ethics, aesthetics, and architecture.

Farah Gendy is a practicing architect who has worked with the engineering consulting group EHAF since receiving a Bachelor of Architectural Engineering from Misr International University (MIU) in 2017. She is involved in the planning and implementation of activities in the House of Egyptian Architecture (HEA), part of the Cultural Development Fund of the Egyptian Ministry of Culture.

Hala A. Hassanien is an architect and activist involved in a number of nonprofit activities and websites that bring together young architects and scholars for joint activities. She played an initiating role in convening the Cinematic Cairo Group which resulted in this book.

Tayseer Khairy is an architect, urban researcher, community development specialist, and lecturer assistant in the IUSD Master program of AASTMT and Ain Shams University. Prior to her experience of more than ten years practicing architecture and planning for nonprofit national and international organizations, she received an MSc in Community Development from Stuttgart and Ain Shams University in Cairo in 2015.

Mariam S. Marei is an architect and adjunct assistant professor at the American University in Cairo. She obtained her MA and PhD degrees in architecture from Cairo University in 2009 and 2018, respectively. Her interests and publications are mainly focused on heritage, transmission of culture, and vernacular architecture, as well as in ancient Egyptian domestic architecture. Besides her academic career and architecture practice, she has lectured and written about architecture and cinema, specifically the work of her late father, the film director Salah Marei.

Ameer Abdurrahman Saad is an independent researcher in architecture and urban studies and had been practicing architecture for more than sixteen years. He holds two MAs in Architecture from the Politecnico di Milano and the University of Cambridge. He initiated Cairo's Urban Research Community (CURC), a volunteer research group which leads public urban expedition tours, conducts workshops with local communities, and collaborates with the British Museum Mission in Upper Egypt and the Danish Egyptian Dialogue Institute in Cairo.

Mohammad Salama is professor of Arabic literature and culture and was director of the Arabic Program at San Francisco State University. He

received his PhD in comparative literature from the University of Wisconsin-Madison in 2005. His main areas of research are intellectual history and theories of modernity, with an emphasis on comparative literary and social and cultural trends in colonial and postcolonial Egypt. He has published numerous articles on comparative literature and modern Arabic literature and film in various journals. He is author of, among other publications, *Islam, Orientalism, and Intellectual History: Modernity and the Politics of Exclusion since Ibn Khaldun* (2011) and *Islam and the Culture of Modern Egypt: From the Monarchy to the Republic* (2018).

Nour Adel Sobhi completed her Bachelor of Architecture from the Faculty of Engineering, Misr International University (MIU) in 2017. With a passion for writing and research, she continues to work as a teaching assistant in the MIU Department of Architecture, and as a freelance writer for architecture news websites. She is also an active member in community participation and environmental development activities at MIU.

Sherien Soliman completed her bachelor's degree in architecture from the Faculty of Engineering Sciences and Art, Misr International University (MIU) in 2017, and has been a teaching assistant in the Department of Architecture in Misr International University (MIU) and a freelance designer. She is currently finishing her MSc in urban development at the Technical University of Berlin (TUB).

Illustrations

Chapter 1
1.1: Poster for *al-Warda al-bayda'* *(The White Rose)* (1933)
1.2: Poster for *Yaqut* (1934)
1.3: Poster for *al-'Azima (Resolve)* (1939)
1.4: The villa's porch and stairs in *al-Warda al-bayda'*
1.5: The Cairene public space in *Yaqut*
1.6: The neighborhood depicted in *al-'Azima*

Chapter 2
2.1: The family gathers for a meal in *Bayn al-qasrayn (Palace Walk)* (1964)
2.2 *al-Sukariya (Sugar Street)* (1969)
2.3. The modern house in *Qasr al-shawq (Palace of Desire)* (1967)
2.4. Cairo: 1930s street scene
2.5. Example of spatial depth in *Bayn al-qasrayn*
2.6. Anis walking through Cairo in *Tharthara fawq al-Nil (Adrift on the Nile)* (1971)

Chapter 3
3.1: The bridge in *al-Qalb luh ahkam (The Heart Has Its Rules)* (1956)
3.2: Poster for *al-Qalb luh ahkam*
3.3: A still from *Law kunt ghani (If I Were Rich)* (1942)
3.4: Zamalek in *al-Qalb luh ahkam*
3.5: The *hara* in *Law kunt ghani*
3.6: Bakery scene in *al-Qalb luh ahkam*
3.7: The *hara* in *al-Qalb luh ahkam*
3.8: Hamdy's Cadillac in the *hara* in *al-Qalb luh ahkam*

Chapter 4

4.1: The officers' mess in *'Amaliqat al-bihar (Sea Titans)* (1960)
4.2: Damascus International Fair in *Isma 'il Yasin fi Dimashq (Isma'il Yasin in Damascus)* (1958)
4.3: Nadiyah's wedding in *Sanawat al-hubb (Years of Love)* (1963)

Chapter 5

5.1: Ali in the sewage-flooded streets in *al-Hubb fawq hadabat al-haram (Love on the Pyramids Plateau)* (1986)
5.2: Ali and Abu al-Azaym out for the night in *al-Hubb fawq hadabat al-haram*
5.3: The confrontation at the police station in *al-Hubb fawq hadabat al-haram*

Chapter 6

6.1: Poster for *Kharaga wa-lam ya'ud (Left and Never Came Back)* (1984)
6.2: Poster for *Huna al-Qahira (Here Is Cairo)* (1985)
6.3: Congestion in the city of *Kharaga*
6.4: Senusi and Sabrin alone and helpless in the Cairo of *Huna al-Qahira*

Chapter 7

7.1: Hasan and his friends in *Sawwa' al-utubis (Bus Driver)* (1982)
7.2: The crowded streets of Cairo in *Sawwa' al-utubis*
7.3: Empty roads in *'Afarit al-asfalt (Asphalt Devils)* (1996)
7.4: The bus parking lot in *Sawwa' al-utubis*
7.5: The microbus terminal in *'Afarit al-asfalt*
7.6: Hasan attacking the thief in Tahrir Square in *Sawwa' al-utubis*

Chapter 8

8.1: Poster for *Ard al-ahlam (Land of Dreams)* (1993)
8.2: Poster for *Fi sha'it Masr al-Gadida (In the Heliopolis Flat)* (2007)
8.3: Poster for *Heliopolis* (2010)
8.4: Panorama of Heliopolis in *Ard al-ahlam*
8.5: Ibrahim interviewing Vera in *Heliopolis*
8.6: Demolished building filmed by Ibrahim in *Heliopolis*

Chapter 9

9.1: Poster for *Shari' al-hubb (Love Street)* (1958)
9.2: Poster for *'Imarat Ya'qubyan (The Yacoubian Building)* (2006)
9.3: The band playing in the *hara* in *Shari' al-hubb*
9.4: The *hara*'s residents bid farewell to Mun'im in *Shari' al-hubb*
9.5: Taha cleaning the stairs in *'Imarat Ya'qubyan*
9.6: Zaki Pasha and Buthaina at the entrance of the building in *'Imarat Ya'qubyan*

Chapter 10

10.1: *Qahwat* Kirsha in *Zuqaq al-Midaq (Midaq Alley)* (1963)
10.2: The installation of the radio in *Zuqaq al-Midaq*

Chapter 11

11.1: Poster for *Ana hurra (I Am Free)* (1959)
11.2: Poster for *Mirati mudir 'amm (My Wife Is a General Manager)* (1966)
11.3: Poster for *678* (2010)
11.4: Poster for *Nawwara* (2016)
11.5: Amina skating in *Ana hurra*
11.6: 'Esmat in front of her villa in *Mirati mudir 'amm*
11.7: Fayza on the public bus in *678*
11.8: Nawwara entering the upper-class residence in *Nawwara*

Chapter 12

12.1: Poster for *Hasan wa Murqus wa Kuhin (Hassan and Morqos and Cohen)* (1954)
12.2: Poster for *Hasan wa Murqus (Hassan and Morqos)* (2008)
12.3: The *hara* in *Hasan wa Murqus wa Kuhin*
12.4: Inside the pharmacy, *Hasan wa Murqus wa Kuhin*
12.5: The stair landing in *Hasan wa Murqus*
12.6: Hasan and Morqos facing sectarian clashes, *Hasan wa Murqus*

Chapter 13

13.1: Poster for *al-Sheikh Hasan (Sheikh Hassan)* (1954)
13.2: Poster for *Lili* (2001)
13.3: Poster for *Mawlana (Our Sheikh)* (2016)
13.4: Midnight scene of the *hara, al-Sheikh Hasan*
13.5: Sheikh Hatem in a sky restaurant with a view of Cairo in the background, *Mawlana*
13.6: An aerial view of the old city, with one traditional minaret and thousands of satellite dishes, *Mawlana*

Chapter 14

14.1: Poster for *Yum mor, yum helw (Bitter Day, Sweet Day)* (1988)
14.2: Film poster for *Khaltit Fawziya (Fawzeya's Formula)* (2009)
14.3: Film poster for *Yum li-l-sittat (A Day for Women)* (2016)

Films Discussed

678, 2010
'Afarit al-asfalt (Asphalt Devils), 1996
'Amaliqat al-bihar (Sea Titans), 1960
Ana hurra (I Am Free), 1959
Ard al-ahlam (Land of Dreams), 1993
al-'Azima (Resolve), 1939
Bayn al-qasrayn (Palace Walk), 1964
Cairo 30, 1966
Fi sha'it Masr al-Gadida (In the Heliopolis Flat), 2007
Hasan wa Murqus (Hassan and Morqos), 2008
Hasan wa Murqus wa Kuhin (Hassan and Morcos and Cohen), 1954
Heen Maysara (Until Better Times), 2007
Heliopolis, 2010
al-Hubb fawq hadabat al-haram (Love on the Pyramids Plateau), 1986
Huna al-Qahira (Here is Cairo), 1985
'Imarat Ya'qubyan (The Yacoubian Building), 2006
Isma'il Yasin fi Dimashq (Isma'il Yasin in Damascus), 1958
Karakun fi al-shari' (Prison Cell on the Street), 1986
al-Karnak, 1975
Khaltit Fawziya (Fawzeya's Formula), 2009
Kharaga wa-lam ya'ud (Left and Never Came Back), 1984
Law kunt ghani (If I Were Rich), 1942
Lili, 2001
Mawlana (Our Sheikh), 2016
Mirati mudir 'amm (My Wife Is a General Manager), 1966
Nawwara, 2016
Qahwat al-Mawardi (al-Mawardi Coffeehouse)
al-Qalb luh ahkam (The Heart Has Its Rules), 1956

Qasr al-shawq (Palace of Desire), 1967
Sanawat al-hubb (Years of Love), 1963
Shari' al-hubb (Love Street), 1958
al-Sheikh Hasan (Sheikh Hassan), 1954
Sawwa' al-utubis (Bus Driver), 1982
al-Sukariya (Sugar Street), 1969
Tharthara fawq al-Nil (Adrift on the Nile), 1971
al-Warda al-bayda' (The White Rose), 1933
al-Wisada al-khaliya (The Empty Pillow), 1957
Yaqut, 1934
Yum li-l-sittat (A Day for Women), 2016
Yum murr, yum hilw (Bitter Day, Sweet Day), 1988
Zuqaq al-Midaq (Midaq Alley), 1963

Cinematic Cairo and the Discourse on Egyptian Urban Modernity: A Prologue

Nezar AlSayyad

This book is the product of a coincidence. In 2018 on a visit to Cairo, where I was giving a lecture on the subject of one of my recent books, I was introduced to Dr. Heba Safey Eldeen, an Egyptian architect and professor who runs a number of cultural centers and programs in Cairo. We discovered that we share many common interests and Heba then invited me, on a following trip, to give a lecture about my work on cinematic cities at El Hanager Arts Center, an institution that is part of the Ministry of Culture in Egypt. Although the subject of the lecture involved discussions of cities like New York and Paris and did not include Cairo or any other Arab city, the lecture was very well attended, mainly by an audience of young professionals: architects, planners, and photographers who were eager to engage with my research. A few meetings with this group in 2018 resulted in the creation of the Cinematic Cairo Working Group. The group met regularly throughout 2019 in a process which allowed us to flesh out the time periods, themes, and films that capture the transformation of Cairene modernity in Egyptian films. By the early summer of 2019, we decided that an edited book should be the output of our collective enterprise. When we proposed the idea of the book to the American University in Cairo Press, the most appropriate publishing outlet for such a work, we were delighted with their immediate interest. *Cinematic Cairo* is the product of this collective thought process.

A bit of personal history may be needed here. I initially began researching the connection between cities and cinema at the end of the twentieth century. Employing my architecture and urban history training, I wrote, produced, and directed a couple of documentary films that dealt with architecture and urban issues, including *At Home with Mother Earth* in 1996 and *Virtual Cairo* in 1998. These visual projects were part history, part contemporary reality, and part narrative fiction. Produced

mainly for the general audience of American public television, these films were well received, and their success led me to experiment with using films in the teaching of architecture and urban history courses. In one of my first seminars that I taught on the subject, the premise was an apocalyptic scenario in which cities like New York or Los Angeles were assumed to have perished in a natural or manmade disaster, and the only evidence that survived about them were reels of fiction films of their cities produced by great filmmakers like Martin Scorsese, Jeffrey Scott, and Woody Allen. I asked my students to reconstruct the imaginaries of these cities assuming that the only evidence we had for them were their images on celluloid. I pondered what kind of history we would write under this condition. My teaching then expanded as I offered a lecture that attempted to narrate the history of a few world cities in Europe and America using film as both the principal form of data and the medium of investigation. And, as I became more involved in the subject, I developed the conviction that the division of spaces into "real" and "reel" is not a useful idea. I started to articulate the notion that reel spaces, because of the power of the cinematic experience, cease to be simply representational spaces as they turn into generative devices that sustain the real city and motor the imagination for alternative possibilities for its growth and critique. This scholarship ultimately resulted in my *Cinematic Urbanism: A History of the Modern from Reel to Real*. Published more than one-and-a-half decades ago, the book became something of a classic over time, particularly for those interested in the relationship between the city and cinema or between reality and virtuality.

Following the precedent of *Cinematic Urbanism*, this book attempts to chart an urban history of modernity in Cairo over a period of a full century. However, unlike the broad Euro-America focus of the earlier book, *Cinematic Cairo* tackles the modernity of a single city during the twentieth century, taking into account its unique status not only within Egyptian history but also within the larger regional cultural context of the Arab world. The book is based on our conviction that in the current era of globalization and the ever-expanding communication technologies, an understanding of the city and urban experience can no longer be pursued independent of the impact of virtual media and, more specifically, cinema. Cinematic space is employed both as an analytical tool and as a subject of critique. The city, real and imagined, experienced and perceived, provides both the spatial domain and medium of this project.

In this regard, the book is not about Egyptian films as artifacts of material culture, regardless of how important these films may be for our analysis. It is also not a book about the real physical fabric of Cairo as a city. Instead, the films about Cairo employed in our analysis become the raw material for the telling of an imaginative alternate urban history of

xxii Cinematic Cairo and the Discourse on Egyptian Urban Modernity: A Prologue

the city. Although some of our chapters will engage with some physical attributes of the city, their focus remains on understanding the connection between the real and the reel in mapping the transformation of the city to urban modernity. However, our book is not only focused on analyzing Cairo as it appears in the films of different decades; indeed some contributors suggest new ways of viewing the urban condition of the city that emerge from analyzing cinematic space. At some level, our project may thus be appropriately subtitled "A Cinematic Epistemology of Cairo."

Visitors to Cairo, and even some of its residents, are often fascinated by the city, its people, its buildings, its social life, and its noise. Many, however, have not been exposed to or have not made the connection to the representations and imaginaries of the city as it appears in film and are often unaware of how Egyptian films have shaped their perception of Cairo. The Egyptian film industry is one of the oldest film industries in the world and it remained very vibrant all through the twentieth century. The films it produced were not only forms of entertainment for the Egyptian people, but were also devices that helped create and articulate the image of Cairo of today. Films in general, and Egyptian films in particular, have been a medium that documented, represented, and reflected human interaction in cities in a manner that no other medium was able to capture.

The relationship between the city and cinema is formidable. The images and sounds of the city found in movies are perhaps the only experience that many in the world will ever have of cities they may never visit. Film captures the mentality of a society, disclosing much about its inner as well as outer life. Films influence the way we construct images of the world and, accordingly, in many instances, how we operate within it. The city itself is a social image which has been studied in various disciplines such as literature, sociology, geography, anthropology, and many others. The links between the "real" city and "reel" city are indirect and complex, but understanding the city in this new age cannot be viewed independently of its cinematic representation. The philosopher Jean Baudrillard has explained this duality between the real city and the reel city by suggesting that, for an understanding of the city, we have to move out from the screen toward the city. However, we believe that a more comprehensive review of this relationship comes not from starting from one and moving to the other, but in doing both simultaneously.

Architecture and urbanism became a fundamental part of the project of modernity in the twentieth century. In this book, we define modernity as an ever-changing experience of encounter between people of different classes, different subcultures, different religions, and different forms of education and knowledge in the spaces of the city. Modernity as seen in the poignant work of Marshall Berman's *All That Is Solid Melts into Air*

was an important frame of reference for many of the contributors to this book. We believe that Cairene modernity played out in the spaces of the city and is often formally consolidated in terms of specific urban forms. Cinema, as a medium and a profession, appeared during a time of major change in the world and in Egypt. Its ability to capture images, process them, and then project them to a general public contributed equally to the making of Cairo's modern image. Egyptian cinema has followed the city, and vice versa, synchronizing its narrative and representational techniques with the spirit of the times. It is this parallel and convergent relationship between the spaces of Cairo in cinema and their real counterparts—a double project in and of itself—which this book hopes to employ to construct an urban history of Cairene modernity in a manner that erodes the boundaries between the real and the reel.

As contributors to this volume, we have not ascribed to a single theory of modernity nor a specific or unified method of film analysis. We felt that each time period and each cinematic genre, as well as each of the films selected, may require different methodological choices. However, we produced a book structure that allows us to cover important events and periods in the history of Egypt that have impacted Cairo and its development. We also each agreed to limit our case studies to no more than four films per chapter so that we can maintain our focus on the specific issues that are relevant to selected themes and time periods. This stemmed from our underlying assumption that the city is not only that which appears on the screen, but also the mental city made by the cinematic medium and subsequently experienced in the real spaces of the physical city. We also understand that the portrayal of space in films is always partial and selective, resulting in different receptions by audiences of different cultures, classes, and even genders. Hence, much of the narrative presented in the individual chapters reflects each contributor's interpretation of these spaces and not necessarily those of a wider Egyptian audience interested in the subject of these films.

The book comprises two parts, each around seven chapters long. The first section includes chapters, arranged chronologically, which use films from the 1930s to the end of the twentieth century to illustrate the development of a modern Cairo and its modern subjects. The second section focuses on tracing the transformation of the cinematic city under conditions of neoliberalism, religious fundamentalism, and class and gender tensions from the middle of the twentieth century to the first two decades of the twenty-first century.

Following this introductory prologue, which fleshes out the discourse on Egyptian urban modernity and the connection to cinematic Cairo, we move to the first part which deals with cinematic Cairo from 1930 to the end of the twentieth century. In the first chapter, titled "Bourgeois Cairo,

1930: Cinematic Representations of Modernity of Place in the Middle-class City," Ameer Abdurrahman Saad uses the films *al-Warda al-bayda'* *(The White Rose)* (1933), *Yaqut* (1934), and *al-'Azima (Resolve)* (1939) to explore the notion of sense of place in bourgeois Cairo in the 1930s. In particular, he studies how the emerging contrast between the modernity of the western part of the city and its more traditional eastern sections affected the bourgeois districts in between. Saad shows how modernity transformed the personality and social standing of the middle-class protagonists, evident from their general behavior and attitude as depicted in the three films. Similar to social status aspirations, conflict was also another facet of modernity experienced in cinematic space, and these conflicts were not just about personal interests, but also about resisting the changes brought by modernity. Those who aspire for evolution and those who reject it were found in both the middle class and the elites. As competition surged, the encounters sparked conflict and individuality, and fueled social fragility, replacing traditional solidarity. The films showed that becoming a modern bourgeois offered salvation for some and afforded middle-class men opportunities for upward social mobility, although this was usually achieved through partnership with upper-class elites.

In chapter 2, which we titled "Naguib Mahfouz's Cinematic Cairo: Depictions of Urban Transformations in Twentieth-century Egypt," Mohammad Salama and I map the transformation of Cairo over the course of the twentieth century as it appears in five important Egyptian films based on the novels of the Nobel Prize–winning author Naguib Mahfouz. After a brief discussion of *Zuqaq al-Midaq (Midaq Alley)* (1963), a film based on Mahfouz's story of a poor Cairo neighborhood during the Egyptian monarchy, we discuss the novel *al-Qahira al-gadida*, made into a film titled *Cairo 30* (1966) that discusses how the corruption of the regime at the time shaped the social life of the city. We then move to the period between 1919 and the late 1940s, seeking to capture the tradition–modernity dialectic as seen through the lens of films based on Mahfouz's *Cairo Trilogy*: *Bayn al-qasrayn (Palace Walk)* (1964), *Qasr al-shawq (Palace of Desire)* (1967), and *al-Sukariya (Sugar Street)* (1969). For us, the three films, which describe the life of a middle-class merchant family in the old city, capture the changing nature of commerce and leisure under colonial rule all the way through the struggle for independence. We conclude with an examination of another Mahfouz novel made into an important film, *Tharthara fawq al-Nil (Adrift on the Nile)* (1971) which captures a dejected Cairo mood following Egypt's defeat in the Six Day War and depicts the feelings and interactions between a group of people from different classes and different neighborhoods, highlighting the different forms of Cairene modernity of that period.

For chapter 3, "Bridge as Border and Connector: Class and Social Relations in Cinematic Cairo, 1940s–50s," Doaa Al Amir and I use the two films *Law kunt ghani (If I Were Rich)* (1942) and *al-Qalb luh ahkam (The Heart Has Its Rules)* (1956) to accentuate the transformation of Cairene society to modernity and the impacts of socio-political change on cinematic Cairo at a time of significant national change. The films show how the 1952 army-led Revolution precipitated a confrontation between Egypt's socio-economic classes and displaced a calmer community lifestyle, more comfortable with tradition and social hierarchy. We show that the distinction in the portrayal of cinematic Cairo between 1942 and 1956 was likely prompted by the political and social change that occurred in the country as a result of the 1952 Revolutionary movement which brought in new conditions of encounter between these classes and created a modernity of aspiration for the masses. But this modernity of aspiration was full of contradictions because it was based on contentment with traditional roles and lifestyles.

Chapter 4 is titled "Cinematic Cairo of the United Arab Republic, 1958–62," and, in it, Kinda AlSamara analyzes three films, the comedy *Isma'il Yasin fi Dimashq (Isma'il Yasin in Damascus)*, the politically charged *'Amaliqat al-bihar (Sea Titans)*, and the romantic film *Sanawat al-hubb (Years of Love)* to explore the influence of films in shaping political awareness by contrasting the two periods before and after the unity between Egypt and Syria and the formation of the United Arabic Republic. AlSamara suggests that the films show how Cairo and Damascus played an important role during the union and postunion period. Produced as a reflection of a new national spirit, the filmmakers, according to AlSamara, translated the realization of their circumstances—or the facts and events they witnessed—which in turn influenced them in a cinematic language. However, she argues that during the postunion period, the filmmakers attempted to uncover the extent to which reality was often falsified. And, from these films, it becomes clear how the cinematic representation of Cairo in terms of its relative advancement compared to other Arab cities of the time helped create Cairo's hegemonic image across all forms of art and culture in the Arab world. AlSamara proposes that such cinematic representations of modern Cairo advanced an imaginary picture of modern culture and identifies a specific flow of ideas related to urban sophistication from Cairo to the surrounding Arab countries.

In chapter 5, "Kafkaesque Modernity: Cairo in the 1980s and the Middle-class Housing Crisis," Ahmed Hamdy AbdelAzim uses the films *al-Hubb fawq hadabat al-haram (Love on the Pyramids Plateau)* and *Karakun fi al-shari' (Prison Cell on the Street)*, produced in the mid-1980s, to examine the effect of social and economic upheaval as a result of migration to Cairo

from the countryside in that time period. It traces the formation of a new social structure and the emergence of a class of nouveaux riches, following the economic restructuring of the Open Door policies of the late 1970s. Poor living conditions forced both its educated professionals and work-skilled laborers to seek a better life in the prospering Gulf states, resulting in a demographic shift and a major housing crisis, particularly for the middle class. AbdelAzim's analysis of these two movies showcases the agony of the protagonists versus the poor response of the state. In both films, the protagonists fail to find an appropriate residence in the city. In *al-Hubb*, the protagonist cannot deal with the logic of the city, preferring to spend time in jail rather than live inside the city, and in *Karakun*, the city pushes the protagonist beyond its boundaries, where he has to reconfigure how to live in the desert. Both films illustrate the necessary urban skills for survival that the protagonists had to adopt during these times, including extreme individuality and what AbdelAzim characterizes as fraudulent cleverness.

We stay with the same time period in chapter 6, "Escaping Cairo: Bureaucratic Modernity in the Cinematic Portrayal of the City in the 1980s," in which Tayseer Khairy discusses Cairo's urban problems in that time period. Employing two films from the realist genre, *Kharaga wa-lam ya'ud (Left and Never Came Back)* and *Huna al-Qahira (Here Is Cairo)*, she explores how living in the big city had become too difficult, stressful, and intolerable. The city, as it is represented in these films, is subject to a warped form of neoliberalism, whereas the daily life of Cairo's residents is devoid of any urban comforts or pleasures. She suggests that the condition of Cairo at that time was a modernity of bureaucracy that drove its citizens toward a mental breakdown. The films show that escape to the countryside and even out of the country altogether became the only viable option to deal with the ever-changing oppressive economic and social conditions of the city.

In chapter 7, Mariam S. Marei takes us into the last decade of the twentieth century by focusing on the different conditions that characterized the 1980s and how they changed by the mid-1990s from the special perspective of the "driver." In her "Cairo beyond the Windshield: From the Modernity of Realism to Surrealistic Postmodernity, 1980s–90s," she uses the films *Sawwa' al-utubis (Bus Driver)* (1982) and *'Afarit al-asfalt (Asphalt Devils)* (1996) to show changes not only in Cairene urban attitudes toward their city, but also the accompanying changes in Egyptian cinema. She argues that in the 1980s, films attempted to capture the struggle between traditional ethics and conduct and new forms of behavior emerging as a result of the Open Door policies. But by the 1990s, the outcome seems to have been an escapism from an unbearable urban present to an introverted imaginary world which she labels surrealistic postmodernity. Comparing the making of the two films and their connection to urbanism, Marei views

Sawwa' al-utubis as a modern film about Cairo as a modern city with all of the encounters and conflicts that occur in urban modernity. However, she suggests that *'Afarit al-asfalt*, on the contrary, is a cinematic narrative that uses postmodern film techniques to illustrate the postmodern condition of Cairo as an increasingly fragmented neoliberal city. It is as if the modern situation of the city required a modern storytelling form making the real and the reel identical, while its postmodern condition could best be represented in the reel medium using a similarly congruent narrative.

The second part of the book deals with a variety of themes in the transformation of cinematic Cairo. We start this section with the chapter "Transformations in the Cinematic Space of a Cairo Suburb in the Late Twentieth Century," by Farah K. Gendy. In this, Gendy outlines how urban modernity in Heliopolis, a major Cairo suburb, has changed over three decades, using the films *Ard al-ahlam (Land of Dreams)* (1993), *Fi sha'it Masr al-Gadida (In the Heliopolis Flat)* (2007), and *Heliopolis* (2010). Following a chronological review of Egypt's political, economic, and socio-cultural changes in the second half of the twentieth century, the selected films demonstrate the urban change that turned a garden city/ oasis in the desert to a congested district that is part of a large metropolis. Through a dissection of the consumption and reproduction of urban space in the three films, Gendy is able to chart the changing perception of the suburb in the eyes of its inhabitants. Her chapter became very timely as, while it was being written, the government began building overpasses and bridges in Heliopolis that changed the character of this significant modern urban setting, possibly leaving films, like the three employed in this analysis, as a historic archive—not only of its built environment, but also of the spirit of its time.

In chapter 9, "From *Hara* to *'Imara*: Social Transformations in Cinematic Cairo," Mirette Aziz exposes the thriving social mobility and economic development in Egypt and reveals the origins of the gap between classes in modern Cairo. Aziz makes the argument using the films *Shari' al-hubb (Love Street)* (1958) and *'Imarat Ya'qubyan (The Yacoubian Building)* (2006). In the two films, both the *hara* and *'imara* were cinematically dealt with as urban spaces that represented many of the traditional values of Egyptian society and the social transformations of Cairo over the second half of the twentieth century. The analysis of the two films illustrates the change in cultural meanings and values of Cairo's current urbanism and highlights the contrast between the utopian aspiration of the *hara* and the dystopian reality of the *'imara* (the *hara* being the traditional old quarter in the city while the *'imara* is the modern apartment building). Aspirations to modernity in the *hara* of *Shari' al-hubb* require a temporary departure from it, while the condition of the *'imara* in *'Imarat Ya'qubyan*, whose modernity was long gone, depicts a

fragmented neoliberal city. As such, the building becomes a microcosm of the whole city with the appearance of the informal and illegal activity on its rooftop within the older formal modern structure.

Chapter 10, titled "Cairo's Cinematic Coffeehouses: Modernity, Urbanity, and the Changing Image of an Institution," by Khaled Adham, builds on the premise that films are an integral part of the urban environment; therefore, cinematic representations over time reveal much about urban transformations in the city. It argues that, throughout much of the twentieth and twenty-first centuries, both urban theories and cinematic representations of Cairo have been linked through their reflections on the city's social, political, cultural, and spatial spheres. In the chapter Adham examines a selected group of Egyptian films that describe, portray, or represent the *qahwa*, or the traditional coffeehouse, and traces its transformation in a chronological order, following the historical timeframe of events: colonial era, Social Nationalism, early Egyptian capitalism, and neoliberal Egyptian capitalism. He proposes the *qahwa* as a bridge between the real and the reel, and argues that the cinematic *qahwa*, like its real counterpart, has undergone a process of modernization and globalization which also makes it another microcosm for what the whole city experienced from its colonial times to its current neoliberal state.

In chapter 11, "Gendered Modernity: On the Changing Role of Women in Modern Cinematic Cairo, 1950s–2000s," Nour Adel Sobhi highlights the issue of gender through the lens of Cairene cinema. She provides a review of the portrayals of women in twentieth-century Egyptian films and shows how cinematic modernity affected women's lives. She suggests that middle- and upper-middle-class, and even urban poor, women have always faced challenges, but that by the mid-twentieth century, women were starting to break social taboos, access higher education, work, and raise their incomes. Using four films that highlighted the connections between personal experience and larger social and political structures—*Ana hurra (I Am Free)* (1959), *Mirati mudir 'amm (My Wife Is a General Manager)* (1966), *678* (2010), and *Nawwara* (2015)—Adel shows how, half a century after the first film, women were still struggling in the streets, at their work places, and on the transportation of both the real and the reel city. The four films accentuate the fact that the changing role of women over the last few decades might have given women a sense of freedom disguised behind burdens of responsibilities toward their families and communities. Harassment extended from overprotection, to dominance in the home and neighborhood, to verbal and physical abuse, and finally reaching physical sexual harassment. Adel suggests that modernity has not liberated women in either the real or the reel media and that the recurring melodramatic victimization of women as shown in

the twenty-first century is a reversal of the trend to showcase empowered woman in mid-twentieth-century films.

In chapter 12, Hala A. Hassanien examines the changing place of religion in the city in "Religious Tolerance in the Cairo of the Movies, 1950s–2000s." She comments that, through its long history, Cairo provided a home for Muslim, Christian, and Jewish communities. However, the 1952 Revolution and the rise of Arab nationalism resulted in the emigration and expulsion of the city's Jewish community in the 1950s. Then, starting in the 1980s, other political factors began to create divisions between the city's Muslim majority and Christian minority, which developed into massacres by the turn of the century and in the aftermath of the 2011 Revolution. Using the two films *Hasan wa Murqus wa Kuhin (Hasan and Morqos and Cohen)* (1954) and *Hasan wa Murqus (Hasan and Morqos)* (2008), Hassanien tracks these changes by investigating the transformation of these urban communities and concludes by discussing how the attempts by the Egyptian film industry to smooth social discord in cinematic Cairo also document the extent to which fundamentalist attitudes controlled much of social behavior in the real city.

Chapter 13, "The City of a Thousand Minarets and a Million Satellite Dishes: The Dilemma of Islam and Modernity in Cinematic Cairo," by Muhammad Emad Feteha, also contributes to the ongoing debate regarding religion and the city. Since the Revolution of 1952, the conflict between the secularists and the Islamists has passed through different stages, with an initial retreat and later expansion and transformation of the role of Islam in the life of the Cairenes. Feteha analyzes three films that depict significant moments in the history of this struggle, *al-Sheikh Hasan (Sheikh Hassan)* (1954), *Lili* (2001), and *Mawlana (Our Sheikh)* (2016). The protagonist of each of these three films is a sheikh, or Muslim cleric, a character which allows us to closely view the changing status of Islam within society in cinematic Cairo through their eyes. The earlier film, *al-Sheikh Hasan*, presents to us the traditional view of the role of the religious preacher in the life of the community at the time of Cairo's exposure to modernity, where the mosque is the space of redemption. *Lili*, at the turn of the century, captures the moral struggle of the sheikh, where conflict exists over what defines morality within the city in light of the conflict between the Islamic ethical tradition and the urban life of modern Cairo. The opening scene of *Mawlana* shows an aerial view of Islamic Cairo in 2016, with a skyline constituted of traditional minarets and modern satellite dishes, an image that perfectly depicts the struggle that the city has been witnessing between the soul of Islam in Egypt and the dilemmas of modernity in contemporary Cairo.

Finally, in the last chapter in the book, "Women's Right to the City: Cinematic Representation of Cairene Urban Poverty," Heba Safey Eldeen

and Sherien Soliman examine the poor popular urban quarters of Cairo through cinema. Using three films that span the three decades of Hosni Mubarak's rule—*Yum mor, yum helw (Bitter Day, Sweet Day)*, *Khaltit Fawziya (Fawzeya's Formula)*, and *Yum li-l-sittat (A Day for Women)*—they reflect on the reality of working women in the popular urban quarters of the city. Through the films, they investigate women's right to the city from three major viewpoints: the cinematic representation of women's roles within the overall social structure of the marginalized Cairene communities; the representation of urban poverty in the areas where women struggle to survive in informal areas; and the representation of gender power relations in the urban spaces of the city. They conclude by demonstrating that women in poor urban areas exhibit traits of wittiness, hospitality, and solidarity that allow them to care for one another in their community. With little or no formal education, they work in or run small businesses that contribute substantially to the microeconomy of their neighborhoods. They suggest that in both the reel medium and in real life, Cairene women defy the socio-physical barriers imposed upon them as they turn deteriorated urban pockets in the city into work places and spaces for leisure and interaction.

I hope that the content of each contribution, the detailed scope of the films used in each chapter, the historical chronology presented in the first part of the book, and the specific themes that we analyze in the second part have all built a substantial image of cinematic Cairo over a whole century, in a manner that allows us to understand the current city, its transformations, its encounters with modernity, and its possible futures—both the real and the cinematic.

References

AlSayyad, N. 2006. *Cinematic Urbanism: A History of the Modern from Reel to Real*. London: Routledge.

———. 2011. *Cairo: Histories of a City*. Cambridge, MA: Harvard University Press.

———. 2019. *Nile: Urban Histories on the Banks of a River*. Edinburgh: Edinburgh University Press.

———, ed. 2001. *Hybrid Urbanism: On the Identity Discourse and the Built Environment*. Westport, CN: Praeger.

———, ed. 2004. *The End of Tradition?* London: Routledge.

Amin, G. 2000. *Whatever Happened to the Egyptians?* Cairo and New York: The American University in Cairo Press.

Anderson, B. 1991. *Imagined Communities: Reflections on the Origin and Spread of Nationalism*. London and New York: Verso.

Baudelaire, C. 1970. "Eyes of the Poor" and "Loss of Halo." In *Paris Spleen*, translated by L. Varese, 52–53, 94. New York: New Directions.

Baudrillard, J. 1997 "Aesthetic Illusion and Virtual Reality." In *Art and Artifact*, edited by N. Zurburgg, 19–27. London: Sage Publications.

———. 2001. "Simulacra and Simulations." In *Jean Baudrillard: Selected Writings*, edited by M. Poster, 169–87. Stanford, CA : Stanford University Press.

Berman, M. 1982. *All That Is Solid Melts into Air*. London: Penguin Books.

Calvino, l. 1993. "The Cinema-Goer Autobiography." In *The Road to San Giovanni*, tranalated by T. Parks, 37–73. New York, NY: Pantheon Books.

Clarke, D., ed. 1997. *The Cinematic City*. London: Routledge.

Debord, G. 1994. "Unity and Division within Appearances." In *Society of the Spectacle*, translated by D. Nicholson-Smith, 35–46. New York: Zone Books.

Foucault, M. 1997. "Of Other Spaces: Utopias and Heterotopias," "Panopticon," and "Space, Knowledge, and Power." In *Rethinking Architecture*, edited by N. Leach, 350–79. New York: Routledge.

Gold, J. 1999. "From 'Metropolis' to 'The City': Film Visions of the Future City, 1919–1939." In *Geography, the Media and Popular Culture*, edited by J. Gold. London: Croom Helm. 123–143.

Harvey, D. 1990. *The Condition of Postmodernity: An Enquiry into the Origins of Cultural Change*. Cambridge, MA, and Oxford: Blackwell Publishers.

Lamster, M., ed. 2005. *Architecture and Film*. New York: Princeton Architectural Press.

Leigh, N., and J. Kenny. 1996. "The City of Cinema: Interpreting Urban Images on Film." *Journal of Planning Education and Research* 16, 1: 51–55.

McLuhan, M. 1964. *Understanding Media: The Extensions of Man*. Cambridge, MA: MIT Press.

Neumann, D., ed. 2000. *Film Architecture*. Munich: Prestel-Verlag.

Penz, F., and T. Thomas, eds. 1989. *Cinema and Architecture*. London: British Film Institute.

Rodenbeck, M. 1989. *Cairo*. London: Penguin.

Roy, A. 2001. "Traditions of the Modern: A Corrupt View." *Traditional Dwellings and Settlements Review* 12, 2: 7–19.

Shafik, V. 2007a. *Arab Cinema: History and Cultural Identity*. Cairo and New York: The American University in Cairo Press.

———. 2007b. *Popular Egyptian Cinema: Gender, Class, and Nation*. Cairo and New York: The American University in Cairo Press. 215.

Shields, R. 2003. "The Return of the Virtual." *The Virtual*. London: Routledge.

Shonfield, K. 2000. *Walls Have Feelings: Architecture, Film and the City.* London: Routledge.

Sims, D. 2012. *Understanding Cairo: The Logic of a City out of Control.* Cairo and New York: The American University in Cairo Press.

Singerman, D., and P. Amar. 2001. *Cairo Cosmopolitan.* Cairo and New York: The American University in Cairo Press.

PART I:
Cinematic Cairo, 1930 to the Present

1

Bourgeois Cairo, 1930: Cinematic Representations of Modernity of Place in the Middle-class City

Ameer Abdurrahman Saad

The 1930s witnessed the emergence of cinema in Egypt amid a multitude of national and international events. It was the time when Egypt, a new kingdom under colonial rule, was undergoing a significant modernization alongside a national awakening. Cairo had witnessed modernity earlier, with the arrival of the French campaign, and it was Muhammad 'Ali and his descendants who carried the torch of modernization thereafter. Encouraged by the state, the community embraced modernity which, in turn, reshaped relationships among individuals. During a century-long transformation, Cairo evolved into two distinct cities: the medieval city and the modern city. The modern city was overwhelmingly populated by European inhabitants who were state officials and investors, while the medieval city was inhabited by the native Cairenes who were yet adapting to the ongoing changes. Aspects of Western modernity gradually diffused into the medieval city, and its middle-class inhabitants were required to navigate their everyday life through the modern system. The film industry emerged as part of the entertainment market, where leisure activities became commodities. Films representing Cairene experience in this period found rich material and garnered attention as they depicted the struggles of the Egyptian people amid modernity.

In this chapter, we discuss three films that narrate three different Egyptian middle-class stories. These are *al-Warda al-bayda' (The White Rose)* produced in 1933, *Yaqut* produced in 1934, and *al-'Azima (Resolve)* in 1939. These films represent stories of individuals who seek to live as modern bourgeois for different reasons. They represent the class that is most vulnerable to the changes brought about by modernity. All the stories explain ways in which the protagonists have to handle the challenges thrown at them by modernity.

We start with a discussion of how Cairo was transformed by modernity as it was embraced by the state. Special attention is given to the middle

class throughout this chapter to provide a better picture of their situation during the 1930s. Analysis of the three chosen films allows us to review the cinematic city in two respects: first, we investigate the representation of the middle-class city and its encounter with modernity as discussed in the academic literature; and, second, while employing the lens of place, we study the middle-class city to understand the role of modernity in shaping and transforming its spaces. This is followed by a comparative analysis of the cinematic city versus the reality of Cairo at that time. As a result, we can finally grasp the filmmakers' own stance regarding the urban experience of the Cairene middle class in the 1930s.

Cairo in the 1930s: Modernity without Industrial Modernization

A visitor roaming the streets of modern Cairo in the 1930s would encounter a city that resembled many European cities like Paris or Barcelona. The industrial modernization of Europe was initiated by the need for the efficiency and productivity of an industrialized society; in contrast, however, modern Cairo's planning regulations did not serve any industrial purpose and did not impact the wider masses of the city, as Egypt remained an agricultural economy till the early twentieth century. As clarified by Raymond, the attempts of Muhammad 'Ali, the founder of modern Egypt, to industrialize the country partially failed for a number of international and national reasons (Raymond, 2001). During the reign of his descendants, mainly under colonial rule, the state was more interested in visions of urban development (Rodenbeck, 1999). Accordingly, a reliance on industrial modernization as a framework to understand Cairene modernity in the early twentieth century would not be very relevant in this case.

Unlike industrialization, capitalism had been evolving in Egypt in the shape of commercial agriculture even before the arrival of Bonaparte (Al-Shalaq, 2006). The colonization of Egypt expanded the presence of capital in everyday Cairene life. Rodenbeck's description of how capitalism directed investment in colonial Egypt is useful here. The British ran Egypt as a business that needed to pay its debts and generate profit from buying British goods. They invested in order and in infrastructure. The main businesses were cotton export, real estate, and tourism (Rodenbeck, 1999). Obviously, the economic sectors related to those businesses thrived in the city. In Cairo, traditional middle-class market sectors like traditional crafts and trades had to find their place in the new economic system. Rodenbeck explains that traditional crafts went out of market quickly as they had to face an increasing influx of European goods. The tourism-related traditional crafts were the only ones to survive thanks to the support they found in the flow of tourists. Medieval Cairo for them was an exotic place of thrill and picturesque sketching (Rodenbeck, 1999; AlSayyad, 2011). The

traditional building crafts suffered decline, even before colonialism, at the hands of Muhammad 'Ali who banned many traditional practices. By the time Isma'il, Muhammad 'Ali's grandson, became khedive, European-style regulations had enforced a new image on the city and changed its architectural character. Accordingly, the traditional workshops and craftsmen had to adapt their practices to match the new national image.

The European-inspired urbanism spread at a much larger scale in modern Cairo, which was the center of the real estate market. The foundations laid by Khedive Isma'il encouraged development. Electricity networks and tramway lines were developed by foreign investors. A central business district emerged, with Parisian style apartment buildings (AlSayyad, 2011). Rodenbeck (1999) explains that the property development boom led to a ten-fold increase in plot prices in the twenty years before World War I.

The modern city was the location of large capital businesses and a home for wealthy clients. Abdelmonem explains that the businesses in medieval Cairo only served their local neighborhoods. They were small-scale businesses with limited capital and were owned by traditional middle-class individuals. Significant trades and businesses moved to the more stylish modern city (Abdelmonem, 2017). These developments in the economic context reshaped the emerging middle-class choices and visions.

Decline of the Traditional Bourgeois and the Embrace of Modernity

The medieval city was transformed as a consequence of the state aspirations for modernity. The traditional bourgeois lost their status as the newly wealthy families moved out from the medieval city to the modern city and embraced the new modern business culture (Rodenbeck, 1999; Abdelmonem, 2017). According to new regulations, the traditional introvert courtyard houses were replaced with smaller, multistory, street-facing apartment buildings. The traditional design and construction processes performed by the master builder were replaced by modern processes of design, permit, and inspection (Abdelmonem, 2017).

The decline of the medieval city and its businesses forced the remaining traditional bourgeois to find additional sources of income. Transforming the ground floor of their buildings to retail units provided assistance in this (Abdelmonem, 2017). But a change in the people's mindset seemed equally necessary. Due to ambitions of social mobility, Cairenes started embracing modern education rather than the traditional *kuttab*. One out of three Cairene children sought education in French and English schools for the clerkship opportunities they promised (Rodenbeck, 1999). Also, the Egyptian University provided a modern higher education alternative to the traditional al-Azhar. However, tuition fees were set to filter out the

poor (Reid, 1990). It provided a chance for the middle class to encounter the elite youth, not as their subjects, but as equals and rivals.

Moreover, commercial entertainment emerged around the turn of the twentieth century. As Egyptian society embraced modernity, entertainment was consumed publicly. Cinemas, which started to emerge as forms of leisure, were commercialized by the modernizing middle class (Ryzova, 2014). By the 1930s, liberal elites like Tal'at Harb established the first Egyptian studios for cinema production (Shafik, 2007). This made the entertainment industry become a part of the Egyptian National Project. These conditions held promise of a successful future for film, in spite of the inevitable disapproval of traditional societies.

The elites were the first who adopted modern habits and lifestyles during the nineteenth century (Pollard, 2003; AlSayyad, 2011). By the 1920s, most Cairenes adopted the modern jacket and tie and would casually speak French phrases as signs of modernity. Middle-class homes displayed Louis XVI–style furniture and tableaux (Rodenbeck, 1999). These transformations in all aspects of the Cairene experience entailed an evolution in the practices and values of its community, and a remarkable departure from tradition.

Berman explains the nature of capitalism in the context of market competition. In the case of the Cairene middle class, this applies to opportunities of social mobility. Inevitably, individuality surges as opportunities run short and traditional moral codes melt amid competition. Only solidarity can provide resilience. Building social support networks was a necessary insurance against descending the social ladder. Market fluctuations could even make pashas bankrupt. Indeed, capitalism renders status volatile and fragile. A status is only as static as the market opportunities allow it to be (Berman, 1982).

In his discussion of Charles Baudelaire, Berman also explains that the construction of boulevards—the modernist urban innovation—aimed to open up the inaccessible medieval city for efficient mobility. But they also connected communities that had been earlier isolated from each other and forced an encounter between people of different classes, creeds, and professions (Berman, 1982). Modern Cairo's boulevards were a world apart from the medieval city. But the new modern district of Cairo in its early days was mainly populated by Europeans and possibly tailored to a Western culture. This may have discouraged Cairenes living in the traditional quarters from engaging with the modern city and its people.

Modernism is an aesthetic movement of modernity. It focuses on aesthetics rather than on function. It was a practice of individualism (Harvey, 1992). But Western modernism shared little with its version of colonial Cairo. During this time, the Egyptian modern identity developed. Intellectuals were engaged in the nationalist movement focused on independence.

Egyptian modernism in art acknowledged Islamic culture and history, but refused to be defined or confined by it. Modern artworks broke from traditional Islamic art (Seggerman, 2019). Writers of the early twentieth century were conscious that modern Egyptian identity was rooted in its culture in spite of their employment of Western writing principles. As Armbrust (1996, 2002) explains, even in Egyptian cinema, modernism aimed to establish this connection with the past. Shafik (2007) argues that Egyptian cinema of that period played the role of upholder of moral values. El Khachab explains that modernism in the Middle East cinema did not follow the Western canon of aesthetics. The main aspect of modernity discussed in regional cinema was the dilemma of identity and the struggle between modernity and tradition. He explains that as Egyptian cinema evolved in its coverage of the issues of modernization and the modernity of the working class, it became more representative of its new modern subjects. He concludes that the realism of Egyptian cinema may represent its modernist version (El Khachab, 2015).

A Lens on Place Construction and the Link to Cinematic Space

Places emerge as the outcome of people coming into spaces. Gehl (2013) explains people's interaction with space in three levels: performing necessary activities, performing social activity, and passively observing the space as a spectator. In his explanation of social psychology, Crisp explains that social activity on its own holds a spectrum of components which can affect a person's cognition. Behavior and response change according to the situation and according to the relationships that tie people together (Crisp, 2015). These interactions provoke impressions which get attached to the experience of space and place (Sepe, 2013). In film, the experience of the characters is necessarily charted to reflect the filmmaker's skill in narrative communication. Nevertheless, the filmmaker might deliberately leave certain aspects open to provoke the viewer's engagement.

Places are important components of film. The more the place is weaved into the film narrative the more it allows the viewers to suspend their disbelief and immerse in the film's universe. Films are essentially subjective constructions; they are built up of fragments of space and time that are arranged to serve the narrative. It is necessary for the film structure to be readable to the viewers in order to make sense of the narrative and prevent them from being disoriented. To this end, films use space to define the geography of the cinematic world.

Cinematic spaces play varying roles in films. In early films and in low-budget production, they may be reduced to a mere backdrop or stage with no connection to the narrative or the action. Moreover, Altken and Zonn (1994) explain that cinematic space in such cases puts the narrative

and the action as the central subject. Lukinbeal (2005), as well, explains that cinematic spaces can be used in a variety of ways to support the narrative, such as defining places, as metaphors or as spectacles. As spectacle, master shots or long shots introduce wide spaces to the audience to speculate about the geography of the cinematic universe and make sense of it.

The activities and events decide the significance of spaces and eventually define cinematic places. Places can then act as symbols for the meanings they represent. In such cases, the film uses place to present the viewer to a subject of cultural politics. It is possible that the symbol builds on the viewers' knowledge of the urban and cultural icons from their stereotype legacy, and films can either reinforce this stereotype legacy or challenge it.

Throughout the film, characters engage in different spaces. Each space stages multiple situations between different characters. As the character develops, places emerge and transform. Seamon uses John Sayles's *Sunshine State* to explore the representation of the phenomenology of place through filmic space. He explains how different interactions between characters and within spaces express different experiences of place (Seamon, 2008). This chapter examines the representation of such place dynamics to explore the impressions of the city as intended by the filmmakers. The chapter examines the representation of the middle-class city against the description of Cairo in the academic literature.

We will proceed to extract from the selected films the represented spaces that constitute the middle-class world and analyze their physical setting and components. We will also analyze the movement and focus of the camera in order to grasp the intended messages regarding the perception of place in the film. The background of the characters, the relationships between them, and their behavior in different situations expose the meanings that become attached to the places for each one. Ultimately, the impact of change on any of the characters, their behavior, or their spaces is studied for what it may entail for the emergent places.

If we are to understand the representation of place in cinema, we have to consider how we perceive the physical setting. The mise-en-scène language and scene sequences are intended to communicate with the spectator. Rasmussen (1964) opposes the idea that space is experienced only visually and explains that many sensual systems get into action to construct our impression of a space. Gibson (1983) also developed five perceptual systems of space of basic orienting, which are represented by the camera angles. Film directors use them to steer the viewers' minds toward specific items or compositions to aid in conveying the intended message. Gibson also discusses the haptic system as one of the perceptual devices the mind employs to experience a space. Pallasmaa (2000) expands on this system by explaining that our subconscious vision forms the majority of our

perception of a place. Koeck follows Ponty, in addition to Rasmussen and Pallasmaa, for the analysis of the experience of cinematic space. He uses Ponty's geometric space to explain that our perception of space is a result of all our sensual input as structured by the mind (Koeck, 2013). We view the action in a film in the way the filmmaker intended to communicate. But it is not only through the visual language that films speak to us; we must also consider the impressions we get as viewers regarding the places and spaces as part of the intended messages of the film.

Accordingly, I approach "place" in two fundamentally different ways. I understand place in terms of "place theory" as the entire location in which things happen and as the arena in which individuals move in the manner that defines them. I am also interested in place as the location in which activities happen in the virtual space of the film.

Egyptian Cinema of the 1930s

In Egypt, the 1930s witnessed the first talking films and Cairo was the Middle East capital of cinematic production. Several films of that period tell stories about old fantasies or village or nomad tales, which is understandable given the emergence of the film industry as an entertainment genre. In such a context, the three films discussed below stand out among their contemporary equals through the immediate questions they address and their relevance to typical middle-class issues. The protagonists in all three films are middle-class men who are trying to find happiness in helping people, including themselves. This section of the chapter starts with a summary of each film and ends with a critical discussion of the struggles of modernity they display, the statement they represent by the end, and the manner in which they intersect and diverge.

al-Warda al-bayda' (The White Rose) 1933

The film stars Mohamed 'Abdelwahab as Mohamed Galal; Soliman Najeeb as Isma'il Pasha; Samira Khlosy as Raga', Isma'il's daughter; and Zaki Rostom as Shafik, the uncle-in-law of Raga'. Galal is a university graduate who lives in Abdin district, a district on the edge of modern Cairo. He is a descendant of an elite family which went bankrupt and is employed by one of his father's old friends. His workplace is in the pasha's villa, which allows him to meet his daughter. He is punished for falling in love with the pasha's daughter by the termination of his employment. Knowing that typical employment will not better his social status, he enters the entertainment business as a musician. He rises in status, fame, and respect, but is still not acknowledged by the elite. His only hope is to perform in the opera house, a venue that can help him earn the respect he needs in the elites' eyes, but it is a dream that is never realized through the film.

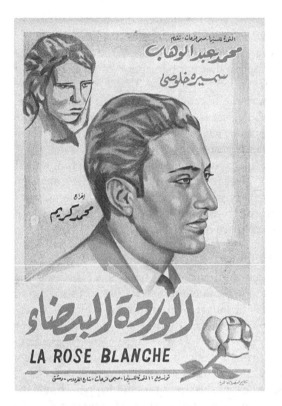

1.1. *Al-Warda al-bayda'* employing 'Abdelwahab's fame in marketing the film.

Yaqut 1934

Yaqut is Naguib al-Rihany's first talking film, in which he plays the role of Yaqut. It also stars Emy Brevannes as Roudy, Yaqut's wife, and Edmond Tuima as Salem, Yaqut's friend. Yaqut is an accountant and rent collector for one of the foreign employers in Cairo. He is approached by Salem asking for his help to get a job to support his family. One day, Yaqut faces trouble at his work as he arrives late. He tries to compensate for this by making sure he brings in all the late rent that day. However, he gets stuck in one villa because the tenant is not available. As he runs late in bringing back the rent to the office, his employer follows him to the villa and tells him he is fired. Roudy, the French tenant, witnesses his devotion to the job and the tyranny of his employer. She offers financial support to make up for the lost job, but he does not accept it—a response that arouses her admiration of his nobility. The plot develops as she gets to know him better and they get married. Their marriage undergoes some tension, as Yaqut is uncomfortable about the cultural difference between the Western lifestyle versus the traditional Egyptian values of the man he is. He decides to leave Roudy in France and, along with his friend Salem, who has become

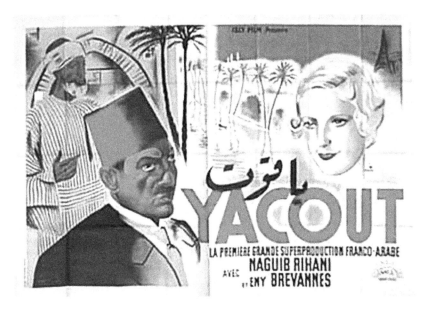

1.2. Being a Franco-Arab production, *Yaqut* may have lost the support of nationalist elites.

Roudy's secretary, to return to the *hara* in Cairo. However, he learns of the death of Roudy's father and gives up the idea to stay with her for the time being in France.

al-'Azima (Resolve) 1939
The film is ranked second on the list of the best 100 films in the history of Egyptian cinema. The main characters are Hanafy, played by Hussein Sidqy; Fatma, Hanafy's wife, played by Fatma Rushdy; Adly, Hanafy's elite friend, played by Anwar Wagdy; Nazih Pasha, Adly's father, played by Zaki Rostom; and Me'alim 'Etr, the local butcher, and rival for Fatma's hand, played by 'Abdel 'Aziz Khalil. Hanafy is a lower-middle-class citizen who lives in medieval Cairo with his father and grandmother. His father invested in his education, believing that a university degree would guarantee a good future and financial status for his son. Throughout the film, Hanafy engages with the community's elite whom he meets in the university and at work, both of which are located in modern Cairo. It is also where he encounters competition from his colleagues, who strive to secure their position in Western workplaces. Career challenges take Hanafy into status turmoil, after which he emerges as an entrepreneur and earns the status he has long been seeking. Finally, he is only able to rescue Fatma from marrying 'Etr through the help of his neighbors.

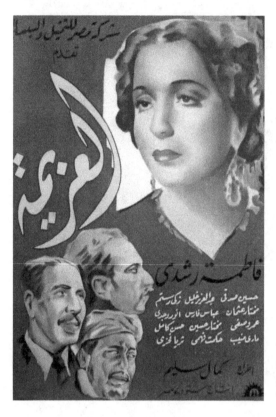

1.3. Fatma Rushdy is the central figure of the poster for *al-'Azima*, presumably for her fame as a singer.

Modernity's Challenge to the Status Quo

The theme of modernity has a profound impact on the plot and the development of the characters through the three films. Armbrust explains that *al-'Azima* and *al-Warda* can be considered modernists for their social criticism and because the films are not about the love story they tell itself, but rather its context (Armbrust, 1996). Al-Rihani's *Yaqut* addresses the same topics through a more controversial narrative and with a clear flavor of traditional values which makes it good material for the present discussion.

Social class difference was a prominent component of Cairene everyday life. The apparatus of modernity in Cairo created opportunities that challenged the existing social structure. *Al-Warda* expresses the impact of capitalism early on, in the introduction of Galal as a fallen aristocrat. As a middle-class employee, Galal ressembles a servant; his office is on the basement level of the pasha's villa. His need to transcend his social and economic class leads him to give up his job to become a musician. By the end of the film, Galal, the famous musician, becomes the one offering assistance to his middle-class friends. Yaqut represents Roudy as one of the

world's richest, arriving in Cairo as a tourist. Her European background allows her to recognize Yaqut's qualities unaffected by local social or economic perceptions. The forbidden marriage of Yaqut is possible for Yaqut and Roudy thanks to her modernist culture. In *al-'Azima*, elites and middle-class men become colleagues because of the modern university where Hanafy enjoys intellectual superiority over many of his elite colleagues. In addition, his disciplined character earns him the pasha's respect; his voice is heard by Nazih Pasha over Adly's. Nazih welcomes Hanafy into his villa and blesses a partnership between him and Adly.

Discussion of traditional views fills the three films. *Al-Warda* challenges the common perception of class limits: Isma'il is the "traditional" person who acknowledges Galal's qualities, but only as an employee and never as Raga''s husband, first for his financial status and later for his profession. He ends up marrying his daughter to a dishonest man. In contrast, Galal employs his talent in the music business regardless of societal views. The film is a statement about the obsolescence of traditional perceptions. *Yaqut* praises the elites' traditional East for its spirituality and simplicity compared to the materiality of the modern West. Yaqut represents traditional values of honesty, consideration, charity, solidarity, and rejection of the Western habits he witnesses in Paris. However, the film shows how few the intersections between tradition and modernity are. Eventually, the couple returns to Cairo in spite of all the privileges they enjoyed in Paris. The film is an approval of tradition and a statement of its incompatibility with the materiality of the modern. *Al-'Azima* represents total immersion in a traditional community. Several traditional values expressed in *Yaqut* are represented here. However, they are not shared by the whole community. Instead, several values of modernity emerge among them, such as competition for personal interests and taking advantage of others' losses. The film underscores the replacement of traditional values by materially measured decisions.

The three films suggest that employment in modern businesses was not always sought as a means to social mobility. In *al-Warda*, Galal needs employment only to fulfill his basic maintenance needs. His need for social mobility only emerges as he aspires to marry Raga'. Yaqut also shows a lack of interest in social mobility. He seeks employment only as a matter of self-satisfaction. As he moves with Roudy to Paris, his main interest is in Roudy herself, not her wealth. When they grow apart, he prefers to return to the *hara*. Similarly, Salem is more interested in sticking with Yaqut than securing social or financial status. *Al-'Azima* represents social mobility as a central subject in a traditional community. Hanafy is a local wonder because of his bold investment in getting a modern education. His success or failure would prove the obsolescence of the rigid traditional views of people like 'Etr. This buildup

Modernity's Challenge to the Status Quo 13

serves the narrative in representing the nature of modern employment. Hanafy's moment of crisis comes with his employment as an office assistant in a modern department store. His job is considered lowbrow enough to cost him his marriage. Ironically, he accepts this employment because it exists outside the traditional neighborhood and requires limited contact with the traditional community. The film does not show him suffering a financial crisis, but rather a social one based on image. That external employment allows him to evade communal judgment, but only for a limited time.

The reactions of the protagonist's community are different in each film. The films present the opportunities and challenges faced by the protagonists and highlight the importance of belief in the self, spiritual and otherwise. *Al-Warda* shows total lack of social solidarity leading to one crisis after another for the film's protagonist. It begins as Galal's employment is terminated. The film shows him receiving no sort of support. He finds inspiration and belief in the achievements of great musicians of the time and gives up traditional employment for the profession of music, regardless of its reputation. Similarly, the collapse of his affair with Raga' is also a result of their isolation. They are deceived and cornered in spite of their struggle to gain a chance for a future together. In contrast, *Yaqut* shows many signs of social solidarity. The opening scenes of *Yaqut* show several acts of assistance to others. Yaqut's conflict with his employer is a result of his being considerate of the situation of the tenants. Also, Salem supports Yaqut by refusing to benefit from his termination, even if it would mean solving his own problems. At this moment of absolute belief, assistance comes in the form of Roudy's interest in Yaqut. In Paris, Roudy's continued absence leads to Yaqut's decision to return to Cairo. Traditions and social cohesion are more important for him than whatever Paris has to offer. *Al-'Azima* displays both social solidarity and prejudiced competition. Hanafy faces both conspiracy and support from the elites, his co-workers, and his local community. Hardships push Hanafy to the edge of despair at various moments in the film. He is only able to survive through all the support he receives. In *al-'Azima*, solidarity becomes a necessity for subsistence rather than a choice inspired by traditions as in *Yaqut*.

The Middle-class Cinematic City: Intersecting Representations
This part looks at the cinematic city in comparison to the city described in academic literature. The three films were filmed in studios, and only *al-'Azima* was shot in an Egyptian studio. Looking at the three films together, we can find similarities in their representation of Cairo at that time. Together, they present nearly all types of districts described by the literature. In addition to the traditional and modern cities, two notable variations are identified.

The modern city of *al-Warda*

Al-Warda represents a completely modernized city. The tram appears in brief scenes, even if Galal never rides it. Urban scenes show wide streets with pedestrian sidewalks. As someone who has received modern education, Galal works as a clerk in a modern office set up in the pasha's villa in modern Cairo. Galal's first residence in Abdin, located in the eastern district bordering modern Cairo, is a small apartment of two or three narrow spaces. The furniture is also indicative of a non-traditional but practical character. His second apartment shows more style of the European taste, and wider spaces. This resonates with Abdelmonem's and Rodenbeck's assumption that the middle class at that time tended to borrow the European interior styles when furnishing their houses. Isma'il Pasha's villa hosts most of the Cairo scenes of the film. It displays the European character in every aspect. Inside, spacious rooms, sculptures, murals, music, a grand piano, and transistors constitute the villa's interior. Outside, the classic character of the villa is generously depicted throughout the film from different sides and angles, in a theatrical manner. The villa entrance and gates are designed to serve as a driveway. A sidewalk leading to the villa's entrance suggests that it is located on the Nile-front. Arguably, the scenes were actually meant to celebrate the villa's glamor. For the unfamiliar spectator, medieval Cairo would be nonexistent. It is possible that the filmmakers deliberately avoided representing traditional Cairo. The Azbakeya theater was specifically mentioned, yet was not shown in any of scenes. Maybe its pseudo-Islamic-style façades would have associated it with medieval Cairo, while it was introduced as the venue of success. Accordingly, its image was obscured to maintain a modern image of the city.

The traditional city of *Yaqut*

Interestingly, *Yaqut*'s Cairo focuses on medieval Cairo for almost all its Cairene urban scenes. The traditional traits of medieval Cairo, as described in literature, are immediately present in the introductory street-level scene. Ground-level spaces are occupied by retail shops; streets are narrow and mainly serve pedestrians. The medieval architecture dominates the urban scenes and minarets are pictured at certain significant moments in the plot. The vocal street activity of street vendors indicates the compactness of the urban space. It is also represented in the continuous socialization taking place on the streets. The shops act as meeting places as they host locals and guests alike. Yaqut lives in the traditional city, but works in the modern city. He is contented with his traditional neighborhood and grows rather cynical about the modern city as he gets more and more in touch with it. As is the case with *al-Warda*, the viewer who is not familiar with the city would only know Cairo as the medieval city of a traditional community.

The film clearly aims to place modernity in contrast to tradition. Considering the finale, picturing a sweeping panorama over medieval Cairo, the film is a celebration of the persistence of tradition against modernity.

The inevitable transformation in al-'Azima

Modern Cairo is given more focus in al-'Azima. It appears in its typical image as the place of elites, business, and entertainment. Regarding the traditional community, the film provides generous coverage of a neighborhood which reflects most of the transformations of the middle-class city as discussed by Abdelmonem: buildings are of European image; ground floors host retail shops and workshops; the buildings are apartment blocks of small units—operable windows and protruding terraces are modular and cabin rooms ('ishash) appear on rooftops. The urban space is predominantly pedestrian, with occasional automobile presence. The street vendors are present right from the opening scenes of the film. However, the appearance of street-level arcades also suggests a transformation in the street-level architecture or a reference to Muhammad 'Ali–era street character, which falls into the interface between medieval and modern Cairo. The urban scenes also contain details that represent modern municipal presence. The opening scene focuses on a public street-lantern over a sign at the corner of a building showing the name of the district in both Arabic and Latin alphabets. In the center of the public space, there is a stone hay trough for the horses of hantur (public transportation carts). By the end of the film, the police force arrives in a van to establish order. A possible reason for such urban detail is that the film was actually shot in Cairo, which provided the filmmakers with rich reference. The urban fabric was organic and compact. Yet, the transformation of the built form to open itself out to the urban space allows the socialization that exists only at street level in Yaqut to be possible at the higher levels of the buildings.

The Place of the Middle Class in the 1930s Cinematic City

In its overall sense, two forces shape the place of the middle-class protagonists. These are the aspiration to modernity and the pull of tradition. The involvement of the place in such a tension varies according to the plot of each film. In al-Warda, the protagonist is continuously changing his place. He navigates through his experience of modernity to finally decide to go back to the class he belongs to. The rigidity of elites' traditional class perception is represented in the rejection of the new bourgeois and the idea of professional musicians. Eventually, the change of place of the middle-class protagonist symbolizes his change of status, but it does not change his place as related to the villa. His last scene there shows the villa's gate looking like a prison cell window, to which Galal clings in despair.

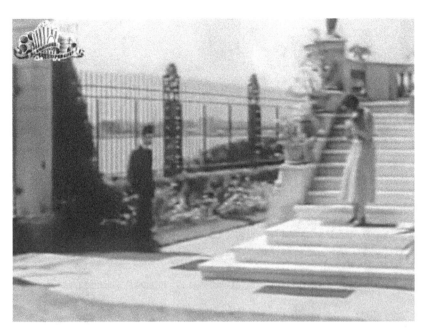

1.4. The villa's porch stairs create the chance of a middle-class encounter with the elite (al-Warda al-bayda').

In *Yaqut*, the protagonist's place changes completely. He starts out as a traditional middle-class man living in the medieval city. But his encounter with Roudy introduces him to the elite class and to the experience of Western modernity. His innate attraction to tradition leads to his rejection of many facets of such modernity. Nevertheless, the film shows that his return to his original place in Cairo is not a total rejection of modernization but rather an acceptance of it in a fundamentally different way. This is symbolized by his return to Roudy before going back to Cairo, and to the *hara* and the coffeehouse.

The case of *al-'Azima* stands in contrast to the two films above. Aspiration to modernity is strongest here compared to the two other films. Nevertheless, the place of the protagonist remains constant throughout the film. The protagonist ascends and descends the social ladder several times, but the traditional neighborhood remains his home. The physical setting itself remains unchanged as well, as if indifferent to the transformation of its population.

The various physical settings which stage the films' narratives depict several middle-class places, and, in some cases, the transformation of these places. The presence of the protagonists in the villa is received differently according to the relationship they have with the elite sphere. In *al-Warda*,

1.5. The public space was the main place of encounter in a traditional neighborhood in *Yaqut*.

1.6. *Al-'Azima*'s traditional neighborhood transformed from the classic Arab character we saw in *Yaqut*.

the protagonist is in need of assistance, which he gets in the form of employment. The villa is only a place to fulfill his employment duties. It is also the place that allows him a chance of encountering Raga', as shown in Figure 1.4. However, his presence beyond his duties and beyond his office is received with unease, even by himself. In the end, the villa remains a forbidden territory due to the pasha's traditional rejection of paid musicians. In contrast, Yaqut appears in the villa as a dominant figure as he refuses to be mistreated. In admiration of his character, Roudy is the one who invites him to the villa. The villa becomes Yaqut's house as Roudy's husband, despite his traditional background. Roudy's modern and progressive mindset is a central component in creating this contrasting outcome. In *al-'Azima*, the villa even welcomes the middle-class protagonist as a respectful individual, superior to the elite resident of his own age. Hanafy earns his presence in the villa by demonstrating himself to be a character of discipline, commitment, and knowledge. Self-conscious, he approaches the villa proud of his identity and proudly defends it when needed. As a place, the villa is transformed from a place forbidden to the middle-class individual to a place where he is proudly welcomed as a guest.

The place of tradition is represented differently across the three films. The *hara* is obscured in *al-Warda* despite the declining financial conditions of the protagonist. Instead, the film represents tradition in an elite sphere. It implies that the regressive mindsets might actually be found in the modern halls of elite villas. *Yaqut* characterizes the interactions in the *hara*, exhibiting spirituality, honesty, and solidarity, as traditional values. Roudy expresses her admiration of its ambience and enjoys her Turkish coffee by the street side, where Yaqut receives her. The film criticizes the materiality of modern life in Roudy's praise of the *hara*. *Al-'Azima* also depicts the *hara* as a place of traditional community. However, the traditional values represented in *Yaqut* are not shared by all. Instead, the *hara* becomes a place of friends and foes alike. The film represents the conflict in the *hara* as one of the progressive mindset against the traditional and rigid one. Nevertheless, the film does not imply an obsolescence of the *hara*, but rather suggests its possible compatibility with modernity. In the three films, the place of tradition emerges within the mindset of people, regardless of their class and where they exercise their power.

On the other hand, the type of urbanism participated in through the sorts of events it allows (or prevents) determines the kind of place it becomes. The traditional neighborhoods in *Yaqut* and in *al-'Azima* encourage continuous interactions. The scale of the urban space, the street-level activities, and the extrovert houses increase the exposure of its individuals. This works for the benefit of its individuals in most of the cinematic situations. The traditional fabric is an agent of social solidarity and cohesion

despite an accompanying measure of social oppression. Alternatively, modern Cairo appears in *al-Warda* and *al-'Azima*. In both cases, it represents the opposite of the traditional neighborhood. Modern Cairo in the 1930s was a place of social segregation. Residents and businesses appeared indifferent to whatever happened or whoever stood outside their door. The big buildings and the wide open spaces made the neighborhoods accessible to all and prevented communal surveillance and monitoring of people and activities. This offered anonymity to those who wished to escape traditions and social oppression, but also exposed them to undesirable encounters with pretentious strangers. Indeed, urbanism shaped the social interactions of its community through the chance encounters it provided or prevented.

Change in Place, Status, and Culture toward Contested Urbanism

The three films under discussion here have a lot in common in their representation of the city bearing the features of modernity. Through the analysis of the films, three dimensions have been identified where modernity impacted the middle-class cinematic city. The first is concerned with the subject of urban form, represented with some variation from the city as discussed in the literature and in relation to the character of each protagonist. The second is the representation of the place of the middle class throughout the films. As explained earlier in this chapter, this consisted of the general representation of an individual's place in the city as well as the shaping of places through their encounters. The third is about the transformation of middle-class cultures, which foreshadows the inevitable change of social structure and of the city.

The cinematic middle-class world reflects many aspects of Cairo as described by AlSayyad, Abdelmonem, Raymond, and Rodenbeck. This suggests a degree of realism in such early films, despite their tendency toward commercial melodrama and comedy. All three films represent several urban fragments of the city. Together, they build up a picture of the city which did not omit any of the widely shared views of 1930s Cairo. However, as far as the discussion of urban form is concerned, cinematic Cairo revealed a wider spectrum than the polar distinction of two cities which is described in the literature (Rodenbeck, 1999; Raymond, 2001; AlSayyad, 2011; Abdelmonem, 2017). *Al-'Azima* represents a modernized traditional district and *al-Warda* shows that a struggling middle-class individual may actually reside in the modern city. Abdelmonem explains the transformation of the *hara* through stand-alone cases or building regulations, but none of the literature depicts a completely modernized *hara* as seen in *al-'Azima*. As for *al-Warda*'s Galal, his district of residence is shown to have a modern character despite his declined social and financial status, a divergence from the common impression of wealth associated with modern Cairo.

All three films use urban form and spaces to stand for the protagonist character. In *al-Warda*, the district Galal lives in is modern, as a reflection of his elite background. In contrast, Yaqut is a traditional character and thus is linked to the classic traditional neighborhood. As for *al-'Azima*, the semi-modernized *hara* relates to Hanafy's aspiration to modernity and, yet, his rootedness in traditional values. This explains the emergence of such transitional urbanism in spite of its less obvious presence in reality.

The variation from the literature mentioned earlier can also be interpreted as an optimistic cinematic take on the city at a time of political and cultural fragility. Contemporary Egypt witnessed the nationalist uprising of 1919, the independence treaty of 1936, the state-funded Egyptian university, the rising nationalist movement, the emergence of national industrial projects, the buildup of World War II, and the coronation of a new king. In such a context, films which instilled hope, supported the common individual, and encouraged the development of modern national identity met the entertainment market demand and the mindset of both intellectual and economic needs. World War I had a massive political and cultural impact. The majority of the Cairene middle class embraced the change of lifestyle after the war. Cairo was departing from the traditional toward the modern. The films under discussion critiqued traditional and modern perceptions alike, which would help the community reflect on such transformation. They promised welfare and social mobility for the middle class, but only by mediating between material modernity and tradition.

Places of the middle class, in a general sense, were tied to the aspirations of the main character. *Al-Warda* shows how change in the place of the individual, physically and socially, could not change the rejection he faced by the elites. In *Yaqut* change in place exposes the protagonist to a different kind of modernity. Despite the pull of tradition the protagonist feels, he brings back with him a version of modernity that is tempered by his values. In the final example, *al-'Azima*, the experience of place and place itself are independent of the ensuing bourgeois modernity of the protagonist. The traditional district ends up in the same state and setting as the opening scene, in spite of the protagonist's dramatic experience of modernity.

Baudelairean encounters appear in cinematic Cairo's context in the mutual exposure of middle-class individuals and elite to each other and to their respective spheres. This is expressed in the representation of the traditional neighborhood. The films indicate that the modernization of traditional neighborhoods increased social encounters among the locals. The emergence of ground-floor retail shops and the exchange of the introverted traditional residences for extroverted apartment buildings were fundamental agents. The only open space was the street which contained all sorts of outdoor activities of the local community. Such a

context in a stable community, as in the case of *Yaqut*, creates compassion and solidarity. But as we reach *al-'Azima*, the community appears to be very dynamic, and the encounters seem to have brought about contestation and conflict. The boulevards were not the channel of encounter in the Cairene context as in the case of Baudelaire's Paris. The boulevards of Khedivial Cairo had already stood for almost half a century, isolated from the medieval city where the Cairene middle class resided. The films collectively show that modernity was brought to the middle class through urban modernization. Thanks to the efforts of modernization of the previous century, the middle class had been able to embrace modernity by the turn of the century.

The films show how the opera and the university, as modern institutions, were pivotal in offering middle-class men several opportunities. These institutions allowed them to meet the elites in both the public spaces of the city and its private upper-class districts. As these institutions were part of modern Cairo; they were the sites of encounter and the envoys of modernity. To the elites, modern Cairo was their home, but for the middle class it was the place to acquire social mobility. Modern Cairo was also a place of anonymity. In fact, this aspect of modern Cairo was frequently used in Egyptian cinema to stage conspiracies and mysteries. *Al-Warda* and *al-'Azima* already provide us with good examples.

The personality development of the middle-class individuals in terms of their general behavior and attitude can be seen through the three films. In terms of social standing, the films depict the transformation of these middle-class individuals through modernity. Aside from the urban poor, the majority of traditional Cairenes at the time were bourgeois as measured by the nature of their private businesses, which provided unreliable and low incomes. In contrast, modern employment was available, but it brought escalating competition and increased the risk of suddenly losing a job and facing financial hardships. It was the traditional social solidarity that saved the day for these employees and helped them overcome such hardships.

The films show that becoming a modern bourgeois offered salvation for some. Becoming a modern bourgeois offered aspirational middle-class men opportunities for upward social mobility. But this could only be achieved with substantial support and partnership with an upper-class elite or by developing a valuable and sellable skill. Although the situations presented in the films are fictional, the apparatus of modernity actually makes them all possible. Eventually, the middle-class men in the three films fight their way to become modern bourgeois who run their own businesses rather than being employed in a modern institution. The films express the necessity of abandoning traditional businesses and jobs if financial security, prosperity, and prestige are to be acquired.

Similar to social status aspirations, conflict was another facet of modernity experienced in cinematic space. In alignment with Berman's discussion of capitalism, the volatile nature of status and employment in the context of modernity made the competition among modern subjects inevitable. In the three films, we witness how competition grows on every front of the middle-class world. Berman highlights the unavoidable resistance of the powerful to change as part of the emergent culture of competition. This aligns with the theme of conflict as it appears in all three films. Conflicts were not just about personal interests, but also about resisting the change brought by modernity. Those who aspire for evolution and those who reject it were found in both the middle class and the elites. As competition surged, the encounters sparked conflict and individuality, and fueled the replacement of traditional solidarity by social fragility.

In *al-Warda*, the protagonist is passive, which is represented by his appearance in the final scene as defeated and depressed. In *Yaqut*, the protagonist is vocal about his rejection of aspects of modernity and his defense of traditions. Finally, *al-'Azima* exposes the confrontation and attempts to offer compromise between the modernized and the close-minded citizen and between the elite and the middle class. In the film's final scene, this conflict is resolved by the late arrival of state forces which indiscriminately side with one party over another. Perhaps this portrayal foreshadows the conflict between the old and the new, the elites and the rising bourgeois, a matter which came to the forefront during the army-lead Revolution of 1952. Perhaps this also is what led to the development of a culture of urban contestation which continues to shape the Egyptian urban community to this day.

References

Abdelmonem, M.G. 2017. *The Architecture of Home in Cairo: Socio-Spatial Practice of the Hawari's Everyday Life*. Abingdon: Ashgate.

AlSayyad, N. 2011. *Cairo: Histories of a City*. Cambridge, MA: Harvard University Press.

Aitken, S.C. and L.E. Zonn. 1994. "Re-Presenting the Place Pastiche." In *Place, Power, Situation, and Spectacle: A Geography of Film*, edited by S.C. Altken, and L.E. Zonn, 3–25. Lanham, MD: Rowman & Littlefield.

Armbrust, W. 1996. *Mass Culture and Modernism in Egypt*. Cambridge: Cambridge University Press.

———. 2002. "The Rise and Fall of Nationalism in the Egyptian Cinema." In *Social Constructions of Nationalism in the Middle East*, edited by F.M. Gocek, 217–50. New York: State University of New York Press.

Berman, M. 1982. *All That Is Solid Melts into Air: The Experience of Modernity*. New York: Simon and Schuster.

Crisp, R.J. 2015. *Social Psychology: A Very Short Introduction*. Oxford: Oxford University Press.

Gehl, J. 2013. *Cities for People*. Washington, DC: Island Press.

Gibson, J.J. 1983. *The Senses Considered as Perceptual Systems*. Westport, CT: Praeger.

Harvey, D. 1992. "Modernity and Modernism." In *The Condition of Post-modernity: An Enquiry into the Origins of Cultural Change*, edited by D. Harvey, 10–38. Oxford: Blackwell.

El Khachab, W. 2015. "Cinema and Modernity in the Middle East: Post-colonial Newness and Realism." In *The Modernist World*, edited by A. Lindgrenand and S. Ross, 481–88. London: Routledge.

Koeck, R. 2013. *Cine-scapes: Cinematic Spaces in Architecture and Cities*. New York: Routledge.

Lukinbeal, C. 2005. "Cinematic Landscapes." *Journal of Cultural Geography* 23, 1: 3–22.

Pallasmaa, J. 2000. "Hapticity and Time: Notes on Fragile Architecture." *Architectural Review* 207: 78–84.

Pollard, L. 2003. "Working by the Book: Constructing New Homes and the Emergence of the Modern Egyptian State under Muhammad Ali." In *Transitions in Domestic Consumption and Family Life in the Modern Middle East*, edited by R. Shechter, 13–35. New York, NY: Palgrave Macmillan.

Rasmussen, S.E. 1964. *Experiencing Architecture*. Cambridge, MA: MIT Press.

Raymond, A. 2001. *Cairo: City of History*. Cairo and New York: The American University in Cairo Press.

Reid, D.M. 1990. *Cairo University and the Making of Modern Egypt*. Cambridge: Cambridge University Press.

Rodenbeck, M. 1999. *Cairo: The City Victorious*. New York: Knopf.

Ryzova, L. 2014. *The Age of the Efendiyya: Passages to Modernity in National-al-Colonial Egypt*. Oxford: Oxford University Press.

Seamon, D. 2008. "Place, Placelessness, Insideness, and Outsideness in John Sayles' Sunshine State." *The Journal of Media Geography* 111: 1–19.

Seggerman, A.D. 2019. *Modernism on the Nile: Art in Egypt between the Islamic and the Contemporary*. Chapel Hill, NC: University of North Carolina Press, https://www.jstor.org/stable/10.5149/9781469653068_seggerman

Sepe, M. 2013. *Planning and Place in the City: Mapping Place Identity*. New York: Routledge.

Shafik, V. 2007. *Arab Cinema: History and Cultural Identity*. Cairo and New York: The American University in Cairo Press.

Al-Shalaq, A.Z. 2006. *al-Imberialya wa-l-hadatha: al-ghazw al-firansi wa Ishkalyet al-nahda fi Masr*. Cairo: Al-Shorouk.

2

Naguib Mahfouz's Cinematic Cairo: Depictions of Urban Transformations in Twentieth-century Egypt

Nezar AlSayyad and Mohammad Salama

Cairo is cinema, one may argue. Its history on film began with the inception of the art form at the hands of the Lumière brothers, who made sure to include short documentaries of Greater Cairo as part of their earliest work in 1897. Cairo thus haunted the imagination of film art from its formative moments, and since the outset of the twentieth century it has continued to be *une ville cinématographique*. Meanwhile, perhaps no other Egyptian writer has captured Cairo in its magnanimity, its oscillation between authenticity and change, tradition, and modernity as well as Naguib Mahfouz, who remains one of the twentieth century's most prolific novelists, with a *camera-stylo* à la Alexandre Astruc. Not only is Mahfouz the first and only Arab so far to have been awarded the Nobel Prize in Literature (in 1988), but he also attained the distinction of having more of his novels made into films than any other Arab writer.

Cairo in Mahfouz's Novels

Born in early-twentieth-century Cairo, Mahfouz lived through the years of British colonialism in Egypt which left indelible scars on the city and which became the background for many of his works. With a solid education in the humanities and a degree in philosophy from Cairo University in 1934, he set out to produce works of fiction that centralized Cairo not merely as a setting for an unfolding narrative, but as the subject of that very narrative. Cairo, for Mahfouz, was the protagonist par excellence—sometimes the hero, sometimes the victim, but more often the silent witness and ubiquitous mise-en-scène for a rapidly changing culture.

This chapter describes the transformation of Cairo over the twentieth century as it appears in two sets of important Egyptian films based on Mahfouz's novels. The first set documents the period between 1919 and the late 1940s, which Mahfouz wrote about in the three novels of his *Cairo*

Trilogy: *Bayn al-qasrayn (Place Walk)*, *Qasr al-shawq (Palace of Desire)*, and *al-Sukariya (Sugar Street)*. The films adapted from these novels, produced between 1964 and 1973, depict the transformation of the city according to a tradition–modernity dialectic, capturing the changes in its spaces of commerce and leisure from the time of colonial rule all the way through the struggle for independence.

The discussion then moves to another set of three films—also adaptations of novels by Mahfouz—which complement *The Cairo Trilogy* and extend its representation of the city all the way to the end of the 1960s. These films are *Cairo 30* (adapted from the novel *al-Qahira al-jadida [Cairo Modern]*), which depicts Cairo during the era of the monarchy, with all its corruption, in the 1930s; *Zuqaq al-Midaq (Midaq Alley)*, which portrays a lower-class urban neighborhood in Cairo of the 1940s; and *Tharthara fawq al-Nil (Adrift on the Nile)*, which reveals the state of affairs in Egypt in the 1960s. Written in 1966, Mahfouz's *Adrift on the Nile* describes the interaction between a group of people who frequent a houseboat for drugs and entertainment. The adaptation of the film made one year later also reveals in concrete terms the face of a dejected Cairo following Egypt's defeat in the Six Day War of 1967. More broadly, however, Mahfouz's work emphasizes a humanistic approach to questions of identity and self-critique, especially during the era of English colonialism, as reflected in *al-Qahira al-jadida* (1945), *Zuqaq al-Midaq* (1947), and the famous *Trilogy* (1956–57).

The Cairo Trilogy, which Mahfouz found challenging to publish as a single volume due to its length, traces the domestic history of an Egyptian middle-class family as it lives through a series of critical episodes of Egypt's national history, starting with the Nationalist Revolution of 1919 and ending with the July Revolution of 1952. It traces the accomplishments and catastrophes, aspirations, and agonies of three generations of the family of storeowner al-Sayyid Ahmad 'Abd al-Jawwad and how political and social change, especially under the British occupation from 1917 to 1944, reflect back within the space of their homes and private lives. As the central figure in the tale, al-Sayyid Ahmad is a stern traditionalist who expects total obedience from his wife, Amina, and his five children. The events of the story take place mostly in Fatimid Cairo—in adjacent neighborhoods that carry the names of the three novels: *Bayn al-qasrayn*, *Qasr al-shawq*, and *al-Sukariya*.

It is important to note that the city represented in *The Cairo Trilogy* is not that which teemed with minorities and foreigners during the British imperium. While non-Muslim characters—notably from Cairo's Jewish, Coptic, European, and Egyptianized Levantine communities—played a significant role in Egypt's cultural and social life during those years, Egyptian minorities seem patently absent from the *Trilogy*. Indeed, the only acknowledged foreign presence in this multivolume work is the

British army. This exclusion may be due to these populations' assumed allegiance with Britain and presumed disloyalty to the cause of Egypt's political independence as a modern Muslim nation. Mahfouz wrote these novels at the height of Egyptian nationalism, when there was no place for pashas except for the selected pictures of anticolonial Egyptian heroes hanging on the walls of living rooms. Among these were 'Abbas Hilmi, the khedive dethroned by the British; Mustafa Kamil Pasha, the first Egyptian politician/lawyer to denounce British colonialism, publicly expose its barbarism, and make a legal case for Egypt in London and France; and Sa'ad Zaghlul Pasha, the leader of the 1919 Revolution and a founder of al-Wafd Party, the one-and-only political party which Mahfouz wholeheartedly supported.

It is not perhaps surprising that a predominantly Muslim Egypt in the early era of nationalism would distrust all foreigners and non-Muslims, with a slight exception of Egyptian Copts. This rationale may certainly be extended to explain the absence of Jews and foreigners in all of Mahfouz's Cairo novels. Yet there are also instances in the *Trilogy* where Mahfouz treats Egyptian nationalism with sarcasm, mocking the hypocrisies of certain Egyptians. In one such instance, al-Sayyid Ahmad 'Abd al-Jawwad rejoices after signing the power of attorney and political representation document for Sa'ad Zaghlul Pasha. But Mahfouz's depiction of this moment of triumph captures a deep irony: 'Abd al-Jawwad recalls this glorious political event while drinking his eighth glass of wine and lying intoxicated in a Cairo apartment between the thighs of his mistress (Mahfouz, *Bayn al-qasrayn*).

The *Trilogy* on film

The immediate success of the *Trilogy*, as serialized fiction, made it a rich project for films, and, in the 1960s, the Egyptian director Hasan al-Imam adapted the three novels for a government media company. Al-Imam's film version of *The Cairo Trilogy* captures the changes in Cairo in the early twentieth century like no other group of films. Economic and social relations, in particular, are depicted in a manner that reflects the city's physical transformation. In scope, each film corresponds to one volume of the *Trilogy* and is named for a location in the medieval al-Jammalliya district that provides the site for, or designates the dwelling place of, one of the main characters. Thus, *Palace Walk (Bayn al-qasrayn)* is also the name of the street in the first novel where the house of al-Sayyid Ahmad 'Abd al-Jawwad and his family is located. Likewise, *Palace of Desire (Qasr al-shawq)* is the name of a house, or the location of a house, where his son Yasin lives in the second novel. And *Sugar Street (al-Sukariya)*, too, is where the sisters 'Aisha and Khadija move to when they marry the Shawkat brothers in the third

volume. The three locations are only a few blocks apart—both in real life and in the fictional world of the books and the films.

In his films, al-Imam (who was aided by Mahfouz himself assisting the scriptwriters) chose to highlight certain characters more than others. But he also generally stayed within the main storyline, allowing the films to become a mostly literal depiction of the plots and subplots in the novels. The choice of spaces to film—as well as the depiction of movement through them—whether on location in the city or using studio sets, further allowed the narrative at times to gain greater depth. For example, to illustrate how 'Abd al-Jawwad has forbidden Amina from ever leaving the house unless she is accompanied by him (and only then to visit family members on religious occasions), al-Imam shows Amina waiting for her husband as he comes home late one night. Here, the camera follows her from the balcony to the bedroom, to the sitting room, and finally to the top of the staircase, where she stands patiently holding a light for her husband as he climbs the stairs. Additionally, al-Imam chose to highlight how the roof of the family's house, with its chicken coop, was a place where its women could escape male domination and find a bit of peace—or the possibility of love or a liaison with a neighbor.

Historically, the film captures a moment of change in the old city. In the early twentieth century, the growth of new districts outside Cairo's traditional core encouraged wealthy and elite families to relocate to new suburbs like Heliopolis. This left the big houses in the old part of town to be occupied primarily by the families of middle-class merchants—like that of 'Abd al-Jawwad. At the same time, smaller and older structures were often occupied by lower-income families, some of whom were migrants from the countryside. The first decades of the twentieth century also saw great changes in public life. *The Cairo Trilogy* films capture all these changes accurately, including the changing position of women in society, which can be clearly seen in the different representations of women and their activities from the first film, *Bayn al-qasrayn*, to the third, *al-Sukariya*.

In al-Imam's films of *The Cairo Trilogy*, the father, al-Sayyid Ahmad 'Abd al-Jawwad (played by the magnificent actor Yahya Chahine), epitomizes the accepted tradition of male domestic dictatorship. He expects no contradictions or objections to his commands. His wife, Amina, and all his five children—Fahmi, Yasin, Khadija, 'Aisha, and Kamal—are sworn to total obedience. As a result, 'Abd al-Jawwad is more feared than loved. But, before long, his duplicitous lifestyle opens up new space in what is otherwise a monotone narrative: the secret world of an Egyptian man who leads a life that is the polar opposite of his life at home and the values he preaches to his wife and children. We thus see 'Abd al-Jawwad pray at home while he shakes his hips at night, living both prohibitively and

permissively, conservatively and uninhibitedly—with only a small circle of close friends who are fully cognizant of and at peace with his fraudulence and inconsistency.

As time passes, the children in the family mature and develop storylines of their own. But this is when tragedy, emanating from the larger world of struggle outside their private domain, also strikes them. More specifically, 'Abd al-Jawwad's second son, Fahmi, recently enrolled in law school, is killed in a protest against the British army. His premature death brings deep grief and mourning to the family, temporarily curbing 'Abd al-Jawwad's desire for nocturnal indulgences. It is also soon revealed, however, that 'Abd al-Jawwad's eldest son, Yasin (played by the young star 'Abd al-Mun'im Ibrahim, who also played the role of the gay waiter in *Zuqaq al-Midaq*) is only a half-brother to his siblings because of an early divorce. This is a condition that both Mahfouz and al-Imam represent as causing Yasin to suffer from emotional instability and personal foibles. As his physical attraction to other women overtakes him, his marital life is ruined and he develops a fervent and hopeless adoration for women's derrieres.

Later, in the third novel, Yasin's two younger sisters are married off to two well-to-do Turkish brothers, while the youngest brother, Kamal, takes to teaching and develops a one-sided romance for the sister of one of his high-born colleagues. As the family multiplies throughout the later films, al-Imam brilliantly shows the architectural shifts and transitions within the old city and the slow onslaught of urbanism. Modern Cairo thus slowly emerges over the course of the films, as seen vividly in shots of Cairo University, street protests, a girls' high school, and colonial architecture. The films brilliantly show how spaces of tradition are slowly being displaced in a changing Cairo. Thus, in *Bayn al-qasrayn*, 'Abd al-Jawwad's son Fahmi and Maryam, his sweetheart and neighbor, use the roof to escape the traditional social codes that forbid their meetings in public. By the time we get to *al-Sukariya*, the family has come to live in an apartment in a building with a staircase whose underside provides a semiprivate space for formerly illicit interaction between the sexes.

The three films of *The Cairo Trilogy* particularly depict a progression in the use of space according to traditional social hierarchies—from the rooftop, to the staircase, to the family dining room. Thus, in *Bayn al-qasrayn*, the family is shown gathering for a meal, with 'Abd al-Jawwad sitting at a low table *(tabliya)* eating, while his sons sit next to him, unable to start eating until he finishes. Meanwhile, his wife and daughters, who cooked the food, stand behind them waiting until after all the male members of the family have finished. By the time we get to *al-Sukariya*, all such hierarchies seem to have disappeared (Figures 2.1 and 2.2). Meanwhile, *Qasr al-shawq* exposes us to the sterility of the modern house and life within it (Figure 2.3).

The *Trilogy* on film 29

2.1. The family gathers for a meal in *Bayn al-qasrayn (Palace Walk)*, the first film by al-Imam from *The Cairo Trilogy*.

2.2. In *al-Sukariya (Sugar Street)*, al-Imam's film of the novel shows that social hierarchies have largely disappeared.

2.3. The sterility of the modern house is captured in *Qasr al-shawq (Palace of Desire)*.

Mahfouz's sharp awareness and representation of Cairo's geography is at work on every page in his fiction; as such, he could well be named the geographer of medieval Cairo and the novelistic photographer of modern Cairo. His narratives seamlessly capture the pulse of the city's modern streets, as well as the dissolving relics of the old city. In this novelistic Cairo, Mahfouz delineates the modern Egyptian psyche in its oscillation between tradition and modernity—its vacillation between financial gain and spiritual fulfillment, the *darih* (scared shrine) and the *guinea* (Egyptian pound), work and thought, whorehouses and mosques, killing and compassion, man and God. Not only the ascetic Sufi, but also the hopeless debaucher, the seeker and the loser, the pedantic and the self-deprecator, the savior and the renouncer—the good, the evil, and the indifferent—all come and go in the city of one thousand minarets.

Mahfouz's Cinematic Cairo beyond the Trilogy

Several of Mahfouz's many other novels extended this view of the city beyond the lives of the family depicted in *The Cairo Trilogy*. Of these, *al-Qahira al-jadida (Cairo Modern)* provides a record of a watershed moment in the Egyptian psyche. Its title alone suggests the prior existence of an old, primarily deindustrialized Cairo, with a traditional culture of high values. But the book goes

on to describe how this idyllic and rustic image of Cairo is being replaced by a modern, organized administrative state, whose new institutions completely cheapen older national values. The novel serves as a desperate witness to this vulgarity, as a "new" Cairene (im)morality rules supreme in the most centrally metropolitan city of the Middle East. Mahfouz's protagonist in the novel, Mahjub 'Abd al-Dayim, belongs to a new, nonaligned group of social climbers. The novel's title instills a "novel" dynamic into the body politic of Cairo, something distinct from the "old" Cairo.

When adapted to film in 1966, the director Salah Abu Sayf also worked with Mahfouz on the screenplay, but he opted to change the name of his film to *Cairo 30*. As it begins, Mahjub 'Abd al-Dayim (played by Hamdi Ahmad), an impoverished young migrant from Upper Egypt, has just moved to Cairo in search of the Egyptian dream of wealth and a happy family. He soon realizes, however, that he cannot get a job without the help of others, and that, when others do help, it will not be for free. When he pleads with his village friend Salim al-Ikhshidi to find him a job, he finds he must agree to marry the mistress of his new employer, Ihsan (played by Su'ad Husni). This condition will allow his boss, the minister to visit his house to get together with Mahjub's "wife" once a week. Abu Sayf's impressive medium-close-up shot of Mahjub 'Abd al-Dayim at his job interview, with two horns of a *tays* (goat) emanating from the shadow behind his head, sums up the entire film. It is a brilliant moment when film style reinforces the narrative.

The setting of the film is Cairo in the 1930s, as the new political system of Sidqi Pasha is being formed in 1932, the unemployment crisis is casting a shadow on every aspect of Egyptian society, and the rise of Fascism and Nazism in Europe has triggered the emergence of communist thought in metropolitan Cairo. In *al-Qahira al-jadida (Cairo Modern)*, one sees the depiction of a privileged class with unique access to centers of power and positions in government—an access wholly alien to the city's marginalized mass of migrants from the south, represented by Mahjub. In his book, Mahfouz introduced this "new" Cairo as one where the working class is literally being raped by a foreign power that puts its own interests above those of native Egyptians. Produced in the 1960s, the film *Cairo 30* thus looks back to the harshest abuses of the colonial order.

Like many cities of the Arab Middle East, Cairo was subject to psychopathic forms of colonial government that attempted to control and regulate every aspect of life. Mahfouz, however, also sought to portray how this power imposed its own values and norms on the new Cairo. He thus foresaw how Cairo in the 1940s stood on the verge of a moral precipice, portending a fall from which it might not recover for decades. In *al-Qahira al-jadida*, Mahjub represents the shattered dreams of Egyptian

2.4. Modern Cairo of the 1930s, with billboards advertising luxury goods.

youth, lost in a colonial Cairo of depression, favoritism, and rampant administrative corruption, with no choice but to sacrifice their honor and accept to live with moral depravity to make ends meet. The following lines, uttered by 'Abd al-Dayim, are some of the most poignant in Mahfouz's novels:

> The Government is a big family.... The ministers hire deputies from amongst their family members, the deputies choose their managers from their relatives, the managers hire chairs also among their relatives, and the chairs appoint their employees from amongst their relatives. Even servants are chosen from amongst those who serve in grand houses. The government is one big family, or one class of multiple families. (Mahfouz, *al-Qahira al-jadida (Cairo Modern)*, 46)

It is important to emphasize, however, that Mahfouz's mystical Cairenism and humane ethics form an intellectual unity beyond the moments of desolation and despair that characterize his Cairo narratives. While it is true that in his novels realism always triumphs, there is still something genuinely mystical and almost antipolitical about the nobility of the poverty he describes—just as there is something revolutionary and political about the idea of social justice.

Perhaps even more than *al-Qahira al-jadida*, which centers on a single character's tragic degeneration into nihilism and apathy, Mahfouz's

cartographical talent shines in *Zuqaq al-Midaq (Midaq Alley)*—and in its cinematic adaptation by Hasan al-Imam in 1963. The film, whose screenplay was written by Sa'ad al-Din Wahbah in cooperation with Mahfouz, follows the story of 'Abbas al-Hilw (Salah Qabil), a local Midaq Alley–born barber, and his love for his poor neighbor Hamida (played by Shadya). To marry her, 'Abbas must have more money, which his current vocation will not yield. He therefore decides to go to work in an English army camp. But, while he is away, a pimp named Farag (played by Yusuf Sha'ban) begins to frequent the alley and lures Hamida into prostitution.

One of the most powerful sequences in the movie occurs in a local coffeehouse. In this scene, we meet the age-old figure of the *'azif al-rababa* (the player of the *rababa* instrument) or *al-hakawati*—the griot or storyteller; but before long, we also realize this traditional figure is on the way to being completely replaced by the radio. Modernity is thus shown to be entering even into Midaq Alley in the form of audio technology and electricity. At one point in the scene, Mu'allim Kirsha, the owner of the coffeehouse (played by Mohamed Rida), stands up and crisscrosses his hands in an antagonistic gesture. He then gazes at the storyteller with disdain as he begins to sing, before forcing him to cease and leave the coffeehouse. At the same time, the camera moves left, revealing the installation of the radio.

Different levels of irony are present in this pregnant scene. Thematically, it depicts the abandonment of the genuine for the artificial; modernity in the guise of a talking box is invading Midaq Alley with its pernicious allure, and no one can do anything about it. This is a common Mahfouz motif, one which may be traced to the influence of Anton Chekhov. In *The Cherry Orchard*, for example, Chekhov references how modernity and industrialization will result in factories that create jobs, but also brutally replace farmlands and eliminate all the cherry trees. The displacement of *physis* with *techne*, of voice with radio, in *Zuqaq al-Midaq* also parallels the disintegration of personal relationships among the story's main characters. It foreshadows, specifically, the displacement that is about to take place in Hamida's life.

Another level of irony is more stylistic. It involves the fact that the storyteller is about to tell the *sira* (the biography of the Prophet Muhammad), while the radio broadcast (likely featuring the mystical voice of Sayyid Naqshabandi) is about to do exactly the same thing. However, the allure of technology is too strong for people to realize they are just replacing one telling of the story with another. And no one seems to see or care that the old man, the storyteller, is about to lose his job and perhaps die of poverty. With the arrival of *techne*, the griot is simply ordered away as the coffeehouse waiter, Sunqur, rushes to turn on the new device and the camera pans

to reveal the spectacle of the talking box. The action thus foreshadows the complete decline and death of a generation of '*azif al-rababa*, storytellers who once brought communities together and created a sense of belonging and authenticity. "We don't want poetry from you anymore," shouts the drug dealer and pedophile Mu'allim Kirsha. Then the camera cuts to a shot of Sunqur's hands lifting the radio and placing it on a pedestal decorated with embroidery designed for the occasion.

The mise-en-scène of the coffeehouse thus becomes a microcosm of the old city, the site of postwar petit-bourgeois society's moral decay—as well as the establishment of marginal and impoverished communities in the late 1940s. In addition, al-Imam effectively captures the very narrowness of Midaq Alley. The audience can almost feel the tightness and claustrophobic effect of this constricted passageway as his camera makes the turn from al-Sanadiqqiya (in the Jammalliya district of Fatimid Cairo). Stylistically, al-Imam's filmic adaptation of Mahfouz's fictional world is almost perfect. It captures in exactitude Kirsha's coffeehouse, al-Hilw's barbershop, 'Amm Kamil's *basbusa* shop, the fragrance shop on the corner, the bookstore, the cigarette kiosk, the old *duhdira* steps leading to the bakery and old stable, and, finally, Hamida's *mashrabiya*, her window to the world of the coffeehouse and beyond. The depiction of the alley contributes to the development of Hamida's character. Its narrowness reflects her own limitedness—her fascination, for instance, with streetlight posts when she sees one for the first time. As Mahfouz depicts her, "she has only been on a carriage pulled by a donkey, and when she rode in a taxi for the first time in her life, she thought it was one of the wonders of the world" (Mahfouz 1947, 174).

Al-Imam could not end his film in the same manner Mahfouz ended his novel. In the novel, Hamida lives, whereas 'Abbas al-Hilw is killed and ridiculed for his wasted life as a simpleton driven by blind love to an untaught woman. The sensibility of Egyptian filmgoers at the time, however, could not have accepted a fallen woman living while her honest lover dies. Al-Imam thus opted for melodrama, a naïve and unfaithful adaptation of Mafouz's merciless realism. In the film, Hamida dies, and 'Abbas carries her in his arms to the very entrance of Midaq Alley, appealing to the audience's sense of a melodrama where virtue supposedly triumphs over evil, at the expense of Mahfouz's more realistic views.

Depth of field plays an important role in the framing of Cairo in al-Imam's films. Through the technique variously called depth of field, deep focus, or deep space, cinematographers use camera angles and point of view to create a sense of depth on a flat screen. Film treats—or, better, creates—depth in the frame precisely through perspective, although the assumption in film is that it is the spectator's own view that is being presented. The impression of spatial depth is not easy to achieve, but requires a special

filmmaking talent and the clever arrangement of setting/mise-en-scène. In other words, it is a construction that utilizes props and often relies on the establishment of various grounds in the frame (foreground, middle ground or grounds, and background). These techniques have been developed over the years, and have become easier to master now through zoom lenses.

André Bazin was perhaps the first to draw attention to the effect of deep-space continuity editing, a filmmaking practice that puts the spectator/subject at the center of the cinematic experience (Bazin, 2005). As an example, he pointed to various shots from Orson Welles's famous *Citizen Kane*. Interestingly, his examples almost parallel al-Imam's practices in the *Trilogy*, where the use of multiple "grounds" creates the tangible effect of real urban space.

In *Bayn al-qasrayn*, al-Imam achieves depth of field brilliantly in one shot in particular. Here, the right side of the frame is dominated by a medium close-up of a veiled Egyptian woman cheering a crowd of females in a school courtyard below as they prepare to exit to the streets to join the already inflamed anticolonial protests of the 1919 Revolution (which led to Egypt's nominal independence from Britain in 1922). Although in Welles's case the camera is positioned at a higher angle, the construction of depth is quite similar. The woman occupies almost one-third of the frame, but al-Imam's composition of the rest of the shot creates four dimensions of depth: the woman (foreground), the column structure (middle ground one), the female students below (middle ground two), and finally the interior of the school building (background). The black and white window frame further intensifies the contrast and sense of spatial depth in the scene.

Within this film, the political connotation of this shot emphasizes the slow but sure quality of the women's movement in Egypt. But depth of field also became one of al-Imam's auteurist signatures, and he continued to use it in other Mahfouz-inspired film adaptations. For instance, in *Zuqaq al-Midaq*, one clever shot shows Hamida as she walks down the alley wearing a traditional *milaya*. Hamida is revealed at the center of the frame in the foreground; but behind her to the left in the middle ground is the *iskafi*, the shoemaker—more accurately, here, the *qubqab*, the clog maker, behind whom is the space of a small side alley; and the depth continues to reveal the presence of a bean seller in the far middle ground, and, finally, a background which depicts the lower portions of a *mashrabiya* and another woman, in the distant background, looking out at Hamida from the center of an arched entrance, probably to the bakery.

The third film in this second set of Mahfouz adaptations, *Tharthara fawq al-Nil (Adrift on the Nile)*, released as *Chitchat on the Nile*, leaves this traditional world behind to investigate the lives of some ten young professionals, from different backgrounds and social classes, who spend their

2.5. Hasan al-Imam's use of spatial depth in *Bayn al-qasrayn* mirrors that of Orson Welles in *Citizen Kane*, creating a multilayered sense of the social conditions in colonial-era Cairo.

evenings drifting in a houseboat on the Nile until a senseless tragedy splits them apart. Mahfouz wrote this short novel in 1966, and it was made into a film, again with his help on the screenplay, in 1967. Its plot is simply a seemingly endless set of conversations. The group's master of ceremonies, Anis Zaki, is a widower who works at the Ministry of Health and who has an addiction to smoking hash that is so severe he can write out and submit a lengthy work document without ever noticing that his pen has run out of ink. Anis marks time from night to night, when he and his group of thirty-something-year-old friends—a translator for the Foreign Ministry, an accountant at the Ministry of Social Affairs, a lawyer, an art critic, and a noted writer of short stories—gather to cast off from the shoreline to engage in endless, aimless conversations about Egyptian society, politics, and religion.

At one of the group's gatherings, Anis comments that "the laws of society are dead" and that they have to invent new laws, at least for the houseboat. But one night the group is joined by Samara Bahgat, a "serious" journalist, and their placid world begins to unravel. Announcing that she "will not be tempted into the abyss," Samara begins to keep a notebook casting her companions as characters in a play about "the Serious versus the Absurd." She then draws ever closer to Anis without acknowledging or returning his love. And when the group, out joy-riding one night on the streets of Cairo, runs down and kills a pedestrian, she insists they go to the police, even if it means a prison term for the driver and the end of their "paradise."

Disturbingly incisive about modern Cairo's uneasy truce between old ways and new, the film provides a powerfully compressed and updated

version of *The Cairo Trilogy*. In it, we are exposed, through conversations, to specific aspects of Cairo life. Thus, the narrator, Anis, a clerk whose job is to write reports that go nowhere and have no value, comments on the fact that the streets of Cairo are always being dug up. The digging may be to install electric or phone lines, but there is no planning or coordination, and so, after a road is asphalted, it may be dug up again—this time to install water or sewage pipes.

When Anis becomes a member of the group on the houseboat, they give him the honorary title of Minister of *Kayf* (drugged mood and entertainment). But, over time, he becomes more of a silent observer, a philosopher of the Cairo condition. He thus listens as his companions discuss how Nasser's socialism has impoverished everyone but how certain groups have avoided this fate because they have access to smuggled goods. We then learn from the discussion about a street in Downtown Cairo, Shawarbi Street, where these goods may be accessed. When the journalist joins the group and Anis discovers what she is up to, he stays silent—but only until the accident happens. It is then that he starts to rebel against the houseboat and what it represents. The journalist, in turn, writes that Anis is a lonely man, half mad and half dead. But his response is to observe that a drugged man does not feel the isolation, as his loneliness makes him self-sufficient. Close to the end, we witness a police raid, which marks the beginning of the end for the houseboat meetings.

When the novel was made into a film, the director added a scene toward its end in which Anis visits the cities of the Suez Canal that were devastated in the 1967 war—in which Egypt was defeated by Israel and lost the Sinai Peninsula. But the film ends with a scene inspired by the novel, in which Anis lets the boat loose, unmooring it so that it floats aimlessly away on the Nile carrying its semiconscious inhabitants.

By the 1970s, the film had become iconic in Egypt because it was one of the few movies to capture the mood of Cairo in the period between 1967 and 1973. Amazingly, it accomplished this despite the fact that it showed very little of the city except the decay of its infrastructure and some touristic and entertainment sites. But its significance lies in its representation of a specific view of Cairo through the eyes of the drug users on the houseboat. It thus provided an important witness to the socialist era in Cairo, in which the life of the city was not only presented through the words of its characters, but also the activities they chose to pursue and the outcomes these brought.

The disgruntled protagonist Anis thus acquires a reputation as a man who speaks largely to himself. But he is also speaking about the irregularities of Cairo as an extension of Egyptian society—from streets that are always dug up and never paved to the policies of a government that bans

2.6. Anis walks despondently in the dug-up streets of Cairo in *Tharthara fawq al-Nil*.

drugs but allows the consumption of alcohol; and from the strange smuggled imports allowed by the government to the strange social relations that exist on the houseboat. Aside from the character of the journalist, Anis seems to be the only person on the houseboat who has a social conscience—even if it is one that he keeps in check by being drugged. But the moment the effect of the drugs wears off, Anis explodes and rebels against Egypt's oppressive socialist politics and corrupt government, which has supposedly resulted in its defeat in the 1967 war. Cairo, and Egypt itself, of course, did not rebel against these conditions until 1973, when its supposed triumph in the Ramadan War allowed it to regain the land it had lost in 1967.

The Discomfort with a Modern Cairo

Various adaptations of Mahfouz's fiction in two important periods in Egypt's twentieth-century history show how cinematic representations have succeeded in depicting key transformations of the physical space of the city of Cairo. What is equally significant, and which must be emphasized, is how those visual metamorphoses—which occur in homes, buildings, streets, landscapes, and neighborhoods old and new—transfer identities from the Mahfouzian text to the moving image. These identities are not in themselves embodiments of the geographical mass we call Cairo; they are rather reproductions of textual and filmic impressions woven in the fabric of the very history they seek to represent.

The films *Bayn al-qasrayn*, *Qasr al-shawq*, and *al-Sukariya*, which correspond to the novels *Palace Walk*, *Palace of Desire*, and *Sugar Street*, capture

an Egypt struggling with colonialism and in pursuit of independence. The decision to set all the action from this historical period in the old quarter of the city achieves two objectives. First, it allows the old district to serve as a microcosm for the whole city, as seen through the eyes of a single middle-class family, whose life is largely separate from larger political movements. It thus affords a heightened view of the practices of daily and family life in urban space and how these changed as the modernization and urbanization of Cairo allowed more freedom both for women and a younger generation. Second, although some parts of the three films were shot on studio sets, the *Trilogy* as a whole provides a historic document, not only of the physical city itself but also of the cinematic city envisioned by filmmakers.

The second set of three films analyzed in this chapter has shown a different cinematic Cairo. *Cairo 30*, a depiction of Cairo during the era of the monarchy (which corresponds to the time of the earlier part of the *Trilogy*), presents a more institutional city. It is one inhabited and governed by clerks and ruled by wealthy pashas—a clean but corrupt city, constituted of individuals who want to climb the social ladder regardless of the price. *Zuqaq al-Midaq*, by contrast, portrays a lower-class urban neighborhood in British-colonized Cairo of the 1940s. Here, viewers witness the changing life of a city where traditional practices are being replaced. Thus, in the coffeehouse, the words of the storyteller are being replaced by the radio, and in the streets outside, Cairo's lower-class residents are having to sell themselves either to the colonizer or to pimps in order to survive. The film shows the tremendous sense of displacement modernity has brought to urban life. Finally, *Tharthara fawq al-Nil* presents the dejected, dug-up modern Cairo of the late 1960s as a home for escapists and drug users.

The portrayal of Cairo in the last three films reflects Mahfouz's understanding of the expanding modern city. However, the films also show Mahfouz's discomfort with how modern life has presented a challenge to Cairo's well-established traditions, as portrayed clearly in the *Trilogy*. Perhaps this is why Mahfouz chose to set half of these stories entirely in the city's old quarter, which was not only where he grew up, but also where an older, unsullied urban condition still provided him with a sense of "home" and inner peace.

References

Abu-Lughod, J. 1971. *Cairo: 1001 Years of the City Victorious*. Princeton, NJ: Princeton University Press.

Almubaraki, S. 2016. "The Cinematic Cairene House in the *Cairo Trilogy* Films." *Traditional Dwellings and Settlements Review* 28, 2: 55–70.

Astruc, A. 1948. "The Birth of the New Avant-Garde: La Camera-Stylo." http://www.newwavefilm.com/about/camera-stylo-astruc.shtml

Bazin, A. 2005. *What Is Cinema?* Berkeley, CA: University of California Press.

Beard, M., and A. Hayder, eds. 1993. *Naguib Mahfouz: From Regional Fame to Global Recognition*. New York: Syracuse University Press.

El-Enany, R. 1993. *Naguib Mahfouz: The Pursuit of Meaning*. London: Routledge.

Le Gassick, T., ed. 1991. *Critical Perspectives on Naguib Mahfouz*. Washington, DC: Three Continents Press.

Mahfouz, N. 2011. *Palace Walk: The Cairo Trilogy, Volume 1*. New York: Anchor.

———. 1946. *Al-Qahira al-jadida*. Cairo: Maktabat Misr.

———. 1947 *Zuqaq al-Midaq*. Cairo: Maktabat Misr.

Mehrez, S. 1994. *Egyptian Writers between History and Fiction*. Cairo and New York: The American University in Cairo Press.

Moosa, M. 1994. *The Early Novels of Naguib Mahfouz: Images of Modern Egypt*. Gainesville, FL: University Press of Florida.

Moussa-Mahmoud, F. 1989. "Depth of Vision: The Fiction of Naguib Mahfouz." *Third World Quarterly* 11, 2: 154–66.

al-Nahas, H. 1975. *Naguib Mahfouz on the Screen*. Cairo: Hayat Alam al-kitab.

Somekh, S. 1973. *The Changing Rhythm: A Study of Najib Mahfuz's Novel*. Leiden: Brill Academic Publisher.

3

Bridge as Border and Connector: Class and Social Relations in Cinematic Cairo, 1940s–50s

Nezar AlSayyad and Doaa AlAmir

The events of this story occur between the district of Zamalek, with its mansions, wealth, and aristocracy, and the district of Bulaq with its simple houses, kind hearts, and modesty.

So speaks the narrator at the beginning of *al-Qalb luh ahkam (The Heart Has Its Rules)*, a popular film from the mid-1950s, as the camera pans across Cairo from a bridge connecting two important districts, one rich and one poor, separated by the River Nile. The districts, Bulaq and Zamalek, with their unique histories, have long been paired in Egyptian films because they provide a contrast between different social classes, while showing continuities in Cairene social relations. Since they are connected by a bridge, our interrogation of them within the cinematic medium will also allow us to examine when a bridge is indeed a bridge, and/or when the river under it is instead a border.

This chapter will examine two films: *Law kunt ghani (If I Were Rich)*, and *al-Qalb luh ahkam (The Heart Has Its Rules)*. The films were released

3.1. The bridge connecting Bulaq and Zamalek as it appears in *al-Qalb luh ahkam*.

in 1942 and 1956, respectively. They allow us to examine several aspects of the transformation of Cairo and its cinematic representation, because the time between their releases saw the transformation of Cairene society to modernity, and it is possible to make connections to the correspond-ing socio-political changes. In *Ghani*, the bridge is portrayed as a physical connector and not a social boundary, at least for the rich who can cross into Bulaq to discover poverty. In *al-Qalb*, by contrast, the bridge appears as both a physical connector and a social boundary—a one-way route from poverty to wealth, if the poor residents of Bulaq can even make it across.

In general, the films show how the popularly supported military coup of July 23, 1952, often considered the Egyptian Revolution, precipitated a confrontation between Egypt's classes that displaced an older, calmer community lifestyle. Indeed, the chapter concludes by suggesting that an aspirational attitude toward modernity emerged mid-century in Egypt as a result of this major political change. The earlier film, produced in the 1940s when Egypt was still a kingdom, thus shows the latent contradic-tion in prerevolution Egypt and the aspiration toward modernity under colonial influence. The later film, produced after the 1952 Revolution, meanwhile, shows how the 1950s brought the classes into confrontation, displacing patterns of social relations previously attuned to traditional social hierarchies. Yet, even though the revolutionary forces removed class distinctions, changes in the forms of social interaction still made the poor feel as if they were a lower class.

A more detailed synopsis of both films is necessary to understand the nuances of these aspects of Cairene life and the urban experience of modernity during this significant period.

The Districts of Bulaq and Zamalek in the Films
Law kunt ghani (If I Were Rich) 1942
Produced and released in 1942 in the midst of World War II, *Law kunt ghani* was written by Abu al-Soud al-Ebiary and directed by Henry Barakat. The film was meant to be a comedy, with its message also reflecting the war that had affected all of Egypt and changed aspects of daily life in Cairo. It revolves around the family of Mahrous, a barber who dreams of being rich. He finally gets his opportunity when he comes into major wealth and moves his family from a poor neighborhood in Bulaq to the posh modern district of Zamalek. But his new social status also leads him to become obsessed with appearances and the maintenance of his newfound status, even when it does not bring happiness to the family. And when the family finally loses all their money, his wife convinces him that this wealth and the move to the modern district have brought them nothing but unhappiness.

Mahrous subsequently decides to move back to their old neighborhood, convinced that he was more content with its poverty and social traditions.

As the film begins, the camera shows the fogged classical mirror of a barbershop with shaving instruments displayed in front. It then moves to Mahrous, the barber, who utters the phrase "Oh, if you were rich." Mahrous's shop is located in front of a building where he lives with his wife Folla, his son Rashid, his daughter Wahiba, and his brother-in-law. But a young man by the name of Kamal also frequents the shop to get his hair cut or get a shave, and we soon discover that the real reason for these visits is his interest in Wahiba. Kamal introduces himself as a clerk with a well-paid job, and he asks for Wahiba's hand in marriage. But Mahrous, who is always aware of status, refuses him, giving the excuse that they are poor and that his daughter will be unhappy with someone so far above her in terms of social class.

We are then introduced to the people of the district, a *hara*, or traditional neighborhood, a majority of whose inhabitants work in a nearby printshop. The printshop workers are dissatisfied with their salaries, and they often gather outside Mahrous's shop to discuss their woes. He advises them to select a representative before confronting the printshop manager to request a salary increase. But when the workers do this, the manager refuses their request. And when they return to Mahrous to complain, he engages in a condemnation of the wealthy and suggests that they file a tax complaint against the printshop. Mahrous is then asked to help write the complaint, but as he is reading it to them he is informed of the passing away of a district beggar who is a distant relative. Dismayed that he has to go to the beggar's poor room to arrange for his burial, he forces himself to, only to discover that the beggar had actually been accumulating considerable wealth. And, being the beggar's only relative, Mahrous also realizes he will inherit it all. At that moment his attitude changes toward the poor, and he starts dismissing the workers' demands. As these events are unfolding, Kamal again asks for Wahiba's hand in marriage. But Mahrous again refuses, this time arguing that Kamal's salary as a government clerk will now place him below his daughter's new socio-economic status.

Mahrous then moves his family to the wealthy district of Zamalek, where he buys a car and a villa. He also buys the printshop in his old neighborhood, and, as its new manager, he appoints his son and brother-in-law as secretary and treasurer, respectively. As the family assumes its new life as big-time spenders, however, they encounter difficulties fitting in among the other wealthy residents of Zamalek. And, in a short period of time, Mahrous and his son squander much of their wealth on gambling, women, and other modern luxuries. As his debts mount, the printshop goes into receivership. His wife then abandons him, and his

daughter follows suit when she discovers he is planning to marry her off to a rich man to cover his debts.

As the film draws to its conclusion, Mahrous is forced to return to his house in the poor district, where he must face the ridicule of the workers he has shunned. But while these events are taking place, we learn that Mahrous's daughter has fled the house and married Kamal, who we discover is truly wealthy and has hidden his wealth even from Wahiba. And, in the end, it is Kamal who saves the day by buying the printshop and keeping Mahrous's family in charge of it. In the final scene, Mahrous speaks again to the workers of the printshop in Harat al-Faqr Heshmah, the name of his old neighborhood—which literally translates as "The Quarter of the Decency of Poverty." This time he apologizes to them for his behavior and declares that there is no shame in poverty because it allows people to maintain their integrity.

al-Qalb luh ahkam (The Heart Has Its Rules) 1956

The second film, *al-Qalb luh ahkam*, was released years later, in 1956, following the 1952 Revolution which overthrew King Faruq and led to the transformation of Egypt into a republic. The film was directed by Helmy Rafla and was produced following a period of relative postwar prosperity and demographic change in the structure of the city. The film features the Egyptian superstar actress Faten Hamama, then known as the "First Lady of the Arab Screen." As mentioned above, it opens with the camera panning between the same two Cairo districts, separated by the Nile yet connected by a bridge. The camera first covers Zamalek, as the narrator describes it as a posh district where the wealthy live in modern mansions. It then moves across to Bulaq, which the narrator describes as occupied by "real people" who espouse traditional values and are kind and content with their modest condition. A contrast is thus immediately established between the two parts of the city, one in which wealth is equated with modernity while, in the other, poverty is assumed to be the main trait of its traditional neighborhoods.

The plot of *al-Qalb* involves a love story between two students of medicine at Cairo University, in which the female student, from Bulaq, becomes interested in a young male colleague from Zamalek, who is athletic, popular, and rich. The woman subsequently engages in a scheme to attract the man's interest, and the two finally fall in love despite their social class differences. The man, however, is afraid that his wealthy father will object to their marriage, so he hides from him the fact that the woman comes from their sister neighborhood across the bridge. In the end, during a party at which their engagement is to be announced, a confrontation occurs between the rich residents of Zamalek and the friends and

3.2. Poster for *al-Qalb luh ahkam* (*The Heart Has Its Rules*) (1956).

family the woman has invited there from Bulaq. During the fighting, it is strangely revealed, however, that the father is a self-made man from a poor background. Ultimately, he accepts the marriage in a scene where the poor and rich meet on common ground.

The film starts with the narrator's comments quoted in the epigraph above, as the camera pans from Zamalek to Bulaq. Viewers are then introduced to the *hara*, the traditional quarter where the heroine, Karima, lives with her mother in a rented apartment in front of a bakery. The owner of the bakery, Zanouba, is an older woman who is a respected figure in the neighborhood, and who acts like a godmother to the young medical student. However, their building is owned by a mortician whose shop is in the same building, and who is the main landlord of the *hara*. Although he is married, he is also thinking of taking Karima as a wife.

The film then moves to the Faculty of Medicine at the university, where we learn that Karima is interested in her colleague Hamdy. But Hamdy comes from an aristocratic family and seems to not even recognize Karima's presence as they do their rounds as medical interns. With the help of Zanouba, however, Karima concocts a scheme to draw Hamdy's attention to her and, by borrowing a fashionable dress from the laundry in

the *hara* and wearing it to a party, she succeeds in achieving her objective. But Hamdy is a playboy, and in front of his friends he cannot show genuine interest in Karima. Indeed, he even engages in a bet with his friends that he can make her fall in love with him without his having any feelings for her. But when Hamdy meets Karima in a park to prove his point, Karima recognizes what he has been up to and is publicly humiliated. This fills Hamdy with embarrassment and regret. And it is at this point that Hamdy recognizes that he is truly in love with Karima and starts to do everything to court her again. We also learn that Hamdy, who comes from the upper class of Cairene society, is the only son of a wealthy contractor and still lives with his father in an impressive mansion in Zamalek. He is thus popular not only because he is a famous footballer, but also because he is the richest of his peers.

Among Hamdy's middle-class friends, however, is a man by the name of Anwar who literally lives off Hamdy. And we soon learn how Anwar is threatened by Hamdy's newfound love for Karima because it will disrupt his plan to get Hamdy to marry the daughter of a bankrupt gangster friend and so ensure that both of them can continue to depend on Hamdy's wealth. Anwar and his friend then concoct a scheme to get Hamdy to sign some IOUs while he is drunk as insurance in case their plan to arrange a marriage to the friend's daughter does not succeed.

As the story progresses, Hamdy's attempts to court Karima finally succeed, and they are reunited—but without him knowing that she comes from a poor neighborhood in Bulaq. And when she subsequently invites him to her apartment to meet her family, he is shocked by the area and makes derogatory remarks about her house. He suddenly leaves, implying that he will end the relationship. But he soon has a change of heart, recognizing that his love can transcend the difference in their social classes, and he proposes marriage—to which she agrees, provided that he tells his wealthy father about her background. When Hamdy introduces the idea to his father, however, he lies about Karima's background and implies that she, too, is a resident of Zamalek. The father then insists on inviting Karima to their mansion and offers to throw a party to celebrate the engagement and invite all of Hamdy's friends.

At the engagement party, Karima meets Hamdy's father and tries to reveal where she really lives, but Hamdy interrupts repeatedly and finds excuses to divert the discussion. As fate would have it, however, two other groups of people then arrive at the party at the mansion. The first is led by Anwar, who arrives with the family of the woman he wants Hamdy to marry, with the intent of pressuring Hamdy in front of his father using the fake IOUs. The second group, led by Zanouba, is from Karima's *hara*. They wish to congratulate her on the engagement, and they arrive at exactly the

same moment as the other group—apparently tipped off to the event by the mortician, who wants to disrupt it.

When Anwar reveals the truth about Karima's poor background, Hamdy's father tries to kick the *hara* people out of his house. But when Anwar brings up the issue of the IOUs and Hamdy denies ever signing them, a fight breaks out between the two groups. During the commotion, Hamdy's father encounters Zanouba and they discover they know each other. We thus learn that the father is a self-made man whose wealth was not inherited and that he also originally came from Bulaq. Finally, as Anwar and the gangster family are kicked out of the house, Hamdy's father announces his approval of the marriage.

Egyptian Society and Cinema in Transition

The Egyptian social classes portrayed in the two films have clear historical origins. In Cairo, the upper or elite classes developed over time and can be traced back to large Egyptian landowners of the early twentieth century (Hussein 1973, 18, quoted in Shafik 2007, 243). The middle class, by contrast, has often been seen as composed of people on fixed incomes, like the state employees who ran the government offices. Meanwhile, the poor, many of whom are assumed to have been of rural origin, lived on the fringes of urban society, marginalized and fragmented because they had little in common except their relatively poor habits and low levels of education (Hussein 1973, 30, quoted in Shafik 2007, 244).

Changes in this socio-economic structure began to appear after the Revolution of 1952, as the growth in migration from rural areas increased the size of both the middle and lower classes. Yet, the categorization of Cairene classes subsequently also became more difficult, as these groups acquired varied degrees of educational, cultural, and economic capital (Abd al-Mu'ti 2002, 297, as quoted in Shafik 2007, 245). There is no doubt that class consciousness was always an important aspect of Egyptian cinema. However, as Viola Shafik has suggested, the narrative of social ascent, which typically drew a clear boundary between social groups, began to be replaced after this time by a more diffuse bourgeois struggle (Shafik 2007, 242).

Egyptian films in the 1930s were often produced by foreigners. And although the first Egyptian film company, Studio Misr, was established by Bank Misr (the national bank of Egypt) in 1927, many of its early themes and genres continued to reflect a European colonial sensibility. Censorship was also officially enforced in Egypt during the early years of cinema. Thus, cinematic representations of conflict between tenants and landlords, or between rich and poor, were forbidden, and criticism of state authority, foreigners, and the monarchy was not tolerated (Schohat 1981, 23). The period between the official independence of Egypt in 1922 and its actual

independence following the Revolution of 1952 was marked by social turmoil and political struggle. But the period, specifically the years between the late 1930s and early 1950s, is also often referred to as the golden age of Egyptian cinema.

At the time, the upper and bourgeois classes in Egypt were selectively adopting Western habits and values, and the movies provided a means of class expression that helped shape the consciousness of the population. However, with the outbreak of World War II and the growing desire for real independence, the orientation of Egyptian cinema confronted the Egyptian bourgeoisie with a paradox. While they resented Western domination and aspired to an independent state, they still admired Western lifestyles, freedoms, and technological innovations. Thus, before 1952, this class often tried to transcend colonial influence by molding themselves in the colonizer's image (Schohat 1983).

The Revolution of 1952, however, brought profound transformation to all spheres of life in Egypt, including politics, the economy, social relations, and cultural production—including the movie industry. The revolutionary movement did not produce a complete transformation, but cinema, like other forms of cultural expression, did find a role in the new phase of nation-building. The nationalist ideology, as conveyed by cinema, thus "aimed to provide the people with an interpretation of reality," whose intent was to transform them "from traditional subjects to active citizens" (Schohat 1983, 27). Cinema, as one of the vehicles of this new ideology, was specifically intended to "produce solidarity and identity among the masses" (Schohat 1983, 27).

Interrogating the Modern Urban Condition Cinematically

In light of this changing socio-political reality, the two films discussed here offer an understanding of cinematic portrayals of Cairo at two times separated by almost a decade and a half. They also provide significant insight into changing "real" conditions in Cairo in the 1940s and 1950s. More specifically, the films allow us to map the subtle transformation of the city and its culture as Egypt was transformed from a traditional state, ruled by King Faruq under British control, to a revolutionary republican one governed by a rising star, Gamal Abd al-Nasser—an army officer who was among the main leaders of the coup that removed the king from power. In this regard, the films present a detailed examination of the environment of the traditional *hara*, the Cairene neighborhood where a majority of the lower classes lived, as well as the modern districts where the wealthy and powerful resided. In both films, this includes depictions of individual houses, urban spaces, areas of employment, forms of transportation, and arenas of recreation and entertainment. In what follows, we will attempt to investigate the changes that occurred in Cairo

during this critical time by looking at the cinematic representations of these urban elements and related modes of living in the two films.

Analyzing film, like analyzing any form of text or painting, is a rhetorical exercise based on evaluating words, images, backgrounds, and narratives. But, unlike literature, the analysis of film requires consideration of the scene, the actors, the lighting, and many other factors. There are also different types of film analysis. These include, first, semiotic interpretation, involving discovery of the meanings behind the signs, symbols, and metaphors used by directors. A second type is mise-en-scène analysis, which looks at the arrangement of the compositional elements of a film and the effect of its scenes to achieve a purpose. Third is narrative-structure analysis, which involves investigation of story elements, including the characters, their motivations, and the plot structure. And, finally, there is contextual analysis, the investigation of a particular film as part of broader cultural and historic developments to understand what that film has to say about its time and place (Hayward 2000). For our purpose here—to unveil the transformations of Cairo during the 1940s and 1950s as the country moved from one political system to another and as a new culture of urban modernity came to influence its population—contextual analysis proved to be the most appropriate method to employ. However, we intend to deploy the other methods to understand the tools invoked by the filmmakers, particularly how cinematic narratives and elements of mise-en-scène were used to embody or communicate modern or traditional urban ideals.

In our analysis, we will not make a distinction between the "real" city and the "reel" city. Indeed, we accept that the boundary between the physical city and its supposed virtual representation on screen is a false divide. In fact, we strongly believe that the virtual, which, in this case, is the image that appears on a screen (often shot in a studio, not on location) often has the power to define a given reality better than the reality it aspires to capture or represent. And, from this, we proceed with the notion that the reel and the real, particularly in experiencing the urban condition, are mutually constitutive (AlSayyad 2006).

Cinematic Cairo Transformed, 1942–56

Mahmoud Qassem (2012) has suggested that the period of the late 1940s and early 1950s witnessed the rise of a number of films that probed how poor people can be seduced by wealth and how such seduction can ruin their lives. Sameh Fathy (2018) has used the film *al-Usta Hasan*, released in early July 1952 (before the movement to overthrow the king), to illustrate this trend. In that film, a rich married woman seduces an honest laborer, resulting in his abandoning his wife until the rich woman moves on, leaving her hapless victim behind. When the rich woman is then killed, the

laborer is accused of her murder—only to be vindicated when the woman's husband confesses to the crime. In the film, the laborer comes from Bulaq and the wealthy woman comes from Zamalek, just as do the characters in our two films, *Ghani* and *al-Qalb*.

In the fourteen years between *Ghani* and *al-Qalb*, Cairo was transformed substantially, both in real and reel life. By looking at the films historically, then, we can thus ask what changed during these years in the traditional Cairene *harat* (plural of *hara*) of Bulaq as well as in the rich districts of Zamalek. For example, what changed in the nature of work, the structure of the household, the forms of habitation and entertainment, and the means of transportation?

All of these factors will give us a clearer picture of the content of modernity in this critical time period—for Egypt in general and for Cairo in particular. It is important as we engage in this recounting of the two films and the changing representation of Cairo during this time period, however, to also understand the history of the "real" Bulaq and Zamalek districts.

3.3. The meeting of the carriage and the car, the old and the new, as the family moves from Bulaq to Zamalek in *Law kunt ghani*.

3.4. The elegant streets of wealthy Zamalek as they appear in *al-Qalb luh ahkam*.

In medieval times, Bulaq was the main port of Cairo on the Nile. And, by the eighteenth century, it had also become the site of many mosques and large houses owned by the Mamluks, who ruled Egypt for three centuries. With the Napoleonic campaign in Egypt at the end of the century, Bulaq, however, became known as a hotbed of resistance to French colonization, and its men acquired a reputation for being *futwat*, bullies loyal to the cause. Then, during the nineteenth century, as it became more connected to the historic core of Cairo, Bulaq also became a destination for poor families, many of whom were originally rural migrants from the Delta and Upper Egypt who came to the city to find work in its expanding industries. Indeed, by the middle of the twentieth century, the period corresponding to our two films, Bulaq was the most concentrated working-class district in the city. Known as a dense area of production, it was filled with small-scale workshops for such industries as printing and metalworking.

The district of Zamalek, on an island in the Nile west of Bulaq, by contrast, has long been one of the most affluent residential areas in Cairo. And, in the nineteenth century, under Khedive Isma'il, the island was planned as a garden with many palaces. This included the famous Gezirah Palace, which housed guests like Emperor Franz Josef of Austria and Empress Eugenie of France, who came to Egypt to attend the 1869 opening of the Suez Canal. In the early twentieth century, Zamalek's apartment buildings, villas, fine restaurants, and quiet leafy streets made it then the most favored residential location for many of Cairo's wealthy families and European expatriates.

But it is equally important to understand the residential neighborhood that we call the *hara* to understand the urbanism of Cairo. Since its establishment in AD 969, Cairo has been composed of such traditional quarters. Each quarter normally contained a small local market and workshops, and its occupants often worked in the same craft or profession. During the Ottoman period, some of these *harat* also had gates that would be closed at night. And some such areas continued to exist in old neighborhoods of the city for many years afterward, sometimes retaining their medieval names. However, by the middle of the twentieth century, they had also become more accommodating of outsiders. The *harat* that appear in Bulaq in our two films can be seen as an extension of this history.

Cairo, circa 1942

World War II had an impact on all of Egypt, and we can see these effects in *Ghani*. In 1942, Egypt was a kingdom, and, although it had nominal independence, the British had maintained a major military force there for decades. The king and the cabinet, despite vibrant parliamentary debate, were also not free to act on most matters without the consent of the British royal envoy. At this time, the symbols of wealth and power remained

concentrated in western Cairo—that part of the city consisted of an area called Isma'ilia (which later became Downtown Cairo) and surrounding residential districts like Zamalek and Garden City. The class structure still also evinced an enormous gap between rich and poor, although a larger middle class was gradually beginning to develop (something that did not gain real significance until later in the decade) (Abu-Lughod 1970). We see this clearly in *Ghani*, in the contrast between the population of the *hara* in Bulaq and the lifestyle of Mahrous's family and those who live in Zamalek after they try to establish a new life there.

In the early 1940s, the economy of Cairo also declined significantly. This was due not only to the war, but also to a number of other factors, including a high rate of inflation coupled with a decrease in labor wages (Amin 2000, 56). This is represented in the film by the complete dependence of the workers in the printshop on its owner's whims, leading to their complaint that their salaries are not sufficient to maintain even a subsistence lifestyle.

Meanwhile, the Egyptian aristocracy was intent on simulating Western ways in many aspects of their everyday life. Yet many such families still also adhered to tradition in certain regards, which may be explained by their confidence about their historic place in the world. Indeed, adhering to tradition was thus not an indicator or measure of backwardness. And members of such families might frequent nightclubs and cabarets and drink whiskey at the same time that they enjoyed traditional belly dancing and religious occasions (Amin 2000). Again, we see this clearly in *Ghani*, as Mahrous and his family try to emulate their wealthy neighbors in Zamalek without having the same confidence in who they are as a community.

In the film, following this model, we observe that most of the men in the *hara* are of the same social class, and they all seem to work in the printshop. The role of women is likewise limited to being housewives who

3.5. The *hara* as it appears in *Law kunt ghani*.

54 Bridge as Border and Connector: Class and Social Relations in Cinematic Cairo

raise children and prepare food—although they also have some say over their husbands' activities. Meanwhile, in the district of Zamalek, we see quiet streets and green areas representing the sophisticated modern Cairo, housing the elite of Cairene society and the many foreigners who lived in Egypt prior to 1952. Shown, also, are the area's grand villas, with their modern furniture, valuable antiques, and luxurious cars.

The commentator Hisham al-Hadidi has suggested that some Egyptians prefer to avoid hard work, as work is not pursued for self-actualization, but mainly to make a living (quoted in Ezzat 2000, 44). We see this in *Ghani* when Mahrous suddenly discovers that he is rich and is no longer interested in working, only in retaining the title of "manager." And even when he loses all his money and returns to live in the *hara*, he still only cares to be the director of the printshop.

The film also shows how the coffeehouse plays an important role in the *hara*. As a place where local men and printshop workers meet before and after work, it is possibly the only place of relaxation and leisure in the *hara*. By contrast, Mahrous's barbershop provides another meeting place for workers—but mainly as a place to discuss their problems and to seek Mahrous's advice.

Adel Hamouda, an Egyptian writer, has opined that Egyptians in general, despite their poverty, are by and large a gentle, forgiving, and content people with an amazing capacity to withstand injustice and inequality until they are confronted with a situation that challenges their honor (quoted in Ezzat 2000, 26). We see this in the behavior of the workers in *Ghani*. Thus, even when they are completely dissatisfied with their wages, they do not go on strike; instead, they complain about it to Mahrous, who prepares for them a symbolic speech to be addressed to the original owner of the printshop. Ironically, they only rebel and refuse to work when they feel that their honor is later insulted by Mahrous, their former neighbor, when he takes over ownership of the shop.

But nowhere is the contrast between the poor *hara* and the wealthy neighborhood more obvious than in the arena of gathering and entertainment. In this sense, Zamalek is thoroughly Westernized, and the rich there go to casinos and nightclubs, wear European clothes, listen and dance to Western music, and eat European-sounding dishes while drinking beer and whiskey.

Cairo, circa 1956

The revolutionary movement of 1952, which had transformed Egypt into a republic by the time of *al-Qalb* in 1956, had a significant impact on the whole of Egypt. The knitting together of Cairo's torn social structure was perhaps one of its biggest achievements. What emerged in Cairo in the years

that followed was a more culturally unified and economically homogeneous city, in which the symbols of class and culture extremes were truncated (Abu-Lughod 1970). We see this very clearly in *al-Qalb* in the behavior of the residents of the *hara*, and, particularly, in statements by Zanouba and in Karima's relationship with Hamdy. Ironically, and despite the pan-Arab orientation of the time, Egyptians in general, and middle- and lower-class Cairenes in particular, became more Westernized after 1952. We see this in *al-Qalb* in terms of their dress, their use of the Arabic language, their interest in Western goods, and, in general, in their social aspirations. Karima's appearance is an excellent example of these new qualities.

Meanwhile, social solidarity was still a key aspect of life in the *hara*, as evident in the support its residents provide to Karima in hopes she will become a doctor and bring honor to them all. Toward this purpose, Zanouba collects material assistance from capable *hara* residents and provides it on a monthly basis to Karima's mother. The film is full of examples of this social solidarity. For example, when Karima is invited to a party that will also be attended by her wealthy colleagues and prospective husband, the owner of the laundry in the *hara* lends her a dress to wear to the event.

The houses of the *hara* are not in great shape, but they appear to be clean. As shown in the film, the *hara* in 1956 is made of old, multistory apartment buildings overlooking shared space. Each apartment is modest, but with a central multipurpose reception space used for eating, ironing and folding clothes, and meeting guests. By contrast, although the 1952 Revolution had already started its nationalization drive, part of which involved the confiscation of mansions of wealthy aristocrats who had supported the monarchy, we see that the mansion of Hamdy's father is still in good shape. It has an iron gate, modern spacious salons, an impressive formal staircase, elegant furniture, and wide terraces overlooking a garden—all qualities necessary to accommodate large receptions and parties like the one that Hamdy's father throws for him to announce his engagement.

3.6. A scene in the bakery, where we learn from the conversation with Zanouba that the residents of the *hara* financially contribute to help Karima study to become a doctor (*al-Qalb luh ahkam*).

3.7: The *hara* as it appears in *al-Qalb luh ahkam.*

Traditional forms of socializing and entertainment in the *hara*, like smoking shisha and drinking tea in coffeehouses, are also shown in both neighborhoods in the film. Yet, while the people of Bulaq would celebrate an event like Karima's engagement with folkloric songs and belly dancing, the people of Zamalek would celebrate with Western dances and European music.

Emerging Themes

A number of themes emerge from these two films in relation to the transformations of modernity in cinematic Cairo. If modernity is anything, it is about the experience of change. And in the films, change is best observed through the encounter between different classes, the aspirations that individuals and communities have within this class structure, and the contradictions inherent between their aspirations and their realities.

Any understanding of modernity as the experience of encounter between different classes, ethnicities, and genders benefits immensely from Marshall Berman's analysis of literature in his seminal work *All That Is Solid Melts into Air* (Berman 1982). Here, Berman explains how literature fictionalizing the remaking of Paris and St. Petersburg documented the encounter between different classes of society in an authentic manner that captured the emerging modernity of those times.

Similarly, in comparing *Ghani* and *al-Qalb*, we see how the encounter between the rich families of Zamalek and the poor workers of Bulaq reveals the nature of an emerging Cairene modernity in the mid-twentieth century. The encounter in 1942 seems to have been limited because, at that time, *harat* were partially self-contained. In *Ghani*, residents of the *hara* are thus shown to be largely self-sufficient, with little need to go outside the neighborhood to fulfill their daily needs. Their knowledge of how the rich live, however, is limited, resulting in a local community that appears content with its fortunes and place in society. Their sense of acceptance is further supported by a lack of aspiration, since they are employed in traditional trades or crafts and cannot rise to a higher level.

Emerging Themes 57

But, by 1956, as *al-Qalb* shows, the exposure of *hara* residents to other sectors of society through educational, recreational, and sports facilities created an aspiration for changes and movement. Their encounter thus becomes more confrontational, challenging, and related to class difference. The university was just such a space of encounter. But it also allows Karima to meet Hamdy, and, in general, it provided a bridge that enabled crossing between different social classes. Thus, although Hamdy may not have noticed Karima initially, it was her access to that space that allowed her to attract him as a love interest.

Aspiration for both money and status seems important, but to different degrees in the two films. In the context of 1942, Mahrous is interested in both, but when he loses the money that has allowed him to become owner of the printshop, his main interest is to retain his title as manager. By 1956, of course, Karima's aspiration is more focused on status and equality in the new age that followed in the wake of the 1952 Revolution.

But poverty and wealth are not portrayed as absolute values in either film. Views of wealth are instead determined based on the economic status of the person making the assessment. Thus Kamal is considered by Mahrous and his wife to be too rich to marry their daughter when he presents himself as a government clerk with a good salary. Instead, they view their daughter as too poor for him, because her lower status will create the possibility he will treat her badly. Yet, when Mahrous and his family become rich, Kamal is again rejected—this time because his income and status are seen to be too low for their new social class. A similar contradiction is evident in Mahrous's own behavior after he becomes rich. After spending time preparing a speech for the workers of the printshop, challenging the rich owner and asking for a wage increase, he abandons the workers' cause. He even switches sides, telling the workers they should be content with their current conditions and leave the rich alone.

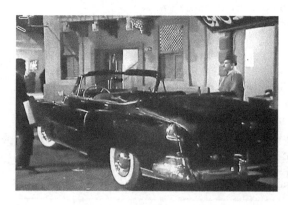

3.8. Hamdy's Cadillac parked outside the house of the heroine in the poor *hara* of Bulaq (*al-Qalb luh ahkam*).

Much of the above issues demonstrate the internal contradictions of modernity present in both films. In the 1942 *Ghani*, Kamal, the wealthy man from Zamalek who does not reveal his wealth, falls in love with a poor woman from Bulaq. And he is shown to not have second thoughts about the matter at a time when the gap between rich and poor was significant. In contrast, in the 1956 *al-Qalb*, Hamdy, in a year of supposed equality, reacts negatively when he discovers that Karima lives in a poor *hara*—to the extent that his initial impulse is to end their relationship. Similarly, his wealthy father is initially dismissive of Karima because of her poor social status. But, ironically, we later learn that he, too, is a self-made man who originally came from Bulaq, and is just being protective of his new social status. In a deliberate move by the director, the film ends by showing us that under his modern European attire, Hamdy's father still wears the same traditional vest that would be worn at home by a *hara* resident.

As mentioned earlier, ordinary Cairenes, despite difficulties in daily life, seem forgiving and content people. If we accept this assessment, it is possible to understand the reaction of the residents of Harat al-Faqr Heshmah in *Ghani*, who forgive Mahrous and welcome him back to the community after he has treated them badly when he was briefly rich. A similar forgiving attitude may be noticed in *al-Qalb* when Karima forgives Hamdy's behavior after he insults her in front of his friends. The same can be said for the entire community of the *hara*, who forgive Hamdy's father after he tries to kick them out of his house (Hamouda, quoted in Ezzat 2000, 26, 47). In both films, the gallantry of the lower classes is what is key to resolving social conflicts.

On the Nature of Cairene Cinematic Modernity

After the 1952 Revolution, class titles were quickly eliminated. Although this was supposed to remove all class distinctions, the class structure remained intact. This becomes evident when we compare the attitudes of the residents of the *hara* toward the elite classes in both films and find very little or no difference between the 1942 *Ghani* and the 1956 *al-Qalb*. Both residents seem to accept their poverty as a product of fate, and they are still conscious of their position within society as evidenced by the deference they afford the elite.

Yet, social solidarity among the urban poor is also a critical aspect of both films. In *Ghani*, it is evident in how the workers band together not only as workers but as residents in response to events—whether to discuss their plight when they cannot get a wage increase from the printshop owner, or to celebrate Mahrous's good fortune when he becomes wealthy, or to console him when he loses it all. And in *al-Qalb*, social solidarity in the *hara* is represented in the support that residents provide not only to each other, but

to Karima's family when they learn she is aspiring to become a doctor. In this sense, we do not see any change in the importance or practices of social support among the urban poor between 1942 and 1956.

Another change in the social structure of the community of the urban poor may, however, be witnessed in the rising of their aspirations. This is evident in the figure of Wahiba, whose interest in moving from poverty to wealth is in love, not in changing status. Indeed, her expectations of modernity are not polluted by wealth. By contrast, Karima, while studying to become a doctor, is very aware of her low status and works hard to change it by affiliating with her new middle- and upper-class colleagues. It is thus possible to suggest that the Revolution of 1952, which challenged the traditional social hierarchy of Egypt, did not immediately change the self-assessment of communities. The poor, while feeling endowed with new rights, continued to feel that the rich, who had lost their titles by decree of the new republican government, were still entitled to behave like an elite.

Galal Amin (2000) has suggested that throughout the late 1940s and early 1950s, Egyptian films were obsessed with the problem of social duality and the extreme contrast between wealth and poverty. This is obvious in our two films. But by the 1960s, this obsession subsided, possibly as a consequence of social changes brought about by the 1952 revolutionary movement. Instead, a whole host of new issues arose, including the status of women, sexuality, housing, and the inaccessibility of the bureaucracy.

Equally important, as Anwar (2018) has suggested, is that the wealthy and more comfortable social classes could always rise above local economic conditions in the city, while the lower classes could only be concerned with the daily local struggle for survival. Our two films, even with the fourteen-year interval between them, and with the intercession of the 1952 revolutionary movement which attempted to remove class distinctions, provide an excellent illustration in the "reel" medium of this "real" fact of life.

As a final note, we might add that the *hara* in both films resembles the depiction of a typical *hara* in the various novels of Naguib Mahfouz set in same time period. But the message from the two films is that the Cairene *hara* represents the true identity of Egypt, an identity that does not reject modernity. It is rather an identity that embraces modernity while maintaining an intermittent and deferential role for tradition.

The change in the portrayal of cinematic Cairo between 1942 and 1956 was likely prompted by the political and social change in the country as a result of the 1952 Revolution. The revolution brought in new conditions of encounter between classes, created a modernity of aspiration with hope for a better future for the masses. But this modernity of aspiration was full of contradictions because it was based on contentment with traditional roles and lifestyles.

The process of the modernization of Egypt that started in the mid-nineteenth century reached its peak in the mid-twentieth century. But, as the films *Ghani* and *al-Qalb* illustrate, the experience of modernity was never deeply rooted. Community traditions as a process continued to exist in the period between 1942 and 1956. Indeed, what we see from these films is more the veneer of an Egyptian modernity struggling for self-definition rather than a mature modernity by itself. This may explain why it was always a fleeting modernity, and why a few decades later, it was all gone.

References
Abd al-Mu'ti, A. 2002. *al-Tabaqat al-ijtimaiya wa mustaqbal Misr*. Cairo: Merit.
Abu-Lughod, J. 1970. "Cairo: Perspective and Prospectus." In *From Medina to Metropolis*, edited by L.C. Brown, 95–115. Princeton, NJ: Darwin Press.
AlSayyad, N. 2006. *Cinematic Urbanism: A History of the Modern from Reel to Real*. London: Routledge.
Amin, G. 2000. *Whatever Happened to the Egyptians?* Cairo and New York: The American University in Cairo Press.
Anwar, A. 2018. *Akhlaquiat al-tabaqa al-wasta wa dawraha al-siasi*. Cairo: al-Mahrousa.
Berman, M. 1982. *All That Is Solid Melts into Air.* New York: Simon & Shuster.
Ezzat, A. 2000. *al-Tahoulat fi al shakhsiat al-Masriya*. Cairo: Dar al-Hilal.
Fathy, S. 2018. *Classic Egyptian Movies*. Cairo and New York: The American University in Cairo Press.
Hayward, S. 2000. *Cinema Studies: Key Concepts*. London: Routledge.
Hussein, M. 1973. *Class Conflict in Egypt 1945–1970*. London: Monthly Review Press.
Qassem, M. 2012. *al-Film al-siasi fi Misr*. Cairo: al-Haia al-Ama lil-Kitab.
Schochat, E. 1983. "Egypt: Cinema and Revolution." *Critical Arts* 2, 4: 22–32, https://doi.org/10.1080/02560048308537565
Shafik, V. 2007. *Popular Egyptian Cinema: Gender, Class, and Nation*. Cairo and New York: The American University in Cairo Press.

4

Cinematic Cairo of the United Arab Republic, 1958–62

Kinda AlSamara

The cinema was not based on clear objectives and executive plans emanating from them, but rather it was subject to individual initiatives or commercial goals. The context of films were chosen at random or aimed to raise the box office success. However, in both cases, Arab cinema had not reached its potential to attain national or cultural achievements. (Qassem, 57)

The origins of cinema emerged in the late nineteenth century, in an era when philosophical and political thought was saturated with concepts of modernity, while the technical dimension was still in its early stages. Egypt was one of the first countries that adopted Western culture and incorporated elements of it into its movies. The industry of cinema in Egypt started in the 1930s and it began to produce three-quarters of all short and long Arabic films, as well as to host many international film festivals (Abu Zayd 2013).

The impact of the first movie was extremely significant, as previously audiences had only known the non-moving image. The phenomenon of watching a moving image was considered comparable to watching pedestrians walk to and fro in a busy city, such as Cairo. Elements such as fast movements, large buildings, and street noise were astonishing for viewers, as this incorporation of sound within film depicted an on-screen representation of the reality of urban life (AlSayyad 2006, 27). It was through this new medium of film that the experiences of Cairo's residents could be exported throughout the Arab world (Abu-Lughod 1970, 98). This significant representation of the city was famously expressed by Edward Said, as he described how Cairo makes one feel the presence of a complex popular cultural system (Said 2011, 78).

Reel Cairo: The Capital of the Arab World

Cinematic Cairo has always been strongly connected to political and social contexts. Egyptian cinema has played a crucial role in the political sphere since the emergence of political films. Some studies have revealed the impact of political trends on Egyptian cinema, as well as the role of the state in the production of different films. Therefore, when cinema criticizes the political and economic situation, it presents a dilemma to the government, and when the authorities ban a film or remove or change scenes in a film, this creates a conflict with the filmmakers, but such actions are often noticed by the wider audience (Joseph 2009, 75).

The city of Cairo embraced the most important film industry in the Arab region, such that the name of the streets and alleys of Cairo's city became engraved in the Arab consciousness. Cinematic Cairo drew the attention of pioneers of the arts so that the Egyptian dialect became the most widely understood among the many Arabic dialects, despite it being only spoken in Egypt. This made cinematic Cairo one of the most important tools of soft power that brought with it cultural and artistic influence at all levels (al-Mutawah 2005, 110).

Egyptian soft power consisted of three dimensions: language, history, and culture. This was in addition to Egypt being geographically situated at the heart of the Arab world (Kholeif 2011, 3). Soft power refers to cultural power and moral and political values, with the aim of changing conditions in a society. Thus, the Egyptian government used cinema to address myriad issues and to project certain ideas. Films are often used to portray the realities of or propagate specific ideas and norms within a society. In the case of an authority that incorporates soft power within its rule, analyzing the way in which films at the time portray these cultural and language norms allows one to better understand the situation of the time. Furthermore, through this look at Cairo cinema and examination of the elements of soft power, we are able to see the ways in which art and creative culture is used to create subtle messages of control and introduce new ideas. However, films were utilized in different ways, according to the views of the Egyptian leadership at the time (Gaffney 1987, 65).

Cinema is a type of art as well as a means of expression, carrying words, images, and other influences through its form. Images were not a form presented only to the masses for aesthetic purposes; the main function of these images is to deliver cultural, political, and social messages, in addition to economic benefit. Thus, Cairo and its constant urban evolution took shape in the imagination of audiences across the Arab world. This representation played an essential role by providing viewers with specific knowledge around issues that were evident in the movies, by changing the traditional media discourse (Gaffney 1987, 58). Thus, an important question poses itself

as to why films were such powerful, essential instruments of analysis rather than the more traditional educational elements such as literature, novels, or songs. One main reason was that films were an innovative, exciting, and contemporary new form of influence that reached large audiences and proved to be more powerful and influential than literature in a cultural sense.

Cinema is now no longer simply just images, events, and emotional stories, but it encompasses a wide field of implicit messages, which are represented through subtle signs and suggestions. These messages become evident through dialogue, decoration, or sound effects (Slowik 2014, 10). Thus, cinema published various ideas and issues which were in line with the nature of the issues society faced in all fields and areas, putting cinema at the cutting edge of ideological expression. In the same way that authors utilized rhetorical devices to enhance their reader's experience and opinion of a novel or piece of prose, filmmakers began to invent and employ cinematic devices to a similar effect.

Cinema is one of the most important tools of soft power. Globalization has resulted in the spread of technology and social media, which have proven their ability to change societies. Therefore, cinema plays a major role in influencing and establishing images of countries, their peoples, and their policies at all levels. This is in addition to its ability to form collective awareness of issues at a political level, especially with regard to those who hold the reins of power. Lila Abu-Lughod states that "people are both pedagogical objects and performative subjects [in visual media productions since] the industry seeks to shape, inform, and educate those who are the intended objects of this modeling" (Abu-Lughod 2005, 11). Abu-Lughod argues that viewers were conditioned by the social texts that were presented to them through films and, therefore, one can recognize certain socio-political norms that were introduced within certain social identities.

This proceeds from the fact that cinema provides the ability to control the cultural and ideological abilities of an audience. Egyptian cinema from the 1950s to the 1960s had a specific focus on restoring relations with Arab countries due to the influence of the intelligence services on soft power (Amin 2018, 103). The main factor needed in order to restore soft power is the restoration of the legitimacy and attractiveness of the Egyptian political system specifically after the Revolution of 1952, especially in cinema. In many political spheres, the state maintained control of all cultural, artistic, and cinematic activities (Tawfiq 1969, 97).

Egyptian culture and values, in addition to the attractiveness of the Egyptian social and political system (specifically during the 1950s and 1960s), were a source of inspiration for the countries of the region in the artistic field. The 1940s and 50s were considered to be the golden age of Egyptian cinema (Amin 2018, 111, as quoted in Shafik 2007, 49). Many

thinkers, intellectuals, and artists contributed to publishing houses, theaters, and cinema in shaping the awareness of the Arab people (Dajani 1980, 89–98). Soft power is one of the most powerful tools in shaping the political awareness of people, so there was adequate attention to and support for Egyptian cinema by state institutions (Lampridi 2013, 11).

Prior to the Revolution in 1952, the vast majority of films shown in Egyptian cinemas focused on entertainment rather that political commentary. However, Egyptian cinema changed during the 1950s and 1960s as a response to the new leaders' needs (Friddell 2012, 6). Furthermore, cinema and films were also used to construct a national identity for the general public through the presentation of famous literature and narratives.

Literary figures such as Taha Husayn and Tawfiq al-Hakim described the Egyptian personality as a combination of three elements: "pharaonic past, Arabic language and Islamic religion" (Schochat 1983). This practice is common in countries which were dominated by colonization and led to reconstruction of a national identity. Frantz Fanon states that

> The passionate search for a national culture which existed before the colonial era finds its legitimate reason in the anxiety shared by native intellectuals to shrink away from that Western culture in which they all risk being swamped. Because they realize they are in danger of losing their lives and thus becoming lost to their people, these men, hotheaded and with anger in their hearts, relentlessly determine to renew contact once more with the oldest and most pre-colonial springs of life of their people. (Griffiths, Tiffin, and Ashcroft 2006, 119)

Cinematic Cairo: Between State and the Politics

Political awareness can be understood as the mental perception of experiences and the variables surrounding them. Thus, individuals have the ability to form a specific attitude toward the reality in which they live, and this awareness can be easily constructed through art, education, and the media (Gaffney 1987, 53). Key rulers created a personality cult and constructed an image of the ideal, good citizen in the urban landscape through both written and visual art.

President Gamal Abd al-Nasser, who is still considered the most significant leader in modern Arab history, was rather a controversial figure with large numbers of both supporters and opponents (Gerges 2018, 17). The history that Nasser created witnessed massive events, beginning with his participation in leading the revolution with Muhammad Naguib. In 1952, they revolted against the monarchy, thus transforming Egypt from a kingdom to a republic and establishing a new period in Egyptian history (Gaffney 1987, 58).

Moreover, the nationalization of the Suez Canal and the experience of two wars, as well as great projects such as building the Aswan High Dam, internal reforms at the economic level, and the momentous unity with Syria for three years, 1958–61 (forming the United Arab Republic) represented a significant shift from Western hegemony and the revival of pan-Arabism (Armbrust 2000, 161). All of these events created the need for the new state to support a civic, modern identity that promoted Arab identity as the best solution for strengthening solidarity among the Arabs. Also, the reaction of people against Western intervention contributed to the formation of the cultural, social, and political awareness of this period. Nasser rejected Western cultural domination: his argument was dependent on the idea that Arab nationalism needed to be independent and could not accommodate globalization (Qassem 2019, 106). The glorification of traditional cultural ideals and nationalism were instruments allowing the return of dignity, pride, and power to Egypt.

Although Nasser's period did not result in a massive cultural trans-formation, in one way or another it contributed to the revitalization of a cultural movement in Egypt (Amin 2018, 28, as quoted in Shafik 2007, 34). Cinema became part of the initial phase of nation-building, which contrib-uted to the formation of national awareness, not only as an Egyptian but also as an Arab in general. The nationalist ideology, as presented through cinematic Cairo, attempted to produce films that were related to reality through the presentation of key modern topics and social issues in order to make citizens more politically active (Gaffney 1987, 53). Consequently, the cinema, used as a medium to introduce new ideology, played a vital role in the growth of a communal identity and solidarity between people.

Once the Egyptian government realized the importance of the cin-ema as a soft influential power that could produce culture and national ideas, they took serious steps to reorganize the cinematic industry. It was a tool to influence national thought and identity surrounding the reality of modernity and inevitable urban developments, and the myriad changes that were taking place in modern Cairo. Nasser viewed cinema as "a space that would transform national identity through the message of the state" (Youssef 2010, 11). This marked a new era in Egyptian film, which was now characterized by state political interference in the arts and industry, and the advent of new genres and topics. The new regime established the Supreme Council for the Protection of Arts and Letters and, in 1957, the Organiza-tion of Consolidation of Cinema, with the aim of achieving a higher level of cinematic art and strengthening the national cinema industry. The new organization launched annual awards for filmmakers, the main purpose of which was to inspire directors, producers, writers, and actors to expand and improve the quality and value of their films (Youssef 2010, 12).

The organization also established a number of laws that outlined the relationships between "producers and technicians, producers and distributors and cinema owners" (El-Mazzaoui 1960, 250), with a view to professionalizing the cinema industry. By 1961, Nasser's regime nationalized the film industry, highlighting the regime's real interest in cinema. The main purpose of these changes was to construct a new civic identity for people by making them citizens of the new socialist nation (Gordon 2002, 8).

Nasser's regime was known for its authoritarian nature, reliant upon a one-party system, banning other political parties from participating in the state, and marginalizing elite members of society by taking away their wealth (Gordon 2002, 37, quoted in Vatikiotis 1986, 56). The regime exercised its power to control its citizens; however, cinema was the essential instrument to present the political views of the government in an attempt to influence people.

The Egyptian regime encouraged overtly political as well as historical films; however, it utilized a double standard since the state's regime was supposed to be exempt from any criticism. To this end, film scripts needed to be approved by the Censorship Department, the approach of which was in turn reliant on the current situation and the prevailing political climate. This resulted in a correlation between cinema and political power.

Cinema always had a close relationship with the state since its inception. Political leaders realized that cinema opened up many doors to help them in the business of government, especially related to their political agenda (Podeh and Winckler 2004, 23). However, the influence on people through cinema was not based on individual artistic work, but rather through the cumulative impact of films in an attempt to identify and encourage specific societal behavior.

Creativity can be an attempt to create a new reality, but the issue lies mainly in the relationship between political and cinematic elites within society. It is a limited relationship due to the divergence of visions and ideas between them: they both look at reality from different perspectives and ignore the needs of the people. Indeed, the influence of intellectuals in society cannot be isolated from political and cultural life (Kholeif 2011, 5).

Cinema had a positive modernist impact by advancing its industry. The influence of cinema on the mindsets of the audience was strong, as it encouraged national feelings. The impact exceeded the influence of newspapers and books; it was an important tool for communication in addition to being no longer a reflection of reality, but rather a partner in its making. It was one of the main tools for disseminating state positions, trends, and values through promoting political awareness in society. Moreover,

Egyptian cinema was a vehicle that was used to shape individual perceptions of the outside world, and in circulating the importance of Cairo to Arab peoples (Samak 1977, 12).

Cinema itself has undergone a set of transformations on its path; it reflects the interactions of society and, therefore, it is not possible to understand cinema isolated from society. It was used to convey topics that contributed to cultural development, the most important of which was political awareness due to its salient role in the process of consolidating the politics of the state. As such, it guided individuals and conditioned them to respond to an action or situation in a specific way. Political awareness contributes to pushing individuals to perform in a particular way, such as participation in demonstrations and other such activities. Therefore, all means of communication to the masses, including cinema, sought to spread political awareness specifically through their actions and attitudes toward the issues that were of concern to the government (Gaffney 1987, 53).

The role of modern cinema and its influence in the political sphere differed from time to time. Cinema was a tool that affected the political awareness of individuals in society, however, framing it as a by-product which has come to serve other political purposes. This highlights the fact that cinema is a more flexible and profound tool for political theorization, and becomes enriched with levels of analysis on the effects of movies (Happer and Philo 2013, 323).

There were a number of films produced at this time that presented general Arab topics and thus promoted the idea of Arab unity. These films presented Arab solidarity and "blood brotherhood," as propounded and championed by Nasser, as the symbol of Arab nationalism and its ambitions of achieving Arab union (Pannewick and Khalil 2015, 82). Among Arab world leaders, Nasser had established himself as a major leader who devoted himself to the unification of Arab countries. This commitment is reflected in the embodiment of the dream of Arab unity in all its forms.

Parallel with that, the climate prevailed in Syria, especially Damascus, for participation in activities for Arab liberation, as the Syrians considered themselves to be the natural leaders of Arab nationalism (Pannewick and Khalil 2015, 52). The yearning for unity was encouraged by admiration of Nasser among Syrians and, thus, the union took place in February 1958. Internal and external elements influenced Syrian leaders, convincing them that the solution to their dreams could be achieved by the union with Egypt. In one of his famous speeches, given after the initiation of the union, Nasser expressed the sheer joy he was feeling at the time and referred to Syria as "the beating heart of Arabism." This powerful statement

highlights the significance of the union in Nasser's mind and the way in which he employed slogans and catchy phrases to strengthen the idea of one united Arab people in the minds of Syrians and Egyptians alike. This would then be transferrable across the Arab world.

The Rise of Pan-Arabism and its Impact on Egyptian Cinema

The Egyptian cinema industry witnessed a major transformation in the 1960s. Nasser valued the benefits of cinema, so he created the Cinema Support Foundation. His cinematic interest was spurred by watching an American film that heavily influenced him, and he ordered this film to be shown in every camp of the Egyptian army. The film tells the story that an individual can change world history, and this led Nasser to believe in the power of cinema and the role it can take beyond being merely a form of entertainment to becoming a powerful educational tool. This led to the approval of the establishment of the Higher Institute of Cinema (Samak 1977, 12). The public sector in cinema was not created as an official response to a shared desire of the people and the leadership, but to radically transform the dominant culture and change the nature of the art of cinema and the film industry. It was essentially a continuation of the process of bureaucratically reshaping the state sectors along the lines of what was described as "Arab socialism" in the Charter of National Action. The filmmaking industry was eventually wholly nationalized in1963, such that the ideas, concepts, and philosophy fell under government control, under a new public-sector structure. The problems of the film industry under the public sector were usually viewed as the results of mismanagement and bad administration. However, it is difficult to separate the managerial and administrative character of the system from its political and social basis.

Cinema in the era of Nasser was often used for political and ideological justification; either by presenting issues indirectly, or by criticizing previous regimes, or by raising awareness across social classes as an influential medium aimed at the masses (al-Sayyid 2008, 38; Happer and Philo 2013, 326). Cinema was used in internal and external propaganda as a tool, and worked to shape both local and international public opinion on various issues of public concern. By addressing issues indirectly through a tightly woven story, it analyzed these issues and tried to find possible solutions for them, thereby affecting the public without addressing the issues in a direct way that might lose public confidence.

Cinematic representation was able to achieve what no other art form could, becoming a believable fantasy. It contributed to raising the degree of confidence in the credibility of films through its depiction of events that already existed in real life, relying on the similarity between these

depictions and reality (Samak 1977, 17). Films drew on real-life situations for their storylines and *'Amaliqat al-bihar (Sea Titans)*, directed by al-Sayyid Badir in 1960, is a good example of this. The story itself lent itself to the promotion of the unity that brought Egypt and Syria together and illustrates how cinema was targeted as a means of conveying various messages to the public and influencing it. Although *'Amaliqat al-bihar* was released after the formation of the United Arab Republic, it was set in the period prior to the union and explored issues surrounding the Suez Crisis (Suwaylim, A., and S. Qalshi 2017, 222).

'Amaliqat al-bihar uses artistic capabilities of expression to explain and embody the political, economic, and social problems. Different symbols are used throughout the film to convey reality and create a kind of interdependence between the scenes and the content of the film. The intention, here, is to have an impact on the consciousness of individuals through the cogency of what the film presents. The viewers are intended to be so engrossed in the film that they enter its paradigm completely and live within its reality.

Furthermore, the film deals with the "blood brotherhood" between Egyptians and Syrians during the Suez Crisis (Banna Du'a' 2019, 176). Syrian navy officer Jul Jamal took part in the naval battle of Burullus, in which an Egyptian naval unit engaged with the enemy fleet: thus, the

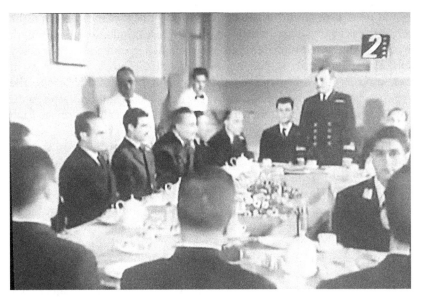

4.1. The officers in the navy mess, where the Syrian hero of '*Amaliqat al-bihar* has a large number of Egyptian counterparts, preparing to honor their commander.

The Rise of Pan-Arabism and its Impact on Egyptian Cinema 71

blood of the martyrs from Egypt and Syria was mixed in the waters of the Mediterranean (Suwaylim, A., and S. Qalshi 2017, 223). The filmmakers decided to hire the brother of the main Syrian hero to portray him in the film. This choice reflects a very interesting indication of the kind of social relations that were established between Egyptians and Syrians in this time period. The production of the film was very much in line with the spirit of unity between the two peoples, and some scenes were filmed in the birthplace of Jul Jamal. The film inspired both condemnation and sympathy for the Egyptian families. The main idea of the film was to promote the importance of belonging to the Arab homeland and the need to triumph over the enemy (Qassem 2012, 128). It is worth mentioning here that, at the time, there was no other art form that could come close to cinema in terms of popularity, as it partly reflected reality, and was able to influence through symbolism. The film is about Egypt and Syria, the connection between them, and the existence of the United Arab Republic in the imaginary of both nations. It is interesting that the entire film seems to focus on the two port cities of Alexandria and Latakia as representatives of all of Egypt and all of Syria: in a sense, this becomes a presentation of a larger national domain.

The unity of 1958 created the promise of socio-political transformation; meanwhile the attachment to the cultural atmosphere of aspiring to prosper remained. Despite the martyrdom of the hero—the tragic ending of the great love story in *'Amaliqat al-bihar*—this romance depicted the strength of the two cities in their unity as surpassing all else. This strength was presented as naturally leading to the channeling of the national energy of the people toward building a promising unified future. The title itself, *Sea Titans*, implies a deep meaning of strength and control. This evokes the regime's goal of maintaining control over Arabs' dreams and aspirations through instilling popular attachment to a cultural sensibility for the Arab people to unite.

Another key film that reiterated the official use of cinema in shaping public political, social, and urban awareness is the popular comedy *Isma'il Yasin fi Dimashq (Isma'il Yasin in Damascus)* (1958) directed and produced by Helmy Rafla. Both the cities of Cairo and Damascus played an important role in this film, and the urban development and modernity of life in these cities was a central focus in the storyline and cinematography.

Isma'il Yasin was a very well-known figure in both Egyptian cinema and Arab society. Having acted in over 260 films, he was extremely popular and iconic in his role within cinematic Cairo. The mere fact that one of his films is centered around regional urban networks and connections between nations is extremely significant. It also highlights the ongoing activity and development of Egyptian cinema at the time as it reiterates

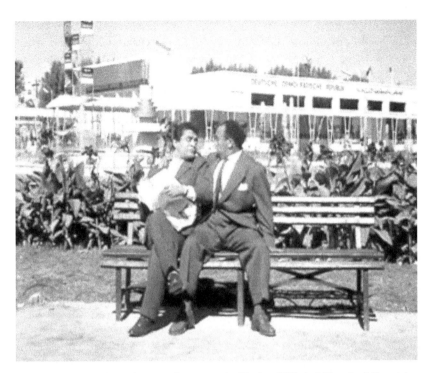

4.2: To demonstrate the modernity of Damascus, the film *Isma'il Yasin fi Dimashq* deliberately takes us to Damascus International Fair.

the way in which film was used to further not only ideas around culture and history, but also the realities of the progress and expansion of Cairo as a globalized Arab center.

The film was initially announced as *Isma'il Yasin fi Lubnan (Isma'il Yasin in Lebanon)*, as its events mainly take place in Lebanon. However, in order to further both viewership and political agendas surrounding the union, the title was changed and the name of the film became *Isma'il Yasin fi Dimashq (Isma'il Yasin in Damascus)*. Despite there being no real references to Damascus as a city, other than in the final segment of the film, this name change was a deliberate attempt to ride the wave of the union, and there was no time to add new scenes or events to what was already filmed. Amid the joy of the people who went to watch the film, which was shown in theaters in Egypt and Syria at the same time, the two presidents of Egypt and Syria announced the union. However, despite the fact that Damascus was not significantly represented, as would be assumed through the title of the film, audiences did not question this, and the film succeeded as a symbol of strength and unity between the two nations.

Despite the minute representation of Damascus in the film, the urban representation of Cairo was very significant. Throughout the film, one can see the city of Cairo as any other European city: clean, spacious streets, lush trees, classic architectural styles—even the homes of the poor were spacious and beautiful. The film revolves around the search for the spirit of the city.

Cairo has always been an attractive city for photography. However, the characters in the film travel to the city of Damascus to see the Damascus International Fair. The camera shifts between the exhibition's sections and its fountains to show audiences its vast area and various wings, such as Hungary, India, the German Democratic Republic, the Federal Republic of Germany, and Union of Soviet Socialist Republics. This was to demonstrate the openness of the city of Damascus and its policy of global cooperation. Furthermore, the constant references to an Egyptian insurance company were a vital addition to the film. The popularity and global nature of the company aimed to represent the development, modernity, and contemporary lifestyle that Cairo was experiencing at the time. Insurance companies and the idea of life insurance were rather radical, innovative concepts for a conservative Arab society. The incorporation of such a company within the film not only serves a very specific cultural significance and highlights the ideological development of the city, but also highlights the urban development of Cairo. The mere presence of such a company in a city like Cairo intensifies the importance of the city and its advancement in the region.

While the film was being showcased, the unification between Syria and Egypt was put into effect. The Egyptians were interested in publicizing the city of Damascus and the Damascus International Fair, mentioning the recurring annual date, and inviting people to visit the city and its major exhibition. The appearance of the two cities together signified new cultural practices, whereby the connection between the two became a symbol of strength and unity accompanied by the flow of ideas, knowledge, and culture.

Egyptian Cinema and the Changing Political Climate

Cinema has the unique ability to reveal previously hidden issues as well as hide other previously known issues. Events that take place in the public eye affect the soul of a nation, inciting reflection on public behavior. The message provided by the arts, including cinema, is usually intentional and what the government wants to deliver to the public (Podeh and Winckler 2004, 4). Art always denotes something that already exists in reality or fiction. The power of art comes from its ability to present issues with an artistic plot that affects the public, as can be understood through the film *Sanawat*

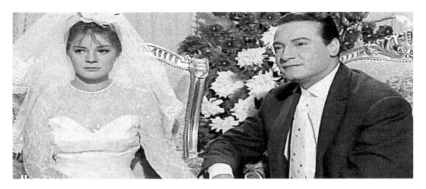

4.3. Nadiyah, the heroine of *Sanawat al-hubb*, is married in a traditional wedding setting.

al-hubb (Years of Love) (1963). During the union between Egypt and Syria, Amin Yusuf Ghurab wrote the novel *Sanawat al-hubb*; the story takes place between Cairo and Damascus. However, the separation between the two regions resulted in a change in the film's adaptation of the novel and led to a dramatic alteration in the setting of the story, which became Cairo and Alexandria instead (Qassem 2012, 359). Damascus was completely removed from the film, and any indication of the union between Syria and Egypt was subsequently edited out.

The film's storyline and the scenes portrayed within it are strong indications of the more liberal, developed ideas becoming popular in Cairo at the time. The protagonist, Adel, is played by an Egyptian icon in the cinematic world, Shukri Sirhan. Sirhan starred in over 150 films, for which he was widely known and very popular. In the film, 'Adil gives up on his love in order to pursue an academic scholarship opportunity in a foreign country, as he views his education to be his priority. Despite the many challenges he faces due to his emotional sacrifice, he completes his studies before returning to Cairo. Furthermore, the way in which urban Egyptian women are depicted indicates the level of openness, the global mindset, and the academic and educational priorities present in modern Cairo. 'Adil's love interest, played by Nadiyah Lutfi, is introduced to him through a graduation photo in one of the Cairo journals of the time. They spend the day together at a coastal area in what is portrayed as a very free, relaxed society environment, in which women are key figures and important social and cultural influences. Nadiyah is able to autonomously travel around the city and create friendships and relationships with the opposite gender in what is presented as an open and understanding society (Qassem 2012, 89).

There is a deep contrast between film productions during the period of union and after it as perceived by the audience. This serves to illustrate the deterioration of Arab unity, as the love story no longer takes place between two people from two cities in different parts of the Arab world,

skewing the reality. Nevertheless, the director of *Sanawat al-hubb* chose to film the metro and the metro station with a view to showcase Egyptian advancement in technology, and presented the modernity of the city during Nasser's period. The depiction of a modern, clean, and urbanized metro station served to reiterate the idea of development and advancement in the city. The film also presented the freedom of women to use the metro independently and share the same metro car as men. This was important to show the progress of Egypt and the modern ideals it had adopted. Furthermore, the film also chose to include a cruise ship and airplanes as symbols of modernity and to portray Egypt as a developed country. In a way, the film was a first attempt to democratize cinema for a modern audience (Shafik 2007, 324).

The political dimension of cinema in general cannot be ignored; it follows that cinema plays an important role in forming political awareness among individuals in addition to influencing public opinion on the issues raised in society. It is manifest that going to the cinema is a form of entertainment, and that the viewer is always looking for some kind of pleasure in watching movies, but it is just as evident that the function of film cannot be reduced to only entertainment (Gaffney 1987, 57). Filmmakers address the hopes, aspirations, and fears of every era. They express all the political and social experiences and real events that run through a country in an exciting cinematic way. In analyzing the three films presented in this chapter, it is obvious that they present some kind of subtle political criticism and carry with them important judgments on the era they present, including political, cultural, social, and economic events.

Cinema generally offers different visions of places and events or makes us look at the world from different perspectives, with a degree of persuasion toward a particular point of view. It enables us to perceive things we would never have seen before. The cultural elements portrayed in our films, specifically those centered around key issues of urban development, are strategically presented. The way in which education was a priority in modern Cairo, as well as the role of women and the introduction of liberal ideas and the development of infrastructure, sheds light on the issues facing the advancement of Egyptian society at the time.

Furthermore, the three films provide images of events and places that audiences did not have access to in reality, especially those that were related to important historical moments. The vision they offer becomes entrenched in people's minds as a substitute for historic or geographically distant reality, since most viewers would not engage in the added step of researching the related history, rendering an alternative perspective based on facts. But, rather, the content of the films becomes aspirational, and Arab viewers, the majority of whom were not living in

large urban centers such as Cairo, developed an imaginary of the city as offering a more sophisticated life. There is no doubt that Egyptian cinema, deliberately or subconsciously, played an important propaganda role during those years through its incorporation of social studies and political theories in its presentation of national events as seen through the eyes of the Egyptian government that was responsible for and ran the United Arab Republic.

Concluding Note: Egyptian Cinema, Cinematic Cairo, and the Arab World

Naguib Mahfouz noted, "The contemporary figure is the worst historian," as one sees everything close-up at a time when some incidents, events, and objects need to be looked at from a distance. It becomes difficult to view contemporary life through an objective lens, as can be understood by the way in which contemporary cinema was used to portray rather one-dimensional representations of urban modern realities in the United Arab Republic.

Egyptian cinema, specifically, became a model for cinema in the Arab world, in which the political dimensions interfered with the art of film making. The role of the state in cinematic production was evident during Nasser's era through a set of films used to present the vision and policies of the ruling regime. Films could be used as tools within political systems, seeking to justify their legitimacy. But the production of films under an authoritarian regime decreased due to the restrictions on artistic content.

The three films analyzed in this chapter represent the voices particular to socio-political views and agencies in Egypt and Syria and how the two cities of Cairo and Damascus played an important role during the union and postunion period. During the union period, films played an essential role in documenting the political and social atmosphere—making them a cultural and historical educational instrument, despite the regime's agenda. Established in this national spirit, the filmmakers translated into visual language the realization of their circumstances—or the facts and events they witnessed and which in turn influenced them. However, during the postunion period, the filmmakers stepped back from engaging with the mandated state narrative about the union.

Cinematic works of the United Arab Republic, including our three films, had a strong influence on public opinion and were also affected by it. Nasser's regime was aware of the importance of the cinema and, for that, directly supported the films that promoted its own agenda. Moreover, the way in which modernity and development were portrayed throughout cinema was vital in shaping the realities surrounding the imagination of Cairo as a city. This representation of the city in terms of its culture and relative advancement, compared to other Arab cities of the time, assisted in

the buildup of Cairo across all forms of art and culture in the Arab world and, possibly, globally. It advanced the association between the name Cairo and an imaginary of modern culture, flow of ideas, knowledge, and urban sophistication among the surrounding Arab countries for decades to come.

References

Abu-Lughod, J. 1970. "Cairo: Perspective and Prospectus." In *From Medina to Metropolis*, edited by L.C. Brown, 95–115. Princeton, NJ: Darwin Press.

Abu-Lughod, L. 2005. *Dramas of Nationhood: The Politics of Television in Egypt*. Chicago: The University of Chicago Press.

Abu Zayd, A.M. "al-Quwwah al-na'imah al-misriyah bayna 'al-su'ud wa-l-taraju'." *Siyasat 'Arabiyah* 5: 76–91.

AlSayyad, N. 2006. *Cinematic Urbanism: A History of the Modern from Reel to Real*. London: Routledge.

Amin, G. 2018. *Whatever Else Happened to the Egyptians?: From the Revolution to the Age of Globalization*. Cairo and New York: The American University in Cairo Press.

Armbrust, W. 2000. *Mass Mediations: New Approaches to Popular Culture in the Middle East and Beyond*. Berkeley: University of California Press.

Banna Du'a', A. 2019. *Dirama al-Mukhabarat: wa-qadaya al-huwiyah al-watani-yah*. Cairo: al-'Arabi lil-Nashr wa-l-Tawzi'.

Dajani, K.F. 1980. "Cairo: The Hollywood of the Arab World." *Gazette* 26, 2: 89–98.

al-Dusuqi Jumay'i, 'A.I. 1998. *Tarikh al-sinima al-misriya*. Cairo: Mu'assasat Ibn Khaldun.

Friddell, B. 2012. "Afraid of Commitment: Gamal Abdel Nasser's Ephemeral Political Ideology—a New Definition of Nasserism." Senior thesis, Department of History, Haverford College, PA.

Gaffney, J. 1987. "The Egyptian Cinema: Industry and Art in a Changing Society." *Arab Studies Quarterly* 9, 1: 53–75.

Gerges, F.A. 2018. *Making the Arab World: Nasser, Qutb, and the Clash that Shaped the Middle East*. Princeton: Princeton University Press.

Gordon, J. 2002. *Revolutionary Melodrama: Popular Film and Civic Identity in Nasser's Egypt*. Chicago: Middle East Documentation Center.

Griffiths, G., H. Tiffin, and B. Ashcroft. 2006. *The Post-Colonial Studies Reader*. London and New York: Routledge.

Happer, C., and G. Philo. 2013. "The Role of the Media in the Construction of Public Belief and Social Change." *Journal of Social and Political Psychology* 1, 1: 321–36.

Joseph, S. 2009. "Representations of Private/Public Domains: The Feminine Ideal and Modernist Agendas in Egyptian Film, Mid-1950s–1980s." *A Journal of Women Studies* 30, 2: 72–109.

Kholeif, O. 2011. "Screening Egypt: Reconciling Egyptian Film's Place in World Cinema." *Journal of Film and Television Studies* 19: 1–27.

Lampridi, A. 2013. "Egypt's National Interest: A Sociology of Power Analysis." PhD diss., Universitat Autònoma de Barcelona.

El-Mazzaoui, F. 1960. "Film in Egypt." *Hollywood Quarterly* 4, 3: 245–50.

Al-Mutawah, H. 2005. "Gender Relations in the Arab World: A Rhetorical Criticism of Naguib Mahfouz's 'Awlad Haratina.'" PhD diss., Bowling Green State University, OH.

Pannewick, F., and G. Khalil. 2015. *Commitment and Beyond: Reflections of the Political in Arabic Literature since the* 1940s. Wiesbaden: Reichert Verlag.

Podeh, E., and O. Winckler. 2004. *Rethinking Nasserism: Revolution and Historical Memory in Modern Egypt.* Tallahassee, FL: Orange Grove Texts Plus.

Qassem, M. 2012. *al-Film al-siyasi fi al-sinima al-misriya.* Cairo: al-Hay'a al-Misriya al-'Amma lil-Kitab.

———. 2019. *Jamilat al-sinima al-misriya.* Cairo: Wakalat al-Sahafa al-'Arabiya.

Said, E. 2011. "Le Caire. Entretien avec Edward Said." *Écrire l'histoire* 7: 77–85.

Samak, Q. 1977. "The Politics of Egyptian Cinema." *Merip Reports* 56: 12–15.

al-Sayyid, A. 2008. *al-Film bayna al-lugha wa-l-nass.* Damascus: Wizarat al-Thaqafa, al-Mu'assasa al-'Amma lil-Sinima.

Schochat, E. 1983. "Egypt: Cinema and Revolution." *Critical Arts* 2, 4: 22–32, https://doi.org/10.1080/02560048308537565

Shafik, V. 2007. *Popular Egyptian Cinema: Gender, Class, and Nation.* Cairo and New York: The American University in Cairo Press.

Slowik, M.J. 2014. *Hollywood Film Music in the Early Sound Era, 1926–1934.* New York: Columbia University Press.

Suwaylim, A., and S. Qalshi. 2017. *'Jaysh 'al-sha'b: al-sura al-kamila.* Cairo: Dilta lil-Nashr wa-l-Tawzi'.

Tawfiq, S. 1969. *Qissat al-sinima fi Misr.* Cairo: Dar al-Hilal.

Vatikiotis, P.J. 1986. *The History of Egypt.* Baltimore: Johns Hopkins University Press.

Youssef, M. 2010. "Egyptian State Feminism on the Silver Screen? The Depiction of the 'New Women' in Nasserist Films (1954–1967)." MA thesis, George Washington University, Washington DC.

5

Kafkaesque Modernity: Cairo in the 1980s and the Middle-class Housing Crisis

Ahmed Hamdy AbdelAzim

As [Gregor Samsa] awoke one morning from uneasy dreams, he found himself transformed in his bed into a gigantic insect.

(Kafka, *The Metamorphosis*)

During the 1970s and all the way through the 1980s, the Cairene middle class had to deal with a set of challenges that ranged from the shortage of adequate housing to their falling social and economic status. Numerous films produced during this period have discussed those challenges, but two of them, produced in 1986, stand out: *al-Hubb fawq hadabat al-haram (Love on the Pyramids Plateau)*, directed by Atef al-Tayeb and based on a novel that carries the same name by the Nobel laureate Naguib Mahfouz; and *Karakun fi al-shari' (Prison Cell on the Street)*, directed by Ahmed Yahia. The protagonist in both films is an educated middle-class male who struggles to find an appropriate place to reside in the city. Through accompanying the protagonist in his quest to find an apartment, we are exposed to Cairo's hostile, unbearable, and, sometimes, surrealistic modernity. Cairo at that time showed great resemblance to the setting and atmosphere of the works of Franz Kafka, especially his *The Trial* and *Metamorphosis*. In both novels, the city transformed the good, obedient, and productive individual into either a corrupt or a marginal character before sentencing him to death. The Cairene middle class had to deal with a Kafkaesque city that challenged their core principles and threatened their identity and status.

The Making and Unmaking of a Local Middle Class

Minna Saavala, in her book *Middle-class Moralities*, offers a valuable insight on some of the defining characteristics of the middle classes in the Indian context which have some general relevance. According to her, identifying

as "middle-class" was tied to the ability to control the surrounding environment (Saavala 2010, 12). Whether in education, marriage, number of children, or professional career, middle-class members are distinct by their reduced vulnerability, compared to lower classes, to external factors beyond their circle of influence. Although this ability to control their surroundings separates the middle class from the lower classes, whom they regard as the carriers of negatively valued elements of society, it is still equally important to distinguish themselves from the elite, whom they regard as immoral due to their excessive Westernization, manifested mainly in their improper dress and religious indifference (Saavala 2010, 114). Saavala's work guides our understanding of the "operating logic" of the middle class. Although her work examines the Indian middle-class primarily, the points she makes, namely the desire to control their surroundings and their perceived distinction from the lower classes, shape, as we see later, the actions of the protagonists in both movies and influence their decision-making.

Being middle class in post-1952 Egypt entailed, according to Walter Armbrust, at least a high school education, a familiarity with modern institutions, and a lifestyle free from manual labor. In media discourses, the middle class was always associated with modernity, bureaucracy, and office work (Armbrust 1999, 111). During Nasser's rule, even before, being middle class meant a secure future and a good salary that would allow the individual to get married and start a family. The housing crisis during the 1970s and 1980s affected the middle class in one of its defining characteristics: the ability to control its surroundings—the lack of a proper residence problematized the present and drew an uncertain image of the future.

According to Janet Abu-Lughod, the housing problem in Cairo is as old as history; however, under Nasser the phenomenon exploded, culminating in a real problem (Abu-Lughod 1971). In 1952, Nasser started, by means of the agrarian reform law, to eradicate the feudal land ownership system which had resulted in one-tenth of the population controlling 45 percent of the net national income (Issawi 1963, 118). The law aimed to break down the economic and political power of the landowning class in order to bring a greater measure of social justice and equality. Later, in 1956, the government started to nationalize, through sequestrations, British, French, and Jewish property, leading to the expulsion of these communities, which left the government with large assets (Issawi 1963, 55). The state started to expand its investments, eventually becoming the one-and-only economic player. State-owned stores began to appear in the Downtown area of Cairo, with Arabic names instead of their previous foreign ones (AlSayyad 2011, 239). Stores that used to sell a wide range of foreign goods began selling a limited variety of state-owned, locally

produced products instead. By the end of the 1950s, the government was responsible for almost 80 percent of the economy; the bulk of engineers, doctors, and lawyers either already worked in government enterprises or would soon do so (Issawi 1963, 64). Nasser's egalitarian policies were gradually homogenizing the population and erasing any differences. The older elite were rarely seen, and the barefoot poor were disappearing in favor of a growing middle class that shared very similar interests in terms of consumption patterns, ways of dress, and leisure time activities that resembled a Westernized modernity (Abu-Lughod 1971, 238–39).

This economic and commercial growth went hand-in-hand with industrial growth that was initially intended to not only decentralize Cairo but also to attract the population toward the six "rising" cities, in order to create industrial centers in eastern and southern Egypt that were attractive to the new middle class (El Kadi 2009, 37). However, due to the political unrest that haunted the first years following the 1952 Revolution and peaked during the Suez Crisis in 1956, the six-cities plan was forsaken in favor of industrial zones that bordered Cairo. This resulted in the continued supremacy of Cairo, as it contained 42 percent of industrial infrastructure and 27.2 percent of employment (El Kadi 2009, 38). Nasser's economic policies served a rising technocratic–bureaucratic urban middle class at the expense of the poorer agrarian and peasant societies, which, despite the reformation law, did not receive much state attention in terms of consumer market share and access to goods (Abaza 2006, 95).

Cairo became the number-one destination for internal migration, absorbing 80 percent of the total work force from the countryside. The city also received massive numbers of internal migrants during the years 1968 and 1969, with estimates ranging around half-a-million to a million, consisting of those who fled the war zone along the Suez Canal (Abu-Lughod 1971, 238). By the end of the 1960s, Cairo proper's population was a little more than 6 million, 2 million more than what was projected back in 1960 (El Kadi 2009, 38). Despite the government's efforts to provide affordable accommodation, the waves of migrants created a massive housing demand that was hardly met (Abu-Lughod 1971, 166). The increasing number of migrants settled in informal settlements built on agriculture land on the peripheries of urban Cairo, leading to a massive building explosion in those areas.

Nasser's modernization project had education among its top priorities. The country was in need of trained Egyptians to replace the expelled foreign technicians, which could happen only through education: primary schools were expanded, free and compulsory; technical schools were initiated (Cochran 2012, 46). According to Moore, the engineer was the hero of the Nasserite regime, which increasingly relied on them to run the state

apparatus and public sector (Moore 1980, 44). During the 1950s and 60s, state education became the main route to social mobility, a secure career, and middle-class status (de Koning 2009, 51). Nasser promised the middle class a better life, and education was the means to this. The education system was characterized by Arabization policies that aimed to break the European language-learning domination through a political stance against the West and a social stance against the old elite (de Koning 2009, 61).

The situation changed dramatically in Egypt as soon as Sadat ascended to power in 1970. The new president adopted the Open Door economic policy, causing a major shift in power: new markets were created; the private sector witnessed a rapid growth; and Egypt was open to the globe (Beattie 2000). The state withdrew gradually from public services, and the private sector started to take over. Mubarak followed in the footsteps of his predecessor, and privatization expanded. The new policies entailed liberalization of the economy and the introduction of new laws to encourage trade and attract foreign investment. It also dismantled the public sector as many of the government-owned services were privatized, most notably the construction of public projects and housing (AlSayyad 2011, 259).

By the late1970s, many Egyptians, especially those from lower social and economic backgrounds, were migrating to the Gulf, seeking better work opportunities, which resulted in a massive transformation in their lives (Amin 1999, 174). According to state figures, Egyptian migrants in the Gulf grew steadily during the 1980s from 1 million in 1981 to 2 million by the end of the decade. The educated middle class, who held university degrees, formed almost 20 percent of the total number of migrants, whereas illiterates and those in possession of literacy certificates formed 35 and 15 percent respectively (Central Agency for Public Mobilization and Statistics 1997). Landowners, for the first time, were not able to find laborers to work on the land, mainly due to the fact that 20 percent of the workforce in agriculture migrated to the Gulf. This led to a massive change in power relations (Abaza 2006, 105).

These numbers indicate that lower socio-economic classes benefited the most from migrating to the Gulf, which subsequently led to their rise at the expense of the educated middle class who chose to stay. This bureaucratic–technocratic middle class witnessed their dwindling socio-economic status in the face of the new rising nouveaux riches who contested them in the spaces they used and were supposed to frequent. As we can see in the movies, their status as the educated stratum became challenged, and, in many cases mocked, by a society which favored and respected the nouveau riche's money over middle-class education.

The returned, from the lower and middle classes, succeeded in accumulating small- to medium-sized financial capital that allowed them to influence

consumer market trends massively. They enjoyed, with varying degrees, a higher living standard compared to the old middle class, which allowed them to buy up-to-date home appliances, imported clothes, and afford a private education. Their ability to afford new apartments made them the dwellers, and the shapers, of the new and improved parts of the city.

De Koning, in her book *Global Dreams*, makes a distinction between the two types of middle class that she observed to exist in Egypt. She identifies the first type as "local" by which she means the middle class created as a result of Nasserist policies, namely the reliance on government institutions for work and education. The second type was identified as "global," which was created due to Sadat's Open Door policy and was characterized by openness to global trends.

In the following section, the two films discussed will shed light on the struggle that faced the "local" middle class at a time when everything they had learned and grown up with was changing dramatically. The films clearly illustrate how the changes in the city not only threatened the economic and cultural capital of the middle class, but also made it impossible for them to maintain a foothold in the city.

The City as an Open Prison

Al-Hubb fawq hadabat al-haram (Love on the Pyramids Plateau) starts with a close-up shot of the crowded and chaotic streets of Cairo, where we can see our protagonist Ali (played by Ahmad Zaki) gazing at the body of a woman crossing the street whom he follows closely. The movement of the camera's focus between Ali's face and the woman's body exposes his sexual fantasies, which he barely manages to contain. After she gives him a look up and down, Ali withdraws quickly from the situation and walks away in the opposite direction. Later, he stops in front of the window display of a men's suit shop where he desperately stares at the black tuxedos, worn by men at weddings, before walking away in anguish. A middle-aged woman in a Mercedes drives by and asks him, with an explicit sexual gesture, to ride with her. Ali joins her and they drive to the middle of the desert where they start making out. The scene ends with the voice of Ali's mother shouting, "Wake up, Ali, you'll be late for work!" Ali's sexual frustration is not a mere dream: as soon as he wakes up, he notices his female neighbor getting dressed—he voyeuristically watches her until she notices and closes the window.

Ali, although a graduate of ten years, still shares a modest apartment with his parents and two sisters. Noticing their humble breakfast menu and clothing, the financial status of the family becomes evident. After finishing breakfast, Ali accompanies his sister Noha to the university on his way to work. While they struggle in their way out of the sewage-flooded street, they are offered a ride by Ahmad, an illiterate plumber, who passes by them

in his car (Figure 5.1). Later in the film, Ahmad proposes to Noha, which distresses her family as they are concerned about the social and educational disparity between them both. Their social concerns evaporate once they recognize Ahmad's very comfortable financial situation that exceeds theirs by far. As for the educational gap between them, Ahmad is able to convince Noha's family that he will provide her with twice what she will earn from her degree. Noha does not hesitate in accepting the marriage proposal.

Afterwards, we see Ali, with other employees at his office in a government building, reading the newspaper in order to cut out important headlines to pass to his boss. Ali struggles to make sense of his "waste-of-time" job, as he describes it, which he has been doing for ten years. In an attempt to find an answer for all his frustrations, Ali meets with Atef Hilal, an intellectual who writes a regular column in the newspaper to help readers deal with their problems. Hilal, who offers no real solution, vaguely proposes challenging the societal "norms and traditions" of marriage and suggests involving the Ministry of Housing in the problem. Hilal cuts short Ali's dissatisfaction with his answers by paying the shoe-shiner, who had been shining his shoes as they talked, and excuses himself as having a meeting to attend, before heading off toward his private driver who is waiting.

Ali soon falls in love with Raja', a new employee in the office, who shares his feelings. Despite the objections of her parents—who seem to belong to the upper-middle class—due to Ali's financial inability to pay for an apartment, the couple insist on challenging the "norms and traditions" of society and get engaged. However, the lovebirds are soon hit by the

5.1. Ali walks through the sewage-flooded streets only to meet Ahmad, the plumber, who offers him a ride in his car *(al-Hubb fawq hadabat al-haram)*.

86 Kafkaesque Modernity: Cairo in the 1980s and the Middle-class Housing Crisis

scarcity of apartments and the astronomical down payments required to secure one. Ali's inability to handle the pressures of society and the constant complaints of his prospective mother-in-law lead him to painfully end the relationship. After this, he once again meets Atef Hilal, but this time accuses him of fraud and delusion, and attempts to beat him up.

Devastated by the situation, Ali meets up with his friend Abu al-Azaym, who tries to lure him into dating older women in return for money. Ali joins his friend as they meet two older ladies (Figure 5.2). After drinking and smoking together, Ali starts to make out with one of them, but it is clear from his body language that he is uncomfortable with the situation. He suddenly stops, leaves the apartment, and rushes back home to find his father waiting for him. He hugs his father and cries.

In the next scene, Ali's family gathers around the TV to watch Sheikh al-Sharaawi, after which we see him praying in a mosque and approaching the imam afterwards for advice. The answers offered by the imam are very idealistic and lack contextual relevance, which does not end Ali's frustration. Ali accidentally meets Raja' in what used to be their favorite spot; she expresses her willingness to challenge her parents. Her words bring life back to him, and, in an unexpected move, in the following scene we see them at a *ma'zun*'s office exchanging vows in what is known as *gawaz 'urfy*, a clandestine marriage, without the knowledge of their parents. Despite their marriage, the couple fail to find a room, even in a cheap motel. Their relationship is under constant regulation, suppression, or control, either by laws and rules that require an updated marital status on their national ID

5.2. Ali and his friend Abu al-Azaym in attendance on two older women for the night *(al-Hubb fawq hadabat al-haram)*.

The City as an Open Prison 87

or by society's gaze, which places them under constant suspicion of immorality whenever they hold hands or get close to each other.

After getting the papers prepared and finding a motel, Raja' gets cold feet because the place seems seedy, which puts them back to square one. They decide to go to the Pyramids, hoping they can escape the attention of both the law and society, but, unfortunately, they are caught by the police and charged with committing indecent behavior in public. Despite pressure from their parents to apologize, the couple refuses and insists on spending time in jail. In the prison's transport van, they get to hold hands and enjoy—at least momentarily—behind bars what they had failed to enjoy outside.

Cairo torments Ali and Raja' to the extent that they prefer to spend time in jail to staying free outside. The ending of the movie, where the couple get to spend some private time together, suggests that Cairo itself has become like a large prison, to the point at which spending actual jail time appears as a plausible solution to the situation it presents. In a manner similar to Kafka's *The Trial*, Cairo gradually pushes the couple to break the law and insists on punishing them mercilessly when they do.

From the Old City to the Desert

Karakun fi al-shari' (*Prison Cell on the Street*) is a light comedy film that tells the story of Sherif (played by 'Adel Imam), a married architect and a father of two who lives with his mother in her apartment, and his quest to find his own place to live. The film starts when Sherif and his wife Su'ad (played by Yousra) wake up in the middle of the night to realize that their apartment is falling apart and that the whole building is collapsing. They all run outside and spend the night on the street. The government responds the following morning by sending a representative who moves the affected families to *mu'skrat al-iwa' al-'ajl* (urgent housing camps) as a temporary solution and promises each family an apartment. However, the reality is not as promised: the camp consists of several cloth tents placed next to each other with no sewage or sanitation. At night, the situation gets even worse due to the noise coming from the surroundings tents, which sometimes gets very intimate. Complaining places Sherif in a confrontation with his large, tough neighbor that does not end well for him. The extreme living conditions force the couple to start looking for other options.

In the meantime, Su'ad's best friend 'Awatif expresses her willingness to share her apartment with the family until they find a permeant solution. It is clear from early on that 'Awatif's husband is not happy with the new guests, as he makes his discontent clear in several instances. Sherif's family only manages one night there, after which they decide to leave due to a fist fight between Sherif and 'Awatif's husband.

With nowhere to go, Sherif's mother suggests staying at their family's burial plot which has some rooms attached. The family is surprised to find that their burial plot is already occupied by Abu Douma, a single male who does not seem to have a clear profession. Sherif and Abu Douma take their dispute to the police station where it is decided that the "situation should stay as it is and the aggrieved should appeal before the court of law." It is very difficult for Sherif to comprehend that the state, represented by the police, is not able to protect and return his property.

Sherif discusses his frustration with work colleagues the following day, only to receive help from the office assistant who directs him to a contractor, whom he personally knows and who is offering apartments for sale in the new satellite cities at a reasonable price. Sherif is suspicious about the offer, but the religiosity of the contractor and the outward signs of Islamic orthodoxy all over the contractor's office reassure him, even more so when he sees police officers signing contracts for apartments in the same building. It soon becomes clear that Sherif should have listened to his doubts, as the whole thing is a scam and the contractor flees the country after selling each apartment several times. Both Sherif and Su'ad rush to the building site to witness a fierce fight between deceived buyers. On their way out they notice the police officers, whom they saw earlier signing contracts, sitting with hands crossed over their chests. When Sherif asks them about the situation, they reply that the "situation should stay as it is and the aggrieved should appeal before the court of law."

Upset by the situation and concerned by a change in her children's attitude, Su'ad decides to accept a job offer in the Gulf and take the children with her. Sherif threatens Su'ad with divorce if she proceeds with her plan, but her mind is already made up. Depressed and lonely, Sherif starts working on a prototype for a portable living unit which he assembles by himself. Su'ad agrees to come back under one condition: that he is to remove the unit from the burial plot. They place their unit by the Nile Sheraton, a five-star hotel, in order to enjoy the spectacular views of the Nile and the city. It is only a matter of time before the police show up at their doorstep and take Sherif to the police station. Despite the prosecutor's fascination with Sherif's idea, he charges him with three offenses that could lead to three years in jail. During Sherif's time in detention, his wife gives birth to a son whom she decides to name Karakun, which means detention center.

In order to drop the charges, Sherif's attorney proposes that they transform the fixed unit into a portable one by adding wheels and a donkey. The idea is successful and Sherif is now able to tour the city with his unit and stop whenever and wherever he wants. However, he only has to park his unit and donkey once at the wrong spot to get himself into trouble

once more, and this happens to be by the residence of an important figure. Sherif is detained again, but this time he speaks out before the prosecutor and criticizes the government's unresponsiveness. After being released, Sherif is quickly detained yet again for not having the papers for his donkey. Su'ad, who is fed up with the continuous police harassment, decides to leave for good and takes the three children with her.

In the following scene, we see Sherif being interviewed on national television to discuss his prototype as a substitute for conventional apartments. Later, we see him in the middle of the desert with a group of men of a similar age and several other copies of his prototype in the background. Apparently, his idea is being replicated by others who have decided to go to the desert and start their own community. As soon as the TV coverage is over, the police show up and accuse Sherif and the other men of building on "state property," which is not only a punishable crime, but the units should also be destroyed. In defiance, the new desert dwellers are willing to protect their units even if it costs them their lives. At the last minute, the police receive a call to stop; an order has been issued by the president, who saw the news report and apparently liked the idea, to allow the community to own the land and build their own town. The film ends with a scene of the dwellers celebrating their victory and Sherif being reunited with his family.

A Kafkaesque Modernity

According to Frederick R. Karl, author of the critically acclaimed biography *Franz Kafka: Representative Man*, the term Kafkaesque better describes a situation where a protoganist finds themself pitted against a force that does not lend itself to the way they want; yet, despite how hard they struggle to change or overturn that force, they stand no chance of success (Edwards 1991). Despite the light comedy in *Karakun*, both *al-Hubb* and *Karakun* share a Kafkaesque quality that resonates with two of Kafka's most famous novels, *Metamorphosis* and *The Trial*. In the first novel, Gregor, an underpaid employee and the only bread winner in his household, wakes up one day to find himself transformed into a huge cockroach. His family is more upset at the prospect of losing their source of income than losing a son. His boss does not seem to care much about his condition so long as he is on time. He gradually loses the empathy of those around him, who decide, in the end, to get rid of him (Kafka 1999). Meanwhile, in *The Trial*, Mr. K is arrested and sent to trial without—thanks to the bureaucracy involved—having a clue of what he has done. Mr. K spends a year in this state of frustration, as no one answers his questions. His frustration finally ends when he is sentenced to death (Kafka n.d.).

The resemblance between Kafka and cinematic Cairo depicted in both movies lies mainly in the inhumanity of the modern world and the daunting

bureaucracy manifested through state apparatus. Both films share a similar sense of coldness in human relations as the protagonists are left alone to deal with uncertainties, fear, and depression while everyone watches.

Al-Hubb and *Karakun* are blunt in exposing the challenges that face the educated middle class and their vulnerability to them. Both films have very similar notions of Cairo during the 1980s, as a stressful, illogical, and nightmarish place for the middle class. The housing crisis, addressed in both films, embeds more than a mere quest for an apartment; rather, it manifests the middle-class struggle to maintain a foothold in an increasingly changing city. The protagonists in both films, Ali and Sherif, are caught up in a reality that has left them powerless in a manner quite similar to that presented by Kafka. Ali has done everything right; he is a university graduate, has a job, and tries to be a morally conscious individual. However, life has not gone as expected. His dreams of getting married and having a "normal" life are crushed, probably like a cockroach, by the city and society at large. He is powerless and has no clue as to what he has done wrong to deserve such a fate. On the other hand, Sherif's house collapses and, *voilà*, he is on the street with insufficient and inappropriate support from the government which, in fact, only excels at making things much worse for him. Our two protagonists fail to deal with the city and they end up either in jail or in the desert.

In the following section, I will discuss three defining features of Cairo's Kafkaesque modernity. First, I examine the deteriorating status of the Nasserite-era heroes, the governmental employee and the engineer, and the social pressure resulting from their new, lower status. Secondly, I discuss the Egyptian bureaucratic system that operates as a family business, which only increases frustration with it and makes criticizing or rebelling against it a complicated stance. Finally, I discuss the role of the Gulf which, though not addressed extensively in the films, affected the essence of the city, resulting in a feeling of alienation among its residents.

The fall of the "hero" figure

During Nasser's rule, the *muhandis* (engineer) and the *muwazaf* (government employee) were the heroes of the era: both represented the rising technocratic–bureaucratic middle class that was destined to pull the nation toward modernity. Nevertheless, times changed and the 1970s and 1980s witnessed the fall of these societal heroes to rock bottom.

Ali, the protagonist of *al-Hubb*, belongs to an educated, bureaucratic middle class. His father is a retired *muwazaf* who served during Nasser's era and not only got to benefit from Nasser's socialist welfare policies, but also enjoyed social capital, reflected in a sense of self-worth, as he belonged to a social class that carried the nation's hopes and aspirations

toward modernity. The high status of a government employee was clearly illustrated in an Egyptian proverb: "If you missed the *miri* [governmental position], then wallow in its dust" (Amin 1999, 131). Ali is not as privileged as his father, although he would have attended Nasser's schools and benefited from the free education, and so had been fed the Nasserite rhetoric, his professional life is in a totally different world. Due to the Open Door policy of the 1970s, the private sector was being established, and offered higher pay and better chances of promotion. According to Amin, the financial inflation during the 1970s which helped the private sector grow came at the expense of the social status and economic stability of the government employee (Amin 1999, 141). This deterioration in the status of the bureaucratic middle class can be clearly seen in the case of Ali. At the age of thirty, we find Ali sexually frustrated, wanting to get married, still sharing a modest apartment with his family, and lacking the financial means to get or even rent an apartment of his own. On a professional level, he has a deep feeling of self-worthlessness as he struggles to make sense of his pointless and poor-paying job.

Cairo's modernity in the 1980s was a dystopia for the educated and the honorable. Ali cannot find a place in the city, but, meanwhile, his morally loose friend Abu al-Azaym enjoys a better financial position by dating rich old women, and Ahmad, the illiterate plumber, is able to buy a car and an apartment and marry Ali's sister.

The film represents the fall of the bureaucratic middle class in multiple instances, yet one of the most notable scenes is when Ali goes to meet with Atef Hilal. The scene shows Hilal on the left with Ali on the right, and an image of Nasser hanging in the middle between them. On their first meeting, Hilal repeats Nasser's rhetoric of hope, prosperity, and a better future, yet he has a shoe-shiner bent over his shoes, shining them, which entails a level of hypocrisy: Hilal, reflecting Nasser, is trying to give hope and establish a new order, yet he ends up reproducing the old system. Later, the second time they meet, Ali is on the left with Hilal on the right, and Nasser's photo is again hanging between them. Ali in his accusations against and criticism of Hilal is actually criticizing Nasser's rhetoric: his promises were in vain and the middle class had been abandoned.

In *Karakun*, Sherif finds himself and his family on the street and ultimately being pushed out of the city. The film starts with the scene of Sherif and his family trying to flee their collapsing home in one of the old quarters of Cairo. According to state numbers at the end of the 1960s, almost half of the structures in the old quarters of Cairo were in a poor and dangerous condition (El Kadi 2009, 39). After this, he moves to a friend's apartment which, though still in the city, is in one of its newer quarters, built during the 1950s. Later, he seeks refuge at the cemetery, which is normally on

the outskirts of the city. Soon after this, he moves farther away, to buy an apartment in one of the new satellite cities, but gets scammed. Finally, he ends up with a living unit, but with no place to go except the desert—even then, he is still chased by the police. Eventually, the state interferes to save him after he has left the city and relocated to the desert.

Daunting bureaucracy

A cumbersome bureaucracy imposed itself as one of the defining features of modernity during the late 1970s and 1980s, as it represented the unresponsiveness and dysfunctionality of the state. In both films, governmental bureaucracy contributes to the hostile conditions endured by the middle class.

Ali is a government employee in a job where he has spent ten years doing nothing, which has created a sense of self-worthlessness that haunts him. The time he has spent in his job doing nothing makes him question the validity of the rhetoric he grew up with. This uncertainty then explodes during his conversation with Hilal, and characterizes the future that awaits him. Ironically, Ali is suffering as a result of the system he himself is reproducing, whether he likes it or not. With his slackness and indifference, Ali has become a "typical" government employee.

One of the iconic scenes in *al-Hubb* is the last, when Ali and Raja' are detained at the police station. The police call the parents of the married 30-year-olds to confront, or probably shame, the couple. What is more, their parents beg them to apologize to the officer so they will be set free, but the couple refuses, insisting that serving time in jail makes more sense than the world they are living in (Figure 5.3). This scene draws a very complex image of Cairo's modernity, where everyone seems to conform to a very patriarchal or "traditional" manner in dealing with the situation. Thus, a pair of 30-year-olds are not considered old enough to be held fully accountable, so the police bring in their parents; and the state is insulted by that kiss, so the police require an apology for making out by the Pyramids to have the charges withdrawn.

In *Karakun*, Sherif has to struggle with government bureaucracy in several instances. First of these is in the *mu'skrat al-iwa' al-'ajl* (urgent housing camps) when the government employee has the affected citizens stand in line, but instead of serving them he is busy reading the newspaper. He then threatens not to process Sherif's papers as a penalty for his objection to the way they are treated. The situation is resolved when one of Sherif's female neighbors seduces the employee, who forgives him and processes his papers immediately. This instance exhibits the state bureaucracy at its most efficient, where nothing is done without some kind of pay-off in the form of a physical benefit.

5.3. In the confrontation at the end of *al-Hubb fawq hadabat al-haram*, Ali's and Raja's parents blame each other in front of the police officer, who demands an apology to set the couple free.

Sherif's encounters with state bureaucracy were not limited to the urgent housing camp; in fact, the whole film is about Sherif's failed attempts to overcome the system. Bureaucracy keeps narrowing the space in which he can be creative in solving his problem and at the same time shows no responsiveness when it comes to protecting his right to finding a solution.

The influence of Arab Gulf culture and the city

The built environment of Cairo, as seen in both films, was a product of the influence of the Arab Gulf, whether directly or indirectly. The lucrative opportunities in the Gulf states made leaving the country a priority that was attractive to different segments of Egyptian society, ranging from university graduates to cheap labor. Going to the Gulf was presented as the solution to, or perhaps better described as an escape route from, Cairo's pressing modernity. In *al-Hubb*, Ali tells Raja' in one of their scenes together that all he can hope for is an opportunity in a Gulf country that will take him out of here—Cairo. In *Karakun*, Su'ad, who receives a job offer in the Gulf, tries to persuade Sherif to accompany her, but he refuses to play the role of a house husband. In other scenes, Su'ad also uses the job offer as a means to threaten Sherif whenever a fight breaks out between them, saying that she will take the children and leave, which sheds light, though very briefly, on the idea of the Gulf as a threat.

The Gulf, though always represented as an opportunity to grow and accumulate wealth, entailed a threat to those who chose not to go. First of these threats was the increased financial power of the returned, which led to a spike in real estate prices. The housing problem created by this

formed an economic barrier that rendered the city inaccessible to its middle class, as seen in Ali's and Sherif's cases. According to David Harvey, the city started to develop "fortified fragments," allowing only a certain group of financially advantaged individuals the right to access and reshape the city (Harvey 2012, 15).

Second, the educated middle class who were not able to leave or chose to stay were ethically and emotionally challenged, either by an ignorant government, by corrupt members of the middle class that took advantage of the situation, or by the rapidly rising lower class of craftsmen and maintenance workers. In *al-Hubb*, Ali is prey to the three factors combined: his job, his morally loose friend Abu al-Azaym, and his illiterate brother-in-law Ahmad, all of which have created Ali's Kafkaesque Cairo. Sherif also suffers twice from state ignorance: first, in finding a solution for his housing problem, and, second, in protecting his rights when he is subject to fraud.

Third, the Egyptians who returned from the Gulf, along with Gulf tourists who flocked to Cairo during the 1980s, changed the moral landscape of the city on different levels. With the presence of Gulf Arabs, locals were now more likely to ask for money in return for things they would have previously done willingly, such as taking photographs or giving advice or even stopping a taxi (Wynn 2007, 127–68). Increased numbers of beggars and street performers could be seen in neighborhoods with a higher Arab presence. This behavior described by Wynn is not directly addressed in the films, yet one cannot help but see it in the regular transactions between the characters. The continuous requests for money in return for services and the prioritization of those who paid *ikramiyat* (bribes) contributed to the moral and ethical pressures the financially struggling middle class had to deal with.

Fourth, one can identify an increased sense of religiosity and conservatism in the city's public sphere. This could arguably be attributed to the waves of Egyptians returned from the conservative Gulf. Yet, one should not forget that Egypt was a very important hub for the Islamic movement long before it appeared in the Gulf. Despite not being addressed directly in either film, this phenomenon cannot go unnoticed. In both films, the public gaze keeps scrutinizing, with suspicion, the holding of hands or any other intimate physicality between the protagonist and his female partner. Even the state, in *al-Hubb*, positions itself as a moral authority and detains Ali and Raja', a married couple, for making out by the Pyramids.

A Reel Exposing the Real

Cinematic Cairo, depicted through several films produced during the 1980s, did not differ much from the real Cairo in its hostility to the middle class. The housing crisis during the 1970s and 1980s manifested the

socio-economic struggle of the educated middle class to maintain a foothold in the city. During the 1980s, a situation was created where a university graduate, promised prosperity under Nasser, found himself receiving a minimum wage in a job working in an overcrowded governmental office that paid much less than what a plumber earned. The educated middle class witnessed the decline of their living standards. They struggled to find decent, well-paid jobs that corresponded to their educational achievements.

Cairo's modernity did not reward righteousness; it was a place, and time, that cherished the opportunistic and embraced the wealthy. Cairo of the Open Door was changing its skin and this was to happen at the expense of the educated middle class.

For the middle class, modernity was stressful, illogical, and nightmarish. In both films the protagonists not only failed to find appropriate housing in the city, but also struggled to make sense of the situation and to earn the respect of both state and society. In *al-Hubb*, Ali could not deal with the logic of the city and made the choice to spend time in jail rather than to live outside it, in the city. In *Karakun*, the city pushed Sherif outside, forcing him to live in the desert.

Both films illustrate a similar notion of pervasive morality during this period. Selfishness, individuality, and *fahlawa* (fraudulent cleverness) were depicted as skills necessary for survival. The protagonist in both films insists on avoiding such traits and this, arguably, might hinder their ability to adapt to their surroundings.

The hostility of Cairo toward the middle class should not be examined separate from the process of modernization that took place at the time. Egypt embraced neoliberalism under Sadat, which was a total retreat from Nasser's socialist policies. The consequences of this economic shift led to some major changes in society. Lower socio-economic classes seized the opportunity and migrated to the Gulf, where they accumulated enough wealth to allow them to start small or medium businesses and influence the consumer market upon their return. Meanwhile, the middle class, which was fed and bred to be the new bureaucratic class under Nasser, found themselves "stuck" in poor-paying governmental jobs and missing out on the chance to elevate, or even maintain, their status.

References

Abaza, M. 2006. *Changing Consumer Cultures of Modern Egypt: Cairo's Urban Reshaping*. Brill: Leiden.

Abu-Lughod, J. 1971. *Cairo: 1001 Years of the City Victorious*. Princeton, NJ: Princeton University Press.

AlSayyad, N. 2011. *Cairo: Histories of a City*. Cambridge, MA: Harvard University Press.

Amin, G. 1999. *Madha hadath lil Masriyin*. Cairo: Maktabat al-Usra.

Armbrust, W. 1999. "Bourgeois Leisure and Egyptian Media Fantasies." In *New Media in the Muslim World: The Emerging Public Sphere*, edited by D.F. Eickelman and J. Anderson, 106–32. Bloomington, IN: Indiana University Press.

Beattie, K. 2000. *Egypt during the Sadat Years*. New York: Palgrave.

Central Agency for Public Mobilization and Statistics. 1997. *International Migration Survey in Egypt*. Cairo: CAPMAS.

Cochran, J. 2012. *Education in Egypt*. New York: Routledge.

Edwards, I. 1991. "The Essence of 'Kafkaesque'." *The New York Times*, 29 December 1991, Section LI: 12.

Frederick R. 1991. Karl, Franz Kafka: Representative Man NY Ticknor & Fields.

Harvey, D. 2012. *Rebel Cities: From the Right to the City to the Urban Revolution*. London and New York: Verso, http://abahlali.org/files/Harvey_Rebel_cities.pdf

Issawi, C. 1963. *Egypt in Revolution*. Oxford: Oxford University Press.

El Kadi, G. 2009. *al-Tahador al-'ashwa'i*. Cairo: Dar'ain.

Kafka, F. 1999. *The Metamorphosis*. Planet EBook. Available at: https://www.planetebook.com/the-metamorphosis/

Kafka, n.d. *The Trial*. Planet EBook. Available at: https://www.planetebook.com/the-trial/

de Koning, A. 2009. *Global Dreams: Class, Gender and Public Space in Cosmopolitan Cairo*. Cairo and New York: The American University in Cairo Press.

Moore, C.H. 1980. *Images of Development: Egyptian Engineers in Search of Industry*. Cairo and New York: The American University in Cairo Press.

Saavala, M. 2010. *Middle-class Moralities: Everyday Struggle over Belonging and Prestige in India*. New Delhi: Orient Black Swan.

Wynn, L. 2007. *Pyramids and Nightclubs: A Travel Ethnography of Arab and Western Imaginations of Egypt*. Austin, TX: University of Texas Press.

6

Escaping Cairo: Bureaucratic Modernity in the Cinematic Portrayal of the City in the 1980s

Tayseer Khairy

Here is Cairo, finally. Cairo, which they call "Egypt," and Egypt is the mother of the world. Street names have changed, buildings have come into existence, buildings have disappeared and landmarks have been lost while others are trying to impose themselves. New fields and crowds of humans now exist. Everyone is running and in a race.
Balad al-mahbub (*Beloved Country*, author's translation)[1]

The above excerpt is from *Beloved Country*, a novel written by Yousef Alqa'eed and published in 1987. The novel discusses the social and urban transformations that took place in Egypt in general, with a specific focus on the country's bustling capital, Cairo, during the 1980s. The story is narrated from the perspective of a Cairo resident who has returned to his home city after migrating to the Arab Gulf only to discover that the city which he had once known has been rendered unrecognizable. Cairo has become a different city with different residents.

As an architect, a planner, and a migrant myself, who grew up in the countryside in a small village in the Delta northeast of Cairo, I experienced the city initially as a visitor and later as a resident for more than twenty years. I still remember the yearning I would feel as a child every time I watched Cairo on screen. The big city challenged me to try to create a balance between the unwritten rules of the city and my own rural values. The difference and possible interrelationship between the reel Cairo of the films and the real physical city is my main focus in this chapter.

Exploring the difference of the boundary between reel Cairo and the real, physical city through time and space at a deeper level, I use two films produced and screened in the mid-1980s, both of which portray the evolution of Cairo from political, cultural, and urban perspectives. The first is *Kharaga wa-lam ya'ud* (*Left and Never Came Back*), which is listed

as one of the best hundred movies in the history of Egyptian cinema. It was produced in 1984 and directed by Mohamed Khan. The second film is *Huna al-Qahira (Here Is Cairo)*. It was produced in 1985 and directed by Mohamed 'Abdel 'Aziz. In the two films, Cairo is experienced from two different perspectives, each narrated by a distinct character (an urbanite in one of the films and a villager in the other), both of whom come from the same social class but are of different backgrounds, each with their own code of conduct and set of ethics. Both protagonists in the films take the same decision: to escape from Cairo, either to return to their rural homeland or to find another destination, farther away. In this chapter, I am concerned with how social reality is expressed in cinematic urbanism in order to gain a better understanding of escaping the city as it occurs in physical reality compared to the way it is expressed in cinematic realism. The focus here will be on exploring the bureaucratic modernity of the city portrayed in the two films through a comparative study of various urban atmospheres. Several variables will be analyzed, such as the urban streets, modes of transportation, cultural celebrations and family gatherings, and the residents' relationship with both rural and urban spaces. Social interactions and behaviors will also be taken into consideration.

The City through Different Eyes

I analyze Cairo's transformation in the two films through the theoretical framework of two well-known urban sociologists, Georg Simmel, based on his classic paper "Metropolis and Mental Life" (1903), and Louis Wirth, based on his master work "Urbanism as a Way of Life" (1938). The work of Simmel is an approach toward understanding the attributes of contemporary life and the mood of the metropolitan city on its residents, stressing their own freedom to maintain their uniqueness throughout their behaviors and interactions with each other or with the city itself. The work of Wirth is useful in understanding the extensive conflict of norms and values experienced by city residents. Although these important works are around a century old, I believe they are still the most relevant to the study of urbanism in Egypt. A more detailed synopsis of both films is essential to understand cinematic Cairo during that period.

Kharaga wa-lam ya'ud (Left and Never Came Back)

Produced and screened in 1984, *Kharaga* is based on a script written by 'Assem Tawfik. It was inspired by the book *The Darling Buds of May*[2] by H.E. Bates. *Kharaga* starts with a statement clarifying that the characters may be not real, but certainly the places are. The film revolves around a young middle-class man, 'Ateya (played by Yehia El Fakharany), who struggles to afford to buy a flat in order to start a family. He works in a government office and

lives in one of Cairo's low-income, run-down areas close to the center of the city. The first scene in *Kharaga* starts with a huge, noisy road driller adjacent to 'Ateya's house, which startles him out of bed. In the following scenes, the camera gives detailed footage of the poor living conditions at his house, with large cracks on the walls and unclean drinking water.

The camera pans further to show the degradation of his poor neighborhood and the widespread rubbish scattered all over the streets. Once he reaches the city center, he faces a barrage of crowds and cars, and is choked by the poisonous fumes. At work, he meets his boss who offers him a promotion for his hard work. 'Ateya plans to celebrate with his fiancée by inviting her out to dinner, but she invites him to a family lunch at her house instead. Over lunch, her mother starts to nag 'Ateya about his seven-year engagement to her daughter. Under pressure, 'Ateya decides to go to the countryside for two days to sell his inherited farmland so as to buy an apartment and to afford his upcoming marriage. Along the way, as he gets out of Cairo, the skyline starts to change from the new high-rise housing blocks to green farmlands. 'Ateya's mood starts to gradually improve once he arrives at the

6.1. Poster for *Kharaga wa-lam ya'ud* (Left and Never Came Back) (1984).

The City through Different Eyes 101

countryside and meets the prospective buyer, Kamal Bek. Eventually, they build a strong relationship. Despite his original plan 'Ateya starts to develop a strong connection with nature and feels more comfortable with the relaxed lifestyle of the countryside. He falls in love with Kamal's daughter, Khukha, and, in the end, changes his mind about buying an apartment and living in the city, and decides never to go back to Cairo again.

Huna al-Qahira

Intended as a comedy, the film stars two famous comedians, Mohamed Sobhi and Soad Nasr. The film revolves around the story of a couple, Sinusi and his wife Sabrin, living in a small town in Upper Egypt. As an agricultural engineer, Sinusi is conducting research to improve bread production. Driven by the desire to benefit his country, he decides to travel to Cairo to meet the agriculture minister to prevent him signing a costly agreement for research in the same field, and to offer his own for implementation.

Huna starts with featuring the small town in Upper Egypt where Sinusi and his wife live, including details of their daily lives and footage of the pleasant local landscape. The viewer is taken into Sinusi's house, where the family enjoys an early breakfast made at home, followed by a shot of Sinusi taking his son to school by a small boat that crosses the Nile

6.2. Poster for *Huna al-Qahira (Here Is Cairo)* (1985).

river. Later, Sinusi arrives at work to find his boss urging him to travel to Cairo to present his research to the minister himself before the latter signs a high-cost agreement as announced in the newspaper. Despite Sinusi's phobia of flying, he immediately books a flight to Cairo which costs him his entire savings. Believing that meeting with the minister will not take long, Sabrin insists on joining him to do some sightseeing around Cairo.

Once in Cairo, Sinusi and Sabrin start a nightmarish journey. They find themselves struggling with the dense streets, the taxis, and the long traffic jams. They even get involved in a fight between taxi drivers and are mistakenly beaten up. They get robbed on a public bus and lose their personal documents and luggage. Stressed out, they even fight together, blaming each other for the trouble they have been through. Their struggle continues with trying to find a place to spend the night, which is impossible in Egypt without their marriage documents. They spend the night in a public park, only to be kicked out early in the morning by a suspicious park guard.

Delayed by the congested traffic, the couple decides to head to the ministry on foot so as to arrive faster. On the way, Sinusi falls into an open manhole next to a construction site. He is saved by a passing crane, on its way to be repaired at a garage, which hoists him up out of the hole and carries him through the crowded streets of Cairo while Sinusi sings the song *Zahma ya donia zahma (Crowded O Crowded World)*. By the time they reach the garage, it is once again rush hour and Sinusi has to run through the city streets to reach the ministry in time.

When he arrives, he finds the minister is already signing the agreement and he is kicked out without a chance to present his research idea. On his way out, he looks at Sabrin, who is waiting for him outside. With a tired body and heavy soul, he asks, "What research am I concerned with? Apart from my bread research, many things have to change. We can't stay here; we have to move away from the city to somewhere far away from it." The final statement, "A call to leave," sums up the message of the film, which is actually a direct call to escape from the huge, dense, and uncontrolled urban mass of Cairo.

Cinematic Cairo in Transition

Throughout the Egyptian film industry, Cairo has been romanticized as the center of Egyptian culture and a beacon of modernity, to the extent that the country's capital up to now is referred to as Misr, or "Egypt," by the general population. Cairo represents the heart and soul of the entire Egyptian nation. However, the two films showcase almost identical portrayals of an extremely dense and very polluted expanding urban Cairo. To provide a context for this, we must look more into the changes that were occurring at that time, the 1980s.

In her book *Popular Egyptian Cinema*, Viola Shafik states that the problem of cinematic representation is in its "realization" effect that forces viewers to mistakenly understand cinematic discourses on reality to be a literal representation of real life itself. Shafik argues that stereotypes may play an important role in shaping or confirming certain perceptions, but that not every stereotype is damaging. However, I disagree and believe that one cannot generalize the supposedly neutral nature of such stereotypes, as will be explained in the following sections. Comprehensive analysis helps us understand the dynamics of stereotyping depending on the perception of reality, the frame of the viewer, and the degree of knowledge and experience regarding what is presented. Physical realism was portrayed in Egyptian cinema modestly driven by the political conditions during the British occupation and before the Egyptian Revolution of 1952, but flourished throughout the postrevolutionary period—especially after the decline of the influence of the state in cinematic production—with many attempts to present real-life experiences on film, whether by drawing on depictions of Egyptian reality in the works of contemporary or older writers. Another wave of realism, "New Realism," was sparked by the *Infitah* (Open Door) economic policy introduced by the administration of Egyptian president Anwar Sadat in the 1970s. Cinema at that time portrayed the struggle, whether on the economic or ethical level, of real characters from the urban lower class (Shafik 2007). However, AlSayyad pinpoints the importance of contextualizing individual films to understand why and for what audience they were produced, and argues that focusing exclusively on the formal analysis of a film often disguises the actual class relations inherent in its content and in its making (AlSayyad 2006). In adopting Shafik's approach to understanding cinematic realism, presented by the two films in their portrayal of the city's physical reality, I plan to take a deeper look into Cairo's political, socio-economic, and cultural evolution during the 1980s.

Toward an understanding of these urban realities, I refer to Galal Amin's book, *Whatever Happened to the Egyptians?*, in which he suggests that social mobility in Egypt between the 1970s and mid-1990s was the result of drastic reforms in the country's socio-cultural and economic policies. Several changes took place during that time, such as massive urbanization and the expansion of cities into agricultural areas. These trends led to the rise of new social behaviors that were centered around individualism, giving less importance to the idea of collective action and community values. The bonds once enjoyed by the community members of Egypt's rural areas were consequently weakened, due to the swift migration of rural residents into the big cities. Furthermore, the expansion of Egypt's urban centers has led, and is still leading, to more pollution, congestion, and corruption.[3] Further elaborating on the economic reforms that took

place in Egypt under President Sadat's administration, Amin implies that the social mobility witnessed in the 1980s was a result of the Open Door economic policy which focused on attracting foreign investments, establishing a free-market economy based on consumption, and minimizing the role of the state in service provision. Those actions resulted in the state gradually relinquishing its social and economic responsibilities that had been assumed during the 1960s. Amin stresses that the mass migration to the oil-rich Arab Gulf countries has created and encouraged welfare consumption rather than production behavior in Egyptian society. However, Amin claims that the Open Door economic policies that were prevalent at the time were not the exclusive cause of social mobility, but acted as a disruption within Egyptian society and they often led to behavioral changes based on free choices from the community members themselves.

The French sociologist Henri Lefebvre explains the production of space by applying and extending the Marxist concept of alienation. He argues that the production of space is the product of social encounters determined by the individual reacting to other individual urban dwellers. Lefebvre suggests that the city can be seen as a jungle of decay and disease in the eyes of one spectator, while another may view it as a playground of creativity and intellectual contribution. This led me to ask how urbanism can be experienced by different individuals with diverse backgrounds. In his works, Louis Wirth states that the growth of cities and mass urbanization on a global scale is one of the key features of modernity. The degree to which the contemporary world may be said to be "urban" is not fully or accurately measured by the proportion of the total population living in cities, as the influence that cities exert on the social life of human beings is greater than the ratio of the urban population would indicate (Wirth 1938).

Early interpretations of metropolitan life identify it as dull and time pressured, resulting in stress, and characterized by social acceleration and extreme speed of action (Simmel 1903). In a series of articles assessing the work of Georg Simmel and Louis Wirth, the multiplicity of the city affecting the individual's psychology is identified. The same is confirmed by both Aho and Abbot. Aho points out the work of Simmel on value theory: that the rise of urbanization and growth of modernity render money the only rational feature equivalent to anything and everything. One becomes detached from any emotional relationship with the community, which results in a loss of emotional connectivity. This explains why the modern individual suffers emptiness and restlessness (Aho 2007, 450). Abbot argues that city life is widely perceived as stressful and that city dwellers typically experience more noise and more crime than do those outside urban areas (Abbot 2012, 200). Modern cities have generated conditions that have led individuals to become reserved in their relationships with

one another (Borer 2013, 967). The city gives rise to logic and intellect, prompting the individual to be more rational, putting less emphasis on emotions within the urban environment (Simmel 1971). Alternatively, Louis Wirth regards the concept of urbanism as a way of life, arguing that city life breeds impersonality and social distance. Wirth further indicates that the shift from a rural to a predominantly urban area is accompanied by profound changes in virtually every phase of social life.

As social structures in urban areas are characterized by high population density and congestion, residents with no emotional or sentimental bonds are forced to live and work within close proximity to each other. Such an environment fosters intense competition, aggrandizement, and mutual exploitation, and gives rise to a sense of loneliness. The necessary frequent movement of urbanites gives occasion to friction and irritation with different degrees of heterogeneity (Wirth 1938). The social interactions that urbanites experience with one another are characterized by highly segmental roles.

Both Simmel and Wirth refer to the promising incentives offered by many different institutions to motivate city dwellers to seek their own individuality, which includes educational, cultural, political, social, and fiscal benefits (Wirth 1938, 2; Simmel 1971, 48). Cameron Chistian indicates that this creates a mass-made impersonal market which desires individuality and uniqueness within a diverse environment involving large numbers of people with different backgrounds, accompanied with the rise of modern technology and communication (Chistian 2015). Fischer suggests that the members of the crowd are anonymous, aloof, and uninvolved. This type of isolation is considered to be a basic form of "adaptation to psychic overload" (Fischer 1972, 213).

In an act of identifying the nature of the reel city and the physical real city, I will apply the preceding theories by tracing the city images portrayed and processed in the two films, aiming at a better understanding of city transformation.

Cinematic Realism and Bureaucratic Modernity in Egyptian Films

Cities are hubs for governance. We cannot understand how cities function without identifying the complexity of their institutes' division, value system, and correlations with their inhabitants. In an attempt to comprehend the ways in which modern life affects the experience of individuals in cities, bureaucracy as an analogous concept is addressed. The dichotomy of bureaucracy and modernity is used to analyze the two films. According to Goodsell, bureaucracy can be defined by a collection of stereotypes which is simply accepted with empirical evidence of behaviors and attitudes that explains why this is tolerated among the community (cited in Meier and

Hill 2005, 52). According to Max Weber, bureaucracy is characterized by the following: (1) fixed and jurisdictional areas ordered by rules, laws, or regulations; (2) the principle of hierarchy whereby structures are established with superior and subordinate relationships; (3) the degree to which this stereotype is simply accepted without any empirical evidence other than an occasional anecdote.[4]

The cinematic city captured in the two films also addresses forms of governance among individuals and between individuals and the system of the state. Shafik indicates that, since the establishment of the Egyptian cinema industry almost one hundred years ago, it has followed the long-standing tradition of adapting a Western approach, similar to the cinema industry in other countries such as India, Brazil, and Mexico (Shafik 2007). This trend was prominent during Egypt's colonial period, which lasted until 1952, when most prerevolutionary productions adopted the Hollywood model in terms of theme and style. It was not by chance that Egypt's film industry was called the "Hollywood of the Orient" (Schochat 1983). After the Egyptian Revolution in 1952, the new administration under President Gamal Abd al-Nasser instituted swift policy reforms transforming the Egyptian cinema into a platform to promote nationalism, anti-colonialism, and an avenue through which the struggles of the average Egyptian could be expressed. As a result, during the Nasserite era and after, cinema turned into a platform to bring people together with an interpretation of their reality. Realism was initially portrayed in Egyptian cinema timidly in experiences driven by the political circumstances during the time of the British occupation and before the 1952 Revolution. However, it flourished tremendously in the postrevolutionary period, especially after the state's role in cinematic production receded to allow many attempts at productive experiences, whether it was for contemporary or classical writers to visualize events from the Egyptian reality.

While realism in cinema describes the visible appearances and experiences of reality that are apparently accessible to everybody, they form a common denominator of daily life experience (Shafik 2007). The cinema has always been a means of class expression that shaped the collective consciousness of the urban population. The rise of realism in Egyptian films demonstrated several attemps to express the concrete problems of the Egyptian people by several writers and transcripts, to highlight the daily experience of the Egyptian people and help create a depiction of everyday life. This trend started in the 1950s with the films of Salah Abu Sayf and Yousef Shaheen. Like similar movements in Third World cinema, such as Brazil's Cinema Novo and India's New Cinema, Egyptian postrevolutionary cinema was partially influenced by Italian neorealism. Social themes that were drawn from Egyptian life were usually shot on location,

unlike the studio-shot offerings of prerevolutionary cinema. Songs and dances were relegated to the musicals, and the traditional tendency toward melodrama was minimized. The following generation revived this school of realism, and this led to a wave of films following Italian neorealism, such as Atef al-Tayeb's *al-Hubb fawq hadabat al-haram (Love on the Pyramids Plateau)*; Khairy Beshara's *Yum mor, yum helw (Bitter Day, Sweet Day)*; Mohamed Khan's *'Awdat Mowaten (Return of a Citizen)* and *Kharaga wa-lam ya'ud (Left and Never Came Back)*; Mohamed 'Abdel 'Aziz's *Huna al-Qahira (Here Is Cairo)* and *Intabeho ayuha al-sadah (Beware, Gentlemen)*, and Salah Abu Sayf's *al-Mawaten misri (The Citizen Is Egyptian)*.

Modernity versus Bureaucracy: Between the Nightmarish City and the Heavenly Countryside

In the following pages, I will analyze the physical elements and the social behaviors in the cinematic city captured in the two films, and will support my analysis with literature from various relevant sources. As earlier mentioned, the two films show us detailed elements of two totally different settings: the city and the countryside. At the beginning of *Huna* we see the traditional way of life—the homemade food, the galabias, the small housing blocks, the green spaces, and the open skyline to the waterfront of the River Nile. We also see traditional means of transportation such as boats, carts, and camels. The warm relations between family and community members can be invariably sensed.

In stark contrast to this rural idyll, we next see Sinusi and Sabrin traveling to Cairo by plane, the most up-to-date means of transportation. Arriving in Cairo, the camera scans the dense streets of the city packed with different types of transport—taxis, private cars, and buses—, illustrating the intense relations among city residents, the spread of fast-food restaurants, the high-rise blocks, and the poisonous fumes. *Kharaga*, on the other hand, starts with the noisy crane, emphasizing the massive

6.3. Congestion in the city of Kharaga.

urban growth of Cairo, the construction of new high-rise buildings adjacent to the old, deteriorated parts of the city where the main character lives, followed by scenes of the city's dense streets, vehicle exhaust fumes, and noise.

Leaving Cairo, the film director uses a very famous song at the time, from one of the popular pioneer singers, 'Adaweya, *Zahma ya donia zahma (Crowded O Crowded World)*, whose meaning is a direct reflection of the condition of the city. Arriving at the countryside, the dense skyline of Cairo changes to views of the green landscape. The camera shows the traditional way of life in the country: the traditional fabric of mud-brick houses attached to stock pens, the unpaved streets, the traditional means of transportation, farm animals—donkeys, cows, sheep, chickens—, farmers, green fields, and the waterfront of the River Nile. The director continues to portray countryside traditions, the homemade food, and the strong social ties. The sound of the *Zahma* song gives way to the beautiful chirps of the birds. What we see on the virtual screen in both films are the weak personal relations extant in urban centers, despite the crowds. Such urban scenes are described by Fischer as physically compacted, yet socially isolated, and the city's populace is seen as a "lonely crowd." The members of the crowd are anonymous, aloof, and uninvolved. This type of isolation is considered to be a basic form of "adaptation to psychic overload" (Fischer, 205).

In *Hona*, both Sinusi and Sabrin stay for two days in the Cairo streets surrounded by the crowd, but remain alone and helpless. Likewise, in *Kharaga*, 'Ateya lives in the city while experiencing weak relations both at work and with his fiancée's family. The modernity of the cinematic city is shown in the two films by presenting a markedly dense city that is expanding and causing stress to everyone living in or visiting it. Simmel and Wirth explain how the physical narrowness and density of the city impact the social and mental distance, creating a sense of loneliness or the notion of apathy (Simmel 1971, 55; Wirth 1938, 16).

6.4. Senusi and Sabrin find no support from the residents of the city, and feel alone and helpless in the Cairo of *Huna*.

Urbanites are surely dependent upon more people for the satisfaction of their daily needs than are rural people; thus they are associated with a greater number of organized groups. However, rural dwellers demonstrate a lower level of dependence on such organized groups (Wirth 1938, 13). The city displays total dominance over the rural and the urban individual as the controlling center of the social, cultural, political, and economic life (Simmel 1971, 56; Wirth 1938, 5).

In contrast with their depiction of the city, the two directors romanticize life in the rural areas by showing the social solidarity and strong community support. Encountering one's authentic self and attaining a sense of self-achievement are much easier there. A strong connection to nature and tolerance charactertize the mode of life there.

The Rural View of Urban Life and the Urban View of Rural Life

In *Hona*, before coming to the city, both Sinusi and Sabrin, based on the image conjured by radio, television, and newspapers, anticipate Cairo as a modern city with more than enough capacity to serve those who dream big. However, upon their arival, the couple discovers the ugly face of the city. Sinusi himself declares he feels older than his real years having lived for just one day in Cairo, and observes at the end of the film that living in the city is excruciating and that the people are under massive and constant pressure and in a continuous race to access basic needs, including transportation, housing, and food. Brighenti and Pavoni (2019) confirm that the modern city is an unavoidably mentally stimulating environment potentially leading to stimuli overload. "It seems that cities may be making us sick."[5] Anecdotally, the link between cities, stress, and mental health makes sense. Psychiatrists know that stress can trigger mental disorders—and modern city life is widely perceived as stressful. City dwellers typically face more noise, more crime, more slum conditions, and more people jostling on the streets than do those outside urban areas (Abbott 2016).

A stranger encountered by a resident of a nonurban setting is quite likely to become a friend or an acquaintance of that resident's own friends or acquaintances (Franck 1980). This explains Sinusi's misunderstanding of the social rules and attitudes in the city and his naivety in thinking the beggars in the streets who impose themselves on him and his wife to sell them flowers are residents welcoming his arrival. From Sinusi's rural perspective, money is not the only rational value in society, which explains why he spends all his savings to fly to Cairo to prevent the signing of an agreement that is of high cost to the nation. Furthermore, when he tries to intervene between the two fighting taxi drivers, he gets beaten up for his efforts in the end because, in his logic as a rural resident, collective actions

and sense of community are finer and of higher value than the individualistic behaviors of urbanites.

In *Kharaga*, 'Ateya is portrayed as possessing all the key characteristics of urbanites, including his use of the logic of the market because he has no other alternative. At the start of his rural sojourn, he refuses help from a local resident who offers to show him the way to Kamal Bek's farm; 'Ateya also suspects Kamal Bek's intentions and seriousness in buying the land. During a heart-to-heart discussion with 'Ateya, Kamal Bek expresses his longing for a male companion, a true friend and a son. Over time, the two get to know each other better and develop a friendship. In an attempt to more closely connect 'Ateya to the rural life, Kamal Bek and his wife come up with the idea to dress Khukha up like a city girl. When 'Ateya sees Khukha in her new clothes and makeup, he comments, "You used to be in harmony with the atmosphere." After a few days, 'Ateya discovers that living in the countryside is more fulfilling than he thought. Amid the fields, he encounters his authentic self and finds the true meaning of love when he decides to marry Khukha. This can be explained by Franck (1980) when she illustrates how the perceived risk in becoming friendly may be greater for urban residents and, therefore, they may be less willing to make the transition from anonymity or casual acquaintance to friendship.

Both films establish an identical view of the city of Cairo, shedding light on the widespread frustration among many of the city's residents in all aspects of life, whether the limitations are physical or bureaucratic, including housing, transportation, access to clean water, and access to bread (a fundamental staple), in addition to the weak social ties between individuals and within families. The massive consumption of city residents in following trends in fast food, fashion, and modern types of music is also a common theme in both productions. The two films are considered as a call to escape from the city to attain a utopian paradise by living in rural areas or even beyond.

Attributes of Cairo's Cinematic Modernity and the Representation of the Rural–Urban Continuum in the 1980s

Living in modern Cairo is presented in the two films as more of a challenge in every aspect than a "normal" way of life. Insufficient services, mass production, overwhelming crowds, pollution, bureaucratic hierarchy in the work environment, stress, and competitiveness are presented as key features of Cairo's urban life. In both films we see no free choice in the urban environment. The fact that cities bring together massive numbers of strangers with diverse backgrounds who are settled within close proximity is a compelling characteristic of everyday urban life, which is why the city is also known as the "the world out there." Thus, the urban

social environment reinforces feelings of ostracization and marginalization (Franck 1980). Along those lines, Wirth explains how contact in the city, even that which is daily and face-to-face, is nevertheless impersonal, superficial, transitory, and segmental. Wirth recognizes that in the city, "mankind is removed from nature" (Wirth 1938). Franck indicates the same, observing that living in a city involves being surrounded by large numbers of people one is neither acquainted with nor has emotional ties with (Franck 1980).

The bureaucratic system controlling employment in the two films is presented as the only avenue through which one can realize one's dreams. Moreover, with the decreased free space, individual freedom vanishes even from those who seek it. In taking understanding of cities further, as Harvey puts it, the access to city resources is a right that should be enjoyed by all its residents, indicating that changing the city is what can ultimately change the individual behavior of its inhabitants for the better. Such ideas emphasize common rights rather than individual privileges, and such transformation depends upon collective power to reshape the process of urbanization, which also includes the lifestyle and social relations of its inhabitants (Harvey 2012). Furthermore, the two films portray living in a small town in the countryside as living in paradise, with a utopian and idealistic outlook involving more independence and freedom of choice. Such a depiction reinforces Simmel's views of individuality in the city, where there is more specific specialization, which makes an individual irreplaceable and at the same time dependent on all other activities served by others.

Wirth's view of urbanism as a way of life is lived, played, and imagined through the mentalities of 'Ateya and Sinusi, since their original views are a consequence of Cairo being romanticized by the broadcast media as a place of opportunity, human accomplishment, and progression. Between arrival and departure, 'Ateya and Sinusi do not have identical views and experiences of living in the city of Cairo and in the countryside. In *Hona*, Sinusi heads to Cairo with the stereotyped perception of the city as a venue of hopes and dreams, but he remains unfulfilled in the end. In *Kharaga*, however, 'Ateya heads to the countryside without any intention of staying. Both directors make use of the famous song at that time, *Zahma ya donia zahma*. Sinusi's views of Cairo are based on what he hears and sees on the radio and television, which portray Cairo as Misr (Egypt), and these media outlets make repeated use of the phrase *Misr umm al-donia* ("Egypt is the mother of the world"). With the arrival of Sinusi and the absence of 'Ateya, a realistic depiction of Cairo's modernity demonstrates the complete opposite, with the loss of traditional emotions and values, and a lack of social identity.

In contrast to the dominant urban mood of life in Cairo, both films romanticize the countryside as an arena of opportunities and freedom

of choice. In *Kharaga*, for 'Ateya, moving out of the city helps him find a new, more prosperous way of life where he can pursue the career of his dreams and marry his one true love; while, in *Hona*, Sinusi, who travels to the city, struggles to reach the minister's office to present his research ideas. In the city, Sinusi finds himself neglected and unworthy in the eyes of its residents. His traditional culture is not valued and does not help him in reaching his aim. Everything is materialized by money. After a series of struggles, he decides to return to where he comes from or even to settle in a location far more distant from the city. Harvey illustrates the same views about life in a natural environment, where one and the community may be self-sufficient and independent from the actions of "others" to survive, in contrast to life in the city, where the existence of the division of labor makes one individual dependent on the actions of others (Harvey 2012).

The urbanite 'Ateya ultimately represents individuality in his new rural milieu. Previously, in the city, he believes that his work in the state system is promising and will eventually lead to the impressive accomplishment, with an independently high commitment from his side, of fulfilling his dreams of being the boss after twenty years' hard work. However, he finds out that commitment to the rural land is of a higher value and that he experiences much more personal fulfillment by practicing his dream job as an agriculture engineer. Yanling describes a similar idea: that the countryside is a system in itself which gives more freedom of choice. The countryside, as a way of life, is a system where everyone has their own role with a specific communal contribution. Purpose is there for everyone; the individual is recognized and valued for their achievements. Their accomplishments can be celebrated with feelings of self-worth. There are no physical limitations, as the rural mindset is always connected to nature.

The cinematic representation of Cairo as a stereotypical, but illusory, platform for hopes and achievement is damaging in both films, for not only the two protagonists, but, one can claim, for entire generations. This highlights the pernicious nature of stereotypes as presented in the media and brings into question Shafik's view that while cinematic representation of Cairo might be a stereotype, not every one is damaging. In this case, certainly, there is plenty of evidence for damage being inflicted. Cairo, promoted by the media as the last word in modernity, is frustrating to its residents in the film as they cannot even afford access to their basic needs. The transformation and extension of Cairo at that time into its cinematic modernity can be confirmed by actual history. The construction of huge infrastructure projects took place, such as the Sixth of October Bridge, one of the longest bridges in the city and for which one of its famous heritage buildings, in front of the main railway station, was sacrificed. The last

phase of the bridge was constructed from 1973 to 1999. In an attempt to connect the various parts of Cairo's widespread urban growth, the establishment of the first underground metro line in Cairo officially was begun in 1987 and completed in 1999. The city experienced massive construction at that time, and still does.

The romanticized and idyllic representation of the countryside at the same time may also be illusory. As Elmenofi, El Bilali, and Berjan illustrate, the quality of life in rural areas in Egypt in general from 1973 to 2011 depended mainly on both state and international development programs to enable villages to have access to basic infrastructure and different social services, as well as to encourage local participation and accountability of local initiatives. They argue that the mechanism of development is always rooted, and branches out into, many different committees and governmental bodies due to the centralized system in Egypt (Elmenofi, El Bilali, and Berjan 2014, quoted in Khairy 2015). To date, many areas of Egyptian rural land still have no access to basic infrastructure such as clean water or a proper sanitation system. Hence the possibility of having such an easy lifestyle and relaxed outlook in the countryside at that time cannot be accurate and must be fabricated. Furthermore, the intensity of the power of land portrayed in *Kharaga*, illustrated by the large plot of land owned by Kamal Bek, cannot be generalized. The original inhabitants of rural Egypt do not possess such power invested in land, especially after the 1952 Revolution when state policy divided ownership of land into small plots. This actually facilitated urban encroachment over rural lands because the decision to sell for construction became a small-scale individual choice, as explained by Amin (Amin 2000).

Escaping the Circus of the City

In this chapter, the social experience of living in urban and nonurban settings is discussed with specific focus on Cairo as portrayed in the two films. It should be emphasized that these two films in particular are narrated from the perspective of two characters traveling between two different milieux—urban and rural. They come from the same social class and yet have different social and cultural perspectives. Nonetheless, in the end, their views about urban life are almost identical, whether it comes from a life-long city dweller such as 'Ateya or one who travels to the city temporarily such as Sinusi. Both characters find city life too stressful and end up taking the same decision to escape from life there.

The reality of Cairo in the two films comes hand-in-hand with the realization that living in the city is exhausting and depressing. This realization of the modernity of Cairo in the films, and the impact of this on the daily life of Cairenes, proves to be a modernity of bureaucracy that

achieves the opposite of its intentions, resulting in either an urge to escape it or a complete mental breakdown. The city, as indicated in these productions, exhibits a warped form of neoliberalism: the system is supposed to build a new city while it does not invest the time or effort to save a structure on the verge of collapse (symbolically, 'Ateya is reported missing after his house collapses). The fact that the destruction of Cairo as a city is predicted in both films shows that their directors, Khan and 'Abdel 'Aziz, seem to have a common desire to escape from the urban nightmare that modernity has turned into, in order that they can settle into a more serene reality immersed in the pleasure of rural Egypt's natural surroundings. Mohamed Khan, considered a pioneer in neorealism, has four films listed in the best 100 films in Egyptian film history. He liked to set his films in real places, not only emphasizing the places themselves, but also focusing on their architecture, due to his earlier study of architecture.[6]

The city as a circus is supported by Fischer (1972, 189) when he says "the members of the crowd are anonymous." Harvey, however, sees the circus purely in economic terms, and states:

> The growth of the big modern cities gives the land in certain areas, particularly in those areas which are centrally situated, an artificially and colossally increasing value; the buildings erected on these areas depress this value instead of increasing it, because they no longer belong to the changed circumstances. They are pulled down and replaced by others. It is the mirror image of capital absorption through urban redevelopment. (Harvey 2012, 11)

In both films, we can find aspects of the dystopia that is the Cairo of today and which were anticipated by many filmmakers years ago, as well as by contemporary novelists, predicting the complete destruction of the city. *Rebel Cities* by David Harvey, published in 2012, discusses individual rights in relation to urban settings. Harvey states that "the right to the city is far more than the individual liberty to access urban resources; it's a right to change ourselves by changing the city. It's moreover a common rather than an individual right since this transformation inevitably depends on the exercise of a collective power to reshape the process of urbanization" (Harvey 2012, 11). Harvey argues that the freedom to make and remake our cities and ourselves is one of the most precious but neglected aspects of human rights (Harvey 2012, 14). This statement from *Rebel City* is presaged in a speech in *Huna* when Sinusi comes to the same conclusion at the end of the film, stating that his research on bread production will not change the city for the better without a collective will of all individuals to reshape the city themselves.

Yousef Alqaʻeed's statement from his novel *Beloved Country*, quoted at the beginning of this chapter, is an accurate portrayal of Cairo at the time, with his prediction of a city on the verge of a total breakdown. The options, then, are for one to either escape the city or else suffer mental collapse if one were to stay in Cairo. This is nicely portrayed by the late Egyptian novelist Ahmed Khaled Tawfik in *Utopia*, published in 2008, which predicts that Cairo will be in a state of total collapse by 2023, following unrestrained neoliberalism and consumerism. Tawfik draws the margin between two social classes: the super-rich who wall themselves up in gated communities and the masses outside who suffer misery and poverty. The city collapses and is only inhabited by the poor while the super-rich fence themselves off in a stretch of Egypt's north coast.

References

Abbott, A. 2016. "Stress and the City: Urban Decay." *Nature* 490: 162–64, https://doi.org/10.1038/490162a

Aho, K. 2007. "Simmel on Acceleration, Boredom, and Extreme Aesthesia." *Journal for the Theory of Social Behavior* 37, 4: 447–62.

AlSayyad, N. 2006. *Cinematic Urbanism: A History of the Modern from Reel to Real*. London: Routledge.

Amin, G. 2000. *Whatever Happened to the Egyptians?* Cairo and New York: The American University in Cairo Press.

Borer, M.I. 2013. "Being in the City: The Sociology of Urban Experiences." *Sociology Compass* 7, 11: 965–83, https://doi.org/10.1111/soc4.12085

Boydell, J., et al. 2003. "Incidence of Schizophrenia in South-east London between 1965 and 1997." *British Journal of Psychiatry* 182: 45–49.

Brighenti, A.M., and A. Pavoni. 2019. "City of Unpleasant Feelings. Stress, Comfort and Animosity in Urban Life." *Social and Cultural Geography* 20, 2: 137–56, https://doi.org/10.1080/14649365.2017.13 55065

Chistian, C. 2015. "The City – Simmel & Wirth." March 27, 2015, https://justanotherindividual.wordpress.com/2015/03/27/the-city-simmel-wirth/

Elmenofi, G.A.G., H. El Bilali, and S. Berjan. 2014. "Governance of Rural Development in Egypt." *Annals of Agricultural Sciences* 59, 2: 285–96, https://doi.org/10.1016/j.aoas.2014.11.018

Fischer, C.S. 1972. "'Urbanism as a Way of Life': A Review and an Agenda." *Sociological Methods & Research*.1: 187–242.

Franck, K.A. 1980. "Friends and Strangers: The Social Experience of Living in Urban and Non-Urban Settings." *Journal of Social Issues* 36, 3: 52–71.

Charles Goodsell, *The Case for Bureaucracy: A Public Administration Polemic*, New York, Seven Bridges Press, 1983.

Harvey, D. 1990. *The Condition of Postmodernity: An Enquiry into the Origins of Cultural Change*. Cambridge, MA, and Oxford: Blackwell Publishers, https://selforganizedseminar.files.wordpress.com/2011/07/harvey_condition_postmodern.pdf

———. 2012. *Rebel Cities: From the Right to the City to the Urban Revolution*. London and New York: Verso, http://abahlali.org/files/Harvey_Rebel_cities.pdf

Kamolnick, P. 2001. "Simmel's Legacy for Contemporary Value Theory: A Critical Assessment." *Sociological Theory* 19, 1: 65–85, https://journals.sagepub.com/doi/10.1111/0735-2751.00128

Khairy, T. 2015. "Kafr Wahb as a Case of Social Innovation: Social Innovation In Rural Community Development." MSc Thesis, Ain Shams University, Cairo, Egypt; University of Stuttgart, Germany.

Lefebvre, H. 1968. "The Right to the City." In *Philosophy of the City Handbook* edited by S. Meagher and J. Biehl. Oxford: Routledge.

Meier, K., and G. Hill. 2005. "Bureaucracy in the Twenty-first Century." In *The Oxford Handbook of Public Management*, edited by E. Ferlie, L.E. Lynn Jr., and C Pollitt, 51–67. Oxford: Oxford University Press, https://www.academia.edu/27372120/Bureaucracy_in_the_Twenty_First_Century

Schochat, E. 1983. "Egypt: Cinema and Revolution." *Critical Arts* 2, 4: 22–32, https://doi.org/10.1080/02560048308537565

Shafik, V. 2007. *Arab Cinema: History and Cultural Identity*, 2nd ed. Cairo and New York: The American University in Cairo Press.

Shi Y. 2014. "Urbanism Changes Personality Types, or Is Just a Way of Life?—Contrast in Simmel's and Wirth's Metropolis." *Studies in Sociology of Science* 5, 1: 28–31, http://www.cscanada.net/index.php/sss/article/viewFile/j.sss.1923018420140501.3018/5633

Simmel, G. 1971. "The Metropolis and Mental Life." In *On Individuality and Social Forms: Selected Writings*, edited by D.N. Levine, 329–30. Chicago: University of Chicago Press.

Wirth, L. 1938. "Urbanism as a Way of Life." *The American Journal of Sociology* 44, 1: 1–24.

Notes

1 Online: https://www.goodreads.com/book/show/6006778 (in Arabic).

2 *The Darling Buds of May* is a novella by British writer H.E. Bates, first published in 1958. It is the first of a series of five books, extolling a bucolic lifestyle, about the Larkins, a rural family from Kent who enjoy living in the countryside, surrounded by nature, and live off the sale of their crops.

3 On the issue of pollution, see https://www.surrey.ac.uk/news/ cairo-car-drivers-exposed-dangerous-levels-pollution-new-study-finds?f-bclid=IwAR394_IJaIeVz_eYf7K2Dph1bZcUwjBR0SRQTxzX_HWT-PiFP8JHKOX58x5o; https://www.sciencedirect.com/science/article/abs/pii/S1352231017308221

4 See Goodsell 1983 for an early critique and discussion.

5 Jane Boydell of the Institute of Psychiatry in London, who led a study into the incidence of psychosis over a period of more than thirty years in the southern London borough of Camberwell (Boydell et al. 2003), quoted in Abbott (2016).

6 Online: https://www.youtube.com/watch?v=4_Cq9AwSNQA

7

Cairo beyond the Windshield: From the Modernity of Realism to Surrealistic Postmodernity, 1980s–90s

Mariam S. Marei

Viewed only through a windshield, the city appears to be thriving. Buildings of all forms, heights, orientations, plot sizes and uncomfortably brash proximities occupy any and all land. There is no visible logic deterring the growth of this city; there is investment and, in answer, mass construction.

Dynamic to the last, the city displays a remarkable reversal of order where buildings are under threat of demolition at their very inception, discolored and decayed before they are ever painted, and perpetually under construction while having apparently been long in use. . . . [T]he city does not know when or how to stop because it has never had to. (Mardini 2019)

So says Yasmin Mardini as she describes Cairo of 2019 in a short photo essay titled "Behind a Windshield." When I started working on this chapter, my concern was to give an account of cinematic Cairo between the 1980s and 1990s. I was then unaware of Mardini's statement. But as I delved more into my material, I found her words most apt to start this chapter with. Although her focus is the "real" Cairo and mine is the "reel" Cairo, the similarity between the two views is uncanny, possibly proving the larger point of this book regarding the connection and the mutually constitutive relationship between the physical and the virtual, between life and its representation, and ultimately between real Cairo and reel Cairo. In this chapter I raise a couple of questions: How is Cairo viewed through a windshield? What impression does it give a viewer driving along its streets? To view a city from behind a windshield is not to interfere in its urbanism, but rather to allow its problems to speak for themselves, making the windshield another screen, one that reflects the internal agency of the city and not the intent of a single filmmaker. Such a viewing technique is

very useful when providing an alternative narrative. But of course Mardini's view, like mine, may be inevitably partial:

> In the grand scheme of any city, just how valid is one opinion told from the safe distance of a car? As a passenger observing and making your way around the city, the stakes are low. It is when you decide to stop in your tracks that the problems begin to appear. (Mardini 2019)

My intent in this chapter is rather to go beyond the windshield, not only to view from behind it, to see the city as a living organism from the vantage point of professional drivers. The cinematic depiction of this view is a very powerful tool that allows us to analyze the urban experience of the city and its modernity at a time of significant transformations taking place in Cairo.

Being a professional driver of a taxi, a bus, or a microbus implies spending hours driving through the streets of a city, day and night, as a routine, allowing one to perceive the city from different perspectives. In the following lines, Al Khamissi describes Cairo's taxi drivers in his novel *Taxi*:

> Taxi drivers belong to an economically deprived sector of the population. They work at a trade which is physically exhausting: sitting constantly in dilapidated cars wrecks their spines, and the ceaseless shouting that goes on in the streets of Cairo destroys their nervous systems. The endless heavy traffic drains them psychologically. (Al Khamissi 2008, 12)

That theme of driving through a city and narrating the view of the city from behind a windshield is international and is present in films of many cultures. The narration mostly highlights the relation of the driver, as an individual, with the city and its urbanism, as the wider society. Since the relation between the driver and the city is interrelated and mutually constitutive, it becomes a tool for us to view both the physical condition of the city and the social context of the driver. The theme of taxi drivers is explored by great directors like Martin Scorsese in *Taxi Driver* (1976) and Jim Jarmusch in *Night on Earth* (1991). The film *Taxi Driver* tells the story of a veteran who works as a taxi driver. He has just returned to civilian life from fighting in Vietnam, only to experience the decaying and morally corrupt New York City through his interaction with his passengers. He descends into semi-insanity and turns to violence when he decides to clean up the city by killing those he deems criminals. According to AlSayyad, the urban experience in the film describes modernity and explains the duality and irreconcilability in the behavior of the main character as a product of

the contradictions of modernity itself (AlSayyad 2006). In the film *Night on Earth*, five different stories in five different cities are narrated by taxi drivers picking up passengers at night, capturing the urban experiences of modernity and the varieties of these cities from the driver's seat.

Cinematic Cairo of the 1980s and 1990s through Two Drivers

The professional driver is also a major subject in Egyptian cinema. There are several differently themed films exploring drivers' lives and narrating stories from drivers' perspectives. These include *Sawwa' al-utubis (Bus Driver)*, 1982: *Sawwa' al-hanem (The Lady's Driver)*, 1994; *Lyla sakhnah (A Hot Night)*, 1996; *'Afarit al-asfalt (Asphalt Devils)*, 1996; *Sayed al-'atfi (The Romantic Sayed)*, 2005; *Farhan mulazm Adam (Farhan Accompanying Adam)*, 2005; *Hasan tayarh (The Fast Hasan)*, 2007; and *'Ala janb yasta! (Park on the Side, Driver!)*, 2008.

Major changes occurred in Cairo in the 1980s and 1990s that may have been best captured by the two films *Sawwa' al-Utubis* (1982) and *'Afarit al-Asfalt* (1996). My intent is to understand Cairo's cinematic modernity and to connect it to its real urbanism. There are parallels in both films that make their choice appropriate for this chapter. For example, both films represent the first directorial debut of their directors, although they offer totally different representations of Cairo's urbanism and modernity. And despite the short timeframe between the two films, they document the Cairo of their respective times and capture the changes of urbanism, social class, and the behavior of the city's citizens between those years. I will now start my analysis by giving a brief synopsis of each film.

Sawwa' al-Utubis (Bus Driver)

Sawwa' al-Utubis, directed by Atef al-Tayeb and written by Mohamed Khan and Bshir al-Dik, is described as one of the best films in the history of Egyptian cinema (Fathy 2018).

In *Sawwa'*, the main characters are Hasan (played by Nour El-Sherif), the bus driver; his wife, Mirvat (played by Mirvat Amin); his father (played by Emad Hamdi), and his friend and bus-ticket seller, 'Ali (played by 'Abd Allah al-Wazir). Hasan is a middle-class bus driver, whose sick father owns a workshop that is subject to foreclosure due to tax problems. As he is the only brother to five sisters, he tries throughout the film to earn money to save the workshop before it is sold at auction. He is unable to get much help from his sisters and their husbands. It even turns out that one of the husbands has contributed to the workshop's indebtedness without the father's knowledge. Hasan even has to sell his private taxi, in which he has been working beyond his regular working hours, just to raise the money required to save the workshop.

His wife, Mirvat, who dreams of achieving a better life and financial status, is not of much help either. Eventually, the couple divorce, as she rejects the idea of her husband selling the taxi. Hasan's friend, 'Ali, who is a student of law and works as a bus-ticket seller to save up for his marriage, helps him with a small amount of money. In the end, and after Hasan has sold his taxi and collected the money required, his father unfortunately drops dead in front of the whole family in an extremely tragic scene.

The film also presents Hasan's relations with his old friends, showing their social lives and different backgrounds. They were all colleagues during their military service and meet again, a long time after, for an outing which ends with a scene in front of the Pyramids at Giza (Figure 7.1). In the dialogue between the friends, the film explores the wars Egypt has experienced, such as the Yemen War, the defeat in the 1967 Six Day War, and the war of 1973. It is a nostalgic conversation, ending with one of them remembering a friend who was killed in the 1973 war and saying, "I lead a whole, victorious life now only through his death."

7.1. Hasan's conversation with his friends in front of the Pyramids in *Sawwa' al-utubis*.

Early in the film, we see Hasan's reaction to a pickpocketing incident on the bus, as he lets the thief go. However, as Hasan develops a somewhat aggressive attitude after the death of his father, he reacts differently in a similar scene at the finale. When he realizes that a pickpocket is stealing money from a woman on the bus, Hasan pulls up and closes the doors. The thief jumps out of one of the windows. This time Hasan does not leave him to run away, but chases and catches him, and they start to fight. The pickpocket draws a knife, but Hasan has had it as he goes about beating him up mercilessly in a notorious scene that is set in Tahrir Square, arguably the central, and certainly one of the most crowded, squares in Cairo, screaming, "You sons of bitches!"

'Afarit al-Asfalt (Asphalt Devils)

Fourteen years later, the film *'Afarit al-Asfalt*, directed by Osama Fawzy and written by Mustafa Dhikri, was produced in 1996. In *'Afarit*, the life of Sayed (played by Mahmoud Hemeida), a microbus driver, and his family is told. Sayed, who followed both his father and grandfather in this occupation, lives in a poor neighborhood in an apartment with his parents, sister Insherah (played by Salwa Khatab), and grandfather. He drives a microbus in shifts with his father. Through different characters and relationships, Sayed's environment is presented.

The film presents the microbus drivers' community, their lifestyles, culture, language, and special codes. They seem to have come up with their own communication codes; seen, for example, when a microbus driver passes a glass of tea to another driver while driving as a good-morning gesture, or, when a knife is drawn in a fight, blood must be the result or it will be an insult. All the characters live in harmony with these rules they have set for themselves.

There are two levels of relationships: the official ones, clearly unsatisfactory for the characters, and some hidden affairs that are revealed to the viewer throughout the film and create an underlying sense of mystery. Therefore, all the relationships are interlocked and mysterious. For example, Sayed is having an affair with the barber's wife. The father is having an affair with a neighbor, although he is married and living with his wife. Sayed's sister, Inshrah, who is getting old and is still unmarried, is having a relationship with Ringo (played by 'Abd Allah Mahmud). Although Ringo is a microbus driver and Sayed's best friend, when he proposes to Inshrah, Sayed refuses, claiming that he wants his sister to be married into a higher class, different from the drivers' environment. Ringo's aggressive reaction to this rejection is the climax of the film.

The most important and key character of the film is Mohamed (played by Hasan Husni), the barber of the neighborhood. He is always narrating

stories to his clients. These are very long-winded stories, derived from *The Thousand and One Nights*. These fairytale-like stories, and his way of narration, appear to be, at the beginning, too long and boring for the viewer. Even Sayed's grandfather dies while the barber is trimming his hair and narrating one of his stories. But, throughout the film, one discovers that these stories are a reflection of the actions and relationships of the community. Some of the stories, especially the one narrated at a gathering of all the family and neighbors at a funeral dinner at the end, clarify the mysterious relationships between the characters. In due course, the stories turn out to be of significance, and the boring, repetitive delivery of them by the barber takes on an element of sarcasm.

At the end, after Ringo's reaction to his rejection, the death of the grandfather, and the revelations of the barber, life just goes on as before. Everything goes back to the same flow, the same relationships, affairs, and friendships.

Streets and Stations: A Driver's Perspective and a Way of Life

In the two films, two cinematic urban settings are repeated: the urban streets, through which the drivers pass, and the terminals, whether of buses or microbuses. I will compare these cinematic settings in order to describe the characteristics of Cairo's cinematic urbanism and the changes that occurred between the 1980s and 1990s. Whether Cairo's "reel" urbanism can be applied or indicates connections to Cairo's real urbanism will be discussed later in the chapter.

Both films are mainly captured in the streets of Cairo. Here I will describe the actual experience of visualizing the city. In *Sawwa'* the cinematography places the audience into the action through the windshield of the bus driver (Figure 7.2). The film depicts Cairo's urbanism in a realistic way. The streets and their density are very realistic as these scenes are captured from the real streets of Cairo and its Downtown. We see the bus and taxi driving through the crowded streets of Cairo's center. The film starts with a long scene of the heavy traffic and crowded streets. We see many cars bumper to bumper and moving slowly, a motorcycle escaping congestion by moving onto the sidewalk, as well as camels crossing the street between the cars. It is a chaotic scene of the Cairo metropolis, accompanied by a loud upbeat soundtrack to highlight the crowdedness and density of the streets. Landmarks can be identified in the background, such as the Sixth of October Bridge, Jam'a al-Dawal shopping street, the Ramses Hilton hotel, and the Nile Corniche, making the settings very convincing and realistic. Even the National Democratic Party building, which was burned down in the 2011 Revolution, is in the background in one of the scenes. The final scene in *Sawwa'* (see Figure 7.6), where Hasan's rage escalates, is

7.2. The crowded traffic of Cairo, as captured from behind the bus windshield in *Sawwa' al-utubis*.

set in the crowded Tahrir Square, showing in the background the League of Arab States Building, and what was, at that time, the Nile Hilton hotel. It is significant that the bus driver has his outburst in Tahrir Square, as this is not him railing against the thief, but rather against the system. It is significant that the Revolution of 2011, also against the system, took place in the very same place, Tahrir Square, some thirty years later. In contrast, some scenes are shot in Damietta and Port Said, which are presented as much less crowded than the capital. The film succeeds in showing the various aspects of Cairo's urbanism as cosmopolitan.

In contrast, *'Afarit* presents long, open, exurb, empty streets with relatively low-density traffic. Here, the microbuses are depicted racing and maneuvering through the streets as if they own them or, at times, they are the only vehicles present (Figure 7.3). This reflects the film title, *Asphalt Devils*, as they race along like demons through the streets. Although the scenes were shot on the real streets of Cairo, not in studio settings, they do not reflect the reality of traffic density in the 1990s. Landmarks are used to identify the locations. We do not see much of the city, but more of Osama Fawzy's vision of Cairo. He selected the Maadi–Helwan road, in the south of the city, for these scenes. And he obviously chose specific times, when the traffic was quite light and the streets were empty enough for shooting. This has created a distinctive atmosphere for the street scenes: it gives the impression of an imaginary, nonrealistic world. It also reflects how the characters are separated from the ordinary social life of their city.

As for the bus terminals and parking lots, they also differ in the films. The bus garage in *Sawwa'* is very organized and well kept. An early morning scene (Figure 7.4) of the bus parking lot gives the viewer a striking

7.3. The empty roads from behind the windshield in *'Afarit al-asfalt*.

bird's-eye view showing the stacking of endless rows of buses next to each other. Some of the drivers, who are well dressed, are cleaning their buses and windshields. The buses then start to move, each in its turn; they have to pass by the controller to confirm their departure and begin their route. This organization, however, does not prevent the director from depicting, in another scene, the crowdedness of the bus stops. To catch a bus, the passengers have to dash directly toward the moving bus as it enters the station, shouldering their way through the crowds onto the bus. They collide with others who are trying to get off the bus from the same door. The passengers, moving in both directions, are trying to penetrate through the crowd. The sound track is full of the voices of shouting people, and the car horns in the background add to the feeling of the tumultuousness of the scene. This is a typical realistic scene reflecting modern Cairo of the 1980s. The drivers are formally dressed and are engaged in proper conversation in the station atmosphere.

In contrast, in *'Afarit* the microbus terminals are jam-packed with people and bustling with many activities (figure 7.5). There are coffeehouses serving the station and a man polishing the shoes of the passersby. The scenes are swarming with different activities all at the same time: passengers trying to find the right microbus for their destination; drivers shouting out to people; competition among drivers over passengers; drivers chatting loudly together or calling for a cup of tea from the coffeehouse. It would appear that the drivers are selecting their passengers; if they are not comfortable with one, they can be sent to another vehicle. There is also verbal harassment of women, which is not present in *Sawwa'*. This does not mean that there was no harassment of women on public transportation in the 1980s, but the director chose not to focus on it, perhaps indicating

126 Cairo beyond the Windshield: From the Modernity of Realism to Surrealistic Postmodernity

it was not one of the main issues or concerns of that time. There are no parking lots for the microbuses, as in the case of the buses in *Sawwa'*. Here, the vehicles are private property, so each driver can park them anywhere. Here, also, the language the drivers use is different: they have their own vulgar vernacular and their own music, which is extremely loud. Their clothing is very casual, in contrast to that of the bus drivers in *Sawwa'*. Most of them are in jeans, and the main characters wear leather jackets. All of this is another indication of the microbus drivers' separation from the rest of society, through their language, behavior, music, and so on. In general, the microbus terminal, as presented by Osama Fawzy, is extremely crowded, chaotic, and very eventful.

Cairo's cinematic urbanism in each film is presented differently. Obviously, the respective representations of the two decades, the 1980s and the 1990s, show a clear difference between them. It is not just that in *'Afarit* we see a deterioration of social standards, but also of behavior and attitudes in general.

It is necessary to take into account here that I am comparing two different transportation sectors. The public buses of the 1980s are government run and operated by the Cairo Transport Authority, and the bus drivers are employees in a governmental service sector; while the microbuses of the 1990s are privately run and are part of the informal but extensive transportation network connecting formal and informal areas of the city. This could partially explain the differences between the terminals and the quality and behavior of the drivers in each. But, explaining the differences in their behavior also requires that we go back to the major changes affecting society

7.4. The bus parking lot, showing the organization of the buses in *Sawwa' al-utubis*.

7.5. The crowded microbus terminal in '*Afarit al-asfalt*.

in general between the 1980s and 1990s. The rise of the privately run microbus was to supplement the overloaded public transportation system and was facilitated by the new privatization drive of the government as it adopted the Open Door *(Infitah)* policies (Sims 2012). According to Sims, private microbuses started informally in the mid-1970s, and by 1985 there were 14,000 vehicles on 133 different routes in Greater Cairo. By 1998 the number had jumped to 27,000, driving along 650 different routes. It is obvious that the microbuses started to expand in the 1990s. They expanded throughout Greater Cairo, mainly in areas not covered by governmental buses. This was due to their flexibility and their ability to serve informal areas of the metropolis. Subsequently, it has become the main means of transportation for the poor. It is a system under minimal governmental control, as the authorities are only responsible for setting the tariff. According to Sims, microbuses are one of the main contributors to traffic congestion (Sims 2012).

But who are these drivers? Where do they come from? And what are their living conditions? The two drivers in the films represent two different economic classes. They are almost a product of their time—Hasan in *Sawwa'* is a government employee, at a time when the state was still partially socialist and the national bus system was still the main means of transportation. This is a product of its time, part of the socialist system which started in the 1960s and culminated in the 1980s. Sayed in *'Afarit* represents the privatization and capitalism of the 1990s. He does not just represent a different social sector, but also a different economic class.

Hasan apparently lives in a lower-middle-class district, though it is not clear exactly where. From the interior of his house, we can tell it is lower-middle-class, which could be in an area like Shubra, Daher, or Hada'iq

al-Quba. This impression is reinforced by the family's choice of clothes and by their following middle-class conventions such as eating their meals around a dining table, rather than the traditional custom of being seated on the floor.

His wife's family is from an upper-middle-class neighborhood, while, in contrast, the workshop and the apartment where Hasan's family live are in a poor, older district, such as Munira or Hussein. Like Hasan, his father is lower-middle-class.

In contrast, Sayed, the microbus driver, and his family live in a poor, informal, deteriorated district. It is difficult to identify where it is, but from the writings about the film we know it was shot in a suburban district near Helwan. The viewer can see their poor standard of living from the flat they occupy, which is a studio-set design with poor furniture and decayed space. Both their informal meals and the way they are dressed help to highlight their relative poverty.

The cinematic urban settings and environments that appear in each film are fundamentally different in terms of both experience and physical space. The streets, the stations, the language they use, and their social attitudes are all a clear reflection of their time. The 1980s represent the continuity of socialism and the consequences of the Open Door policies, while the 1990s present a new economic system, capitalism, where people are predominantly concerned with the accumulation of money. Each of the drivers in the two films faces different problems.

The Drivers behind the Windshield

If these two films depict the city as seen through the windshield, who, then, do the drivers sitting behind the windshield represent?

Hasan fights against the new materialism—ushered in by the Open Door policies—embodied by corrupt family members or businessmen and the system in general. He is a result of the effect of the 1967 defeat and of 1970s policies on individuals in general. This is clear in the scene of Hasan and his friends at the Pyramids. The nostalgic dialogue, accompanied by a slow-tempo version of the Egyptian national anthem, reflects the impact of the defeat on them all. Despite it having a negative impact on that generation, the defeat still triggered significant changes in attitudes and expectations, and was a turning point for many people and in many aspects of life. None of the characters of Hasan's generation are satisfied with their social standing, and they are trying to find their way into a higher status. It is as if the defeat provided the motivation to improve their social status and living conditions. While Hasan works as a taxi driver in the afternoon to earn more money, his close friend, a bus-ticket seller, studies law, his sister goes to university, and his wife takes an English course to acquire better job opportunities.

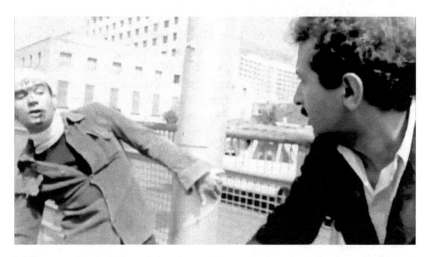

7.6. The famous finale of *Sawwa' al-utubis*, with Hasan punching the thief in Tahrir Square.

Hasan is a representation of the changes that his generation has undergone, and so is the way his anger transforms him from a law-abiding citizen, aware of his rights and following society's governing rules, to a rebel against corruption and moral decay. At the end, when Hasan explodes, shouting, "You sons of bitches!" (Figure 7.6), the plural form used indicates that his fight is against all those who caused the death of his father, against materialism, against corruption, against the decay of the city, and not just against one person. The scene shows Hasan taking things into his own hands and no longer relying on the state and the law to put things right. In the background of Tahrir Square, we see landmarks of the city he is rebelling against, and the Egyptian national anthem is again playing to emphasize that it is the system that he is revolting against.

Sayed in *'Afarit* could be regarded as a newer version of Hasan. He is the 1990s version of the same citizen who rebelled back in the 1980s. Now he is much poorer, though trying to accumulate money, is living isolated from the rest of society, and is forming his own governing rules due to the lack of governing authority and due to a lack of trust that the system can help him to regain his rights. There is an obvious thread linking both films.

Modernity and the New Realism of Cairo's Urbanism in Egyptian Cinema

By the 1980s, cinema in Egypt had witnessed a new movement as a consequence of the 1967 war. Some of the young Egyptian directors started the New Realism movement in Egyptian cinema. This movement was led by the distinguished directors Khairy Beshara, Mohamed Khan, Atef

al-Tayeb, and Dawoud Abdel Sayed, who drew their themes from the social and political conflicts that were sparked by the *Infitah* or Open Door policy. One of these themes was the fight against corruption and capitalism. In the 1970s, cinema became very commercial and without a clear objective. Most of the films were light love stories or social comedies. However, with the beginning of the 1980s, this group of directors started to focus on more realistic themes. New Realism cinema represents the real problems different classes were facing. The directors went out to film in real streets with the actual surrounding physical environment, rather than in studios and set designs. These directors captured reel from real life, and started filming this real life in a manner that truly represented it, telling the audience that this is the reality, and the audience—in turn—perceived it thus.

The endurance of New Realism turned cinematic urbanism into a representation of the physical reality. This, in turn, resulted in a better representation of Cairo's urbanism in Egyptian cinema. The cinematic sceneries were not designed to be references to the urbanism of the city, but, sometimes, depending on the degree of realism involved, they can serve as our eyes on the past. Their analysis is an attempt to understand the visualization of the urbanism of a city through the lens of the cinema. With New Realism capturing a realistic concrete environment, different facets of modernity are illustrated, such as crowded streets, women working to help their families, stories of poverty, the gaps between classes, the use of transportation, types of harassment, street vendors and their wares, as well as documentations of the physical appearance of streets, districts, and landmarks.

For Shafik, *Sawwa'* is the starting point of the New Realism movement (Shafik 2007). The film deals with a realistic theme. It is captured in the streets from behind the windshield, in such a manner as to let the audience experience the action. I consider New Realism as a modern approach to filmmaking. Besides, it captures the modern facets of Cairo's urbanism and the conflicts with modernity associated with them. *Sawwa'* is an archetypal modern piece of cinema about a modern reality.

An Imaginary World of Cairo's Postmodern Urbanism: A New Dramatic Treatment in Egyptian Cinema

In *'Afarit* the director creates an imaginary atmosphere to capture the scenes of the streets. As discussed earlier, the empty streets (Figure 7.3), in addition to a pervasive atmosphere of blue fog, create abstract scenes of the city. It is a totally different mood from the realistic scenes captured in *Sawwa'*. It is a kind of surrealistic reality or an escape from modernity, breaking from modern conditions to a postmodern one.

But what is postmodern about the city portrayed in '*Afarit*? Various attributes are associated with the condition of postmodernity. For Raban, a postmodern city is more like a theater, a series of stages upon which individuals can work their own distinctive magic while performing various roles. However, some individuals lose their true selves under the demands and chaos of urban life, as violence, chaos, and the vagaries of random urban life come into play (Raban 1974). '*Afarit* presents this magical theatrical image of the city, where individuals are performing their diverse roles under this postmodern condition. The film depicts the microbus drivers' community as a very specific sector of society, a new rising social class with their own set of rules and characteristics: they are messy, violent, immoral, and sex-crazed, typified by their use of vulgar language, songs, and behavior. They even have their own special codes, argot, and culture. In the 1990s, in response to the bureaucracy imposed by the state, people were seeking their own rights through a different route. As each citizen tried to act individually, corruption developed and culture and morals progressively decayed (Amin 2019). '*Afarit* shows the decay of morals and ethics, and the resulting conflicts, reflected in urbanism.

For Harvey, the postmodern condition is associated with variables other than those of Raban. It is associated with flexible accumulation, diverse sources and outputs, and decentralized decision-making (Harvey 1990; AlSayyad 2006). Let us look closely at these terms and their relevance to the film we are discussing. Flexible accumulation is the flexibility of labor, labor markets, products, and patterns of consumption. It is associated with a new sector of production, new ways of financing, and flexible work systems (Harvey 1990). In '*Afarit*, the bus drivers' community is indeed a new economic sector. They accumulate things, and this is what gives them status. They may not be rich, although the film shows that some of them are doing well, but they control an entire sector of the transportation economy and this is what can be described as flexible accumulation. In this case, it is an accumulative power rather than an economic one. The accumulation of wealth, power, and capital is associated with individual knowledge (Harvey 1990). Sayed as an individual, with his knowledge as a microbus driver, is accumulating power. Flexible accumulation also supplements the consumption side, thereby leading to a quick change in fashions and the transformation of culture (Harvey 1990). This is also reflected in the culture transformation presented in '*Afarit*.

The existence of diverse sources and outputs is another aspect of postmodernity. There is no longer any central authority. In the 1990s, and in the case of transportation as this is the main theme here, there are multiple forms, or sources, of operation: the bus drivers, microbus

drivers, taxi drivers, and so on. And each sector is subject to different systems, with no coordination and responsibility to a single authority. Thus, diverse sources, as another condition of postmodernism, are also seen in *'Afarit.*

Decentralized decision-making is the result of a series of fragmented communities, cultures, and economics that reflect varied divisions of space and power. Control could be through public–private partnership. This fragmentation results in a radically segregated population (AlSayyad 2006). The film presents the community of the microbus drivers as an enclosed group, with their own decision-making and culture, fragmented from the wider community. Public–private partnership is present as the microbus system is totally privately owned, but routes and tariffs are regulated by the government.

The film presents many of the essential features of the condition of postmodernity. It is as if the rejection of modernity in *Sawwa'* has led to the postmodernity of *'Afarit.* Indeed, postmodernity can very well turn utopian aspirations into a dystopic condition (AlSayyad 2006). Osama Fawzy's film has this dystopian ambience.

The cinematic genre of *'Afarit* may have been a development from the earlier era of New Realism films. Its narrative technique is achieved through the stories that the barber tells his clients in a fairytale-like fashion. These stories, through the unfolding of the film, reveal the interconnected relationships between the characters. There is no sequence or order; the narration of the story is, rather, fragmented. The beginning can be the end and the end can be the beginning. The actions are imaginary, but at the same time there is a hidden reality to them. This can be explained through Gürkan's point of view, that postmodern artists seem to tell a truth, but not reality; an imitation of reality. He even argues that there is no reality (Gürkan 2012).

According to Hoagwood, repetition of images and scenes is, among other variables, a characteristic of postmodern cinema. The repetition deepens and broadens the issue presented (Hoagwood 2006). In *'Afarit,* to indicate the development of his character, one scene showing Sayed smashing the cover of a crate of oranges to take one and start to peel it in an idiosyncratic manner to eat it, is repeated three times, each time with a slightly different action and background music. This repetition, with slight differences, reflects the mood of the character and shows that life goes on as it has always done, and no change occurring to his situation. The film has no climax or real ending. The ending could be understood in different ways. Postmodernity is a condition about several narratives and many simultaneous truths. If one can call the narrative of *Sawwa'* New Realism, then the narrative of *'Afarit* is, indeed, postmodern. *'Afarit* is a postmodern film narrating a postmodern condition.

Concluding Notes

In this chapter, I have focused on the different conditions, urban and social, that characterized the 1980s and how they changed by the mid-1990s from the specific perspective of the "driver." The films *Sawwa'* (1982) and *'Afarit* (1996) have proved to be most suitable for tracing the changes in Cairene urban attitudes toward their city. Through both films I have also discussed not only the changes in the making of Egyptian films, but also the changes in Egyptian society and the Cairene urban condition.

In the short time span between the films, major changes happened to the urbanism and society of Cairo, as presented in the cinematic elements in each. In the 1980s, films attempted to capture the struggle between traditional ethics and codes of conduct and the new forms of behavior emerging as a result of the Open Door policies and the defeat of 1967. But, by the 1990s, the outcome seems to have been an escape from an unbearable urban present to an introverted imaginary world of the individual, which I describe in the current chapter as surrealistic postmodernity. Changes are apparent in the streets as well as in the behavior of the citizens and different social classes. Apparently, the drivers' class got poorer and is living in a poorer district. Those who inhabited middle-class or lower-middle-class parts of the city are now living in very poor districts of informal areas. The hierarchy of social classes has changed, which is a reflection of modernity.

As for the making of the two films and their connection to urbanism, *Sawwa'* is a modern film about Cairo as a modern city, with all of the encounters and conflicts that occur in urban modernity. On the contrary, *'Afarit* is a postmodern film that uses some of the fragmented qualities of postmodernity as cinematic techniques to present Cairo's postmodern condition in an increasingly fragmented, neoliberal city. It is as if the modern condition of the city required a modern narration making the real and the reel identical, while the postmodern condition is represented in the reel medium, using a similarly corresponding cinematic narration allowing the reel to be realized as an urban reality.

According to Raban, cities are plastic by nature. They are shaped by the individual citizen who molds them in their image. But they also shape the individual by their resistance. It is a two-way process (Raban 1974). Both films presented here show that cities are plastic. Hasan in *Sawwa'* has shaped the resulting city we see in *'Afarit* by the image he sets for himself, that he must take into his own hands the fight against corruption and materialism which represent modernity. In *'Afarit* we see the resulting shaped city in the community of the microbus drivers, where they are now not just fighting corruption and materialism, but have moved further on, to be living under their own governing rules. This has now

turned the shaped city from the modern to the postmodern condition. But the city, by its resistance, also has its impacts on the individuals, as presented in both films.

There is an obvious link between the two films in the character of the drivers. Hasan, the public bus driver, is willing to turn a blind eye to the improprieties he encounters in his bus. Although he is performing the duties of his job, he is willing to tolerate the thief and the harasser who violate the norms of society because there is no direct impact on him. But he finally rebels on behalf of the entire society in the scene where he leaves the bus to chase the thief and beat him. Sayed, the private informal microbus driver, could be seen as a continuity and a reaction to what happened to Hasan. By his time, twenty years later, Sayed is disengaged from most of the issues that could enrage Hasan. He is now socially isolated from the larger society, creating an informal economy with its own governing rules outside of governmental authority.

We started with Hasan in *Sawwa'*, who in the 1982 film experiences an outburst of intense anger in the middle of Tahrir Square. This is only on the reel medium, but we can see the events of January 25, 2011, as an extension of the breakdown that Hasan experienced back in the 1980s. It took thirty years for the event predicted in the reel medium in 1982 to happen in real Cairo in 2011. It is ironic that this almost corresponds to the thirty years of Hosni Mubarak's regime. It is not surprising, then, that we encounter Sayed in *'Afarit* in 1996, almost exactly in the middle of Mubarak's time in office, as an extension of what could have happened to Hasan in real life. Hasan and Sayed were travelers along the road of cinematic Cairo before they became real protagonists of Cairo's urban modernity.

References

AlSayyad, N. 2006. *Cinematic Urbanism: A History of the Modern from Reel to Real.* London: Routledge.

Amin, G. 2019. *What Happened to Culture in Egypt?* Cairo: El Karma.

Fathy, S. 2018. *Classic Egyptian Movies.* Cairo and New York: The American University in Cairo Press.

Gürkan, H. 2012. "Postmodernizm ve Sinema: David Lynch'in Mavi Kadife Filminde Postmodern Söylem (Postmodernism and Cinema: Postmodern Values in the movie of David Lynch's Blue Velvet)." *Akdeniz Üniversitesi İletişim Fakültesi Dergisi*, 17: 102–11, https://dergipark.org.tr/en/pub/akil/issue/48078/607877

Harvey, D. 1990. *The Condition of Postmodernity: An Enquiry into the Origins of Cultural Change.* Cambridge, MA, and Oxford: Blackwell Publishers, https://selforganizedseminar.files.wordpress.com/2011/07/harvey_condition_postmodern.pdf

Hoagwood, T. 2006. "Postmodern Mirrors." *Literature/Film Quarterly*, 34, 4: 267–73.

Al Khamissi, K. 2008. *Taxi*. Translated by J. Wright. Laverstock: Aflame Books.

Mardini, Y. 2019. "Behind a Windshield: An Unsolicited Narrative." *Amsterdam: Archis*, March 2019, http://volumeproject.org/behind-a-windshield-an-unsolicited-narrative/

Raban, J. 1974. *Soft City*. London: Hamish Hamilton.

Shafik, V. 2007. *Arab Cinema: History and Cultural Identity*, New Revised edition. Cairo and New York: The American University in Cairo Press.

Sims, D. 2012. *Understanding Cairo: The Logic of a City Out of Control*. Cairo and New York: The American University in Cairo Press.

PART II:
Themes in the Transformation of Cinematic Cairo

8

Transformations in the Cinematic Space of a Cairo Suburb in the Late Twentieth Century

Farah K. Gendy

> The suburb is not an isolated entity, but intimately linked with the city from which it derived its raison d'être. As the city changes, so too do its suburbs. It is essential, therefore, to understand and explore the history of the suburb in a situate way, within the changing context of the metropolis. (McManus and Ethington, 2007, 337)

Overwhelmed by the current rapid transformation of the once picturesque suburb, I aim to outline how Heliopolis' urban experience has changed over half a century. In this chapter, I argue that the continuous shaping and reshaping of the suburban experience of the "Heliopolitan" community is a result of political and economic dictates. Through the lens of cinema lenses, the chapter will support this argument exporing the urban context shown in three films, *Ard al-ahlam (Land of Dreams)* (1993), *Fi sha'it Masr al-Gadida (In the Heliopolis Flat)* (2007), and *Heliopolis* (2010). Introducing the suburb through a film of the 1950s, *al-Wisada al-khaliya* (1957), that pictures Heliopolis during its heyday, I will highlight its distinguished urbanism and its residents of unique caliber, "the Heliopolitans." Then, thirty-five years later, a second generation, discussed, *Ard al-ahlam*, expresses its intolerance of life in the suburb and its aspiration to escape it to pursue alternate dreams. About fifteen years after that, through two more films from the early 2000s, I will illustrate the deteriorated conditions in the suburb. Throughout the chapter, the socio-cultural transformations intertwined with the physical changes the suburb has been through will be discussed, concluding that the transformation of the cinematic space of Heliopolis is but a clue to the overall uncontrolled deterioration of Cairo.

The Genesis of Heliopolis

The late nineteenth century and the turn of the twentieth century witnessed the foundation of numerous districts and suburbs around Cairo. In 1905, the Belgian Baron Empain proposed a visionary project, an oasis that would offer a new lifestyle for a new demography through implementing the latest modern urban theories. The dominant movement of that time was ruled by the utopian idea of a city which merges both features of the city and countryside—the garden city. The concept was a response to the increasing overpopulation, pollution, lack of green areas, and unsanitary living conditions in the city resulting from industrialization (Dobrowolski and Dobrowolska 2006, 87).

According to Robert Ilbert, Heliopolis—the ancient Egyptian name for which was "On" —was a success in terms of urban planning. Though "stamped with the image of the ruling class," it attracted different societal segments due to the affordability of its varied housing types. Like all garden cities, the new oasis attracted potential inhabitants who loved it and took pride in being Heliopolitans. Additionally, and although the project was instigated by a private foreign and capitalist initiative, it managed to provide low-cost, comfortable accommodations and at the same time make a substantial profit (Ilbert 1985, 36). The model of Heliopolis, as Ilbert explains, adopted both an imported appearance as well as an imported pattern of daily life. Ilbert elaborates that the urban structure of Heliopolis was organized around a hotel, one of the most luxurious in the city at that time, with the cathedral as the heart and center, and the club, the racecourse, and the amusement park, named Luna Park, as key landmarks of the suburb. Agreeing with Ilbert, other researchers confirm that presenting European building designs detailed with oriental elements managed to project the image of a modern type of town. Moving to Heliopolis in the early and mid-twentieth century was perceived as inclusion in a newly aspired-to pattern of living. Observed demographically, the population of the residents was composed of many Europeans, particularly Italians and Greeks, along with Levantines who represented a remarkable percentage of the residents (Ilbert 1985, 37–39). In their book *Heliopolis: Rebirth of the City of the Sun*, Dobrowolski and Dobrowolska describe Heliopolis as cosmopolitan, especially in light of its early property owners who were a mixture of French, British, Germans, Italians, Armenians, Jews, Greeks, and both Christian and Muslim Egyptians (Dobrowolski and Dobrowolska 2006, 176).

According to Galila El Kadi, the prominence of Heliopolis experienced an upsurge after the 1952 Revolution; it attracted more residents from the upper-middle classes as a result of the newly adopted visions for urban development by the regime that followed. In her book *Cairo: Centre*

in Movement, El Kadi asserts that a shift happened in the seat of power from Downtown—the center of Cairo—to Heliopolis in the periphery for two reasons following the Cairo Fire of January 26, 1952. One reason was to reduce the possibility of uprisings against the seat of power in the center of Cairo, and the second was to completely break free from the prior regime through a change in location. With the seat of power shifted to Heliopolis, it attracted the new dominant classes as well as technocrats, companies' CEOs, officers, members of the Revolutionary Council, and others (El Kadi 2012, 87). Further political changes, such as the Six Day War, the Suez Crisis, and the nationalization process within the same era, led to the expulsion or voluntary exile of foreigners and a large part of the Egyptian aristocracy in successive waves, resulting in dramatic demographic changes in Heliopolis (El Kadi 2012, 83).

Heliopolis from the 1950s to the Early 1990s

Due to successive changes in the state system, the Egyptian social pyramid altered dramatically in the 1960s and 1970s, leading to consequent demographic shifts. These changes included the nationalization process implemented by the socialism-oriented Nasser regime in the 1960s and the Open Door policies *(Infitah)* under Sadat in the 1970s which continued into Mubarak's era, with almost no major changes (Amin 2011, 57). With the subsequent privatization process, Egypt joined the ranks of the international capitalist system and adopted its concomitant economic liberalization (Aoudé 1994; Waterbury 1985). With every changing political context, the Cairene middle class was affected by the political and economic situation. "Whereas the middle class was preoccupied with education and civil service careers, most urban Egyptians, who belonged to the lower class, were concerned with earning a livelihood in an economy characterized by persistent and extensive unemployment and underemployment" (Hooglund 1991, 117). Hooglund's study concludes that, during the 1960s, the lower classes aspired to better living conditions, including education, work, and residency in the suburbs, while in the late 1970s and early 1980s, a new upper-middle class appeared with more opportunities and aspirations. With the privatization of the public sector in the late 1980s and early 1990s, the social pyramid changed once more, and, now, with added aspirations of "escape," to live the Western dream, like never before (Hooglund 1991, 117). The Egypt of Hosni Mubarak was a place of increased corruption, according to Galal Amin. Exploitation intensified due to the weakened state, the absence of a national project, and the poor enforcement of the law (Amin 2011, 41). This corruption extended to not only the upper classes, but also the middle and lower classes as a result of the economic deterioration, slackening

of labor migration, growth of slums, and unemployment. With the rapid growth of population, many people were further driven to break the law out of fear of loss of status and in the hope of improving their living conditions (Amin 2011, 42–43).

The 1960s marked an era of homecoming of the seat of power to Heliopolis (El Kadi 2012, 101). From then on, the development of the east side of Cairo was realized to be of high importance, leading to the creation of a "tertiary pole" in Nasr City with the construction of the airport, exhibition grounds, and luxurious hotels along the road to the airport. The presidential palace also benefited from the existing infrastructure and facilities. In addition, the development of other projects to the east of Salah Salem Boulevard, including residential, governmental, and commercial construction, resulted in the elevation of Heliopolis, together with Nasr City, to the largest residential area of the Cairo elite (El Kadi 2012, 101).

Heliopolis from the Early 1990s to the 2000s

Amin notes that the span between the years of 1986 and 2006 is considered one of the worst epochs for the Egyptian poor, as a result of the arrangements made by the International Monetary Fund coupled with the escalation of the external debt, leading to a decrease in public state programs for the people (Amin 2011, 73). Due to these circumstances, deterioration in different sectors led to a deterioration of the overall quality of life in the country, as well as a sharp increase in inequality that accompanied declining economic status for many. Amin also sheds light on the strong sense of oppression and the intensified alienation felt among many Egyptians (Amin 2011,73–74). In the urban panorama, vast residential mobilization took place from the center of Cairo to the formal and informal areas in the periphery of Greater Cairo, in addition to the creep of new satellite cities between 1996 and 2006 (El Kadi 2012, 108). This explains the major reasons for the city's physical deterioration.

In their book *Heliopolis: Rebirth of the City of the Sun* (2006), Dobrowolski and Dobrowolska argue that Heliopolis changed from being the "oasis of greenery in the desert to simply being one piece of a much larger urban organism"—though still uniquely distinguished by its special architectural style, albeit surrounded by undistinguished modern buildings. Moreover, and despite ongoing demolition of the old buildings and their replacement by modern structures, Heliopolitans still remember the "good old days" of their district. For them, Heliopolis is more than just a place to live (Dobrowolski and Dobrowolska 2006, 159). This accentuates the palpable feeling of nostalgia mixed with sorrow experienced with each destructive act and sign of deterioration.

Depicting Suburban Changes through the Cinematic Medium

As rapid urbanization takes place in both the centers and peripheries of metropolises, suburbs worldwide are becoming part of the bigger cities. Once a suburb is established, it continues to change and evolve within both its physical and social settings. The succession of residents with changing socio-economic conditions results in changes to the layers of places. According to Whitehand, the aspirations and problems of each society are reflected through the marks it leaves on the landscape; these marks are the physical record of both past and present societies to be read (Whitehand 1994, 5).

Ruth McManus and Philip J. Ethington have expressed an interest in the transition of suburbs, stating that "a most fruitful area of research in urban historical geography lies in the study of what happened to specific suburbs after they were originally planted, throughout their life-cycles of repopulation, generational change and fluctuation with the life-cycles of individuals who inhabit these places." Actually, McManus and Ethington proposed a concentrated study of suburbs, discussing their "ongoing transformation and reinvention," especially after becoming a part of the larger metropolis, rather than the study of their "initial founding on the periphery" (McManus and Ethington 2007, 319).

To analyze the urban transformation of Heliopolis chronologically, along with the change of its inhabitants' urban experience, the next part of this chapter adopts the abovementioned urban historians' approach. Following that approach, and through the reel medium, Heliopolis will be examined longitudinally with the aim to respond to the question: "What happens to a suburban seedbed after it has been planted, after it ceases to occupy the leading edge of a metropolis, once it no longer stands as the historically typical suburban form?" (McManus and Ethington 2007, 318). In order to answer the question, the following three areas are focused upon: the inscription of history in a landscape, changing the perception of the suburb; its modified built and social fabric; and the reconsumption and reproduction of suburban spaces (McManus and Ethington 2007, 327).

In his book *Cinematic Urbanism: A History of the Modern from Reel to Real*, Nezar AlSayyad considers films as an arena of discourse in which our present understanding of cities and urban experience is challenged (AlSayyad 2006, 4). The book emphasizes how films are a rich medium for documenting, reflecting, and representing human interactions in cities like no other. Other theorists, such as Douglas Muzzio and Thomas Halper, have used films as a medium to study, analyze, understand, and explain the emergence and dominance of American suburbs. Although the nature of suburban life was described, analyzed, and transmitted through a variety of media, films were particularly chosen as a medium for the study

by the theorists as they reflect their time and offer richness in the cultural description of the time. According to Foucault (1997), films do not objectively report unquestionable reality, but they are, instead, interpretations of contentious and unstable accumulations (Foucault 1978; Muzzio and Halper 2002, 544). In this manner, films should be analyzed within their original social and political context while also considering the audience for which they were created in the first place. Factually, like any other historical document, films are meant to reveal the way people live and the changes happening in their lives over time (Muzzio and Halper 2002, 545).

With this half-a-century overview of the political and economic contexts, I will now move on to analyze three films that depict the transformation of the district that has been described in theory. *Ard al-ahlam (Land of Dreams)* (1993) articulates the paradox between two Heliopolitan generations: the middle-aged with their nostalgic belonging to the suburb versus youth's aspirations to escape it (and the entire country) in favor of the American dream. *Fi sha'it Masr al-Gadida (In the Heliopolis Flat)* (2007) and *Heliopolis* (2010) show the turn-of-the-millennium reality and generate different meanings for the same suburb that was photographed in black and white back in older films from the 1950s. According to the theoretical framework, the films will be used to discover how the cinematic space of Heliopolis has changed over fifty years of its history. Further examination will focus on the cinematic representation of the successive forms of both the interior spaces—mainly the apartments of Heliopolis—and the architecture and its significant elements, and on to the urban level. An exploration of the successive social groups and their transformation, considering the different ethnic groups and classes, will also be tackled. Throughout the discussion, the protagonists' aspirations and problems signifying their changed experience within the suburb will be revealed.

Cinematic Snapshots of Heliopolis

The original Heliopolis was captured in several films, such as *Rosasa fil 'alb* (1944), *Ayna 'omry* (1957), *al-Bab al-maftouh* (1963), *Bae'at al-garayed* (1964), *Saghira 'al-hob* (1966), *Losous laken zorafaa'* (1968). In those films, various areas, buildings, and architectural elements are highlighted. Through various panoramic scenes, the films—sadly, but luckily—are the only reference to numerous details that exist no more in today's Heliopolis. One of those films is *al-Wisada al-khaliya (The Empty Pillow)*, 1957. Based on a novel by Ihsan 'Abd al-Quddus and directed by Salah Abu Sayf, it narrates the first-love story of Salah ('Abdel Halim Hafez) and Samiha (Lubna Abdel Aziz). The film frames Heliopolis as a secluded suburb that only upper-middle-class Cairenes can afford to live in.

The physical representation of Heliopolis shown through the film gives the viewers both a reference to and an insight into how people experienced the relatively new residential suburb. Samiha lives in a luxurious apartment building located in Elsabaq Street. Different scenes show the street and building with the spacious balcony overlooking a view of the relatively new metro line. Such scenes reveal the upper-middle social class lifestyle of the time. Throughout the film, we see wide streets lined with trees on both sides with few cars and few pedestrians. Other scenes where the two main characters meet privately, away from people, show the ruins of an ancient Egyptian temple in Matareya, marking the original location of ancient Heliopolis and drawing attention to the origins of the suburb and its name.

The hippodrome (horse racing arena, later demolished) appears in the film when Salah strolls through the streets of Heliopolis, exhibiting one of the most luxurious architectural elements that characterized the wealthy suburb and how it was perceived. *al-Wisada* marks the beginning of social conflict in Heliopolis, a district to which Salah aspires to belong. Throughout the film, Salah attempts to ascend the social ladder to achieve a higher socio-economic class by rejecting his current status and working hard, hoping to both impress Samiha and take revenge for her marrying a wealthier man. It is worth mentioning that, when the film was first screened in the 1950s, it was criticized as betraying the working class by stressing the social conflicts addressed by the two protagonists of the love story, as noted by the cinematic critic Sameh Fathy in his book on 'Abd al-Quddus and his novels that were made into films.

Under Nasser's socialism-oriented regime (also referred to as a state-capitalist regime, due to the vast industrialization process controlled by the state in Nasser's era [Aoudé 1994,7–8]), the film shows how Heliopolis was highly regarded by the new emerging educated middle classes, though it had been originally designed and zoned with different segmented types of housing for different classes.

I will now proceed to present a synopsis of the three films, followed by an analysis of how the films express the urbanism of the suburb chronologically over an almost twenty-year period.

Ard al-ahlam (Land of Dreams), 1993

Ard al-ahlam is written by Hani Fawzi and directed by Dawoud 'Abdel Sayed. Nargis (played by Faten Hamama) is a middle-aged woman living in Heliopolis who is expecting to travel the next day to join her son, who is pursuing an opportunity in America, the land of dreams. The main plot of the film takes place over one full day as Nargis, the main protagonist, visits her son, friends, and mother before her departure to America, and

meanwhile loses her passport. She returns to all the places she has been to in search of the lost passport, but fails to find it anywhere.

This embroils her in a day-long troublesome adventure with Raouf (played by Yehia El Fakharany). She meets him in the street early that day and later realizes he is a magician. When she calls to ask about her passport, he claims to have it. Now, what is supposed to be her last day in Egypt turns into an adventurous tour of Heliopolis like nothing she has ever experienced before. She follows him to Le Chantilly, where he usually sits. Later, she is arrested by policemen, having aroused their suspicion while searching for Raouf's car (assuming her passport is there). She later follows him to his apartment, to a hotel where he performs his magical tricks, and even attends a party with him at a private villa. She ends up taking him to a hospital when he suffers a heart attack. It seems that Nargis has need of such an adventure, out of her conservative comfort zone, to help her realize she has the will and the choice to decide her own future. In the end, she finds her passport in her bag and rethinks the whole idea of travel and emigration.

The main idea of the film revolves around "the land of dreams" from two different perspectives belonging to two different generations: Nargis,

8.1. Poster for *Ard al-ahlam* (*Land of Dreams*) (1993).

representing the middle-aged generation of the 1990s, dreams of spending the rest of her life in Heliopolis, while her youthful son dreams of emigration to America. The two disparate dreams show the divergence between two generations living in the suburb. Nargis, on the one hand, is upset by the transformation of the neoclassic, stately suburb with its crowded streets and the bustling pace of modern life that has intruded upon it, but still feels rooted and safe there. Her son, on the other hand, is frustrated by the general situation in the entire country, and is searching for the modernity, luxury, and liberty promised by the United States. However, during his conversation with his wife, he still expresses doubts about his decision to emigrate: he questions the real purpose of their departure, as they already have all they need in Egypt. On finding out that the realization that Egypt holds all she needs has led Nargis to decide to stay, he, too, lets go of the idea of emigrating.

Fi sha'it Masr al-Gadida (In the Heliopolis Flat), 2007
Fi sha'it Masr al-Gadida is written by Wessam Soliman and directed by Mohamed Khan. It narrates the story of Nagwa, a music teacher (played by Ghada 'Adel), and Yahya (played by Khaled Abou El Naga), a resident of an old flat in Heliopolis. On a school trip to Cairo, Nagwa decides to visit her old teacher who lives in Heliopolis. Nagwa fails to meet her teacher, who has left her Heliopolis flat, and, instead, meets Yahya, the new resident, who works as a stock market speculator and lives alone in his rented apartment.

Deciding to stay in Cairo to try to contact her teacher, Nagwa explores Cairo and its residents, not just in Heliopolis, starting with Shafiq, the landlord and neighbor who has kept the teacher's belongings in case she returns. With the help of Yahya—who now lives in the teacher's apartment—Nagwa meets her teacher's colleagues and traces her calls to a radio program, and satisfies herself that she is fine. Although the name of the film, *Fi sha'it*, suggests that most of the story takes place inside the flat, throughout the film, the whole of Heliopolis—just like the old flat—is seen as introspective, focused on its memories of the past.

Most of the interior scenes of Yahya and Nagwa in the flat evoke a sense of nostalgia, with dimmed lighting and classical music. Yahya thinks that the ghost of Nagwa's teacher still lives there; having left without taking her belongings, he thinks she might already be dead. Different scenes of the film elaborate on Yahya's perception of the flat as an outsider in the suburb and as a temporary resident. He is irritated by the different unexplainable incidents that take place, such as the light turning off accidentally and the frequent strange sounds from the elevator. On the contrary, inspired by the latent presence of her teacher still in the flat, Nagwa has a different perception and is always relaxed and at home there. She is even happier when she finds her

Cinematic Snapshots of Heliopolis 147

8.2. Poster for *Fi sha'it Masr al-Gadida* (In the Heliopolis Flat) (2007).

teacher's letters and belongings. Shafiq's balcony on the ground floor, with the garden of the building, is the place where most of the dialogue takes place—between Nagwa and Shafiq about her teacher, and between Shafiq and Yahya about the flat. The film ends with Nagwa traveling back to her city, thinking happily about her adventure in the big city.

Heliopolis, 2010

Heliopolis is written and directed by Ahmad Abdalla. The film narrates the story of the suburb itself, through the eyes of the reporter Ibrahim (Khaled Abou El Naga). It takes place in Botros Ghali Street, in two neighboring residential buildings. The film starts with Ibrahim interviewing an old woman, Vera ('Aida 'Abd el-'Aziz), about the minorities still living in Heliopolis, especially after the Revolution of 1952. Though refusing to reveal her identity to her neighbors, we learn from their conversation that Vera is an Armenian Jew who is known only as a "foreigner." While waiting in her apartment, Ibrahim explores with curiosity the old photos of the lady and a Jewish (Hebrew) ornament hanging on the wall. When asked by Ibrahim about how Heliopolis has totally changed, Vera describes the places she used to visit in the past, from the elegant restaurants and stylish bars to the old clothes shops. During the day, Ibrahim wanders along the street, which has been transformed into a market for cheap clothes and is now full of fast-food outlets.

8.3. Poster for *Heliopolis* (2010).

Over the course of a day, Ibrahim's report intertwines with the stories of various original residents. One of these is Hany, a physician, who lives in the same street in a nearby residential building. Hany is offering his apartment for sale as he is emigrating to Canada, following his mother and brother. This raises the prevalent desire and decision to leave the suburb and emigrate. Other stories represent different residents from different classes. There is the lower-middle-class young woman who is working as a receptionist in the Heliopolis Hotel and is dreaming of traveling to Paris and living there. Another story is about a couple preparing for their wedding, and who can never make it to their appointment with Dr. Hany to buy his apartment due to the congested streets of Cairo. More stories express other residents' aspirations, struggles, and fears. Evidently, though dealt with differently, both films of the 2000s show a deep sense of nostalgia; they both represent Heliopolis from the eyes of an outsider searching for the bygone suburb.

The Transformation of Cinematic Space in Heliopolis

Several studies by Ruth McManus and Philip J. Ethington have shed light on the changes that occur in small urban areas on both the physical

and social levels. Utilizing films, the studies provide examples of how a peripheral suburb, once perceived with all its gardens and tall trees as a low-density zone, has changed to become a series of busy intersections following the emergence of high-rise buildings and tower blocks (McManus and Ethington 2007, 328). These studies elaborate on the "inscription of history in landscape," or the changing meaning of the fringe or suburb to a central city. Back to Heliopolis, and thirty years after *al-Wisada*, the land of dreams has much altered. Heliopolis and the way it is perceived have changed; however, its past beauty is still celebrated in *Ard*. The physical representation of the suburb is seen from the eyes of the protagonist, scanning along the façades of the original Heliopolis buildings. The film affirms the transformation of Heliopolis from a peripheral suburb to a central part of the city. As shown in this film from the 1990s, the cinematic representation involves scenes of noisy streets, full of different types of transport, highly congested with people, and newly constructed upper stories on older buildings. However, focusing on the appealing aspects of the suburb, long street shots show the arcades and the windows of al-Korba, which mark the distinctive eclectic architectural style of Heliopolis. The basilica and its surrounding gardens illustrate and celebrate the bygone beauty of the heart of the suburb. Some particular architectural elements are emphasized, such as the arcades, the balconies, and the building façades. Undeniably, *Ard* documents old Heliopolis's urban spaces, residential buildings, and means of transportation, as well as some of its service buildings and leisure spaces. The scenes visually confirm Ilbert's summary of the original plan and vision for the new oasis, Heliopolis: covering 2,500 hectares, incorporating industries, wide open green spaces, and dwellings of all types, ranging from grand villas to very small workers' dwellings. Despite the fact that Heliopolis was zoned with different types of residential buildings, such as palaces and villas, bourgeois apartments, and a quarter containing factories and workers' dwellings, that zoning did not cause a physical or psychological barrier, which was the case in some other parts of Cairo (Ilbert 1985, 37). Nargis—in *Ard*—lives in an affluent, spacious apartment in a building which appears in different scenes during the film. The actual building is in Beirut Street, typical of a type of building to be found in "garden cities" as described in *Heliopolis: Rebirth of the City of the Sun*, with its neoclassic architectural style, spacious staircase, and surrounding garden (Dobrowolski and Dobrowolska 2006, 120).

In the opening scenes of the film, Nargis visits her mother in a nursing home for the elderly. The place has a beautiful garden, and simply, yet elegantly, furnished rooms that are adequately equipped for the residents. Other scenes show a Heliopolis hospital when Raouf needs medical care. The police station is also depicted when Nargis is arrested after her attempt

to unlock parked cars in order to find Raouf's. Although a negative experience for Nargis, it appears as a well-maintained and accessible place. Le Chantilly café-restaurant-bar is shown and mentioned as the place where Raouf (and other Heliopolitans) often hang out. Le Chantilly (formerly a renowned bakery, once owned by a Swiss owner and then by Swiss Air) was one of Heliopolis' landmarks and popular with foreign residents from the suburb and its surrounding areas (Dobrowolski and Dobrowolska 2006, 184). The film also shows Nargis following her mother into the cinema to ask her about the passport. That cinema scene shows how and where the older Heliopolitans used to meet up and socialize, and recalls the spirit of the place in its heyday. Places of leisure were once integral to the culture of the bygone suburb. Such mutual interaction between the residents and their surroundings in *Ard* accentuates how the suburb maintained some of its glory and splendor till the 1990s.

In *Urban Sociology, Capitalism and Modernity*, Mike Savage and Alan Warde elaborate on how the middle class has a desire to attain a sense of security and reduce the risks associated with life in central locations, distancing themselves from danger and unwelcome interaction with other social groups when choosing to live in suburbs, since insecurity and freedom are felt in different ways depending upon a person's place in a material hierarchy in an unequal society (Savage and Warde 1993, 191–192). In *Ard*, Nargis, the upper-middle-class widow, is strongly attached to the district. The sense of belonging, warmth, and intimacy with the place where she lives is clearly shown in her hesitation about and eventual opposition to the decision to emigrate and to leave her neighbors and friends. The fact that she roams independently through the streets in her pursuit of the magician accentuates the sense of safety and security she feels around the district. Through the film, the relationship between the main protagonist and the suburb is revealed in different situations and in long monologues when she questions her life, her friendships, and the warmth she feels within the intimate suburb. Such scenes highlight her affection for and sense of belonging to all that she has been through since her marriage, despite all the transformation she has witnessed the place undergo. Even mention of the tree in front of her building, that had once been so small when she first came to live there, emphasizes her desire to retain her life in the suburb and not relinquish it for anywhere else.

Through the conversation between Nargis's son and his wife, we discover the aspirations of the younger generation. His wife accuses him of lacking ambition, like his mother, when he refuses to take a third job beside his two current jobs as a doctor in a hospital and at a private clinic, to save money to travel to America, their ultimate dream. This corresponds to Galal Amin's observation of Egyptian society in *Whatever*

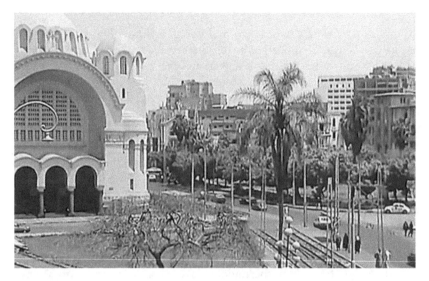

8.4. Panoramic scene of the cinematic Heliopolis in *Ard al-ahlam*.

Else Happened to the Egyptians? He points out that, by the end of World War II, a phenomenon that he terms the "American age" emerged, which was provoked by mass-media promotion of the American dream, along with the export of American culture and lifestyle as premium must-have commodities (Amin 2004).

Heliopolis of the 2000s and Beyond

Shaet provides background to the socio-cultural changes in the Heliopolis of the 2000s and explains the transformation of the suburb in the relationship between people and place. In the film, original Heliopolitans are represented by the old landlord and Nagwa's teacher (who has already left), while new Heliopolitans are represented by Yahya, the recently arrived tenant of the apartment. Both are middle-class residents. However, the film revolves around Nagwa—the outsider and the main protagonist. The cinematic representation of the suburb in *Shaet* focuses on a few exterior shots of the decaying suburb, and many interior shots of the building where Nagwa's teacher used to live. The old apartment in the film is used by the film's creators to represent Heliopolis today. Some elements in the building, such as the balcony and the elevator, are representations of the fact that all that is left of the suburb is a series of detached elements. There are only two scenes shot in Heliopolis streets. One is of the arcades of al-Korba by night, where Nagwa is assaulted by a passerby, revealing the social heterogeneity of the suburb. The other is of Yahya waiting on his motorcycle, with the noise of the streets and the sound of a radio in the

background. The scene highlights the congestion in the street and the poor-quality content of the material broadcast on the radio.

Since the film focuses more on the interior spaces than the exterior environment, Yahya's apartment stands in clear contrast, in terms of focus and importance, to the apartments in *al-Wisada* and *Ard*, and even to the landlord's in the same film. Yahya's apartment is rather plain, without any definite style or mood. The older belongings of Nagwa's teacher are piled up in one corner and covered with dust. This can be argued to be a reference to how Heliopolis of the 2000s combines both the old and the new. The old piano, belonging to the teacher, surrounded by all her letters, books, and classic furniture seems to conflict with the modern-furnished red bedroom of Yahya, highlighting the intense change in the domestic environment and the evolving lifestyles of the new Heliopolitans.

In the most recent film, *Heliopolis*, the protagonist Ibrahim is also an outsider, who tries to commemorate the remaining Heliopolitan urban sociological cues by developing a documentary of the suburb. The representation of the suburb shows the deteriorating built environment and how it has massively changed overall. Several exterior scenes display streets with workers digging up the pavements or preparing to demolish older buildings, in favor of new out-of-place constructions. Scenes of al-Korba show some closed old shops, and other shops with modern metal fronts with advertisement banners encroaching into the building above them and ruining the authentic identity of the streets. The sounds of the street and car horns can almost always be heard, immersing the viewer into the urban atmosphere and creating an intense sense of overpopulation, noise, and crowd. However, an old song constantly playing in the background heightens the ever-nostalgic longing for the suburb of bygone days. Along with the filmed narratives of the original residents on which the film focuses, several other scenes show how today's Heliopolitans live, walk, talk, play, hassle, and shop around their beloved district. There are scenes showing the blurred movement of people in front of the basilica and outside the metro, and large crowds around bakeries and shops. Throughout the film, the sense of nostalgia is the main theme, raising questions about how the previously elegant Heliopolitan society has changed, and how the uncertain future of the ageing suburb is anticipated.

The interior scenes of Vera's apartment are depicted in the film through Ibrahim's eyes. In this way, the apartment is explored, showing the old black-and-white photos of Vera and her family in different places around Heliopolis and taking the viewers back to the good old days. The scenes also show her Jewish ornaments fixed on the walls. As in *Shaet* and *al-Wisada*, the balcony as an architectural element is emphasized. The large Heliopolis balconies act as both reception and living areas—and

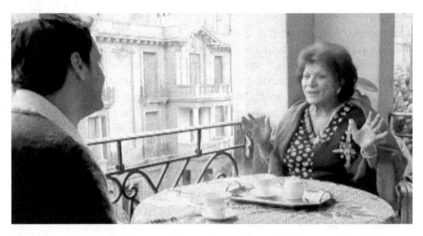

8.5. Ibrahim interviewing Vera on her balcony, chatting about the old days, in *Heliopolis*.

this is where Ibrahim and Vera talk. Another apartment is offered for sale, a spacious one with two bedrooms and two balconies in one of the original elite residential buildings with no elevator. Despite the beauty and elegance of the building and commodiousness of the apartment on offer, the potential buyer denounces the absence of a security guard. This reveals how the perception of security has changed between *Ard*, *Shaet*, and *Heliopolis*.

Even the once beautifully designed urban spaces of Heliopolis, once cherished by everyone, appear in the films of the 2000s to be rejected by the inhabitants. One piece of evidence for this is the increasing focus on the indoors more than the outdoors. More evidence comes from *Heliopolis*: the film shows two different scenes that verify this neglect. The first is when Hany goes to an old photography shop to get some new pictures for his passport, and we can see the huge deterioration in the interiors of the shop. The second scene shows Heliopolis Hotel losing its glory and splendor to a deteriorating condition.

Questionably, and despite the excessive nostalgia, the main protagonists in both films of the 2000s are outsiders. The loss of its identity is avowed by both Nagwa and Ibrahim, yet both films romanticize the suburb. In his article, "Specters of History," Peter Fritzsche discusses the changed meaning of nostalgia "as a vague, collective longing for a bygone time rather than an individual desire to return to a particular place." According to him, the meaning changed in the middle of the nineteenth century due to massive displacement caused by industrialization and urbanization (Fritzsche 2001, 1591). Consequently, and since nostalgia admires the past for its unique qualities as well as admitting the absence of these qualities today, it completes the modern experience of time (Fritzsche 2001, 1593).

154 Transformations in the Cinematic Space of a Cairo Suburb in the Late Twentieth Century

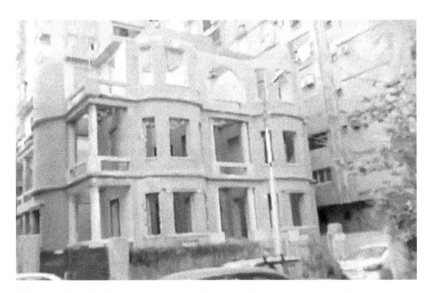

8.6. A demolished building captured by Ibrahim on his video camera in *Heliopolis*.

In *Heliopolis*, Ibrahim uses his video camera as a means of documenting the suburb while experiencing its life. On the other hand, in *Shaet*, Nagwa, in her Heliopolitan adventure, visits her teacher's apartment as if recreating her teacher's journey in searching for love and romance.

Heliopolis between the Reel and the Real

Like any other community, the suburb has its life cycle. In both the reel and the real, Heliopolis has endured major evolution over the years. The films discussed here show a chronological shift from the 1950s to the 1990s, then a dramatic change in the later films of the 2000s. Indeed, the built environment changed a lot over a span of fifty years. However, it has still been undergoing a process of alteration over the past few years. Meanwhile, despite the fact that the films are thought to exhibit a true image of the suburb, at the same time, Heliopolis is showcased in an extensively nostalgic manner. To explain this, and based on the studies by McManus and Ethington, a modified built fabric results, due to the continual types of construction which bring new suburban forms. Moreover, the changes happen in the dwellings at the hands of their residents, to either modify or upgrade them in response to the life cycle of families and generations, thus emphasizing the notion that people who grow up in certain suburbs are likely to continue to live there. Social change, which takes different forms, is affected by group succession either through changes to the social classes or by different ethnic groups moving into that particular area (McManus and Ethington 2007, 329–333).

Moreover, and according to their comparative view of suburban definitions, Harris and Larkham argue that the term "suburban" itself seems formless. Rather, they propose five dimensions that, to varying degrees, have commonly existed in different countries as a manifestation of this phenomenon. These dimensions are peripheral location in relation to a dominant urban center; a partly (or wholly) residential character; low densities, often associated with decentralized patterns of settlement and high levels of owner-occupation; a distinctive culture, or way of life; and separate community identities, often embodied in local governments (Harris and Larkham 1999, 8–14). Such traits can be argued to be highly applicable to the Heliopolis of the film *al-Wisada* in which the aspirations of the 1950s luxurious suburb of the upper middle-class and elite residents during Nasser's era are emphasized. Then, by the 1990s, the successive transformation process of the suburb is revealed on all levels; the overall urban setting as well as the architectural elements have changed, as shown in later films. Harvey claims that a capitalist city is a place of social and political confusions acting like a driving force for the conflicts of capitalism's uneven development (Harvey 1985, 250). Harvey's position may explain the rapid change that occured in Heliopolis as a suburb, because the suburb was long considered a success, attracting inhabitants who took pride in belonging to it. Heliopolis contained zones of different residential building types for different classes, without any physical or psychological barriers (Ilbert 1985, 37). But reaching the 2000s, the films showcase the few remaining original Heliopolitans in an attempt to document what is left of the suburb and its long-gone beauty under the uneven development of Cairo.

Undeniably, throughout its history, Heliopolis has well endured its urban transformation. Summarizing the different perceptions of the suburb, reel Heliopolis of 1957 was presented in black and white. Fifty years old, the relatively new suburb appeared to be luxurious and calm. In *Ard* (1993), thirty-six years later, vestiges of the original luxurious suburb are eloquently highlighted. Comfort and intimacy, and a sense of belonging and of safety are all accentuated, together with the suburb's unique architectural identity. However, the film exhibits such vestiges in a nostalgic light, seen only through the middle-aged protagonist's eyes, in contradiction to the reality of the suburb at that time. Nargis is experiencing an internal conflict between her desire to continue living in Heliopolis versus her son's aspiration to emigrate to America. Mixed feelings of reluctance, anxiety, and a deeply rooted attachment to Heliopolis are all experienced by her.

Two decades later, the films of the early 2000s show how the few existing Heliopolitans still have the same affection toward their suburb. Heliopolis in both films is showcased as mere memories of the long-gone days in the

minds of the old Heliopolitans who are still alive. Both films underscore the entire urban transformation of the area, along with the overpopulation, crowdedness, pollution, and associated socio-cultural changes.

Adopting David Harvey's position, it may be argued that, since changing the city depends upon the exercise of a collective power over the processes of urbanization, then the right to the city is collective. Therefore, it is not only the right to have access to the resources that the city offers, but there is also a right to change ourselves by changing the city more after our hearts' desires. Harvey suggests that one of the most neglected human rights is to have the freedom to make and remake ourselves and our cities (Harvey 2012, 3–4). Under capitalism, the political, economic, and social transformations of Cairo have created an urge for building new urban zones and opening new markets, which, in turn, have resulted in the deterioration of the previously founded districts (Savage and Warde 1993, 46–47). Discussing Heliopolis's urban transformation from that perspective, the argument is strong for the claim that such transformation has not been matched by a demonstration of our rights as inhabitants to make and remake ourselves and our district.

Transformations in the Cinematic Space of Late-twentieth-century Cairo

Through more than a century, the picturesque suburban oasis of Heliopolis has not only transformed and been integrated to become a mere district of Cairo after once being an exquisite oasis, but it has also undergone a severe urban deterioration that has deformed it into a repelling environment for its inhabitants. This chapter presents Heliopolis's oasis history and development from its foundation in 1905 to the early twenty-first century, using the selected films to illustrate the appearance of the suburb and the prevalent social issues and concerns of its inhabitants at those times. Following this is a chronological review of the political, economic, and socio-cultural changes experienced in Egypt in the second half of the twentieth century. An analysis of the films discussed in this chapter demonstrates the urban and socio-cultural changes experienced along the suburb's transformative journey from a garden city/ oasis in the desert to its merging with the congested districts of the metropolis. An examination of these films emphasizes the consumption and reproduction of the urban space and the changing perception of the suburb in the eyes of its inhabitants. Then, two more-recent films from the first decade of the twenty-first century affirm further reshaping of the suburban experience into an unworldly nostalgia fueled by imaginings and memories, "a blast from the past." Today, in the third decade of the twentieth-first century, the suburb is witnessing the erection of a

number of bridges planted in most of the intersections and major streets of the district, the bulldozing of the remaining green areas, and the felling of its evergreen trees. With the demolition of the few original buildings left, the district is the subject of controversial debate, not least by its infuriated and outraged inhabitants. Insulted by its transformation into a gray, congested, and repellent district, the few remaining original "Heliopolitans" still lament the loss of their garden city that was once the aspiration of upper-middle-class and elite Cairenes. On the other side of the debate, outsiders and beneficiaries view the changes as genuine urban development and a road and transportation breakthrough, envisioning the district as a mere passageway to the new urban zones of our forever expanding metropolis. This leaves me wondering: How will future films represent Heliopolis?

References

AlSayyad, N. 2006. *Cinematic Urbanism: A History of the Modern from Reel to Real.* London: Routledge.

Amin, G. 2004. *Whatever Else Happened to the Egyptians? From the Revolution to the Age of Globalization.* Cairo and New York: The American University in Cairo Press.

———. 2011. *Egypt in the Era of Hosni Mubarak.* Cairo and New York: The American University in Cairo Press.

Aoudé, I.G. 1994. "From National Bourgeois Development to 'Infitah': Egypt 1952–1992." *Arab Studies Quarterly* 16, 1: 1–23.

Dobrowolski, J., and A. Dobrowolska. 2006. *Heliopolis: Rebirth of the City of the Sun.* Cairo and New York: The American University in Cairo Press.

Fathy, S. 2018. *Ihsan Abdel Quddous, bayn al-adab wa-l-sinima.* Cairo: Sameh Fathy Publications.

Fritzsche, P. 2001. "Specters of History: On Nostalgia, Exile, and Modernity." *The American Historical Review* 106, 5: 1587–618.

Harris, R., and P.J. Larkham, eds. 1999. *Changing Suburbs: Foundation, Form and Function.* New York and London: Routledge.

Harvey, D. 1985. *Consciousness and the Urban Experience: Studies in the History and Theory of Capitalist Urbanization 1.* Baltimore: The Johns Hopkins University Press.

———. 2012. *Rebel Cities: From the Right to the City to the Urban Revolution.* London and New York: Verso, http://abahlali.org/files/Harvey_Rebel_cities.pdf

Hooglund, E. 1991. "The Society and Its Environment." In *Egypt: A Country Study*, edited by H.C. Metz, 91–154. Washington, DC: GPO for the Library of Congress.

Ilbert, R. 1985. "Heliopolis: Colonial Enterprise and Town Planning Success?" In *The Expanding Metropolis: Coping with the Urban Growth of Cairo*, edited by A. Evin, 36–42. Singapore: Concept Media/Aga Khan Award for Architecture.

El Kadi, G. 2012. *Le Caire. Centre en mouvement: Cairo. Centre in movement. (Petit atlas urbain)* (Multilingual Edition). Paris: IRD Editions, Institut de recherche pour le développement.

McManus, R., and P.J. Ethington. 2007. "Suburbs in Transition: New Approaches to Suburban History." *Urban History* 34, 2: 317–37.

Muzzio, D., and T. Halper. 2002. "Pleasantville?: The Suburb and Its Representation in American Movies." *Urban Affairs Review* 37: 543–74.

Savage, M., and A. Warde. 1993. *Urban Sociology, Capitalism and Modernity*. Basingstoke and London: The Macmillan Press Ltd.

Waterbury, J. 1985. "The 'Soft State' and the Open Door: Egypt's Experience with Economic Liberalization, 1974–1984." *Comparative Politics* 18, 1: 65–83.

Whitehand, J.W.R. 1994. "Development cycles and urban landscapes." *Geography* 79, 1: 3–17.

9

From *Hara* to *'Imara*: Social Transformations in Cinematic Cairo

Mirette Aziz

That street . . . the source of art . . . and the cradle of genius. . . . From it . . . artists have risen up . . . climbed the ladder of glory between its flanks. . . . There are still artists patiently awaiting their turn. . . . And it's been too long for them. . . . Falling stars came back to settle in the forgetfulness corner. . . . To all those . . . we present this rosy and laughing image. . . . (Opening statement in the film *Shari' al-hubb*)

It was Sunday. The stores on Suleiman Pasha street closed their doors, and the bars and cinemas were full of customers. With its locked stores and old-fashioned, European-style buildings, the street seemed dark and empty, as though it were in a sad, romantic, European film. (Al Aswany 2002, 7)

These two epigraphs capture the nature of Downtown Cairo during the 1950s and early 2000s, successively. The first is the text that appears on screen at the beginning of the film *Shari' al-hubb (Love Street)* (1958) as a dedication to Muhammad 'Ali Street, founded in the second half of the nineteenth century during the reign of Isma'il Pasha, commemorating his grandfather, the founder of modern Egypt, and linking the historic city to the modern one. The street design resembles the arcaded streets of many European cities. *Shari' al-hubb* is a musical comedy produced in 1958, and the epigraph captures the spirit of Muhammad 'Ali Street where the action takes place. The second epigraph is written by Alaa Al Aswany in his most popular novel, *The Yacoubian Building*, published in 2002. The building itself was actually built in the 1930s by an Armenian-Egyptian merchant in Downtown Cairo to be home to elite and culturally diverse metropolitans during the Egyptian monarchy. The novel was adapted in 2006 into a popular film *'Imarat Ya'qubyan ('imara* in the colloquial Egyptian Arabic

dialect means "apartment building"). The epigraph describes life in the prominent Suleiman Pasha Street (currently Tal'at Harb) in Downtown Cairo, where the Yacoubian Building is located.

This chapter borrows part of its title from Samia Mehrez's chapter "From the Hara to the Imara: Emerging Urban Metaphors in the Literary Production of Contemporary Cairo," published in a popular book a decade ago (Mehrez 2011, 145–70). It tracks social transformation in Egypt and reveals the cultural changes in modern Cairo. Notions of homogeneity and social solidarity versus heterogeneity and rivalry are discussed. Using the two films—half a century apart—I will further explore the social class gap as portrayed in cinematic Cairo. In his book *Whatever Happened to the Egyptians?*, Galal Amin states that the rate of social mobility in Egypt in the second half of the twentieth century was faster than ever experienced before. He argues that the Egyptian cultural paradigm has drastically changed and, accordingly, many of the traditional values of the Egyptians—as well as many other behavioral changes that occurred in Egypt—are results of this social transformation. Amin also argues that the economic and social crisis in Egypt has been a result of the change in the social structure which, in turn, accelerated the rate of social mobility during the last three decades of the twentieth century. He affirms that Egyptians' lifestyles changed over this span of time and, consequently, negatively affected numerous aspects of life that have long identified Egyptian culture (Amin 2000, 4–10).

Reflecting on the work of Sorokin (1959), Amin gives examples of how the lower classes tend to copy behaviors of the higher classes during times of stable social structure. However, he adds that during periods of rapid social mobility the opposite seems to happen, when the declining upper-middle classes are inclined to adopt many of the values associated with the rising lower classes. This is paralleled with a decline of upper-class influence on society (Amin 2000).

In order to explore the transformations from the *hara* to the *'imara* in cinematic Cairo, the two films *Shari' al-hubb* and *'Imarat Ya'qubyan* are chosen as clear representations of the social transformation that took place in the fifty years that separate their production. Actually, Muhammad 'Ali Street is not only depicted in *Shari' al-hubb* as the street of art, but also as a self-contained *hara*, which will be explained later in this chapter. Thus, a street may not be literally named a *hara*, but yet it can represent the Cairene social norms of the *hara*, which is the case in *Shari' al-hubb*. (In Arabic, the term *hara* means a residential quarter but it literally means "alley" in colloquial Egyptian Arabic. However it carries with it, in Cairo in particular, a much deeper meaning of an insular social community located in a specific physical area.) In the same area, Downtown Cairo, *'Imarat Ya'qubyan* was filmed. The social and economic transformations that took place

in Egypt in the later twentieth century—social mobility, as well as many behavioral changes that took over Cairo—are all represented cinematically in *'Imarat Ya'qubyan*, mainly all in one single building through the different stories of its residents. That is why we can say that *'Imarat Ya'qubyan* provides a perfect and vibrant overview of those transformations that had occurred over the previous fifty years.

Shari' al-hubb (Love Street)

The film *Shari' al-hubb* was written by Youssef AlSiba'ei and directed by 'Ezz ElDin Dhulfuqar in 1958. It stars 'Abdel Halim Hafez as 'Abd al-Mun'im (later referred to as Mun'im) and Sabah as Karima. It is the story of the young amateur singer Mun'im, who comes to Cairo and arrives at Muhammad 'Ali Street seeking shelter and work after the death of his father. Here he is helped by his father's friend Mokhtar Saleh (played by Hussein Riad), who is a music conductor. This man treats Mun'im like a son, teaches him music, and becomes the reason why he then joins the amateur vocal troupe. This allows Mun'im to become a member of this *hara* community, which is constituted mainly of aspiring musicians who live like a close-knit family. With their sacrifices, Mun'im manages to study music professionally.

Aside from Mun'im, the protagonist around whom the story revolves, there are other main characters, including Karima, that contribute to the sequence of the story. Saneya Terter (played by Zeinat Sidqy) is the owner of the *dokkan* (shop) and the building in which all the musical band members live and work. Terter longs to marry Hassab Allah (played by 'Abd El Salam El Nabulsi), the leader of the musical band the story is about. After Mun'im has come to live in Muhammad 'Ali Street, Terter decides to take him under her wing and does her best to help him reach his dreams. The third main character is Mun'im's father's friend Mokhtar Saleh, who is living under cover having escaped the charge of killing his wife. He is disguised as a poor musician who can play a few notes using his oud, and calls himself Gadolio. Mokhtar decides to adopt Mun'im after his father's death with the promise that Mun'im will never reveal Mokhtar's real identity.

After Mun'im gets his degree, the community decides to find him a better job than singing at weddings. A good opportunity arises as a music teacher in a high-class social club, under the condition that he disguise himself as an old man. It is then that he first encounters the higher classes, a totally different world of elite people with their modern perspectives, customs, and manners. He then works as a private instructor to Karima, the daughter of one of two rival families. He falls in love with her to later discover that she has only shown him affection as part of a conspiracy: she has bet her competitor, Mervat, that she can convince him to shave his

Shari' al-hubb (Love Street) 163

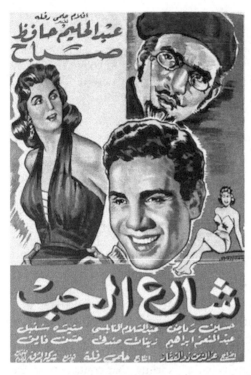

9.1. Poster for *Shari' al-hubb (Love Street)* (1958).

beard and mustache, which are part of his old man disguise. Singing at Karima's birthday party, he is heard by a guest who promises to help him perform in the opera. On the day planned for this, Mervat plants drugs on the conductor to prevent him from attending. At this point, Mokhtar comes forward and risks revealing his true identity as a conductor by leading the orchestra. The film ends happily with Mun'im and Karima deciding to get married and living happily ever after.

'Imarat Ya'qubyan (The Yacoubian Building)

The film *'Imarat Ya'qubyan* was produced in 2006. It is written by the novelist Alaa Al Aswany, directed by Marwan Hamed, and stars 'Adel Imam as Zaki Pasha. It is filmed in Downtown's most central square, in a building similar to the real one nearby, which is still quite densely inhabited, possibly making it rather difficult to film in the original location. The film tells the story of an old apartment building located in Downtown Cairo, built by one of the elite Jews in the first half of the twentieth century. The apartment building, like most of the Cairo Downtown area, used to be inhabited by foreigners and elite residents. As time passed by and with the many social changes following the 1952 Revolution, the original inhabitants were replaced by a heterogeneous mixture of residents. Internal migration

to Cairo, as well as uncontrolled overpopulation in the city, have led to the full occupation of the building. Even the service amenities on the roof are rented to families. The film starts with a panoramic view of the prominent residents of the building. Their stories show how the building adapted to a different class of occupants in this stage of a later modernity. As the narrator tells us at the beginning, this old building has a unique European design and the name of its owner is still written in Latin over the entrance. However, now it has small rooms on the rooftop for the doorkeeper's family—which was not the case in the 1930s; the original inhabitants of the building were aristocrats who never used the roof for their servants. After the 1952 Revolution, many inhabitants left and officers of the armed services became the new owners of some of the apartments. Only then were the small rooms on the rooftop turned into accommodation for servants, upon the wish of the officers' wives. These servants started raising domestic animals on the roof. The narrator here reflects on the change in the social structure in the building, which is a microcosm of the actual changes that occurred in Egyptian society at that time. "By the 1960s, half of the apartments' owners were officers. In the 1970s, the upper classes living in the Yacoubian Building started moving to Mohandessin and Madinat Nasr, while some other officers used their apartments as startup offices or clinics for their fresh graduate sons, and others rented them out to other people. Consequently, more migrants from the countryside came to live on the rooftop since Downtown Cairo has become a relatively cheap place for living" (Al Aswany, 2002, 17).

The film does not focus on one protagonist; however, I will highlight only four main characters here. The first of these is Taha, the young secondary-school student who has just finished his *thanweya 'amma* (high school graduation) and dreams of joining the Police Academy, but is rejected at the interview on account of his father's profession as a doorkeeper (*bawwab* in Arabic). Joining the university, Taha gets involved with a fanatic religious group. He gets arrested and is even raped in jail. Coming out of jail, he avenges his misery by murdering the officer. The second main character is Dawlat al-Dessuki (played by Esaad Younis), sister of Zaki Pasha and the daughter of an aristocratic family, who lives with her brother in an apartment in Downtown Cairo near the Yacoubian Building. The third is Zaki Pasha al-Dessuki, a very charismatic elderly gentleman who received his Bachelor of Petroleum Engineering in France and who runs his own business, an engineering office, in the Yacoubian Building, in an apartment that he has bought from one of the officers who moved out in the 1960s. We are also introduced to his conflict with his sister, Dawlat, over the ownership of the apartment they live in. The last character is Buthaina (played by Hend Sabry), the young daughter of a poor family living on the rooftop of

'Imarat Ya'qubyan (The Yacoubian Building) 165

the Yacoubian Building. Buthaina decides to give up her high school education to get a job and support her family. She is engaged to Taha and they share their ambition for a better life. However, the couple breaks up as Taha starts to develop interest in the religious movement at his university. She is recruited by another rooftop resident to seduce Zaki Pasha and joins in a conspiracy to make him sign a contract to sell his apartment. However, having fallen in love with him for his kind heart, the film ends up with Buthaina marrying Zaki Pasha. From its opening scene, the film focuses on the transformation of the demographics of the Yacoubian Building residents, as if giving a panoramic view of the actual demographic transformation of Cairo in the second half of the twentieth century, and, accordingly, its effect on the reshaping of the urban landscape as well.

While the formal and informal communities are happily united as represented by the marriage of Zaki Pasha and Buthaina, the other stories, especially that of Taha, end unhappily. Taha plans to take his revenge and kill the police officer responsible for his rape and torment in jail; consequently a street battle erupts between the officer's security guard and a group of Taha's fanatical colleagues. The battle ends with both Taha and the police officer dead, lying next to each other on the ground, in a pool of blood.

9.2. Poster for ʻImarat Yaʻqubyan (The Yacoubian Building) (2006).

Hara and ʿImara as Cinematic Spaces

In "From Hara to Imara," Samia Mehrez argues that literary works that include scenes set in Cairo reconstruct and remap the city (Mehrez 2011). To validate her argument, she gives examples of some novels that were adapted into films and/or TV series. She focuses on Naguib Mahfouz's use of the *hara* (alley). According to Mehrez, Mahfouz—the literary architect and the writer of the city himself—draws new boundaries of Cairo along with the economic and social changes taking place there. Mehrez argues that the city becomes a text that is constantly rewritten (Mehrez 2011). Another scenario is also arguable; that films, too, have an influence on the physical city. In *Cinematic Urbanism*, Nezar AlSayyad argues that urban environments and their image in film are mutually constitutive. Accordingly, cinematic techniques and representations reveal urban conditions through time, where the actual city and the reel city simultaneously reference and represent each other (AlSayyad 2006, 1–15). Therefore, cinematic representation becomes also the architect of the cinematic space. "Mahfouz's novels provide a dense commentary on Cairo as it navigated the twentieth century, presented through the life and times of the three generations of the ʿAbdel-Jawād family" (AlSayyad 2011, xiv). AlSayyad explains how the novel was able to document the social changes occurring in Egypt in the twentieth century, and since Mahfouz's *Trilogy* stories took place in a *hara*, the *hara* as represented in novels is thus an important and integral part of Egyptian society.

As changes occur economically and socially in Egypt, and as urban spaces expand, scholars start to map out its new boundaries (Mehrez 2011). Mehrez quotes André Raymond's work about the physical expansion of Cairo beyond its original historic core and its modern colonial extensions, specifically after the 1960's, where Raymond speaks about Cairo's expansion forming a fragmented city that hinders the formation of a complete image of the city (Raymond 2001, quoted in Mehrez 2011, 146). Mehrez suggests that Sadat's economic Open Door policies of the 1970s and rural migration have resulted in urban problems and class inequalities, in addition to the appearance of skyscrapers and fancy commercial centers right beside informal settlements and shantytowns. Hence a new urban affiliation emerged. Cairo has actually undergone major transformation and this has been represented in many literary works where also the historic role of the *hara* has faded away. Mehrez writes, "Gradually, the historic 'Hara', which dominated the representation not only of Cairo but also of Egypt in general, faded out and was replaced by new metaphors that are more representative of the new realities of both the city and the country at large" (Mehrez 2011, 147).

In *Shariʿ*, the "real" Muhammad ʿAli Street represents Love Street, which is a major thoroughfare. But the "reel" Muhammad ʿAli Street is

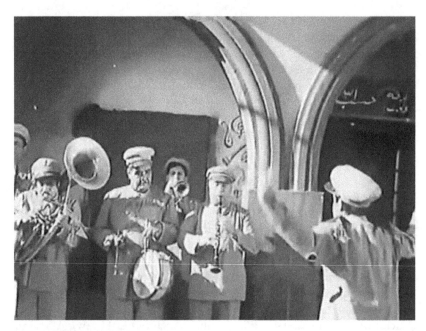

9.3. Hassab Allah's band playing the march to see Mun'im off in front of the *dokkan* (*Shari' al-hubb*).

actually a tightly knit *hara*, an extremely self-contained space where people are mutually affected by each others' lives and conditions—in addition to the solidarity and communal bond connecting them. Some may leave the *hara*, but they cannot help coming back, just as Mun'im leaves for his education but returns right after he gets his degree. That is why, when Mun'im needs support, he goes back to his *hara*, and, even at the end, when he realizes his dream outside of the *hara*, he is still surrounded by his "family" there.

The details of every element of the life of the *hara* are clearly seen in the "Abu 'Youn Gari'a" clip. Terter looks out for the car carrying Mun'im back to the *hara* so as to inform Hassab Allah, who is standing beneath her balcony, of the approach so he can then signal to the band to play the welcome march. People in Hassab Allah's shop, from his music band, are joined by street vendors and girls on the balconies in their wait, and when Mun'im arrives, the march starts playing as Mun'im sings. A minute later, every person in the *hara* is involved in the song, dancing and cheering.

Mehrez, in explaining the *hara* from Mahfouz's novels, notes

> Mahfouz's Hārā is predominantly depicted as a self-contained world: it has been there since the beginning of time; only "God and the archaeologists" can date its history. The Hārā's residents seem

to be as old as the alley itself. Their lives, fortunes, and misfortunes have all been shaped by their presence within it. True, they venture out into what the narrator describes as the "surrounding activity" of other neighborhoods like Ghureya, Hilmeya, and 'Abbaseya, but they all return to the Hara at the end of the day (Mehrez 2011, 151–52).

The people of the *hara*, as the film portrays them, must find their way back. The scenes with the *mashrabiya*, the coffeehouse, the balcony, and the arcades all show the *hara* as a horizontal community.

In her book *Changing Consumer Cultures of Modern Egypt*, Mona Abaza notes the "dichotomies between the modern western downtown grid of the Khedival Cairo and the Islamic Cairo" that Janet Abu-Lughod highlights in her *Tale of Two Cities* (Abu-Lughod 1965, 429–57, quoted in Abaza 2006, 38). She argues that we have now a dual city which was once Islamic and then Westernized. Janet Abu-Lughod also traces the history of the Westernized Cairo of the nineteenth century's second half in her book *Cairo: 1001 Years of the City Victorious* (Abu-Lughod 1971, quoted in Abaza 2006, 39). Abaza explains that

> The native pre-industrial city was juxtaposed to the colonial city; the architecture, life style related to the Harat (plural) and *durūb* [narrow alleys], was left aside and *rond-point, maydans*, and grid-iron street patterns were adopted. The contrast between the two 'symbiotic communities' of Egyptians and foreigners was sharpened. Cairo's history during the second half of the nineteenth century as Abu-Lughod notes became the history of the new Western city. (Abaza)

Abaza concludes that Downtown Cairo, occupied by foreigners in colonial times, is now populated by different people that vary more in the morning than at night, creating a flamboyant heterogeneous mix (Abaza 2006, 40). From the old urban fabric through the colonial conditions to the new conditions, not only did the urban fabric differ, but also some real transformation took place. Those mixed cultures that Abaza mentions can be found in the *'imara* of Downtown, all gathered in one building, though with different behaviors and lifestyles. The first scene in *'Imarat* narrates such a history. Though represented here in the film as the history of the *'imara*, it can be viewed as telling the story of the whole of Downtown.

Whereas the *hara* represents the well-ordered urban fabric of the old city, the *'imara* has come to embody the contradictions of the global face of the mega-metropolis. *'Imara* as a one-unit urban element captures the fragmented city with its chaos and deconstructed social relations (that were self-contained in the *hara*) (Mehrez 2011). *'Imarat* tells the story of

Hara and 'Imara as Cinematic Spaces 169

the transformation of society that took place in the fifty years following the 1952 Revolution, in addition to revealing much about the inequalities that emerged in the two neoliberal decades before the novel was published. Thus, *'Imarat* can be a lens through which we can trace the transformations of the city during the fifty years separating the two films examined in this chapter. Built in the 1930s, the Yacoubian Building used to host pashas and elites. Those have been replaced several times over the years in correspondence with the changes in the social pyramid in Egypt. Pashas and foreigners were replaced by military personnel in the late 1950s, who were then replaced by the nouveaux riches returning from the Gulf countries in the 1970s, who again have been replaced at the turn of the century by internal migrants, the lower-middle class, and informal laborers. In *'Imarat*, the building is filmed seventy years after its construction; its roof has become home for many poor families of very different backgrounds, who rent the roof amenities that were originally used for storage and then for servants and security guards. The families are packed into what look like *'ishash* (henhouses), as described at the beginning of the film.

Cairo between the 1950s and the Early 2000s

In his book *Whatever Happened to the Egyptians?*, Galal Amin asserts that after the 1952 Revolution the rate of social mobility increased and accelerated, even more so after the initiation of Sadat's Open Door policies *(Infitah)* during the 1970s (Amin 2000). This has led to the appearance of some socio-urban phenomena. Amin argues that many individual behavioral aspects are revealed by desires and the rate of social mobility. On the social side, corruption and disrespect for the law started to prevail. Moreover, people's sense of belonging and loyalty to their motherland declined. On the intellectual side, religious fanaticism started to appear and is mentioned under the umbrella term "low culture." Meanwhile, the quality of life in the city declined under the burden of overpopulation together with the increase of air pollution, overcrowding, noise, and ugliness. Higher aspirations among the middle and lower classes were attributed to the policies in Egypt following the 1952 Revolution. Consequently, a huge difference in the social structure took place where the role of the middle class became maximized while that of the aristocratic one was minimized at almost the same rate (Amin 2000, 7–30).

Nasser's period marked Egypt's high industrialization attempts. Rapid urbanization resulted in large increases in internal migration, especially to Cairo, during this period. This caused a parallel expansion of Cairo's buildings vertically and horizontally. Therefore, this period can be considered as the starting point for the change and transformation of Cairo into a very different city that carried with it the problems of industrialization.

According to Amin, these changes have caused a shift in the mindset of the people as well as the city. Louis Worth asserts that the characteristics of life in the city are made up of a set of traits (Wirth 1938). He defines urbanism as a set of traits that outline the characteristics of city life. Therefore, it is possible to say that Nasserite Cairo presented the centralized industrial city that is formed by the new aspiring mindset of the people. The 1952 Revolution and its aftermath during the 1950s and 1960s witnessed both centralization and nationalization. Then came the wars of 1967 and 1973 followed by the Open Door policy, starting in 1974, where centralization was replaced by the new economic policies. The latter phase is argued by many to have been the actual beginning of the urban decline. With the privatization of the 1980s and 1990s and the influence of globalization at the turn of the millennium, Cairo's new urban and architectural form started to reach its peak, especially after the January 2011 Revolution, when the city got totally out of control in terms of the level of informal takeover of its formal structures. The Cairene urban status could at that time be described as spontaneous, improvised, or ad-hoc. As a result, an unexpected loss of control occurred in total population numbers as well as a breakdown in social classification. This deficiency is accompanied by a large and speedy construction movement all over Cairo, like nowhere else in the world (Safey Eldeen 2013, 917–25).

Sadat's presidency in the 1970s introduced new policies named Open Door, or *Infitah*, which was a set of neoliberalization policies. Nezar AlSayyad suggests in *Cairo: Histories of a City* that Sadat put an end to Nasser's "pan-Arabism" regime and centralized economy. AlSayyad also explains that Cairo became a venue for the restructuring of free-market and private initiatives, and that some of the measures that came with Sadat's economic policy were specifically focused on transforming Cairo. These measures included the dismantling of many public-sector institutions and the state's withdrawal from the construction of public projects, particularly housing. Thus, the government could not manage housing needs, and new towns were planned and constructed by the private sector in the suburbs of Cairo (AlSayyad 2011, 255–280).

Accompanying the political and economic upheavals following the 1952 Revolution and its associated nationalization and centralization processes, plus a series of wars from 1967 to 1973, was social turmoil. Then, in 1974, came the Open Door policies, associated with a lot of political, economic, and social chaos. Several factors have led to a deterioration of the authentic Egyptian traditional identity(ies). Some of these are growth and overdensification, disbelief and mistrust in the government, the appearance of the nouveau riche social sector created by the wealth gained in the oil-rich Gulf countries, and, finally, the influence of the hybrid images brought

into Egyptian houses through television and other media. More economic shifts between the 1980s and the turn of the millennium augmented the formation of hybrid images, also prevalent within commerce and business. The influence permitted to such projects reflects the current societal search for identity, with an eye on the "global icon." A cultural crisis can be broken down into the following phenomena: a weak sense of belonging; the reign of uncultured capital; a tendency to follow the "Western" other; uncontrolled and unplanned growth of population and of the building industry; over-centralization in Cairo; an idle economy; inflation; immigration from rural areas to the large cities; a lack of aesthetics and beauty as values; and an overall deterioration of the entire educational system (Safey Eldeen 2013).

As Sarah Ben Néfissa mentions, the 1970s and 1980s witnessed heavy urbanization in addition to the redistribution of population into the out-skirts. She adds that real estate investors built new gated communities on the outskirts for the richest Cairenes, while the less privileged were left to choose informal settlements, and the working classes to choose the edges of the city or houses built on farmland, or apartments on state-owned land. In order to reach social calm and to house the expanding population, Ben Néfissa argues, the state tolerated these forms of informal urbanization. She adds that these informal settlements are represented by the Yacoubian Building's rooftop, where the structures were not designed to accommo-date a whole community of underprivileged individuals.

Ben Néfissa also remarks that in the late 1980s, the central government ended its tolerance of the expansion of these spontaneous working-class settlements, and, in the middle of 1990s, central government and the munic-ipalities aimed to renovate the deteriorated buildings in the center of Cairo, and so started relocating large populations (with promises to provide public services in the new locations). Despite these political efforts, the demographic pressure still overwhelmed Cairo's margins and center (Ben Néfissa 2011).

These half-century transformations are represented cinematically in *'Imarat* as well as being narrated at the beginning of the film. The rapid rate of social mobility has resulted in multiple transformations in the Yacoubian Building, where not only has the aristocratic class almost disappeared, but also aspiring lower classes have taken over the *'imara*. Migration to Cairo, that resulted in the centralization of the city, is also represented in the film, where inhabitants of the *'imara* are migrants, along with others of the lower-middle class, have replaced the aristocracy, represented by Zaki Pasha. Urbanism and the uncontrolled growth of population are repre-sented in the rooftop of the Yacoubian Building which, as Ben Néfissa has pointed out, can be said to represernt informal urban expansion. Not only does *'Imarat* represent class conflict (inside the *'imara* itself), but also other characters and storylines introduced in the film represent issues such as

corruption and socially tolerated informal agreements, as well as the struggle for money and mobility that dominates the majority of the narratives (for example, the conflict between Dawlat and Zaki over their apartment and Buthaina's attempts to earn a living to support her family).

The Utopian Aspirations of the *Hara* versus the Dystopian Reality of the *'Imara*

In *Shari'*, aspiration is represented not only in the protagonist Mun'im's ambitions, but also in the aspirations of all the *hara*'s inhabitants for modernity and a better life. Mun'im's dream becomes the focus of his people, for which they make sacrifices in terms of their money, their work, and their willingness to endure the harsh conditions of their lives until Mun'im finds his way to success. Three scenes in the film are chosen for analysis in this chapter, as they clearly tackle this theme. All three of these scenes take place in the plaza in front of the *dokkan* where the band conducts its meetings. The first scene is at the very beginning of the movie when Hassab Allah, standing at the building entrance, is praying to God to send them food and Saneya Terter (the owner of the *dokkan*) pours *mulukhiyah* (green soup) onto his head from her balcony. The second scene is when the people of the *hara* bid Mun'im farewell as he leaves to pursue his academic career; they assemble all as one big family who willingly sacrifice all they can afford for his yet unknown future. The third and most expressive scene is the return of Mun'im after he has received his degree. As described previously, in this scene, the *hara* appears as both an autonomous and cohesive urban setting and a homogenous, consolidated community. It is as if here the *hara* people's aspirations are compressed withinin Mun'im's ambitions for progress and modernity. While he himself has not yet achieved any real success or fame, he is doing his best for the sake of his people, who put their trust in him and tirelessly encourage and motivate his progress. Mun'im personifies the *hara*'s aspiration for modernity; his success in singing is an achievement for each and every member of the *hara*'s one big family. The utopian aspiration to modernity in the *hara* is crowned with success at the end.

In contrast, aspiration in *'Imarat* is met with scorn and disappointment and turns into a dystopian reality. Represented by Taha's youthful dream of joining the Police Academy and marrying Buthaina in the *'imara*, such aspiration is never realized. When comparing Taha and Mun'im, it is clear that both are the young generation of their time, both are ambitious (although Mun'im develops his ambitions only after he starts singing as part of the *hara*'s big family), and both aspire to a better life and future. While the utopian aspiration of Mun'im and his *hara* family actually turns into reality, Taha's aspiration in *'Imarat* not only vanishes into thin air, but also turns into a nightmare. Taha breaks up with his fiancée, Buthaina,

9.4. The *hara*'s residents bid farewell to Mun'im as he leaves to pursue his career *(Shari' al-hubb)*.

after being rejected by the Police Academy and joins a group of religious fundamentalists at the university. Taha gets more and more attached to the group, spends more time with them, offers his services to them, and finally gets arrested and is tortured and raped in jail. Finally, as mentioned previously, his nightmare comes to an end with the murder of the police officer responsible for his treatment in jail and his own death.

When defining modernity and modernism, David Harvey quotes Marshall Berman's definition: "To be modern means to find ourselves in an environment that promises adventure, power, joy, growth, transformation of ourselves and the world." Berman defines modernity as being part of the universe, letting go of things we know or have, and letting things that are solid melt into air (Berman 1988, 15, quoted in Harvey 1990, 11). Harvey focuses on the combination of ephemerality and eternality. He mentions that Berman explores writers' works dealing with the sense of fragmentation, ephemerality, and chaotic change as characteristics of the conditions of modernity. Berman describes modernity as a body of experience that unites all mankind, resulting in a maelstrom of disintegrations. He suggests that such a maelstrom makes some people feel nostalgic and consider their premodern life as "Paradise Lost," as they come to consider their experience of modernity a threat to their traditions and history. Berman then adds that, specifically in the twentieth century, the idea of modernity

when conceived in fragmentations (multitudes of fragments resulting from the expansion of modernization and the developing culture of modernism) results in a modern age whose roots that connect it with modernity are cut (Berman 1988). Hence, Harvey suggests that "most 'modern' writers have recognized that the only secure thing about modernity is its insecurity, its penchant, even, for 'totalizing chaos'" (Harvey 1990, 11). He then argues that modernity can have no respect for its own past as it strongly breaks with previous historical conditions and is characterized by a continuous process of internal fragmentations with itself (Harvey 1990).

In *Shari'*, we can see the promising environment that surrounds Mun'im in his *hara*. He finds courage for his adventure by the empowerment he receives from the people of the *hara*. Moreover, the transformation of the character, as seen in his lifestyle, clothes, and type of work, as well as his mindset, occurs when he starts working for the upper-class community. The people's aspiration for modernity is all poured into Mun'im's departure from the *hara* to the world outside. To them, this is the fulfillment of their aspirations to become part of the universe. For the sake of this, Mun'im lets go of his true identity and his real appearance and is disguised as an old music conductor. Mun'im dissolves his solid connection to his humble origin into air to realize his own and his people's aspiration for modernity.

Similarly fifty years later, the ambitious young man Taha, the son of the doorkeeper in the Yacoubian Building, does his best to join the Police Academy despite his awareness of the improbability of someone from his class being admitted there. Two scenes show how Taha is willing to survive his miserable situation in the city and how his ambition is perceived by others. The first takes place while he is cleaning the stairs, only to be scolded by some angry residents annoyed by the wet steps. The residents ask Taha about his dream college after he finishes high school; astonished by Taha's

9.5. Taha cleaning the staircase at midnight (*'Imarat Ya'qubyan*).

ambition to join the Police Academy, one of the men gazes at Taha scornfully and harshly demands a dry passage to their apartments. The second is on the roof where his fiancée Buthaina is praying to God that Taha passes the Police Academy test and gets admitted there. On the staircase of the building, each floor manages to put Taha down and progressively kill his dreams and ambitions, until he is actually rejected because of his father's occupation. Several other scenes in the film affirm similar situations of a descent into unhappiness and hopelessness, not only for Taha and Buthaina, but also for other protagonists in the film, such as between Dawlat and her brother, and are also filmed on the building's staircase.

The two films reveal the change in the social norms of Cairenes over half a century. The *hara* symbolizes the collective hopes of modern times while the *'imara* becomes a trope of urban postmodernity. The *hara* community is united by Mun'im's dream and pushes him to succeed in a utopian fantasy, while the *'imara*'s community throws Taha, Buthaina, and Zaki Pasha into despair. They give up on their dreams and ambitions, accept the awful degradation of their status, and thus reveal the miserable dystopian reality of today's Cairo.

David Harvey suggests that experience of space and time affects aesthetic and cultural practices, forming the nexus between "Being and Becoming." He claims that strong aesthetic movements follow crises of overaccumulation in the postmodern times (Harvey 1990). Accordingly, the concern for aesthetic, social acceptance has conquered that for ethics. The Yacoubian building represents this issue, where this *'imara* known for its European architecture conceals the transformed and deteriorated social relationships within. This becomes clearer in the scene where Dawlat expels her brother from the apartment. Moreover, the film reveals other behaviors that only take place inside the *'imara*'s apartments and on its roof, while outside of the building, where the concern of the residents is to keep up their image as residents of a cosmopolitan area, nobody admits to their behaviors inside.

In *'Imarat*, Zaki Pasha's argument with his sister results in her throwing him out of the apartment. He finds no place to stay but his office in the Yacoubian Building. Zaki Pasha becomes totally drunk and can only walk to his office with the help of Buthaina. The scene is filmed with views of the street in the background. The drunken Zaki Pasha seems to be pitying and commiserating with the city for its current condition. The director chooses to pan the camera, showcasing the historical buildings in the square while Zaki Pasha is in the foreground lamenting the degradation of the city. His words sound like a public speech, though with the buildings as his only audience. He ends with the most iconic quote of the film: "These buildings have turned into dumps on the rooftops and into monstrosities downward; we live in an era of abomination." He crosses the street

9.6. Zaki Pasha and Buthaina at the entrance of the Yacoubian Building (*'Imarat Ya'qubyan*).

with difficulty, with the help of Buthaina, and then stops in front of the Yacoubian Building and in a way recalls his memories in the place. It is as if Zaki Pasha, here, is representing the nostalgic feelings for the paradise lost that Berman writes about when he compares the past city with the present time's ugly reality. The scene shows us the entrance of the building where the ground floor has been deformed and transformed into a store with hanging colored banners on the front. This also represents the self-destruction of the historical building as a direct result of the socio-economic and behavioral transformation recounted by Zaki Pasha earlier in the scene. It also represents the insecurity of the *'imara*'s modernity, where its past is fading away and its modernity pays no respect to its history.

A Concluding Note: A Split History of the City?

> The city is not a framework but a social practice in constant flux. The more it becomes an issue, the more it is a source of contradictions and the more its social manipulation is linked to the ensemble of social and political conflicts." (Castells 1972, 93)

In "Urbanism as a Way of Life," Wirth mentions that urbanization results in the loss of tradition and argues that certain urban characteristics have emerged, setting a new way of life in the city (Wirth 1938). We can see this transformation from the *hara* to the *'imara* in Cairo. The *hara* represented Cairo of the mid-twentieth century, before and after the 1952 Revolution, and the lower-middle-class aspiration for upward social mobility. With the rapid urbanization and unstoppable social transformation that followed, the *'imara* became the symbol of the loss of traditions and identity. Wirth also mentions that the interaction among larger numbers of people resulted in lower communication levels. The *'imara* combined many diverse groups; thus the communication between them

was at its lowest. From a retrospective point of view, in *Cinematic Urbanism*, AlSayyad uses the model of the small town as the representative of tradition; the equivalent to this in the Egyptian case is the *hara* (AlSayyad 2006). The *hara* in the film *Shari'* displays the same aspects and values of the small town as described by AlSayyad, particularly in the form of the social solidarity displayed by the residents of Muhammad 'Ali Street.

It is evident that the continuous social flux in contemporary Cairo has made it a perfect example of urban change. The struggle between politics, history, and place since the 1950s has resulted in erasures and demolitions of past urban identities, and the city with all of its intensity seems to have developed a self-destructive character. The two films depicting the transformation of the *hara* to the *'imara* are only two examples from the canon of cinematic Cairo that have relevance to our understanding of the real Cairo. Urban identities come from somewhere and have their histories. However, like everything human, they undergo constant transformation.

Reflecting on the earlier quote from Manuel Castells, throughout this chapter both the *hara* and *'imara* are cinematically dealt with as urban spaces that represent the social transformations of Cairo over the second half of the twentieth century. Hence, an important and busy street is still cinematically represented as a *hara* although it may not physically be the case in reality. This is meant to show that both the *hara* and, to a lesser extent, the *'imara* still represent many of the traditional values of Egyptian society. Mehrez was right to identify and trace the disappearance of the *hara*, and to suggest that it was replaced by the *'imara*.

The analysis of the two films illustrates the change in cultural meanings and values that are reflected in Cairo's current urbanism, and highlights the contrast between the utopian aspiration of the *hara* and the dystopian reality of the *'imara*. Aspirations to modernity in the *hara* of *Shari' al-hubb* require at the very least a departure from it, while the condition of the *'imara* in *'Imarat Ya'qubyan*, whose modernity is long gone, demonstrates a quite fragmented city. As such, the building is presented to us as a microcosm of the whole city with the appearance of the informal and illegal activity on its rooftop within a formal modern structure. It is as if a new and different kind of *hara* with different values has been born there. The building, which only half a century earlier had been at the zenith of Cairo's modernity, is now struggling to survive in this new era of fundamental demographic and socio-economic transformation.

References

Abaza, M. 2006. *Changing Consumer Cultures of Modern Egypt: Cairo's Urban Reshaping*. Cairo and New York: The American University in Cairo Press.

Abu-Lughod, J. 1965. *Tale of Two Cities: The Origins of Modern Cairo.* Comparative Studies of Society and History. Cambridge: Cambridge University Press.

———. 1971. *Cairo: 1001 Years of the City Victorious.* Princeton, NJ: Princeton University Press.

AlSayyad, N. 2006. *Cinematic Urbanism: A History of the Modern from Reel to Real.* London: Routledge.

———. 2011. *Cairo: Histories of a City.* Cambridge, MA: Harvard University Press.

Amin, G. 2000. *Whatever Happened to the Egyptians?* Cairo and New York: The American University in Cairo Press.

Al Aswany, A. 2002. *The Yacoubian Building.* London: Fourth Estate.

Ben Néfissa, S. 2011. "Cairo's City Government: The Crisis of Local Adminstrations and the Refusal of Urban Citizenship." In *Cairo Contested*, edited by D. Singerman, 177–95. Cairo and New York: The American University in Cairo Press.

Berman, M. 1988. *All That Is Solid Melts into Air.* New York: Penguin Group.

Castells, M. 1972. "Urban Renewal and Social Conflict in Paris." *Social Science Information* 11, 2: 93–124.

Harvey, D. 1990. *The Condition of Postmodernity: An Inquiry into the Origins of Cultural Change.* Cambridge, MA and Oxford: Blackwell Publishers, https://selforganizedseminar.files.wordpress.com/2011/07/harvey_condition_postmodern.pdf

Mehrez, S. 2011. "From the Hāra to the 'Imārā: Emerging Urban Metaphors in the Literary Production of Contemporary Cairo." In *Cairo Contested*, edited by D. Singerman, 145–70. Cairo and New York: The American University in Cairo Press.

Raymond, A. 2001. *Cairo: City of History.* Cairo and New York: The American University in Cairo Press.

Safey Eldeen, H. 2013. "The Heart of the City from a Socio Cultural Perspective." In *Proceedings: Real Corp Tagungsband, 20–23 May 2013, Rome, Italy*, edited by M. Schrenk, V.V. Popovich, P. Zeile, and P. Elisei, 917–25, https://www.corp.at/archive/CORP2013_197.pdf

Sorokin, P. 1959. *Social and Cultural Mobility.* Glenco, IL: The Free Press of Glenco.

Wirth, L. 1938. "Urbanism as a Way of Life." *The American Journal of Sociology* 44, 1: 1–24.

10

Cairo's Cinematic Coffeehouses: Modernity, Urbanity, and the Changing Image of an Institution

Khaled Adham

> The city is a map of both dwelling and travel, and so is the cinema. In between housing and motion, these spaces question the very limits of the opposition. They force us to rethink cultural expression itself as a site of travel and dwelling. (Bruno 1997)

Barely a few weeks had elapsed after the Lumière brothers arranged a public screening of the cinematograph in December 1895 at the Grand Café in Paris when a similar spectacle was scheduled for the first time in Egypt at a coffeehouse, *qahwat* Zawani, in the center of Alexandria (al-Sharqawi 1970). On this occasion, scores of people from "the upper classes and enlightened intellectuals" crammed in the narrow interior space of the coffeehouse after sunset to experience this much talked about new invention. Attendees were befuddled when the coffeehouse lanterns were removed, enshrouding the whole interior in dark hues and, suddenly, through the beaming light of the noisy machine at their rear, they could envisage within the peripheral outlines of bridges, hotels, train stations, and boulevards in Berlin, Paris, and Lyon, moving images of people "strolling, laughing, and behaving exactly the way real people behave in their daily lives" (al-Sharqawi 1970, 14). At its inception in Egypt and before it, elsewhere, film, the unfolding of a spatio-temporal narrative, would be imbricated with the spatiality of the city. In Egypt, specifically, it was the coffeehouse which would come to serve as site and, later, as mise-en-scène, for the translation and interspersal of one urban space unto another.

This turn-of-the-century wonder that had mesmerized Egyptians on this premiere occasion would subsequently create spectacular, entertaining vignettes for many coffeehouse regulars and introduce them to European cities, then the locus of cataclysmic events in the cultural panoramas of modern life (Bruno 2007). Cinematic explorations of Egyptian

cities shortly followed. In 1912, another coffeehouse owner in Cairo financed the production of a short film capturing the diversity, intensity, and increasing mobility of Egyptian urban life: Opera Square in Cairo; tourists riding camels at the Giza Pyramids plateau; the return of Khedive 'Abbas Hilmi II to Alexandria; and travelers moving around at Sidi Gaber train station (al-Sharqawi 1970, 15).[1] This emerging distinctive ability to capture and express the spatial complexity and social dynamism of the city, its "spatiovisuality" to use the words of Giuliana Bruno, contemporaneously mirrored an urban moment in the history of Egyptian metropolitan cities incarnated in a new wave of architectural venues and real estate expansions (Bruno 2007). As in Europe, these incendiary sparks of short film images begat a propulsive history of Egyptian cinema, inescapably volatilized by the modern history of Egyptian cities. Interestingly, throughout this near century of Egyptian city–cinema relationship, the coffeehouse, with all its later metastases, has remained inexorably linked to films. This is so not only through the recent omnipresence of the TV screen in its interior space, but also through cinematic depictions of real city life, where the reel coffeehouse has been almost ubiquitously present, even if in an incidental way.

Of course, Cairo's urban historical transformations and current condition have been a subject of considerable critical inquiry and research in various fields within academia. Various urban, political, cultural, and social theorists have all contributed invaluable insights to our understanding of the urban transformation of the city during the modern era. In this chapter, building on Nezar AlSayyad's premise that movies are integral constituents of the urban environment (AlSayyad 2006), I want to examine these shifting paradigms from a different angle. Specifically, I want to examine how the cinematic lenses of selected Egyptian films have illustrated in their respective historical period the various social and spatial transformations and responses to the perceived shocks of modernity. While the timeframe of my investigation spans mainly cinematic representations of three historical periods—namely, the colonial period, the socialist or nationalist period, and the period of early Egyptian capitalism—I will follow this inquiry with a brief discussion of our contemporary, neoliberal period. Given the wide span of the periods under investigation, as well as the various urban and architectural spaces that constitute Cairo, I will focus on specific movies that partially represent more than five decades of transformations that took place to one architectural and urban space, the coffeehouse.[2] There are three points I would like to highlight concerning my selection of the reel coffeehouse as an analytical tool for interrogating the impact of modernity on the urban restructuring of the city in these historical periods.

182 Cairo's Cinematic Coffeehouses

To begin with, coffeehouses have always been pervasive in Cairo's life and urban environment. Whether in the old or the modern sections of the city, before or after the turn of the twentieth century, they have been the city's main resorts for business, entertainment, socialization, information, and political discussions and actions. Max Rodenbeck tells us that Napoleon's army at the beginning of the nineteenth century counted 1,350 coffeehouses in the city of a thousand minarets, with a ratio of 200 citizens per coffeehouse (Rodenbeck 2000, 206). Fast-forward two hundred years and the 1996 census shows about 15,000 coffeehouses in Greater Cairo—but this counts only those establishments that pay taxes.[3] According to Rodenbeck, this ratio has not declined much throughout the years; thus, he posits an estimate of 30,000 coffeehouses at turn-of-the-twenty-first-century Cairo (Rodenbeck 2000).

Second, for many Egyptian novelists *al-qahwa* is a microcosm of Cairo and even the whole nation: For sure, the coffeehouse played a major role in many of the Nobel laureate Naguib Mahfouz's novels—the films of two of which, *Zuqaq al-Midaq (Midaq Alley)* and *al-Karnak*, I select here. Likewise, in these selected films, the coffeehouse is portrayed as a societal terrarium during the particular historical juncture, through which the viewer can gaze onto an elapsing moment in time. Nevertheless, I would like to concede that my examination of these reel coffeehouses will remain limited by the constraints inherent in any act of representation.

Third, because of their significant socio-economic and political function, as well as their contribution to the creation of a public sphere in modern Egypt, Cairene coffeehouses have drawn the curatory gaze not only of local writers; foreign visitors to the city have also been led to effuse about the phenomenon. In 1911, the British visitor Fyfe noted that "no city has more active café life than Cairo" (Ayalon 1997, 115). This was the time of the rise of the Egyptian educated class and the establishment of the modern institutional bases that transformed the urban environment of the city, which indeed owes much to the presence of the coffeehouse (Skovgaard-Petersen 2001). Fyfe was bemused to observe that whenever he passed a coffeehouse in the city, he saw large numbers of *effendiya* reading newspapers (Ayalon 1997, 115). Like their European counterparts, the coffeehouses in Egypt contributed to the development of an Egyptian modern public sphere by linking the growth of a modern urban culture with the modern infrastructure for social communication, such as the radio and the press. 'Abd al-Rahman al-Rafi'i, for example, who would later become a nationalist party activist and leader and who chronicled the Egyptian nationalist movement at the beginning of the twentieth century, wrote of the role played by the traditional coffeehouse in the establishment of the movement's programs and newspaper, *al-Liwa'* (Lockman 2002, 148). At

around the same time, Samir Raafat tells us that both Alexandria and Cairo bourses began in coffeehouses before they moved to their current locations (Raafat 1997). And, as has been narrated at the outset of this essay, the first motion picture played in Egypt was relayed in a coffeehouse. I wish to underscore that on this occasion, it was not only the real coffeehouse that would encapsulate the modern transformations taking place in the city; concomitantly the new medium of film would also capture, document, and archive the experience of Cairo's urban modernity.

The Cinematic *Qahwa* in the Colonial Period

Based on Nobel laureate Naguib Mahfouz's 1947 novel with the same title, *Zuqaq al-Midaq* takes place during World War II and represents Cairo standing at the threshold of a new postcolonial era.[4] Faithful to the novel, the film explores and develops issues prevalent at that historical time period, such as social mobility, morality, politics, and class conflicts—themes that transcend Cairene society and are relevant to Egypt as a whole. The film shows how a group of characters living in the same narrow alley in the medieval part of the city responds to the combined promise and threat of Western-influenced modernization. While the film focuses tightly on the narrow life of Midaq Alley, particularly the story of the main female protagonist, we are occasionally reminded of the impact of modernity on the city through the presence of the West in the form of the British army, Western-oriented Egyptians, and the modern urban spaces of Downtown Cairo.

Throughout the film, we discern the division between the traditional and the modern worlds in Egypt during the 1940s, which is to some extent a re-enactment of the East–West dichotomy that usually accompanies discussions of these two worlds. On the one hand, the topography of the alley symbolizes the closed, self-contained, traditional world it envelops. The alley's entrance, or exit, is narrow and marked by an archway that defines its boundary with the world beyond. From within, the alley resembles a cavern with walls from all sides, making darkness one of its dominant features. These walls are punctured with a few spaces that include a sweetshop, a barbershop, a bakery, and *qahwat* Kirsha. The latter is physically and socially located at the heart of the alley. On the other hand, and in sharp contrast to the timeless Midaq Alley, the film depicts scenes from modern Downtown Cairo of the 1940s: its squares and wide open, unbounded streets and boulevards; its modern apartments and apartment buildings; its modern shopping; and its nightlife and cabarets. It is precisely this spatial contrast between the traditional, nearly hermetic, spatially cloistered world of the alley and the world beyond it which reinforces the major theme of the film. While the modern city is viewed as public and the streets are correspondingly useful to all, where individual freedom is

184 Cairo's Cinematic Coffeehouses

granted, mainly, because of the mutual anonymity of each one in the street, the alley is shown to belong to another geographical map, which, though having major thoroughfares, splinters into a number of small alleys. These alleyways are not public spaces to be useful to everyone. Rather, they are the small fortresses of traditional, private life, impregnable to the scrutiny of others, with the *qahwa* at their kernel.

A telltale emblem of the plot's significance and main theme, particularly for the role of the *qahwa*, appears in one early, arresting movie sequence. A storyteller walks into *qahwat* Kirsha presuming he will ply his trade as usual. The scene is familiar to readers of Edward Lane's book which chronicles the habits and customs of Egyptians in the nineteenth century (Lane 2003). We are witnessing a traditional mode of entertainment: the vehicle through which stories such as "al-Sira al-Hilaliya" have come down to us. But the poet-singer is summarily kicked out of the *qahwa*. The owner, Kirsha (played by Mohamed Rida), speaks aggressively to him, reiterating that "people today don't want a poet; rather, they ask for a radio." And, as they quarrel, the camera moves to show a joyous procession hoisting a radio, crossing the alley to the *qahwa*. Ironically, when the radio is installed and switched on, the sound of yet another poet-singer comes out, causing Kirsha to slap his hands in mock aggression and disappointment. It is as if this symbol of

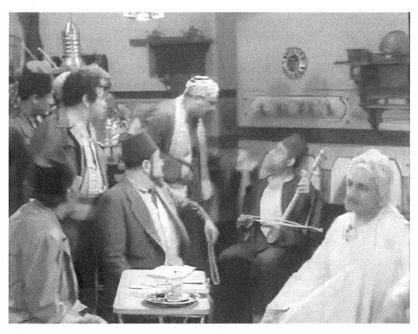

10.1. Qahwat Kirsha is physically and socially at the heart of the alley *(Zuqaq al-Midaq)*.

The Cinematic *Qahwa* in the Colonial Period 185

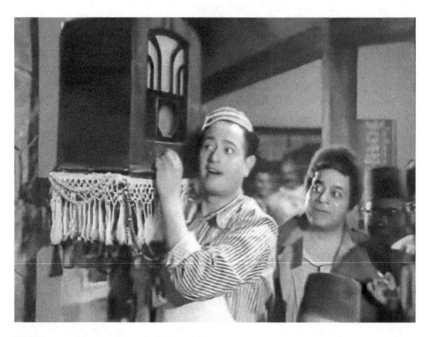

10.2. The installation of the radio (Zuqaq al-Midaq).

modernization and change, the modern instrument for social communication, fails to induce its intended effect and this *qahwa*, the microcosm of the natives' world, will remain virtually intact.

Much of the social life for men in the alley revolves around *qahwat* Kirsha. Day and night, we see them gather there to drink tea, smoke shisha and chat. It is in the *qahwa* that the viewers are introduced to many of the colorful characters of the film. The *qahwa* appears socially and spatially an integral part of the alley. In one of the film's early sequences, Sunqur, the only waiter at *qahwat* Kirsha, is seen hollering orders to the back of the room. In a humorous way, he takes the orders almost simultaneously from across the alley, from one of the characters sitting on a rickety table set outside, and from one of the customers sitting inside caressing his shisha. There is no line that marks where the *qahwa* ends and the alley begins, together forming an organic unity. Although we are never told where most of the characters live in relation to the *qahwa*, the fact remains that all the customers know each other, with no space for strangers. The *qahwa* space appears as an extension of the customers' private spaces. Moreover, most of the sequences show customers preferring company to solitude: they huddle in groups around a small table to gossip and discuss politics or the alley's daily affairs. It is important to comment here on the small tables found in *qahwat* Kirsha, which are also prevalent in the real *sha'bi* or

traditional *qahwa*. Although the small size of the table may seem functionally inappropriate, it reinforces the feeling of proximity among the group physically and psychologically.

The orientation of *qahwat* Kirsha toward the alley tells us something about the gender relationships in the neighborhood. As in a real vernacular *qahwa*, *qahwat* Kirsha is a male domain, where men sit and observe women passing by in the alley, with occasional comments and flirtations taking place. Women, on the other hand, peek into the *qahwa* and the alley to observe men through the traditional *mashrabiya*, the intricate wooden screen designed to allow light and air through windows while screening residents from view. It is only in the modern section of the city, or in the relatively larger streets of the medieval city, such as al-Muski or al-Mu'iz streets, where men and women can meet free from the aspersing gaze of neighbors and acquaintances.

Social mobility is a significant theme in the film plot. A few characters in the film yearn to escape from strict tradition and the poverty that seems to be the perpetual destiny of the alley. It is only through leaving the alley for the modern side of the city that social and economic improvement can actually be achieved. In her rebellion against lower-class life and desire to climb the social ladder, Hamida escapes the alley to work as a female entertainer and a prostitute in a cabaret frequented by British soldiers. While the *qahwa* represents the space of native Egyptians, the cabaret represents the space of Western modernity. In this cinematic dualistic view, the *qahwa* stands for the spiritual, loyal, dignified, and authentic, while the cabaret signifies faithlessness, disgrace, superficiality, materialistic values, and moral depravity. This social dualism was typical of the period, Galal Amin tells us, but receded during the ensuing two decades only to return again after the 1970s (Amin 2000, 134).

Stanley Lane-Poole described the urban dualism that separates these two parts of Cairo in the first chapter of his 1906 guide to the city: "There are two Cairos, distinct in character, though but slenderly divided in site. There is European Cairo, and there is an Egyptian Cairo" (Lane-Poole 1918, 46). This urban dualism resulted from Khedive Isma'il's efforts to modernize the city during the 1860s and 1870s (Abu-Lughod 1971). Native Cairo was a living museum, arranged and objectified for the examination of visitors to the European Cairo (Mitchell 1991). And Cairo of the 1940s represented this same physical duality between traditional Islamic and modern Western architecture and urbanism. Urban discourses have viewed the modern part of the city as distinct from the native. Dichotomies such as traditional versus modern, East versus West, authentic versus inauthentic have been always used to analytically examine the two parts. Likewise, real coffeehouses presented a similar dualism: *sha'bi* or *qahwa* in the native, medieval part of the

city and modern cafés in the modern Western, Downtown area, such as the newly opened coffeehouse, "À l'Américaine."[5]

Unlike the novel, where Mahfouz leaves no doubt in his equivocal treatment of the *qahwa* that its world and the modern world outside are, morally speaking, on an equal footing, the film stresses the moral superiority of the *qahwa* and the alley (Deeb 1983).[6] In the film's concluding scene, the injured, moribund Hamida returns to the alley, to her "authentic origin." As she fades, she gazes remorsefully at *qahwat* Kirsha before dying in the arms of her former lover 'Abbas al-Hilw. While emphasizing the 1940s' discouragement of social mobility, the film also mirrors the urban condition of the city, which remained dichotomized between these seemingly irreconcilable spheres.

The Cinematic *Qahwa* in the Nationalist Socialist Era

In the critically acclaimed political film *al-Karnak*, based on another of Naguib Mahfouz's novels, *al-Karnak Café*, the coffeehouse is located not in a vernacular neighborhood like that of Midaq Alley, but rather in what is a presumably modern neighborhood in Cairo.[7] The film plot broadly discusses the modernity of urban Arab socialism of the late Nasserite era, highlighting its darkest side: the state policing, control, and suppression of the urban public sphere. The story focuses in retrospect on the coffeehouse regulars, a mixed group of young university students, retired high-ranking government employees, and a famous writer, as they respond to one key moment in contemporary Egyptian history, namely, *al-naksa*, or the loss of the 1967 war with Israel. For the young people at the coffeehouse, "history began with the 1952 Revolution." From the time Gamal Abd al-Nasser became president of Egypt in 1954, the hopes of a whole generation, particularly the young, who call themselves throughout the film "the children of the Revolution," were high until the mid-1960s. The film focuses on the fates of three young people among the Karnak coffeehouse regulars, who inexplicably disappear several times amid reports of waves of arrests. In each period of incarceration, the film dwells on their deplorable conditions and interrogations by the presumed head of the intelligence agency. Their lives are profoundly changed by the experience; indeed, one of them dies under torture. Even so, the others keep coming back to the coffeehouse.

There are a few points that I would like to highlight concerning the reel coffeehouse in this film. First, the film begins with a view of the closed glass door of the coffeehouse being cleaned while the viewer gradually begins to comprehend its interior space. Unlike *qahwat* Kirsha, al-Karnak coffeehouse is to a great extent introverted as it is inward looking, with

limited visual access to the street: the inner space is clearly separated from the public gaze, except through the windowpanes of the door.

Second, when the coffeehouse door is fully opened, we see the female owner giving orders. The presence of females in the coffeehouse, which is confirmed later by women clients, is another sign of the social changes that distinguishes al-Karnak coffeehouse from other traditional, male-dominated coffeehouses and that also signifies the liberal Cairene society of the 1960s. In a later scene, however, Zeinab Diab, the young female protagonist of the film (played by Su'ad Husni), expresses indignation when it is suggested that she join the male group at al-Karnak coffeehouse, which, despite this, she eventually does. I proffer that the film chronicles a transitional period in the social urban history of the city, when women began to play a greater role in the public space. Many other films from this era take the theme of working women as central to their plots—the film *Mirati mudir 'amm (My Wife Is a General Manager)* is a prime example. However, as in Midaq Alley, Zeinab can only meet her lover and neighbor, Isma'il, outside of their traditional, conservative alley.

Third, in the first sequence of the film, the camera moves inside the space of the coffeehouse and we hear the sound of a news broadcaster emanating from the radio, announcing that the Egyptian army has succeeded in crossing the Suez Canal in what sounds like a victorious war over Israel. All the customers gather around the radio with the exception of Isma'il, one of the three young men, who, even years after his encounters with the secret police, still appears shattered and disillusioned. Clearly, over the two decades since the film of *Midaq Alley*, the radio has been assimilated into the daily lives of Cairenes as the source of information and entertainment—an increasingly dominant instrument in the public sphere.

Fourth, the film portrays the social mobility that came out of the rapid changes in Egypt's social structure due to the social policies of the revolution. The film's main young protagonists are educated students in medical school who come from poor neighborhoods reminiscent of Midaq Alley. In a way of linking the two films, the reader can hypothetically imagine these young students to be descendants of Hussein Effendi (played by Hussein Riad) of Midaq Alley, the educated character among the *qahwat* Kirsha regulars who speaks English. Unlike the people of Midaq Alley of the 1940s, however, these young students of the 1960s move freely from the poor to the more affluent sections of the city, and their Karnak gathering is indeed a mix of all social classes. Al-Karnak's space has thus helped to create cross-class and citywide alliances. In reality, rapid social mobility and the dream of climbing the social ladder characterized urban social movements in Cairo during the 1960s: Traditionally affluent sections of the city were invaded by people from lower classes, scores of village

dwellers moved to the city in search of jobs and opportunities in factories, and new geographical residential areas opened up for the growing middle class. At the end of the film, Zeinab, who has just graduated from medical school, leaves the alley along with her family to live in one of the new housing projects built for the growing middle class. During the nearly two decades of the socialist period, Cairo had expanded in all directions. Predominantly low-income groups were attracted to heavily subsidized houses close to the two large industrial poles established in the north and south of the city, Shubra al-Kheimah and Helwan. Toward the east and west, the middle-income class was attracted to better living conditions in the newly developed Nasr City and Madinat al-Mohandessin, respectively. At the center, the area around Tahrir Square—the former colonial zone that constitutes the western part of Downtown Cairo and where al-Karnak coffeehouse is presumably located—was redeveloped as an Arab–national–socialist space: large governmental buildings, the Socialist Union headquarters, and the Arab League building almost rub shoulders in a vast urban space. In short, under the socialist ideology, urban policy experienced a fundamental shift toward large-scale urban projects developed to cope with the rapidly expanding Cairo, with public urban spaces dominating the cityscape.

Ironically, the social justice and freedom that is felt in the city, represented by the cinematic coffeehouse, is in stark contrast to the injustice and brutality of the political regime. It is here that we reach the heart of the plot's paradox: the coffeehouse space, Jurgen Habermas's example par excellence of a public sphere in which the public organizes itself as the bearer of public opinion (Habermas 1989, 12), the space from which "the Egyptian renaissance emerged, where Gamal al-Din al-Afghani went," as Zeinab laments in one scene in the film, is dialectically contrasted with the prison cell, the space of incarceration and despair. Toward the end of the movie, however, the secret police enter al-Karnak coffeehouse and, consequently, all political commentaries and arguments are suspended and replaced by trivial discussions, a total depoliticization of the coffeehouse, the public sphere. The key aspect of the modern political system depicted in the film is its system of control through coercion and surveillance.

It would be instructive to highlight the main discrepancy between the novel and the film, as it is consequencial to the portrayal of the coffeehouse. The film begins and ends with triumphant footage of the October 1973 war, which rescues the two remaining young characters from despondency and gives them a new sense of hope and purpose in life. The novel, on the other hand, ends with the reformed head of intelligence, who had subjected the young students to coercion and even torture, becoming himself a regular to al-Karnak coffeehouse after having served a prison

sentence following Anwar Sadat's 1971 corrective revolution in which he purged the centers of power from the Nasser era. While the novel's ending suggests that nationalism has not lived up to its promise, implying that it may be time to search for alternatives, the film omits this idea and instead embraces Sadat's version of the nationalist discourse (Deeb 1983, 128). To be sure, while the cinematic coffeehouse was not given any clear role in the new era, the literary one was portrayed as a repository of liberal, oppressed, or even reformed political discourses, with the hint that all of them might remain confounded by the closed doors of the coffeehouse. I suggest that the ending of the film *al-Karnak* reflects more the political atmosphere of 1975 in which the film was used as propaganda to revive the legitimacy of the nationalist discourse which the 1967 war had thrown into doubt. Moreover, the interior space of the coffeehouse shows a large advertising poster for Si Cola, a local drink developed as a substitute to the American Coca Cola brand, which to a great extent both reflects the closed economic reality of the 1960s and foresees the coming Open Door economic policy of the post-1974 years, the aftermath of the changing economic regime due to what is known as *Infitah*, or Anwar Sadat's liberal economic policies, and on to which I shall now move, to discuss its corresponding cinematic coffeehouses.

The Cinematic *Qahwa* and the Rising Consumer Society

Qahwat al-Mawardi (al-Mawardi Coffeehouse), according to the film critic Hassan Haddad, is one of the first serious films to tackle the negative social impact of *Infitah* or Open Door policies on Egyptian society (Haddad 1994). The film plot takes place during the late 1970s in a presumably traditional neighborhood in Cairo, al-Mawardi Alley. It portrays Cairo's transition to a new postsocialism era, a capitalist modernity, and explores issues prevalent at that historical juncture, such as social mobility, moral decline, corruption, and the widespread acceptance of material values and conspicuous consumption. It shows how a group of characters living in the same alley responds to the temptations and threats of liberal economic *Infitah*, which brought with it strong winds of urban change to Cairo not intensively experienced since Khedive Isma'il's efforts to modernize the city in the nineteenth century.

The economic Open Door policy coincided with climbing oil prices in the aftermath of the 1973 war, which brought an indirect windfall and relative prosperity to the Egyptian economy: the increase in oil and Suez Canal revenues came at the same time as remittances of Egyptians who sought opportunities in the Arabian Gulf in record numbers. The wages remitted back home allowed families once accustomed to subsistence living to step into a nascent consumer economy, buying televisions, home

appliances, and the like (Amin 2000). The search for rapid gains by the new bourgeoisie made speculative investment the main means of wealth accumulation and depredation of the migrants' savings. Cairo was growing and expanding without control, changing hundreds of acres of fertile Egyptian land into urban districts, which housed the social sectors marginalized by public and formal private-sector investments. In the city center, small buildings and houses were destroyed and replaced by high-rise blocks. The drawbacks of this "liberal" policy, which already made life unbearable for the urban poor, began to threaten social stability and justice in the city.

Thus we find urban discourse during these days dominated by a negative view of *Infitah*, which was perceived as a Westernization, Americanization, or even Gulfanization process that devastated Egyptian traditional values and environments. In numerous conferences and symposia during this era, Cairo was repeatedly examined in relation to these outside forces, and a general critique of modernization was constructed vis à vis this framework (Serag al-Din, Fadil, and al-Sadik 1986). And cinema reflected this view. Dorriya Sharaf al-Din tells us that movies produced during this period could be categorized into two main groups: films critical of *Infitah* and films pliant with it (Sharaf al-Din 1992).

Qahwat al-Mawardi's opening sequence introduces its main critique of *Infitah*. With the background sound of advertisements, which many viewers could identify with from 1970s radio and TV commercials, the camera moves around the center of the city to explore the urban chaos of Tahrir Square and the shopping streets of Downtown Cairo. From the outset, the film's message is clear: Cairo's urban chaos in the late 1970s is linked to the staggering impulses of excessive consumption caused by the new economic policies. And the whole plot unfolds from this point forth—an encroachment of consumerism's signs and values from the center of the city into traditional districts, nearly seizing their symbolically final bastion, *qahwat al-Mawardi*. Ibrahim al-Mawardi (played by Farid Shawqy), the owner of the *qahwa* and an avid believer in maintaining local traditions, sees all the changes and the looming threat of the dominance of materialistic values, but is helpless to do any thing about them. The shiny, glittering façades of boutiques and the tacit desire of people for consumption are unstoppable. His *qahwa* becomes a witness to the changes that take place in the city during the post-1974 *Infitah*: the spread of corruption and nepotism, the deterioration of traditional values, the lack of work ethics, the contagion of the blasé individual, the spread of material values, the estrangement of social life, and the growing respect for whatever is foreign and disdain for everything local. Ahmed (played by Farouk el-Fishawy), a young journalist, chronicles the changes taking place in the alley from his seat in the *qahwa*, before he is killed toward the end of the film. His published

chronicles, however, reinvigorate the spirit of resistance among the *qahwat* al-Mawardi regulars, who rally around the owner. The film's last scene returns the viewer to the dialectic of tradition versus the modern, and symbolically concludes with a call for the forces of tradition and resistance to overwhelm the onslaught of the corrupting *Infitah* and consumerism.

In reality, *Infitah* was never a complete transition to a capitalist economy. The national economy remained dominated by the public sector and central planning. True, *Infitah* allowed foreign investment in Egypt—largely banned since the country's 1952 socialist revolution—and the film depicts the return of Western economic domination, signified by the economic and cultural recolonization of the alley. For example, the film shows two Western investors buying the sole vernacular restaurant in al-Mawardi Alley, *al-Massmat*, and turning it to a fast-food restaurant, "Linby," alluding doubly to the British fast-food chain Wimpy, which began to spread in Cairo during the 1970s, and the symbol of economic colonization, the British Field Marshal Allenby, who was sent to Egypt at the end of World War I. Whereas in the film *Zuqaq al-Midaq*, the cabaret and British soldiers represented Western military and political presence and influence, in this film, it is the boutique shop, the import–export office, and the fast-food restaurant that signal a relentless process of economic infiltration and dependency. At one point, the alley's thug (played by Youssef Sha'aban), who represents all the moral decline of the post-*Infitah* years, enters *qahwat* al-Mawardi and forces the owner to display advertisements for his consumer-oriented products against his will, only for these to be removed and shredded at the end of the film when the *qahwa* regulars unite against him. In addition, the cinematic *qahwa* witnesses the growing influence of another foreign presence: Gulf Arabs. With their new accumulated wealth from the sale of oil, Gulf Arabs began to pour into the city at this time, seeking entertainment and marriage, and *qahwat* al-Mawardi witnesses their arrival.

In a sense, the film returns the *qahwa* to its physical and social location at the heart of the alley, where it plays an important role not only in the social lives of the men of the *hara*, but also, eventually, as a space of resistance to the negative modern impulses it witnesses. Like *qahwat* Kirsha, al-Mawardi is portrayed as the "good" place that is interwoven with the social space of the alley, or as one character in the film describes it, "*qahwat* al-Mawardi is the home for all of us." The physical boundary, however, that separates the *qahwa* from the alley is not as indistinct as in *qahwat* Kirsha, nor is it as rigid as in *qahwat* al-Karnak. With a few tables and seats arranged outside, its main interior space is inward looking. Typologically, al-Mawardi appears as a more elaborate version of *qahwat* Kirsha, with wooden chairs, traditional woodwork decorations, small tables, a radio, a

telephone, and a typical traditional service counter. A mix of male clients, which on the whole represent the various social groups that constitute the lower and middle classes of Cairene society, frequent al-Mawardi. Moreover, the majority of its regulars are portrayed as blasé individuals who seem oblivious and passive to the changes taking place and appear to live in a world of their own. Two points are worth mentioning here: first, as in the films *al-Karnak* and *Zuqaq al-Midaq*, the *qahwa* and the alley appear as gendered, male-dominated spaces. Once again, for the film's female protagonist Farawla (played by Nabila 'Abid) to meet her lover Ahmed, she has to get outside the confines of the traditional sphere of the alley to the modern part of the city. Second, among the *qahwa* regulars, the film includes characters who are Islamic zealots, highlighting an increasingly visible group—and with an ominous inkling of political problems to come, a theme that will be picked up in the following section.

The Coffeehouses in Neoliberal Cairo

Over the last several decades, Cairo's urban spaces have undergone a sea change along with the ways we experience them. By adopting a neoliberal economic policy at around the late 1980s, the government has accelerated the breakdown of the urban social framework. Today, the city's impetuous expansions defy any form or image one might attempt to conjure up for it; it is a city out of control (Sims 2010). The notable historian of Cairo André Raymond has rightly noted that "the faces of the city blur; its centers are many and mobile" (Raymond 2001, 361). No doubt, the boundaries between traditional neighborhoods, modern Downtown, suburban divisions, informal settlements, and rural peripheries are blurring, and so are those between high culture, mass culture, and popular culture. But while some see an increasing homogeneity, others discern diversity and heterogeneity through increased hybridization of categories and urban patterns. Raymond concludes that Cairo "can still be reconstituted to more or less coherent wholes, each clearly revealing deep social differences" (Raymond 2001, 361).

Like the production of urban spaces, the recent publication of literary texts has revealed these social transformations. Samia Mehrez observes that as the city transformed itself, so did the metaphors that came to represent it in literary texts (Mehrez 2009). The *hara*, which dominated the representation of Cairo, argues Mehrez, was displaced by new metaphors that are more representative of the city and the country at large. Among them is the metaphor of *'imara*, the apartment building. In cinema, I will suggest that a similar representational shift took place. In lieu of the *qahwa*–alley couplet, which dominated the cinematic representation of traditional Cairo, the *'imara*, the cabaret, or the casino have become alternative microcosmic representations of Cairene society for some contemporary movies.[8] These

new spaces, however, differ from the coffeehouses in the sense that they do not function as places of community or social resistance. On the other hand, the coffeehouse, though it has lost its former centrality as a representative microcosm of society and appears in films in a rather incidental way, like its real counterpart, it has metastasized in a dizzying speed into various types and forms, reflecting a huge range of the social and urban diversity that characterizes the current urban state of affairs.

In the sphere of urban planning, the result has been an uncomfortable coexistence of skyscrapers and affluent commercial centers side by side with shantytowns and informal settlements: "enclaves of affluence amid mass squalor," as Mehrez puts it (Mehrez 2011, 146). In this jumbled spatiality, urban discourse has become focused on the impact of the neoliberal economic regime on the spatial restructuring of the social mosaic of the city, particularly the way it has produced greater inequality. Two interrelated strands of literature and research from within this discourse have become paramount: studies of the rising tendency to privatize public space and create urban enclaves; and researches on the rise of informal settlements, *ashwa'iyat*—a term used as pejorative objectification of social disorder. Not surprisingly, similar strands in cinematic coffeehouses of the post-1990s have mirrored these urban conditions, adding them to the already existing typologies: sleek café and informal *qahwa*.

As for the first strand, that of the "sleek café," Eric Denis among others has written on how the Egyptian government's planning and land-use policies have transformed the physical spaces of the city in a way that helped investors construct gated communities for the upper class, hence, isolating them from the rest of the population—a gradual urban process that is in tune with the new economic liberalization and International Monetary Fund (IMF) approaches (Denis 2006; Adham 2006). Cinematic representations of these new elite places are evident in many contemporary movies. Like emerging real sleek cafés, reel coffeehouses of this genre began to display ultramodern lifestyles that cater for the upper class. Three main features characterize these coffeehouses. First, they are divorced from their surroundings—they are inward looking and separated from the public gaze; their inner spaces are totally hidden from the street so that females can behave according to different dominant social norms. Second, their internal furniture and décor show a mix of Western international coffee chains and bars, with TV sets replacing radios, constituting a common feature among all of them. Third, the arrangement of their furniture does not encourage cross-tables discussion; hence, they do not encourage strangers to get to know each other. In short, the sanctuary of the coffeehouse space has been reduced to a sense of comfort in a well-designed interior space where other people do not intrude.

The Coffeehouses in Neoliberal Cairo 195

The second strand of urban research focuses on the rise of informal settlements in the city. According to David Sims, slums and informal, unplanned areas, which emerge without license from competent authorities, started to appear in the mid-1960s (Sims 2010). Asef Bayat tells us that these haphazardly developed areas have proliferated over the years to "more than 100 squatter communities with some six million inhabitants, accounting for at least 80% of Cairo's total urban growth" (Bayat 1997). According to Bayat, these informal developments signify the starkest component of the growing socio-economic disparity in Cairo since the start of Sadat's *Infitah* in 1974 and the more recent implementation of the IMF's structural adjustment program. Since the 1990s, the millions of people who put up their shelters unlawfully have become, in the eyes of the government, a security threat to the city's social order, "a Cairo as a bomb trope" (Singerman and Amar 2006). One particularly significant threat to the government emerged in the early 1990s when an Islamic militant group sought to create a microcosm of their proposed socio-political and religious order within one of these informal areas, an Islamic Republic of Imbaba. The government reacted with a siege of the area, indiscriminately arresting many people and clearing urban spaces to improve the area's permeability for police trucks and armed vehicles. Since then, media reportage and official texts have pigeonholed such settlements as squalid havens for criminals and terrorists (Dorman 2009).

The film *Heen Maysara (Until Better Times)*, directed by Khaled Youssef, reinforces this pathology and focuses on the dismal living conditions of *ashwa'iyat* inside and around Cairo, representing them as a direct threat to the city's urban future. The film title alludes to the current political and social stagnation, or "the feeling of waiting for something to happen," which, according to the movie director, stretches back for several decades (al-Shouky 2008). The film is more than a re-enactment of the events and episodes that took place in the district of Imbaba during the early 1990s. It paints a dark picture of life in these predominant areas in Cairo's cityscape through several interrelated themes that run throughout the film: violence, drug trafficking, corruption, Islamic insurgency, terrorism, police brutality, sexual promiscuity, drugs, child delinquency, and prostitution.

The film leaves no doubt that the *qahwa* in informal areas has become a dangerous place, claimed either by gangsters or by Islamic insurgents. The *qahwa*, which significantly is never given a name in the film, thus reinforcing the characterless feeling of its immediate environment, consists of a shed, a canopy made out of cheap materials. Like *qahwat* Kirsha and *qahwat* al-Mawardi, it occupies a central location in the slum's main public square. The closing of the film contains one of the bluntest images of confrontation between government and insurgents, played out in the space

196 Cairo's Cinematic Coffeehouses

facing the *qahwa*. While initially losing to the insurgents, the police force reacts by bulldozing the *qahwa*, echoing some commentators' statement that "clearance is the solution" for informal areas (Dorman 2009, 428).

Parting Thoughts

I began my essay with an epigraph from Giuliana Bruno, who suggests that cinema, like the city, is a map of both dwelling and motion. In a sense, in this essay I have moved through these cinematic coffeehouses as someone walking through a building or a city, assembling their various representations of different eras, cutting some scenes from each one and putting them side by side in what is like a montage of half a century of coffeeshop representations. With admittedly limited validity, a glaring pattern has emerged. Throughout its cinematic representations up until the early 1990s, the coffeehouse was portrayed as a physical gathering space that could contribute to concrete social projects. The coffeehouse was a form of opposition, a space of resistance, or an anchor for organizing collective action against what was in every historical stage perceived as a threat—whether the modern forces of change, domination, or social control—which endangered traditional and societal norms and values. The community it helped create was in many ways "imagined," but it was still linked firmly to a specific site, which, in turn, was embedded in a larger matrix of socio-economic and political dynamic relations. This broader sense of community, represented cinematically with the symbolic genre of the coffeehouse, significantly affected political activism and perhaps the production of urban space at large.

If one were to characterize the present Cairo urban state of affairs based on the cinematic portrayal of coffeehouses in the post-1990s, one would describe it as the long present moment when the coffeehouse genre has exploded upon us, "not that it has attenuated or disappeared because of the amplitude of the burst, but rather, its existence has proliferated and metastasized into a fractal mode of dispersal," to quote the French philosopher Jean Baudrillard (Baudrillard 1994). In today's Cairo, the economic forces of the neoliberal age and the virulence of rapid social mobility are creating the tendency for architectural and urban patterns in the city to continually mutate beyond their former forms and logics. These new mutations, however, do not actually replace older ones; sleek cafés do not replace *sha'bi* ones; rather, they simply join their ranks and take their place in an invisible matrix of the city, reflecting the increasing fragmentation and complexity of today's socio-urban condition of Cairo. The realm of this public sphere has been steadily decreasing in signification as portrayed through recent reel coffeehouses. Is this so because Cairo has been increasingly lacking the presence of a strong civil society? The question posed

in the light of my reel coffeehouse tour is this: with cinema no longer portraying the coffeehouse as a social space of resistance, is there another space that is taking its function? Should this space necessarily be identified with a physical space assigned to it, or more with a sphere performing its function, whether this is physical or in the cyber space of the internet?

References

Abu-Lughod, J. 1971. *Cairo: 1001 Years of the City Victorious*. Princeton, NJ: Princeton University Press.

Adham, K. 2006. "Globalization, Neoliberalism, and New Spaces of Capital in Cairo." *Traditional Dwellings and Settlement Review* 17, 1: 19–32.

AlSayyad, N. 2006. *Cinematic Urbanism: A History of the Modern from Reel to Real*. New York and London: Routledge.

Amin, G. 2000. *Whatever Happened to the Egyptians?* Cairo and New York: The American University in Cairo Press.

Ayalon, A. 1997. "Political Journalism and Its Audience in Egypt, 1875–1914." *Culture and History* 16: 100–20.

Baudrillard, J. 1993. *The Transparency of Evil*. London: Verso.

Bayat, A. 1997. "Cairo's Poor: Dilemmas of Survival and Solidarity." *Middle East Report* 202: 2–12, http://www.merip.org/mer/mer202/poor.html

Bruno, G. 2007. "Haptic Space: Film and the Geography of Modernity." In *Visualizing the City*, edited by A. Marcus and D. Neumann. London: Routledge.

———.1997. "Site-Seeing: Architecture and Moving Image," *Wide Angle* 19, 4: 8–24.

Deeb, M. 1983. "Najib Mahfouz's Midaq Alley: A Socio-Cultural Analysis." *Bulletin (British Society for Middle Eastern Studies)* 10, 2: 121–30.

Denis, E. 2006. "Cairo as Neo-Liberal Capital? Walled City to Gated Communities," In *Cairo Cosmopolitan*, edited by D. Singerman and P. Amar. Cairo and New York: The American University in Cairo Press.

Dorman, W.J. 2009. "Informal Cairo: Between Islamist Insurgency and the Neglectful State." *Security Dialogue* 40, 4–5: 419–41.

Habermas, J. 1989. *The Structural Transformation of the Public Sphere*, translated by T. Burger. London: Polity.

Haddad, H. 1994. "Qahwat al-Mawardi." *Huna al-Bahrain*, July 27, 1994: 23–35.

Lane, E.W. 2003. *An Account of the Manners and of the Customs of Modern Egyptians*. Cairo and New York: The American University in Cairo Press.

Lane-Poole, S. 1918. *The Story of Cairo*. London: J.M. Dent.

Lockman, Z. 2002. "Exploring the Field." In *Histories of the Modern Middle East: New Directions*, edited by I. Gershoni, Y. Erden and U. Wokock, 137–54. Boulder, CO and London: Lynne Rienner Publishers.

Mehrez, S. 2011. "From the Hara to the 'Imara: Emerging Urban Metaphors in the Literary Production of Contemporary Cairo." In *Cairo Contested*, edited by D. Singerman, 145–70. Cairo and New York: The American University in Cairo Press.

Mitchell, T. 1991. *Colonizing Egypt*. Berkeley: University of California Press.

Proyect, L. 2003. "Naguib Mahfouz, 'Midaq Alley': A Book Review." *Swans Online Reviews*, April 14, 2003, http://www.swans.com/library/art9/lproy02.html

Qasim, M. 2008. *Dalil al-aflam fi al-qarn al-'ashrin fi Misr wa-l-'alam al-'arabi*. Cairo: Madbouli.

Raafat, S. 1997. "The Cairo Bourse." *Cairo Times*, October 30, 1997: 7.

Raymond, A. 2001. *Cairo: City of History*. Cairo and New York: The American University in Cairo Press.

Rodenbeck, M. 2000. *Cairo: The City Victorious*. New York: Vintage Books.

Serag el-Din, I., R. Fadil, and S. al-Sadik. 1986. *Tahadiat al-tawasou'a al-'umrany: halat al-Qahirah*. Cairo: The Aga Khan Award for Architecture.

Sharaf al-Din, D. 1992. *al-Sinima wa-l-siyassa fi Misr 1961–1981*. Cairo: Dar al-Shorouq.

al-Sharqawi, G. 1970. *Risala fi tarikh al-sinima al-masriya*. Cairo: Al-Hayaa al-'Amah lil Kitab.

al-Shouky, A. 2008. "Interview with Khaled Youssef." *Al-Quds al-arabi* 19, 5784, January 9, 2008.

Sims, D. 2010. *Understanding Cairo: The Logic of a City Out of Control*. Cairo and New York: The American University in Cairo Press.

Singerman, D., and P. Amar. 2006. "Introduction." In *Cairo Cosmopolitan*, edited by D. Singerman and P. Amar, 1–44. Cairo and New York: The American University in Cairo Press.

Skovgaard-Petersen, J. 2001. "Public Places and Public Spheres in Transformation." In *Middle Eastern Cities 1900–1950*, edited by H. Nielsen and J. Skovgaard-Petersen. Aarhus: Aarhus University Press.

Notes

1 By that time, the cinematograph was moving out of the coffeehouse to its permanent house, the movie theater. In the years preceding World War I, there were more than ten movie theaters in Egypt (al-Sharqawi 1970, 15).

2 The total number of Egyptian movies produced in these four historical periods exceeds 2,500 in number. My selection depended on a quick review of the content of these movies in Mahmoud Qasim's anthology of Egyptian films. See Qasim 2008. One criterion for selecting the movies is that the coffeehouse is significant in the film plot.

3 It is important to note that Western-style coffeehouses which began to spread at the beginning of the 1990s led to the colloquial Arabic distinction between, on the one hand, *qahwa*, and, on the other hand, the cafeteria, café, coffee shop, and casino. While the former remains primarily about coffee and tea drinking, shisha smoking, and all-male all-night gatherings with no food on offer, the others, by and large, cater for both men and women and offer a variety of drinks, food, and in many cases shisha. With these general characteristics laid out, various anomalies can still be found: smoking shisha in restaurants, selling fast food from food stands in dilapidated *qahawi* (plural for *qahwa*), or even serving alcohol in some exceptional coffeehouses.

4 The film *Zuqaq al-Midaq* (*Midaq Alley*), directed by Hasan al-Imam, is based on a novel published in 1947 during the colonial period. The film's production date, however, is 1963, which falls into the period of socialist rule under Nasser. Admittedly, this time lag limits the validity of my interpretations of this film, but I choose to ignore this issue for one main reason: the setting and cinematic depictions of the social and spatial characteristics of the *qahwa* in the film are to a great extent faithful to the description given in the original novel.

5 According to Galal Amin, À l'Américaine catered to visiting and resident Westerners as well as upper-class Cairenes. According to him, it introduced the first experience of American influence and way of life to the modern Egyptian coffeehouse. See Amin 2000, 137.

6 In his soico-cultural analysis of the novel, Marius Deeb tells us that Mahfouz is "wittingly or unwittingly, shattering the mythical aura which surrounds the old Cairene quarter as the embodiment of Egyptian authenticity by showing us, first, its utter uncomeliness, and secondly, its remarkable lack of any redeeming moral values" (Deeb 1983, 129).

7 The novel was completed in 1971, but was not published until 1974. The film was directed by Aly Badrakhan and released in 1975. It was immediately and immensely popular. Critics' reactions to the film created a controversy about the revolution that much surpassed the impact of the original novel.

8 Several movies from this passing decade have used the cabaret to reflect on larger societal issues. See, for example, the films *Cabaret* (2008) and *al-Rayis Omar Harb* (*Chief Omar Harb*) (2008) directed by Sameh 'Abd el-'Aziz and Khaled Youssef, respectively.

11

Gendered Modernity: On the Changing Role of Women in Modern Cinematic Cairo, 1950s– 2000s

Nour Adel Sobhi

Amina's days went by as her news of mingling with the youths of al-Daher neighborhood had reached every ear in the homes of the Abbasiya neighborhood. Mothers forbade their daughters from going out or playing with her, while the elderly sheikhs of Abbasiya complained sadly of what they viewed as the loss of a daughter from their neighborhood. Equally angered by this, the young men from Abbasiya gathered more than once to set a plan of attack against al-Daher neighborhood and the boys there. They sought revenge for the honor of their neighborhood which they saw as having been tarnished by Amina. Still, they would often sneak one by one to the rollerskating rink to watch Amina as she moved and played, each looking lustfully at her. (Ihsan Abdel Kouddous, *Ana horra*, 1952, 88 [Author's translation])

Whether upper class, middle class, or the urban poor, Egyptian women have always faced many social challenges. By the mid-twentieth century, women had started their struggle to break societal taboos, to obtain better education, to work, and to achieve equality with their male co-workers. Half a century later, women of every occupation are still challenged on buses, in the streets, and in public spaces. In the analysis and discussion contained in this chapter, I use four films—*Ana hurra (I Am Free)* (1959), *Mirati mudir 'amm (My Wife Is a General Manager)* (1966), *678* (2010), and *Nawwara* (2015)—to demonstrate the struggle for a decent life for women in the big city. I do not only present an investigation of Egyptian women's portrayal in twentieth-century cinematic Cairo, but I also explore how modernity has affected their lives in the city.

The above epigraph from the novel *Ana hurra (I Am Free)* tells the story of a young woman and her struggles in the Abbasiya neighborhood

in Cairo where she was brought up by her aunt and uncle. Considered one of the most prominent feminist works of the 1950s, the novel was later made into a film in 1956, which depicts the journey of a middle-class Egyptian woman on her path to liberation: fighting for her rights to a college education, career fulfillment, and political freedom, and the right to go wherever she wants in the city without being harassed. The epilogue is evidence that urban freedom was—and still is—part of the Egyptian middle-class struggle on the path to liberation, away from the rigid traditions of the conservative community toward modernity with all its facets. About a decade later, another film titled *Mirati mudir 'amm (My Wife Is a General Manager)* tracks the development of the role of a female Cairene CEO having to deal with various speedbumps on her road to modernity. In the films *678* and *Nawwara*, fifty years later, particularly in the aftermath of the January 2011 Revolution, we find Cairene women facing rather different urban challenges in the city, where their work is a basic necessity for survival and not simply a desire for more freedom.

From a historical perspective, the first two films were set at the time of the rise of Egyptian socialism and the 1952 Revolution, the latter two are a product of the discontent that led to the Revolution in 2011, centered around Tahrir Square, and its impact on present-day Cairene women. Set in Cairo of the 1950s and the 2000s, the plots of the four films act as a chronological documentation of Cairene women in the city at these times. A backdrop of socio-political changes, economic turmoil, class conflicts, and the modern urban lifestyle of Egyptian women is also captured by these films.

Through a comparative analysis of the four films, working women's social class, lifestyle, behavioral patterns, and the perception of safety are examined. The four films, considered representative of their times, have been carefully selected. Through each film, a modern phenomenon is highlighted and analyzed in terms of how it has affected Cairene women's roles and how it has created new challenges. The chronological juxtaposition of the mid-twentieth century and the second decade of the twenty-first century highlights the changes that occurred for Cairene women, as viewed through the cinematic medium. It is worth mentioning that apart from the four films that are analyzed here, there are various other cinematic works that discuss women's roles within a Cairene urban context set in the same time period. These films include *Ah min Hawa' (Beware of Eve)* (1962), *al-Bab al-maftouh (The Open Door)* (1963), *Orido hallan (I Want a Solution)* (1975), and *'Afwan ayoha al-qanun (Pardon Me, Law)* (1985). Some of these films have had an influence on Egyptian society and have, in fact, contributed to changes to civil and family laws.

The effect of politics on the film industry has been a timeless phenomenon not only in international cinema, but also in Egyptian films

11.1. Poster for *Ana hurra (I Am Free)* (1959).

11.2. Poster for *Mirati mudir 'amm (My Wife Is a General Manager)* (1966).

11.3. Poster for *678* showing the three women protagonists and their spouses (2010).

11.4. Poster for *Nawwara* depicting the protagonist as a struggling woman, living in an impoverished neighborhood with no access to clean water or sanitation.

Gendered Modernity: On the Changing Role of Women in Modern Cinematic Cairo 203

(Buskirk, 2015). This effect was especially prominent during the British occupation as well as during the Nasserite era. More often than not, we find modernity serving whoever is in power rather than the common Egyptian. It is worth mentioning that filmmakers of the 1950s came of age during the period of the World War I, which can be said to have shaped their perspectives and contributed to their realistic approaches in their films (Youssef 2010). The main film types that emerged in this era were melodrama and realism. According to Maro Youssef, the films of this era are believed to highlight state policies aimed at creating what Youssef calls the "New Woman," who was modern, educated, and politically conscious, and an equal contributor to the production of the new Egyptian state. The British assumed that Egyptians were regressive and could not achieve modernity or reform the status of the Arab woman without their aid, which legitimized British control over all Egyptian resources. Youssef argues that the "New Woman" is a concept that surfaced around the British occupation, especially during the later part of the nineteenth century. It served as one of the "goals" of Egyptian independence (Youssef 2010).

Middle-class Women in the Mid-twentieth Century: Prerevolutionary Modernity in Cinematic Cairo

In this section, I analyze the two films of the 1950s, *Ana hurra* and *Mirati mudir 'amm*, to explore how the role of modern Egyptian women in Cairo was portrayed in the cinematic city after the 1952 Revolution. In addition, the various forms of indirect violence that women faced at that time as a result of modernity are examined. This will serve as a contrasting theme to the modern films that were made around the time of or post-date the 2011 Revolution, namely *678* and *Nawwara*, which will be analyzed in the next section of the chapter.

The first film *Ana hurra (I Am Free)*, produced in 1959, is based on a novel of the same title written in 1952 by Ihsan Abdel Quddous. The main protagonist is Amina (played by Lubna Abdel Aziz). Directed by Salah Abu Sayf, the film was the first to openly question the status of women in modern Egypt and to advocate a feminist woman's liberation message. *Ana hurra* defies the conservative conventions of Egyptian traditional society of the time. The film is an account of a college girl's perception of freedom and her frustrations with her life within the limitations of her society. It captures many of the feminist concepts that emerged after the 1952 Revolution and how they are reflected in scenes of urban life. Amina is a young woman living with her aunt's family, which also comprises the husband and the son—her cousin. Living in the popular urban district of Abbasiya in the late 1950s, Amina's life is always under surveillance.

In the apartment building where they live, there is such a strong social bond that all the neighbors observe her actions, and even just standing on the balcony is frowned upon. Through the first half of the film, Amina opposes the societal conventions that view women as merely housewives, preparing young girls for the role of cleaning the house, cooking, and pleasing the male members of the family. In the upper-middle class, women like Amina were supposed to be good entertainers; playing the piano or dancing were a bonus for girls. Neighbors and matchmakers were the only means to an arranged marriage. In *Ana horra*, not only is Amina's family trying to control her life, but the whole district of Abbasiya always has something to say about Amina's personal decisions and life encounters, and even attempts to dictate such decisions. Constrained by these traditional and closed mindsets, Amina rebels and always behaves differently. She develops a friendship with a Jewish family who teach her foreign languages, dancing, and skating, and open her eyes to modern life outside of the district of Abbasiya.

Although college education was unpopular for females at that time, Amina pursues her education at the American University in Cairo and after graduation gets a job at a private company. Amina feels she has started to enjoy her "freedom," even though it has come with a price and has brought new responsibilities. In the second part of the film, Amina finds out that she has to commit to fixed working hours and deadlines where all her time is "owned" and controlled by the company. At this point, she realizes that she is actually not free, as she had thought she would be. Coincidentally, she meets her neighbor 'Abbas, who has become editor in chief of a newspaper and who is also a political activist. They engage in long conversations about the concept of freedom in which Amina starts to consider how she can use her freedom to serve a purpose larger than her own personal gain: the freedom of her country. Believing in 'Abbas's ideology, she gets arrested while taking part in demonstrations and is sent to jail. The film ends with the couple getting married behind bars. Amina finally senses freedom.

Themes of urban modernity are presented differently through the film. Starting with scenes of the authentic streets of the Abbasiya district—which was founded in the earlier twentieth century as an elite district and by the time of the film was transforming into a middle-class district—moving on to the interior settings of the apartment, to the social clubs, and, lastly, the particularly feminine fashion of the time. Urban modernity is also expressed in the socio-behavioral aspects of daily events, such as the women-only gatherings for matchmaking, and so on. Other scenes depict different features of modernity from various other aspects of mid-twentieth-century urban life, such as scenes of

11.5. A scene from *Ana hurra* of Amina skating at the rollerskating rink while the curious men of Abbasiya stare at her and later initiate a public fight.

youth clubs, Downtown streets and apartments, the American University in Cairo, and "modern" corporate companies.

Amina's judgmental aunt criticizes her for refusing the proposal of a suitor after she has met with him and realized that he is too close-minded for her as he does not want her to have a career. Amina's prioritizing career ambitions over marriage and family were unusual for Cairene society and not yet generally accepted. However, her pursuit of freedom is somehow applauded by Cairenes as well as by the audience, as it fits with the vision of politicians and leaders at the time. This perception could be a result of not having enough female figures of authority or female politicians. In the first scene of *Ana horra*, Amina is standing on the balcony, resting her elbows on the handrail, overlooking al-Ganzoury Street in Abbasiya. She watches the male students of her school walking down the street and some of them look up at her, as well. Her aunt scolds her for acting indecently and "allowing people to watch her and stare and gaze at her as she stands outside on the balcony." Although the balcony is a part of the house, in this scene it is an urban setting where men can gaze at women and invade their privacy, as if they are watching a film.

The "right to the city" is defined by David Harvey as "far more than the individual liberty to access urban resources: it is a right to change ourselves by changing the city. It is, moreover, a common rather than an individual right since this transformation inevitably depends upon the exercise of a collective power to reshape the processes of urbanization"

(Harvey 1985, 5). Urban density and consumer culture in Egypt have increased the sort of behavior where women are also consumers in the public arena. Strict societal roles and gender biases make women less entitled to the city in some areas or at certain times in the Egyptian context. The balcony scene and the rollerskating scene where Amina is harassed suggest that women like Amina may not have the same "right to the city" as their male counterparts.

The second film under analysis here is the 1966 *Mirati mudir 'amm (My Wife Is a General Manager)*. Based on a story by 'Abdel Hamid Gouda al-Sahar and Saad Eldin Wahba, it is directed by Fatin 'Abdel Wahab, one of the pioneer Egyptian directors. The film chronicles the societal challenges faced by a woman once she successfully attains the position of a company's general manager. The main protagonist is 'Esmat (played by Shadya) and, at the beginning, her husband Hussein seems supportive of her success and proud of her promotion. Little does he know that 'Esmat, whose name can be used for both a male and a female, is assigned to the position of the head of the very public-sector construction company where he works. Later at the office, the husband's insecurities all of a sudden come to the fore when he realizes that it is his wife who has become his own boss. He snaps and even pretends that 'Esmat is not his wife. They decide to hide their relationship from their colleagues. In doing so, Hussein starts to hear gossip about his wife from the entire department.

'Esmat struggles to prove herself at work, while at the same time striving to please her husband at home. By the end of the film, 'Esmat has gradually succeeded and proven herself as a manager: she gains respect from her subordinates and leads the organization to remarkable national accomplishments. Throughout the film, numerous comic incidents highlight the conflict between the acceptance of women in the workforce, as a mid-twentieth-century Cairene phenomenon, and the unorthodoxy of them being in a managerial position from the point of view of male employees, including 'Esmat's husband. Subtle hints from her husband about how masculine she has become at home and the series of rumors among her work colleagues are examples of the indirect violence 'Esmat has to deal with. Themes of modernity appear vividly in the film, which showcases the modern design of the villa where 'Esmat and Hussein live in the modern district of Maadi. The exterior of the couple's villa even belongs to the Bauhaus style of architecture.

Maadi is a southern suburb of Cairo, founded in 1905 by the retired English-Canadian officer Alexander Adams. Shortly after the railway between Cairo to the north and Helwan to the south was built, Maadi emerged as a new neighborhood on the east bank of the Nile with unusual modern street planning and became mostly inhabited by expats and upper-class Egyptians.

11.6. A scene showing 'Esmat in the driveway in front of her villa, waiting for the company driver to drive her to work in *Mirati mudir 'amm*.

In *Mirati*, 'Esmat is assigned a company car with a private driver which takes her to work every day, while her husband drives an older car and even rides a bus in one scene. Halfway through the film, we see 'Esmat successfully managing her work and securing her new position in the construction company, encouraging the employees to have a progressive mindset and to forget the traditional and outdated ways of getting the work done. In one scene she tells her employees, "There is no use constructing new buildings if we have old-fashioned minds."

After several rumors spread among curious colleagues in the office, Hussein finally announces that 'Esmat is his wife. He starts to get annoyed by some colleagues as they keep asking him for personal favors related to his wife's managerial position, such as promotions and vacations. Tension arises in the office when 'Esmat reproaches Hussein in front of their colleagues for delaying some work. She publicly announces that his actions were irresponsible and deducts part of his salary as a penalty. Hussein expresses his discontent later at home, which shows he is having difficulty adapting to this "modern" and unprecedented situation and is unable to detach his private life from his professional one.

After a prestigious construction project is finished, 'Esmat is invited to give a speech at the Conference of Working Women to share her success

story. She says that she owes her success to her husband's support and highlights how he is progressive, educated, and cultured. However, he is nowhere to be found among the audience. Abu al-Kheir, a colleague who is always seen praying and who is known as the office meddler, decides to interfere and force Hussein to attend. This is when Hussein finds himself getting dragged to the conference building by the police. Feeling humiliated, he throws a tantrum in front of their colleagues and tells 'Esmat that he has had enough and that from now on she will have to stay at home. Shortly after, a powerful scene depicts Hussein looking at the River Nile as he wanders along the waterfront promenade of Corniche al-Maadi. He has a moment of clarity as he watches a fisherman and his wife in a simple wooden boat on the Nile. The woman rows the boat while the man catches the fish, working together as a team. Later at home, he apologizes to 'Esmat, admits he was wrong, and explains that he lost his nerves after the misunderstanding with the police.

The team bids a sad farewell to 'Esmat after she decides to move to another office. As 'Esmat introduces herself to her new team, a plot twist unfolds as Hussein suddenly and excitedly enters the office and announces that he will be joining the team too. The final scene closes with the reunited happy couple helping each other push their broken-down car in the streets of Maadi overlooking the Nile, symbolizing equal participation in the workforce by men and women. The cinematography of the film cleverly captures this scene of the couple in correspondence with the previous scene of the fishing couple, and in contrast to the depiction of 'Esmat pushing the car on her own in another earlier scene, showing how a man and woman should work together equally as a team. *Mirati* documents the birth of a new era where women are not only successfully taking leading positions in their jobs, but are also choosing their own roles in society rather than holding on to roles of the past that were predetermined by previous generations. The film also documents how it took a lot of effort for members within society to adapt and accept the unfamiliar modern phenomenon of female leaders.

The two films of the sixties shed light on women's newly claimed rights in Egypt—particularly Cairo—before and after the 1952 army-initiated revolution. *Ana hurra* sheds light on the difference in the concept of freedom between the traditional conservative Cairene community and the developing revolutionary society. *Mirati* illustrates the normalization of education, work, and professional escalation for women according to the updated Egyptian constitution, while highlighting the unconventionality of a woman being a manager despite her experience. However, both films reveal a level of harassment toward women. As well as her family's physical abuse, Amina is also verbally harassed by the youngsters from Abbasiya and

her female neighbors who never accept her aspirations for freedom. She is also frequently approached by the customers of the company where she works. The harassment and rejection of her chosen role worsens in *Mirati*, where 'Esmat experiences it from her driver and the rest of the employees, and intensifies with her husband's fury at the climax of the film.

Modernity is expressed both in the physical settings and—more importantly—in the ideologies of the society represented in *Mirati*. It is a modernity that is imposed from the top before people have been able to adjust to its consequences. The modern here is not only expressed in the interior details and the open-plan offices where 'Esmat works, but also in the newly introduced phenomenon of a woman being her husband's boss. A woman being successful at her work had become accepted as normal in Egyptian society by then, yet the subversive "modern" element here is the concept of surpassing her husband's position within the professional hierarchy. We see a similar situation more than four decades later in the 2007 romance titled *Taymour and Shafika* but with a rather regressive turn of events. The latter film should be expected to show a more open-minded progressive approach that encourages women's liberation. However, the ending turns out to be disappointing as Shafika sacrifices her prestigious position in the Ministry of External Affairs to marry her irrationally close-minded lover Taymour, who works as her bodyguard.

The term "modernity" has been debated by various scholars such as the American Marxist Marshall Berman, who defines tradition mainly as the "encounter between classes made possible as a result of the societal changes of the nineteenth century" (Berman 1998, 5). Perry Anderson refines Berman's definition of modernity as a host of social processes such as scientific discoveries, demographic transformations, urban expansions, national states, and mass movements (Anderson 1984). According to Berman, modernity is "the ideas that aim to make men and women the subjects as well as the objects of modernization, to give them the power to change the world that is changing them, to make their way through the maelstrom and make it their own visions and values that have come to be loosely grouped together under the name of 'modernism.'" In many films, such as *Mirati modir 'am*, we see this concept of the protagonist having her own voice and attempting to change perceptions. Anderson, on the other hand, considers modernity as "neither an economic process nor cultural vision but the historical experience mediating the one to the other." In other words, modernity is somehow "development" (Anderson 1984, 97).

This "historic experience" Anderson describes can help us understand how modernity can be a result of a series of political events throughout history, as well as an experience that leads to the development of society. This understanding of modernity explains how political events, especially

revolutions, are closely interlinked to modern phenomena. This is apparent in all four films discussed in this chapter, especially *Ana horra*, *678*, and *Nawwara*, as they showcase consequences of such political incidents.

The films in this chapter, *Ana hurra* in particular, express this modernity of postrevolution, which might be the reason why the director manipulated the ending of *Ana hurra* to be more revolution centric, as discussed earlier in the chapter. The film ends with a scene of Amina and 'Abbas, having served their time together in prison, on their way to march in a political protest. In *Mirati*, the modernity aspect is expressed vividly in the elaborate modern-style interior designs of the locations.

However, this is still a continuation of the postrevolutionary modernity. Interestingly, when we reflect on the real Cairo of the time rather than the cinematic one, we find that women had been granted most of their basic rights three years before *Ana hurra* and ten years before *Mirati* were released. As of 1956, women in Egypt acquired the full right to vote. It was explicitly stated in the 1956 Egyptian constitution in order to prevent gender-based discrimination. The constitution also included laws that protected women's rights in the workforce and guaranteed maternity leave. Paradoxically, and despite other aspects of control over women, Egypt is one of the few countries that by law grants women a longer paid maternity leave, possibly a leftover from its socialist past.

Middle-class Women at the Turn of the Twenty-first Century: Consumeristic Modernity in Cinematic Cairo

In contrast to the films of the twentieth century, the films of the early 2000s provide a clear chronological juxtaposition between the two eras. The films *678* and *Nawwara* were respectively produced right before and after the fall of Mubarak's regime in the popular 2011 Revolution. Despite the fact that there is a half century of difference between the two pairs of films—*Ana hurra* and *Mirati* against *678* and *Nawwara*—some things have changed and others have remained the same. One noticeable change is that middle-class women have undergone tremendous socio-economic deterioration rather than progress. In these relatively recent cinematic works, we see urban exploitation of women in a more violent form.

The film *678* was released in 2010. It is authored and directed by the award-winning Mohamed Diab. At this time, women largely occupied the workplace and provided financial support for their families. However, some Egyptian women were—and are—still having a hard time going to work, not because of societal norms like in the fifties and sixties, but due to the modern phenomenon of street harassment. The film showcases three women from three different societal sectors and their exposure to different kinds of harassment in the city. The three central characters are the

upper-class Sabah, middle-class aspiring stand-up comedian Nelly, and the working-class Fayza. The wealthy Sabah gets violently harassed by a group of men in the crowds at Cairo Stadium. She is then divorced by her husband as both have difficulty coping with the situation and its societal repercussions. She starts a nonprofit nongovernmental organization to raise awareness among girls and to teach them how to defend themselves. Meanwhile, Nelly, the middle-class telemarketer and comedian, receives indecent invitations from random male clients over the phone. Her fate is sealed when she gets horrifyingly dragged along the street by an unknown male harasser while he is driving his car. Nelly decides to file the nation's first sexual harassment lawsuit. She joins Sabah's organization, where the three women meet. The third protagonist is Fayza, the lower-class mother of two, who is harassed daily on the public bus.

After joining Sabah's organization, Fayza decides to physically defend herself using the pin from her headscarf to stab her harassers in their private parts. Doing so, she injures several men who end up having to go to hospital, but refuse to confess the cause of their injury. After one of the harassment incidents, Fayza finally gathers her courage and brings charges against the microbus driver at the police station, defying all her community's counterarguments. The incidents escalate as each of the women files a legal case requesting the issuing of a law to criminalize harassment. A

11.7. A scene from *678* showing Fayza squeezed among men on the public bus.

sympathetic police detective investigating the stabbings eventually gets involved, bringing all three women in for questioning. He eventually sets them free. The film portrays the peak of violence against women in Cairo, at the point where it has escalated to reach an extreme form of physical harassment. Most of the scenes are filmed in real urban settings: Cairo Stadium, public transport, public squares, police stations, streets, and in different Cairene districts. It reveals the fact that dense, modern Cairo has transformed into a cruel arena that complicates the lives of women and exposes them to multiple savage encounters with unknown men. The intense crowding within urban spaces creates a platform for people to be standing in close proximity to each other, as in the case of Sabah.

In the first five minutes of the film, we watch Fayza taking a taxi to go to work. She notices the male taxi driver suspiciously adjusting his rear mirror to look at her rather than look at the cars while he starts to make inappropriate facial expressions. She immediately notices the sexual innuendo, feels uncomfortable, and jumps out of the taxi to take the bus. Interestingly, this scene strongly resembles a scene in *Mirati modir 'am* where 'Esmat rides in the car with her public-sector company's driver to go to work. She notices how he adjusts the mirror so that he can get a view of her and tells him to "keep things the way they were" when her male predecessor rode the car. She realizes that this would never happen to a man on his way to work. Although this is a subtle move, it shows how men in urban settings think it is acceptable to objectify women and consume them as sexual objects. At this point in history, Cairo has become familiar with consumer culture as a part of the "modern" city. One wonders whether the consumption of women in the neoliberal Cairo of today represents an expansion of its modern consumer culture!

Even if there is a general definition of urban modernity, modernity in these films cannot be defined by its historic attributes; rather it is presented differently in each film. Newly introduced ideologies, lifestyles, and habits, as well as new perceptions of public spaces constitute the so-called modern Cairene society. This modernity is also manifested in the reshaped public spaces of the time.

For example, the public transportation system with its buses in *678* has been around for decades, even with its huge crowds. But the violation of personal space inside the buses is a contemporary phenomenon which has resulted in excessive sexual harassment on the buses. In addition, the increasing number of working women in lower- and middle-class families along with the chaos that followed the 2011 Revolution resulted in an increase in the parallel phenomenon of street harassment.

For the most recent film *Nawwara*, we see the emergence of the woman as the main breadwinner, who works as a maid to provide for her family.

This female prototype has become more common as a "modern" aspect of society since the 2011 Revolution as well as being a result of the economic crisis that followed the revolution. *Nawwara* is written and directed by another woman, Hala Khalil, and the main protagonist is Nawwara, played by Menna Shalaby. The film is set during the outbreak of the January 25 Revolution. Nawwara is a young woman who lives in one of Cairo's slums. She works as a domestic maid for a rich family that lives in a villa in the luxurious Lakeview gated compound located on the periphery of the city in a new expansion called New Cairo. The villa residents are closely linked to the Mubarak regime. Nawwara is the provider for her grandmother and for her unemployed husband 'Aly, who struggles to find work to support his family and his elderly father.

Nawwara manages to save some money so she can afford a tiny apartment for herself and 'Aly to live in. The film starts by highlighting the daily struggle, with Nawwara waking up early, having to walk a long distance to fetch fresh water in heavy buckets for her grandmother to store and use for the day, then her horrifying, long journey to her work by different means of public transportation. Arriving at the gated community, Nawwara has to comply with the totally different Cairo of the upper class. Eventually, the January 2011 Revolution unfolds. The family Nawwara works for decides to flee Egypt for fear of arrest and assigns her to look after the house in their absence. They give her a considerable amount of money as a reward in advance. Thus, Nawwara stays in her employers' empty home and calls 'Aly, with whom she spends a night in the villa. When a travel ban and property seizure orders are issued against the family, the police arrive at the villa and confiscate all Nawwara's money, leaving her with nothing.

Throughout the film, a continuous contrast is displayed between the compound where she works and the deteriorated urban slum where she lives. Depressing scenes exhibit two different Cairos. She and her neighbors have poor electricity service, no access to clean water, muddy and unpaved roads, and accommodation unfit for human habitation that houses a high-density population of desperate souls. As the film gives glimpses of the class conflicts, strong urban contrasts, and intersectional discrimination, it also accentuates the struggles of low-class women in twenty-first-century Cairo. In *Nawwara*, the contrast between the two worlds is emphasized from the opening scene on. The director cleverly captures Nawwara splashing her face with water from a bucket in her tiny impoverished house in an informal settlement. Right after this scene, we see a rich woman swimming in her private pool in a residential compound, Lakeview, in the Fifth Settlement.

In the latter two films, we witness how consumer culture has not only affected the way people experience public spaces, but also how it has

11.8. A scene showing Nawwara as she enters the upper-class residence where she works as a housemaid for a family with a political background.

created new challenges for women. This has been thoroughly analyzed by Warsh and Malleck. They argue that the postwar period has initiated a new culture of consumption and has affected the way we perceive gendered social roles.

> Along with this accelerating consumerism, the mobilization of citizenry during the Great War forced a consideration of gendered social roles, with the result that, in the interwar period, ideas of womanhood (and manhood) challenged a status quo that was already in flux. The intersection of the changes in gender roles and the growth of mass consumption presented new challenges and opportunities. (Warsh and Malleck 2013, 6)

They also mention how different mass-produced consumer products—such as fast foods, ready-made clothes, and labor-saving household devices that were advertised through the media—had an impact. Such products were acquired because they promised to free up women to pursue other interests.

We can see how this consumer culture has been manifested in different forms within society, and how cinema has presented it. Although the films chosen for analysis here do not focus on consumerism in a materialistic sense, they show us some consequences that consumer culture has bestowed upon our society. They present how women's values, attitudes, and

behaviors have changed, and how women are at times viewed as commodities by society, becoming objects of consumption themselves. This does not mean that the woman is always bluntly objectified or over sexualized as in some Hollywood films, but women are still perceived as possessions.

This is apparent in *Ana hurra* when the men from Abbasiya deal with Amina in an overly possessive manner as if she were their personal property simply because they live in the same neighborhood. We witness this toxic possessiveness and sense of entitlement more abruptly in *678* with the men who harass Fayza on public transport, as well as the gang rape incident that apparently occurs in the midst of crowds. In this context, the public space acts as the market and the women are regarded as commodities, just like any other consumer goods.

In the most recent film, *Nawwara*, on the other hand, the protagonist's husband falls into the trap of materialistic consumerism as he keeps buying stuff relentlessly and falls heavily into debt. Nawwara tries to work extra hours to help pay off his debts. She is the main source of financial support for the couple, who are unable to consummate their marriage since they cannot afford to buy an apartment. Both films, *678* and *Nawwara*, do not only reveal the urban deterioration in Cairo that has reached its extreme, but also the socio-economic degradation that reigned over Egypt during the Mubarak rule.

The resulting socio-cultural gap and its impact on urbanization is carefully captured in both films. In *678*, the film portrays women experiencing violence within different urban settings in Cairo, mainly taxis and public buses, but in the famous Tahrir Square in Downtown Cairo as well. The portrayals in the two twenty-first-century films, the protagonists as well as the supporting female characters, identify working women in Cairo as the major or the sole breadwinners for their families and hence a cornerstone in their societies. Despite this presence in the labor force, women in the city—from all classes and sectors—are not safe from urban violence and gendered domination, which is strongly expressed in numerous forms of violent harassment.

In the early 1990s, some theorists offered interesting perspectives on city culture. In her book *The Sphinx in the City*, Elizabeth Wilson explains that the city culture has been developed as one pertaining to men: "Woman represented feeling, sexuality and even chaos, man was rationality and control" (Wilson 1991, 6). Within this context, women present a threat, and in two ways. First, in the metropolis, women are freer, in spite of all the associated dangers, because it allows them to escape the rigidity of patriarchal social controls which are often more powerful in smaller communities. Second, and following from this, women have also been seen as representing disorder in the metropolis. There is fear of the city as a

realm of uncontrolled and chaotic sexual license. Hence, some believe that control of women in cities becomes necessary to avert this outcome. This recurring portrayal of women as a "threat" as discussed by Wilson seems to be one of the main issues when it comes to violence against women on the streets of Cairo. Although this concept was more radically expressed in the streets of the United States during the 1990s, it still resonates with the film *678*. Perhaps it is this deep-rooted belief held by some men that a woman has risked her safety by stepping out into the streets that allows criminal male perpetrators to justify their assaults.

The Changing Role of Women in Modern Cinematic Cairo: A Paradoxical Modernity?

The synopses of the four films, above, reveal several paradoxical facts about women in Cairo. The 1959 drama *Ana hurra* features the rebellious protagonist and middle-class high schooler Amina living in Abbasiya then moving to Downtown. It narrates the struggle of a middle-class woman trying to free herself from the restrictions forced upon her by her family and her neighborhood. A few years later, the popular comedy *Mirati modir 'am* (1966) shows that even liberated upper-middle-class modern women can face discrimination in the workplace as when 'Esmat becomes a general manager. Later, in 2010, we see how *678* depicts incidents of sexual harassment of women around the city, regardless of their socio-economic strata. Shortly after the January 25 Revolution, the 2014 film *Nawwara* discloses the inhuman living conditions of Cairo's lower working class. Indeed, this study of women's roles through the lens of Egyptian cinema provides an essential chronological investigation of the portrayal of Egyptian women in twentieth-century Cairo and at the beginning of the twenty-first century, and the way modernity affected their life in the city.

The changing role of women in modern cinematic Cairo from the 1950s to the early 2000s is intertwined with the concepts of intersectionality, identity, and class differences. Being a woman in a city going through turbulent political changes is one thing, and being a female of a low social class facing double the challenges is yet another issue. One of the analytical tools which helps capture the dynamic power of the relationships between social groups is the concept of intersectionality. The originator of the term "intersectionality" is the legal scholar Kimberlé Crenshaw, who coined it to describe overlapping systems of discrimination. She underscores the "multidimensionality" of marginalized subjects' life experiences (Crenshaw 1989). Crenshaw argues that our identities are complex and that marginalized groups can face oppression at the intersections of identity. In 2005, Leslie McCall stressed the importance of intersectionality, calling it "the most important theoretical contribution to women's studies, in conjunction

with related fields, that has been made so far" (McCall 2005). This important theoretical contribution has become a multidisciplinary approach for analyzing subjects' experiences of both identity and oppression.

Oppression at the intersections of class and gender is slightly hinted at in the 1950s' *Ana Horra*, but is witnessed at its greatest in *Nawwara*. The film *678* captures some of the struggles that can only be experienced by someone who is both a woman and a citizen of the urban poor. In one scene, Fayza's lower-class husband scolds her for wanting to take a taxi to escape harassment rather than take the public bus to go to her work. He implies that taxis are only for the rich people, exclaiming, "Whose daughter do you think you are to be riding taxis?"

Intersectionality themes are presented in other recent films such as *Yom lel-sittat (A Day for Women)* (2016), which tells the stories of women in one of the working-class neighborhoods who decide to come together at a women's pool in the local youth center and discuss their daily struggles. Outside of Cairo, the exploitation of marginalized women in Upper Egypt is also depicted in one of the earlier classic works of the 1950s starring Faten Hamama and entitled *Du'aa' al-karawan (The Nightingale's Prayer)* (1959). The contrast between films set in Cairo versus Upper Egypt shows that the threats faced by non-Cairene women, such as honor killings, are different and more extreme.

In *Popular Egyptian Cinema: Gender, Class, and Nation*, film scholar Viola Shafik has contributed greatly to the field of Egyptian cinema studies. In the gender-oriented section in her book, she uses what she considers feminist film methods to analyze multiple Egyptian films, an approach derived from feminist theory (Shafik 2007). Shafik has pointed out the concept of "misery feminism" as a recurring theme in Egyptian cinema. In this case, the woman protagonist in a film is usually struggling and may be harshly victimized in order to arouse the audience's sympathy. In *Ana horra*, after Amina becomes an ally to 'Abbas in his rebellious political views, she helps cover up for protesters and hides one of them in her house where the police later arrest her. However, the director changed the miserable ending of the novel, where Amina leaves her job and ends up being the mistress of 'Abbas, into a more optimistic ending where the couple gets married and ends up fighting together for their political freedom. Unlike the novel which was written before the 1952 Revolution, the film was released after it and after the overthrow of King Faruq's regime, and the director may have felt the need to accommodate the new political and social climate.

We recognize this very melodramatic theme in *Nawwara* where the protagonist is portrayed as a hardworking, kindhearted, gullible woman from a poor Cairo slum. Strong melodramatic effects are induced by the contrasting scenes of the urban setting of Nawwara's home with poor

amenities in the worn-out slum and of her workplace in the fancy, high-end, gated residential community in New Cairo. The camera zooms in over the scarce and contaminated water Nawwara uses to wash her face where she lives, and then the scene shifts to the spacious pool of the rich family for whom she works.

The script of the film contains multiple analogies between Nawwara (exemplifying her societal sector) and weak, helpless animals. An example is a scene in which she compares her lower-class family to a flock of small chicks they raise at their home, describing how they are helplessly weak and defenseless in the face of any powerful entity. The ending of the film shows Nawwara being arrested on false charges and being powerless and helpless against the police. Such melodrama at the climax of the film would not be possible without the stark urban contrast having been illustrated right from the opening scene of the film, and its accentuation throughout.

Mulvey (1989) introduces the idea of "to-be-looked-at-ness" as a mechanism to understand the male gaze. I believe her formulation is useful in analyzing gendered modernity in relation to Cairene women. The way Amina in *Ana hurra* is watched on the balcony as an object of speculation by the prying eyes of Abbasiya school boys and then, again, as an object of desire in the rollerskating scene in the al-Daher district is a striking example of the male gaze. Mulvey suggests that sexual inequality—the unevenness of social and political power between men and women—is a controlling social force in the cinematic realm. The way Amina is described by Ihsan Abdel Kouddous in the novel as a curvy, attractive woman who passively and unintentionally attracts the men of Abbasiya is an example of what Mulvey calls the "to-be-looked-at-ness," where women are considered as "spectacles" and the men are "the bearers of the look."

Additionally, Abbasiya men in the rollerskating scene go all the way to al-Daher to watch Amina skate at the rink. Feeling overprotective about the "daughter of their neighborhood," they assume an attitude of toxic masculinity and they fight with her just because she has broken the social norms of their conservative community. However, Amina's role is not completely passive, as she herself actively engages in these gazes and searches for 'Abbas among the groups of men walking in al-Ganzoury Street. She spends a lot of time gazing from her balcony, considered socially inappropriate by her aunt and uncle. Although the phenomenon of street harassment was not as prevalent at that time in real Cairo as it is today, some incidents in this film and in the novel indicate that a subtler form of street harassment existed, especially in the form of verbal harassment experienced by Amina. For example, the following excerpt from the novel portrays the urban violation of Amina's personal space and the sense of entitlement of men toward their female neighbor:

Word had spread among them that Amina was an easy girl who would offer anything to anyone; if she could offer herself like this to the boys of al-Daher neighborhood then wouldn't it mean that they, the boys of Abbassiya, were entitled to a piece of her too? (Ihsan Abdel Kouddous, *Ana horra*, 1952, 89, author's translation.)

The men here are strolling around the city's public spaces with no purpose other than watching Amina. Are these men then simply flaneurs? These ambivalent figures represent the ability to wander and to be detached from society with no purpose other than to be close observers of the urban scene. Charles Baudelaire describes the flaneur as an anonymous man who aimlessly "strolls" the streets of nineteenth-century France (Mitchell 2008). The flaneur was described in European literature and was portrayed as a cultural observer of modern urban life, rather than a man with underlying negative motives. However, the flaneur was considered a modern phenomenon in the mid-nineteenth century and has since become a permanent feature of the modern city. Additionally, the flaneur is exclusively a male figure, who consumes the city and its women. Even the term itself comes from the French masculine noun *flâneur*—basically meaning a stroller, lounger, or loafer—which itself comes from the French verb *flâner*, which translates as "to stroll."

Mulvey argues that most popular cinematic works are filmed in ways that satisfy masculine scopophilia. Along these lines, another example of the "Male Gaze" can be seen in *Mirati*. 'Esmat (a unisex name) is portrayed in one scene in the bedroom of her ultramodern house as a woman with a fake mustache. This is a nightmare created in the head of her husband who is having trouble accepting that his wife is in a higher position at work than himself. In the office, 'Esmat's husband hides the fact for some time that she is his wife to avoid the awkward reactions of his male colleagues.

The scene mentioned earlier when 'Esmat faces the subtle encounter with the male driver on her first day as general manager when he tilts the rear mirror to get a better view of her would be looked upon today as an unacceptable type of harassment. But since most managers at that time were men, Mulvey's concept fully applies here. Hence, it is understandable why the film director—probably unintentionally—being aware of the biases within society at the time, retains the scene as a comic scene to please and not alienate his male audience.

With the evolution of modernity, we witness new patterns of urban life and new modes of experience. Modernity often acts as a double-edged sword. Although it may seem that modernity has helped women on their path to freedom, it has brought with it many undesirable modern phenomena such as street harassment. The acknowledgment of modernity having

negative consequences on societies is not a new concept. In 1995, the sociologist Stuart Hall mentioned that "this is the beginning of modernity as trouble. Not modernity as enlightenment and progress, but modernity as a problem" (Hall 1995, 3). Hall has researched the nature of modernity and analyzed what developed industrial societies look like and how they work. His idea of modernity as problematic and unsettling is further tied to the revision of older definitions of identity based on psychoanalysis and the construction of a distinct sense of "Self" and "Other" (AlSayyad, 2006).

On the Consequences of Modernity

Since the first quarter of the twentieth century, Cairene women have struggled to break societal conventions and taboos, to get a better education, to work, and to achieve self-fulfillment. However, their struggle has always been challenged by male prejudice. The four films accentuate the fact that the changing role of women over the last few decades might have given women the "illusion" of freedom disguised behind ongoing burdens of responsibilities toward their families and communities. Harassment has extended in nature and scope from overprotection, to dominance in the home and neighborhood, to verbal and physical abuse, and, finally, to physical sexual harassment. Although the earlier and most recent Egyptian constitutions passed after revolutions stress gender equity, to date, this remains an ideal state not yet reached in the Cairene urban reality.

Cinematic Cairo has not only exposed the effect of modernity and consumer culture on women's changing roles during the late twentieth century, but has also revealed that persistent male bias and patriarchy still exist in Egyptian society in some areas. Ironically, and based on our four films, it may be argued that modernity has not liberated women in either the real or the reel world and, in fact, may have instead burdened them with more responsibilities, hence creating more possibilities for abuse. The recurring melodramatic victimization of women as shown in the twenty-first-century films is definitely a reversal of the trend to showcase empowered women in the twentieth-century movies.

Perhaps what Egyptian cinema needs today is to pay attention to the practices of gender mainstreaming which has recently been attempted in Hollywood. Gender mainstreaming, introduced in the late 1980s, is an approach to policy-making that takes into account both women's and men's interests and concerns (Kabeer 2008). This requires observing and taking into account the inequalities between women and men at all times and in all areas. It is the process of assessing the implications of any planned action for both women and men.

The four films highlight the connections between personal experience and larger social and political structures. Clearly, politics and political

orientation can substantially affect the private everyday lives of ordinary people, especially low-class working women. In the end, it all boils down to the 1960s slogan of second-wave feminism, which is still relevant to all of us today: "The personal is political."

References

Abdel Kouddous, I. 1952. *Ana horra.*

AlSayyad, N. A. 2006. *Cinematic Urbanism: A History of the Modern from Reel to Real.* London: Routledge.

Anderson, P. 1984. "Modernity and Revolution." *New Left Review* I, 144, https://newleftreview.org/issues/i144/articles/perry-anderson-modernity-and-revolution

Berman, M. 1998. *All That Is Solid Melts into Air.* New York: Penguin Books.

Buskirk, W. 2015. "Egyptian Film and Feminism: Egypt's View of Women through Cinema." *Cinesthesia* 4, 2, https://scholarworks.gvsu.edu/cine/vol4/iss2/1/

Crenshaw, K. 1989. "Demarginalizing the Intersection of Race and Sex. A Black Feminist Critique of Antidiscrimination Doctrine, Feminist Theory and Antiracist Policies." *The University of Chicago Legal Forum* 140: 139–67.

Hall, S. 1995. "Introduction." In *Modernity: An Introduction to Modern Societies*, edited by S. Hall, D. Held, D. Hubert, and K. Thompson, 3–18. Malden, MA: Basil Blackwell Inc.

Kabeer, N. 2008. *Mainstreaming Gender in Social Protection for the Informal Economy.* London: The Commonwealth Bookshop.

McCall, L. 2005. *The Complexity of Intersectionality.* Chicago: University of Chicago Press.

Mitchell, J. 2008. "Painting Modern Life: A History of the Flaneur from Baudelaire to Bob Dylan." MA Thesis, Dalhousie University, Halifax, NS, https://www.academia.edu/22948359/Painting_Modern_Life_A_History_of_the_Flaneur_from_Baudelaire_to_Bob_Dylan_2008_

Mulvey, L. 1989. *Visual Pleasure and Narrative Cinema.* London: Palgrave Macmillan.

Shafik, V. 2007. *Popular Egyptian Cinema: Gender, Class, and Nation.* Cairo and New York: The American University in Cairo Press.

Warsh, C.L.K., and D. Malleck. 2013. *Consuming Modernity: Gendered Behaviour and Consumerism Before the Baby Boom.* Vancouver: University of British Columbia Press.

Wilson, E. 1991. *The Sphinx in the City.* Oakland, CA: University of California Press.

Youssef, M. 2010. "Egyptian State Feminism on the Silver Screen? The Depiction of the 'New Women' in Egyptian Films During the Nasser Years (1954–1967)," MA thesis, George Washington University, Washington, DC.

12

Religious Tolerance in the Cairo of the Movies, 1950s–2000s

Hala A. Hassanien

The seed that yields its fruits does not ask whose hand has planted it.

With these words, the priest in the 2008 film *Hasan wa Morqos* starts his statement at an official conference on national unity, denouncing terrorism and condemning fundamentalism on both sides. His worries expressed here are very real and have actually driven my analytic journey in this chapter.

In Cairo, as well as in other cities in Egypt, until the early 1950s, Egyptian Muslims, Christians, and Jews coexisted peacefully together, and Cairo was still home for people from all around the world. However, by the late 1960s, not only had the entire Jewish community disappeared from Egypt, but also coexistence between Muslims and Christians, and even between people of the same religion, had fallen apart. In the following pages I will track the cinematic representation of this decline in religious coexistence in Cairene society through the urban conditions and the changes brought about by modernity. I will specifically use two comedies: the 1954 *Hasan wa Murqus wa Kuhin* and the 2008 *Hasan wa Murqus*.

Muslims, Christians, and Jews in Egyptian Films

The 1923 silent film *Mo'alim Barsum yabhath 'an wazifa* was probably the first film in the history of Egyptian filmmaking and, interestingly, it was about the cordial relationship between two friends, a Muslim and a Christian. In addition, through their films in the 1930s, both the Jewish actor Shalom and the Jewish director Togo Mizrahi reflected Alexandria's diversity, where Shalom unprecedentedly carried his real Jewish name.

However, Christian and Jewish social concerns have seldom been represented in Egyptian cinema, apart from in a few films; only a very limited number of the approximately 3,100 fiction films released by the

12.1. Poster for *Hasan wa Murqus wa Kuhin* (1954).

12.2. Poster for *Hasan wa Murqus* (2008).

Egyptian film industry up to 2005 dealt seriously with the Coptic religious environment (Shafik 2007), which also applies to issues concerning Jews. Among the Egyptian films which deal with religiosity are *al-Sheikh Hasan* (1952), which is a dramatic love story between a sheikh and a Christian girl; *Hasan wa Murqus wa Kuhin* (1954), which is about the cordial relationship between three partners—a Muslim, a Christian, and a Jew; *Akher shaqawa* (1964), in which a Jewish family exploits their two young Muslim neighbors; *al-Erhab wa-l-kebab (Terrorism and Kebab)* (1992), which criticizes the absurdity of the Egyptian bureaucracy, and in which a father is mistakenly considered a terrorist; *al-Erhaby (The Terrorist)* (1993), which shows an Islamic fundamentalist who eventually starts to doubt his own beliefs; *Teyour al-zalam* (1995), which depicts the power struggle between the ruling regime and Islamists; *al-Tahwila* (1996), which tells the story of a corrupt officer who unfairly arrests an innocent Christian citizen after the original convict escapes; and *Baheb al-cima* (2004), in which a Christian fanatic father considers all fun and artistic activities, including cinema, a sin. The 2008 *Hasan wa Murqus* is about the steep decline in the relationship between Muslims and Christians.

Among these films and others, the two films *Hasan wa Murqus wa Kuhin* and *Hasan wa Murqus* together cover the time period I am investigating while also providing a wider contradistinctive picture that helps track the change in religious coexistence in Cairene society. The first part of this chapter starts with a brief summary of both films, reflecting the relationship

between the three religious groups in Cairene society, followed by a timeline of this relationship, and finally drawing a framework for the cinematic contradistinctive picture of Cairo. The second part includes an analysis that cinematically traces the change in religious coexistence in Cairo's urbanism and modernity, followed by some concluding remarks.

Hasan wa Murqus wa Kuhin, produced in 1950 and released in 1954, was directed and scripted by Fouad el Gazayerli. The film is about three affluent, friendly partners who successfully run their pharmacy together: the Muslim Hasan (played by Abdel Fattah el-Kosary), the Christian Morqos (played by Mohamed Kamal), and the Jewish Cohen (played by Estephan Rosty). The three partners, who consider themselves *awlad balad* (literally "sons of the country" or "salt of the earth"), actually represent the privileged class in a capitalist order. Hasan is moving from the older part of the city to modern Cairo, to live on a *dahabiya* (houseboat) at al-Zamalek. He seems like a kind father, but insists on marrying his daughter to a rich man. Morqos, from a city in Upper Egypt, lives in the Coptic quarter of Mari Girgis. Cohen, though quite wealthy like his partners, lives in a *hara* (a community based around a street or alley). He seems to be a caring father. His daughter, a modern young lady, is also employed in the pharmacy.

'Abbas (played by Hasan Fayek) is a poor worker in the pharmacy and is the true *ibn balad* (singular of *awlad balad* above). He lives in the old district of al-Qal'a, in a humble room overlooking Sultan Hasan Mosque, in a house owned by his cheerful, funny, and popular neighbor Umm Tenten (played by Zeinat Sidqy), who desperately loves and supports him. Yet, 'Abbas loves Hasan's daughter, while the modern young lady is in love with a young man her own age. One day, while flirting with Hasan's daughter, 'Abbas is caught by Hasan, who fires him as a result. But as Morqos has coincidentally just discovered that 'Abbas has inherited LE 80,000 and has not yet been informed, the three partners proactively plan to exploit and deceive 'Abbas. 'Abbas returns to work with a new contract and on a higher salary, under the condition that whoever terminates the contract will pay the other LE 20,000. 'Abbas falls into the trap, and, just as he has signed, he discovers that he has inherited the large sum of money from his rich uncle. Dazzled, 'Abbas embarks on his journey toward a life of luxury, but soon finds himself asked to pay back the LE 20,000. He returns to work, planning to counteract their plot. Meanwhile, a famous actress who has accidently clashed with 'Abbas in a restaurant refuses to help the plotters as originally planned unless they fire 'Abbas. Consequently, the three partners resort to making use of 'Abbas's love for Hasan's daughter. 'Abbas, discovering the plot, ends the contract problem on the condition that Hasan's daughter marries the young man she loves. The film ends with a scene where 'Abbas goes to al-Qal'a and finds Umm Tenten feeding

geese on the roof. He is not alone, as he has brought with him the *ma'zoun*. Finally, Umm Tenten marries 'Abbas, the man of her dreams.

Fifty-four years later, in 2008, in response to the growing sectarian division between Muslims and Christians, *Hasan wa Murqus* was produced, purposefully using the 1954 film title and purposefully, too, without "Cohen." The film, which was first released in July 2008, is a story by Youssef Ma'aty about a sheikh (played by Omar Sharif) and a priest (played by 'Adel Imam) who are forced to go undercover after fundamentalists from their own faiths attempt to assassinate them. So, the priest becomes Sheikh Hasan al-'Attar, and the sheikh becomes Morqos, the Christian. They both, coincidentally, move to a safe house in a Coptic quarter and meet each other, in their new disguises and religious identities. Consequently, through this complex masquerade, as both families mistakenly believe that they both belong to the same faith, funny religiously based paradoxes are created and developed. Both the sheikh's and the priest's families, who belong to the mid- and upper-middle classes respectively, seem like conservative and ordinary citizens. The friendship between the two families is deepened through the relationship of both wives, and their children, who unavoidably fall in love.

In the Coptic quarter, the Coptic jeweler's son, seeking to marry the sheikh's daughter, thinking that she is Christian like him, fuels the wrath of the neighborhood after noticing her relationship with the supposedly Muslim neighbor, in reality the priest's son. As interreligious clashes heat up, both families separately decide to move out. As they meet coincidentally at their doorsteps, they realize that they are destined to stay together, and, indeed, head off together to Alexandria. One night, in a romantic scene on Stanley Bridge, over the bay, the two young lovers, filled with innocence, love, and hope, enthusiastically confess their love to each other along with their true religious identity, only to discover—to their great disappointment—that they still belong to different faiths. Consequently, the shocked wives turn into enemies and decide to move out again.

Meanwhile, as fundamentalist sheikhs and priests in mosques and churches are delivering their hate speeches, crowds from a mosque and a church in the neighborhood are incited to break out, armed with sticks and hatred, to meet in bloody confrontations, and the two families' apartments catch fire in consequence. As the priest's wife rushes out in the street, the sheikh hurries through the battling crowd to protect her, while the priest manages to save the sheikh's wife and daughter, helplessly trapped in the fire upstairs. The film ends with the scene of fighting mobs, the rising flames and smoke, and the sound of clashing sticks. The two families, with injured bodies and souls, firmly hold each other's hands and make their way through ignorant fundamentalist crowds.

228 Religious Tolerance in the Cairo of the Movies, 1950s–2000s

Muslims, Christians, and Jews in Cairene Society

Historically, in the land of Egypt, Egyptian Jews constituted one of the oldest Jewish communities in the world. By the mid-first century, Christianity entered Egypt via the apostle Mark, who founded the Patriarchate of Alexandria. By AD 300, Alexandria became one of the greatest Christian centers. Members of the Coptic Church constituted, and still do constitute, the majority of Egyptian Christians, and to them the term Copt is assigned. When Islam entered Egypt by the seventh century, Christians and Jews were designated as *dhimmi*, which refers to specific individuals living on Muslim lands who were granted special status and safety by the Islamic law in return for paying the *jizya* tax. With the foundation of al-Azhar, Cairo became a leading cultural hub in the Islamic world.

By the fifteenth century, after the Jewish expulsion from Spain, Jews emigrated to North Africa, and Egypt became a major destination. Then, later, another wave of immigration occurred: "in the modern era, they made their way to Egypt" (Beinin 2005, 4) taking advantage of the emerging economic opportunities.

> As Egypt underwent quick modernization under Khedive Ismail, the Jews started immigration from Eastern Europe fleeing from persecution (as of 1865), to find a hospitable shelter in the land of the Nile. Jewish immigration to Egypt increased after it was occupied by Britain in 1882. By 1897, their numbers had reached 12,507 out of a total population of around nine million. By 1917 the number of Jews had swelled to 34,601 and after that many Ashkenazi Jews sought asylum in Egypt. (Dinstein 2019, 213)

By 1948, Jews numbered around 80,000 in Egypt. In 1840, Copts in Egypt were estimated to number around 150,000 from a total population of around 3.5 million, but in 1929 they numbered 912,000 from a population of around 14 million (Hulsman 2012). Meanwhile, an Islamic renaissance backed by intellectuals emerged in Egypt by the mid-nineteenth century. Although this renaissance was welcomed by religious conservatives, the growing rise of the national movement against British occupation outshone it. In 1928, the Muslim Brotherhood was founded, establishing a radical form of Islam that called for the dismantling of the modern state and the establishment of an Islamic one. By the 1970s, extreme branches of the Muslim Brotherhood engaged in acts of violence and terrorism, and Islamic fundamentalists thrived in many cities, particularly in Cairo.

By the early twentieth century, Cairo was becoming a cosmopolitan city. According to the 1927 census, "One fifth of its one million Cairo inhabitants belonged to minorities groups: 95,000 Copts, 35,000 Jews,

20,000 Greeks, 19,000 Italians, 11,000 British, 9,000 French, and smaller numbers of Russians, Parsees, Montenegrins and others" (Rodenbeck 1998). But gradually, this variety was declining, and the Egyptian Jewry started to disappear: some were expelled, others were compelled to leave, while some emigrated to other countries in response to the escalated Palestinian crisis in the 1940s, the declaration of Israeli independence in 1948, the 1948 War, the 1954 Lavon Affair, the 1956 tripartite invasion following the nationalization policy, and, finally, the 1967 War. From 1952 to 1956, "out of the around 80,000 Jews who constituted the Egyptian Jewry by that time, 4,918 Jews left for Israel, around 5,000 to Europe and the Americas, and around 50,000 remained on the eve of the Suez/Sinai war. But by the late 70s, there were no more than a few hundred Jews in Egypt" (Benien 2005, 41).

Cinematically Speaking: Analyzing Urban Films

The two films, fifty-four years apart, draw a contradistinctive picture of coexistence and religious tolerance in Cairo. The 1954 film depicts the peaceful coexistence between Cairene Muslims, Christians, and Jews as successful partners and cordial friends who together manage to form an inclusionary society.

To make it easier for the reader to follow the analysis, I will be referring to *Hasan wa Murqus wa Kuhin* as the 1954 film, and to *Hasan wa Murqus* as the 2008 film. Cairo of the 1954 film seemed quiet and peaceful. The upper classes lived in modern Cairo (Khedival Cairo), founded on the western borders of the old medieval city and which is partly depicted by the location of the pharmacy and its surroundings, the anchored *dahabiya* on the Nile shore at al-Zamalek, the Mena House hotel with the Pyramids in the background, and a film studio. On the eastern side of modern Cairo, the popular and lower-middle classes lived in the the old medieval city, depicted through Sultan Hasan Mosque, the Hanging Church, and the intricate network of *hara*s in Harat al-Yahud, al-Qal'a, al-Masr al-Qadima, and Gamaliya. As usual, women from higher classes seem modern and quite liberal, while lower-class women seem to preserve, as ever, traditional popular culture.

Fifty-four years later, the Cairo of the 2008 film had become an aggressive megacity suffering from growing terrorism, fundamentalism, sectarian division, and religious control and expulsion. And while the Egyptian Jewry no longer existed by then, Muslims as well as Christians were further split into inharmonious groups. Muslims themselves were split into moderate Muslims and Islamists (Islamic fundamentalists) and often the fundamentalists would go so far as to practice violence against citizens from their own faith. Religious intolerance, segregation, and violence were

endlessly manifested through aversion attitudes, Islamization, hate speech, interreligious confrontations, and even terrorism. This turbulent megacity is featured in the film through the following diverse locations and structures: highways; a conference hall; Cairo University; popular modern and historic cafes and restaurants, including al-Fishawy coffeehouse in Khan al-Khalili; streets and public spaces; a *hara* and a spice store; an apartment in the Abbasiya district; and details of a Coptic quarter.

While both films showcase the contemporary style of furniture and fashion among different social classes and religious groups, the 2008 film includes the Islamist dress code and the spread of the veil in its different forms. The time difference between the films reflects how means of communication have been revolutionized, from the telephone to Facebook and the cell phone, while transportation, as depicted in them, has witnessed huge advances in vehicles, modes of transit, and roads. Probably the one thing the films share is that they both start with fresh dreams and a light innocence and end with harsh realities.

I will now begin to investigate coexistence and religious tolerance as important aspects of urbanism. Like AlSayyad, I view these as the form and culture of the urban society (AlSayyad 2011). This will require the identification of specific attributes that allow us to engage in this examination. For this purpose, and as an analytical tool, I draw on the work of the Egyptian philosopher Zaki Naguib Mahmoud in his book *Bezour wa guezour (Seeds and Roots)*, in which he suggests the idea of a cultural tree as a mode of analysis. The tree's five seeds, referring to Egyptian society, are identity, empathy, cultural order, *turath* (traditional heritage), and language (Mahmoud 1990, 28). As a theoretical framework, I will use the habitus theory developed by the French sociologist Pierre Bourdieu.

Habitus, which according to Frederick Ma'touk is the backbone of identity (Ma'tuk 2015), is the deeply ingrained habits, skills, and dispositions that we possess due to our life experiences. Habitus "is a set of preconscious dispositions, including taste, a sense of the self, bodily stances, and, crucially, skills" (Riley 2017, 111). Now that habitus is rendered perceptible, let's examine the coexistence habitus in Cairene society in the 1954 film.

Drivers of Cairene modernity in the 1950s: *Hasan wa Murqus wa Kuhin*
Cairene society in the 1940s "encompassed nearly three million inhabitants, covering 8,000 hectares mainly spread out on the east bank. . . . The image portrayed by this city was a discriminated one, the social differences sharp between the quarters of a modern city and an old city, abandoned by its affluent population in successive waves since the beginning of the twentieth century" (El Kadi 2012, 78).

Cinematically, the Cairenes in the 1954 film, though divided into privileged and unprivileged, seem like a harmonious society in which Muslims, Christians, and Jews coexist peacefully together. Modern Cairo's urban fabric seems peaceful and quiet, with a relaxed tone and an intimate balance providing connectivity and accessibility, as depicted mainly through the surroundings of the pharmacy. Through the cordial relationship between Hasan, Morqos, and Cohen, the pharmacy itself partly reflects the inclusionary Cairene urban culture, further enhanced through the humorous atmosphere they create between them and 'Abbas, who considers them equally mad, the friendship between Morqos's and Cohen's daughters, and the friendly relationship with the visiting clients.

To the east, the old city's urbanism reflects the usual warmth and communal spirit of the *hara*. The *hara* represents the focal point of people's lives before the advent of television, after which its use waned. The *hara* appears as an interactive public realm, satisfying the concept of "reclaiming bits of public realm for public use" (Garvin 2016, 84). A *hara* in al-Qal'a where 'Abbas lives depicts his modest room on a roof overlooking Sultan Hasan Mosque, with goats and poultry being raised around it. Down in the *hara* itself, the film depicts the feeling of warmth through the use of the stone gate and staircase behind, a popular wedding celebrated there, the services provided by its vendors, and a sign encouraging the eating of beans. A *hara* in the Mari Girgis quarter where Morqos lives is featured through an arched stone gate and a sign to the local train station indicting its location.

An urban scene in the *hara* where Cohen lives captures true peaceful coexistence and religious tolerance reflecting a real sense of belonging. The scene portrays Cohen sitting relaxed at a café that partly occupies the passageway of the *hara*. While the passersby and Cohen cordially salute each

12.3. An image of a *hara* as a space shared by all in *Hasan wa Murqus wa Kuhin*.

other, Cohen's daughter appears on a balcony that also seems part of the passageway of the *hara* and starts to chat with her father. From another balcony, a young Jewish girl is calling her friend to go with her to the cinema. Historically, Jewish quarters formed when "Jews who worked in the service of the ruler began to settle within the confines of the imperial capital established by the Fatimid dynasty and established their own Hāra. Because of its high concentration of Jewish residents, the district became known as *Hārat al-Yahūd*, or the Jewish quarter" (Starr 2004, 140).

The 1954 film depicts a habitus and a behavior accommodated by an urban context which reflect inclusionary aspects of coexistence between Muslims, Christians, and Jews: namely, that Cairenes seem to consider their religious differences part of their culture; that different religious and ethnic groups do not live in enforced segregated ghettos; that the Cairenes often consider their diversity a benefit on the social levels; that urban society—though divided into privileged and unprivileged—seems harmonious; and that citizenship and a sense of belonging exist and also enhance a sense of place.

The drivers for these inclusionary aspects of coexistence, given that coexistence is an attribute of civilized urbanism, can be examined through Mahmoud's Egyptian cultural tree. According to Mahmoud, religion is a constant element in the Egyptian identity, the first seed of the cultural tree. The film also reflects an image of relationships that draws people together. Mahmoud states that the continuity aspect of identity does not contradict the change process over time as long as there is an image of relationships that gathers people together, drawing the analogy of when the wooden boards of a boat are replaced one after another until all boards are replaced, but the boat is still the same boat (Mahmoud 1990). Briefly, the 1954 film depicts an identity which includes conservative and religious dispositions, coexistence habitus, and attitudes of religious tolerance, in addition to the demeanours of *ibn balad* (native gallantry) and *al-fahlawa* (cleverness), as well as sense of contentment. Interestingly, empathy as a seed by itself in the cultural tree became an integral part of the social culture. The 1954 film depicts a communal sense and a sense of belonging in the *hara*, supported by its unique urban fabric. It is from the *hara* that the term *ibn balad* originated, while in modern Cairo, the intimate urban fabric allowed connectivity and accessibility, promoting a relaxed environment, thus allowing suitable conditions for empathy to exist.

In the 1954 film, an inclusionary social order as a cultural product seems well inscribed in Cairenes' minds (Mahmoud 1990). "It is through cultural product that 'social order' is progressively inscribed in people's minds, i.e. through the systems of education, language, judgments, values, methods of classification and activities of everyday life. All of these factors

lead to the formation of a person's habitus, which marks her/him as belonging to a certain social class and supplies that person with a sense of place" (Ghosh-Schellhom 2018, 76). As such, the sense of place depicted in the 1954 film reflects the presence of a well-defined cultural product. However, according to Galal Amin, though from the end of the nineteenth to the early twentieth century, Egypt witnessed a rarefied cultural climate, a noticeable decline in the quality of the dominant culture occurred between 1939 and 1952. This is the period during which Tawfiq al-Hakim published *The Age of Shukuku* (Amin 2004). "World War II, which had brought foreign armies and great events to Cairo's doorsteps, had shaken up the new generation. The disastrous 1948 war with Israel had embittered it. . . . Cacophony reigned in this city that produced 11 Arabic newspapers, 190 magazines, 60 featured films a year, and scandals and strikes every day. Tolerance succumbed to violence as Fascists and religious extremists rallied to radical vision of an Egypt 'purified' of alien influence" (Rodenbeck 1998, 127).

Nevertheless, this new radicalism in Egypt encountered an intellectual environment, which had emerged since the early nineteenth century and had achieved remarkable Islamic reformation that contributed substantially to modernizing Cairene society. All through the 1954 film, Cairene society never shows any sign of antagonism toward any different other. Indeed, it shows practices of modernity if we particularly consider modernity as an ever-changing experience of encounter between people of different classes, different subcultures, different religions, and different forms of education and knowledge in the spaces of the city (AlSayyad 2011, 258). Not far from this vision, Charles Taylor's theory of modernity states that "modernity is not that form of life toward which all cultures converge as they discard beliefs that held our forefathers back. Rather, it is a movement from one constellation of background understandings to another, which repositions the self in relation to others and the good" (quoted in King 2010, 84). Modernity for Taylor "is the human desire to be free, authentic and fulfilled." He brings into focus the closed horizon of modernity in the field of religion, arguing that "as long as modernity considers religion and spirituality as unimportant and pushes them aside from our daily life, it effectively closes off some possible answers regarding agent's fulfillment, flourishing and freedom" (Svetelj 2012, 5).

This takes us to issues of *turath* (traditional heritage), the fourth seed in Mahmoud's ideas linking authenticity to modernity, as he states that we should not abandon our heritage to realize modernity, rather, we should emphasize the rational and intellectual part of it in alignment with contemporary sciences and thoughts (Mahmoud 1990, 10). Cinematically, the link between authenticity and modernity in this sense is present in the 1954 film; the three partners do not abandon their traditional

heritage. Most of the time, Hasan is in a kaftan, and Morqos is seen in a traditional suit with a stick, while Cohen always wears his kippah and is frequently in a galabia with a belt and a cardigan. On the other hand, they bear signs of perfect modernity as they peacefully coexist, work, and succeed as a team and as friends. In other words, the deep-rooted habits, skills, and dispositions that they possess due to their life experiences have enabled them to coexist as equal citizens despite their belonging to different faiths.

As depicted in the 1954 film, minorities—particularly Jews—did not live in segregated ghettos as in European cities. Rather, they lived in self-selected quarters, often named after them because they constituted the majority of their residents, as do Morqos and Cohen in the 1954 film, living in Mari Girgis and in Harat al-Yahud, respectively. These quarters also accommodated other citizens who were Muslim, though they numbered less than 35 percent of the population in many *hara*s at that time, including al-Yahud al-Qarain al-Yahad al-Rabaniyin, Bayn al-Sourein (Gamaliya), Fagala (Daher), Tawfikeya (Abdin), Qantaret al-Dekka (Azbakiya), and Ismaʻilia (Abdin). It is in these quarters often called *sheyakha* that most Egyptian Jews were concentrated, and the poorest were in the ones in the old city (El Kadi 2012).

12.4. Hasan, Murqus, and Kuhin, with ʻAbbas in the pharmacy.

The original play on which the film is based, as one of the original playwrights, Badie Khairy, states, was a symbol of unity, and the working conditions prove that unity was not only realized on paper but in reality, too (Ghaleb 2015). It is self-evident, then, that the 1954 film was meant, in turn, to accentuate unity and coexistence between Muslims, Christians, and Jews. The film as a comedy presents a funny but stereotyped portrayal of the three partners. From their dress codes as they appear on the film's poster to the actual script and dialogue, the usual stereotypes, current at that time, can be seen. Cohen is portrayed as having an accent and concerned with finance while Morqos is seen to have worldly concerns. As for the two Muslims, Hasan is depicted as generous but impulsive, according to the stereotype of the Sa'idi, or Upper Egyptian temperament, with 'Abbas, although the lowest in social terms, as the perfect gentleman. Despite being Egyptian, Cohen is referred to as *khawaga*—a term meaning "foreigner" mostly used to refer to Western foreigners. Stereotyping Cohen and calling him *khawaga* indicate that religious tolerance, though seemingly present, still held a latent tendency to exclude minorities. This means religious tolerance was rather a behavior derived from the presence of peaceful coexistence rather than a true, innate acceptance. Because of this stereotyping and perception of "other" through the use of the term *khawaga*, it could be argued that the film is anti-Semitic. Anti-Semitism is defined as the showing of hostility toward or discrimination against Jews as a cultural, racial, or ethnic group. The Jews in Egypt were prominent in many fields like banking and commerce, "working as merchants in gold or other goods, jewelers, and professionals" (Benien 2005, 114), all of which were related to practices that require being careful with money, thus allowing others to historically stereotype Jews as greedy. In fact, the Egyptian Jewish community had historically enjoyed a high status, with some members closely associated with the Egyptian royal family, and were highly regarded by society (Benien 2005). The stereotyical depictions in the film were a product of their time.

But why were Egyptian Jews called *khawagat* (plural of *khawaga*)? The Egyptian Jewish community at its core consisted of "indigenous Arabic-speaking Rabbanites and Karaites with a Judeo-Arabic culture. Indigenes composed perhaps 20,000 of the 75,000–80,000 Jews in Egypt in 1948" (Benien 2005, 3). The Sephardi (Spanish Jewish) community in Egypt is associated with the arrival of Maimonides in 1165, then in 1492 with their expulsion from Spain, and, in the modern era, they made their way to Egypt from the Ottoman cities including Jerusalem to take advantage of the cotton boom of the 1860s and the opening of the Suez Canal in 1869 (Benien 2005, 18). The Ashkenazi (Eastern European Jewish) Egyptian community was a product of the modern era after

fleeing persecution in Europe. They maintained a separate communal organization in the Darb al-Barabra quarter, where Yiddish was spoken in the streets until the 1950s (Benien 2005, 19). These diverse Jewish communities tended to be Western oriented on different levels, starting with the Jewish bourgeoisie and the Francophone middle classes, with Western influences and attitudes trickling down to the lower Jewish classes, depicted in the 1954 film in scenes such as Cohen's daughter smoking cigarettes. But it is important to recognize that Westernized Muslims and Christians were also often referred to as *khawagat*, based on their upbringing and education. Thus, it is no surprise that the term was applied to some Egyptian Jews, and, with the gradual foundation of Israel in the twentieth century, Egyptian Jewry was torn "between two homelands" (Benien 2005, 21). "War with Israel made the status of Egyptian Jews an urgent public question. The return of the Wafd to power in January 1950 suggested the resurgence of democracy, secular-liberalism, and cosmopolitanism; and many Jews began to think they might resume life as it had been before the war" (Benien 2005, 50). It is in these turbulent circumstances that the film was produced, to assert coexistence, similar to Sayed Darwish's famous song *Ewa'a weshak* in the early 1920s which emphasized unity between Muslims, Christians, and Jews in the face of the British occupation.

And while the title of the film reveals much, the circumstances surrounding the title reveal even more. The film was originally a play produced in 1941 by the two old friends Naguib al-Rihany (a Christian) and Badie Khairy (a Muslim). Once, as they were on their way home, a store sign bearing the name of its owners—"Absakhros wa S. Osman" (again, a Christian and a Muslim)—inspired Khairy to write a play bearing a Muslim and a Christian name, while al-Rihany added the Jewish character. The play is actually an adaptation of *Le Petit Café*, by the French playwright Tristan Bernard (1866–1947). Ironically, al-Azhar, the Church, and the Rabbinate objected to the release of the film, each claiming that the names used in the title are sacred and should be better respected (Ghaleb 2015). Nevertheless, the film was released, proving again the modernity of Cairene society. The play was produced as the 1954 film, then again as a play in 1960, both bearing the same title, and both becoming classics of the Egyptian cinema and theater.

It is possible to conclude that this coexistence and religious tolerance, as portrayed in the 1954 film, can be attributed to the fact that until the early 1950s Cairo was still a cosmopolitan city. In general, "cosmopolitanism gives priority to the individual and promotes a common community, where citizens from varied backgrounds and locations are considered 'equal' and enter into relationships which mutually respect their differing

beliefs with humility and an awareness of interdependence" (Kakabadse and Khan 2016, 1). So, when the Cairene society, conservative as usual, encompassed large foreign communities from different religious and ethnic backgrounds, this exposure to diversity had a direct effect on conservative groups of all faiths, enabling them to deal with the others with openness and inclusion.

Faith and Cairene Modernity of the Twenty-first Century: The Change to *Hasan wa Murqus* Only

Cairenes today still watch the film *Hasan wa Murqus wa Kuhin* and seem to consider it as part of their cultural heritage. The title, which later inspired the 2008 film, has actually become a famous catchphrase reflecting a latent respect for religious diversity and nostalgia for the bygone days of peaceful coexistence and religious tolerance. On the ground, the Egyptian Jewry has totally disappeared, and the growing sectarian division between Muslims and Christians has been fueled continuously by fundamentalists on both sides, dividing Cairene society into inharmonious, conflicting groups and splitting Muslims into non-observant Muslims, observant Muslims, Muslim Brotherhood, Salafis, and many others.

Though conservatives and fundamentalists would seem alike, they are not. Both are traditionalists, but while conservatives focus on stability, resisting change, and generally want to keep things the way they are,

12.5. The stair landing as a common, shared place between the apartments of Hasan and Murqus in *Hasan wa Murqus*.

fundamentalists long to return to the way things were. Today, "in common usage, fundamentalism is defined mainly in religious terms and is understood as embodying a pathological condition of violence" (AlSayyad 2011, 5). Islamic fundamentalists, or Islamists, comprise radical Islamic groups which all adopt political Islam. Their core doctrine is blind obedience, surveillance, and expulsion. Because they seek political power, the establishment of the Islamic state, and the rule of Islamic law (sharia), violence is justified as a means to that end. Cairenes, conservative as ever, whether Muslims or Christians, were invaded by both a populist culture, which emerged with authoritarian populist rule following the Revolution in 1952, and by Islamists in the 1970s. Both Islamists and populists are antipluralist. According to J.W. Müller, "populists claim that they and they alone represent the popular will and are both a reflection of political institutions in crisis and a threat to democracy" (Berville 2017, 17). "In the new Egypt (of the July 1952 Revolution), the paternal state would take care of everything" (Rodenbeck 1998, 102).

In other words, in the new paternal state, society, with its usual conservative disposition based on a traditionalist set of habitus, became subject to an authoritarian populist rule which projected an antipluralism habitus. By the 1970s, during the rule of President Sadat, the Open Door policy was implemented along the lines of a pure capitalist economy contradicting the ethical values habitus, and fundamentalism flourished while projecting an exclusionary habitus. Galal Amin suggests that the July 1952 Revolution "contributed to the explosion of the phenomenon of a mass society in an unprecedented way in the Egyptian history . . . leading to an increase in the 'effective size' of the population" (Amin 2004, 25). In addition, "The social mobility witnessed has had an enormous influence on the content of Egyptian literature" (Amin 2004, 26). He adds that "the two major weaknesses of the development policies adopted were the excessive dependence on the American aid and the unjustifiable tendency to the disproportionate consumerism of the middle class" (Amin 2004, 31).

With the emergence of these new conditions in Cairo, dominated now by antipluralism, an exclusionary habitus gradually developed accompanied by certain behavioral patterns, namely violence, segregation, and religious intolerance. Meanwhile, Cairo was transforming into a megacity and by 2006 its population had reached 9 million, doubling at the metropolitan level. These conditions are depicted in the 2008 film through cinematic techniques meant to accentuate this exclusion, violence, and religious intolerance. The masquerade is the main one of these techniques, whereby the sheikh has to pretend that he is Christian bearing the name of Morqos, while the priest has to pretend that he is a Muslim sheikh bearing the name of Hasan al-'Attar. Each thinks that the other belongs to

his own faith. The use of twin consecutive scenes, one related to Muslims and the other to Christians, showing the positives and negatives of each context, is a tool used alongside the masquerade and various analogies to accentuate a number of aspects. The first is that this vast population seems largely dominated by populism and fundamentalism. The second is that both faiths comprise a mix of inharmonious groups ranging from modern to extremely traditional. The third aspect is the rise of exclusion, surveillance, symbolic and physical violence, and religious intolerance, triggering in turn a wave of terrorist attacks. The fourth aspect is that of a social alienation and a state-approved segregation that has severely damaged citizenship and the sense of place. We see the manifestation of some of these antagonistic and contradictory conditions in the film when the priest is subject to an assassination attempt by fundamentalists from his own faith as well as when the sheikh refuses to succeed his late Islamist brother as leader of a fundamentalist group or *gama'a*. And here it becomes important to understand how these aspects are reflected in urban culture. Ghaly Shoukry states that sometimes the fundamentalist groups would seem to dominate, while at other times other groups would seem to take the lead. This climate is reflected in culture, creating thoughts and thinkers that would seem to avow double standards. This is a condition of a structure run by informality, making all groups seem as if they are one body strangling society, detaching it from any organizational rules or constraints that govern the economic, cultural, and social capital. This is also a condition of multiple states inside the one state, as these different groups possess financial and cultural power and even armed militias, so no wonder that society is dominated by violence and aggression. This is a frightening chaos, and it is shaping the cultural structure of society, making culture seem like it is about armed militias and brokerage deals (Shoukry 1994).

This frightening chaos contributes to creating a sense of social alienation and deepens segregation, all of which are clearly depicted in the film in scenes set in the Coptic quarter and in Alexandria. This is especially evident when the neighbors in the Coptic quarter slowly gather like strangers looking upward, tracking the sounds of priests praying at the apartment of Morqos (who is actually the sheikh) and sheikhs praying at the apartment of Hasan (who is actually the priest). This illustrates the considerable change from the time when Cohen would be sitting at the cafe in the *hara* in the 1954 film with a clear sense of peaceful belonging. In the Coptic quarter, a very conservative Coptic jeweler and an Islamist persist in spreading division in the neighborhood, constantly fueling it and leading to interreligious clashes. Moreover, the Islamist considers the Coptic quarter a battleground that should be Islamized, leaving the Coptic jeweler in a constant state of bitterness. At the university, we see Islamist students

trying to recruit the priest's son to their *gama'a*, believing him to be a Muslim. It also becomes clear that the notion of citizenship is challenged by the behavior of the Islamist and the Coptic jeweler, each favoring the people of their own faith while demonizing the others. When the sheikh and the priest partner in a bakery shop, the Coptic jeweler severely reprimands Morqos (actually the sheikh) for his partnership with a Muslim, while the Islamists do the same with Hasan (actually the priest).

The last aspect accentuated by the contrastive tool utilized in the film, which is actually a response to rather than a reflection of antagonism and religious intolerance, is nostalgia. This is depicted in the scene of the two families together watching the film *Ghazal al-banat*, starring Laila Mourad (who was Jewish), Naguib al-Rihany (who was Christian), and Anwar Wagdy (who was Muslim), as the priest describes how al-Rihany and Khairy were friends for many years without either of them knowing or caring about the religious identity of the other. However, the sheikh grimaces when he realizes that al-Rihany was Christian. This example shows how things have changed from the way they were in the 1954 film *Hasan wa Murqus wa Kuhin* where acceptance and coexistence were a fact of life.

Actually, the major factor behind this exclusionary state lies in the fact that the Egyptian cultural tree has dramatically changed, starting with the absence of the image that gathers people together, that is, the absence of identity. Mahmoud wonders "why the nation that could unite its citizens seems today just a gathering of individuals, each trying to gain the largest spoils with the least effort. . . . [and] that this is rather evident on the political level not on the cultural level, otherwise we would have said that we are about to become extinct" (Mahmoud 1990, 7). Naturally, in such frightening disarray, the cultural product is obviously chaotic, reflecting the absence of any national cultural vision or goals. And while the cultural products of this changing society have been increasingly engraining exclusionary habitus in the individual's mind, the sense of place has been further fading. "Cairo's urbanism since the 1960s witnessed in 2011 'an eclipse that began forty years ago. . .' The visible part of the crisis of centrality in Egypt is the decadence of the city, indeed, the foreign visitor is struck by the degradation of public space and infrastructures, and the deterioration of built-up areas, which hardly correspond to the image originally enjoyed by the Arab world's largest metropolis" (El Kadi 2012, 18).

As the urban form of Cairo kept expanding extensively alongside its continuous decadence, the new urban infrastructure fostered social and spatial inequality as expressed in Graham and Marvin's theory of splintering urbanism (Caletrío 2013). Considering also the rise of the networked society—a term coined in 1991—which produces serious social, political, economic, and cultural changes, no wonder then that segregation

and social alienation deepened more and more, and the sense of place was further weakened. This condition of exclusion and its patterns of behavior depicted in the 2008 film may be connected to or explained by the rise of urban informality which had replaced urban order, leading to what Shoukry calls: "a frightening chaos," as explained earlier. As AlSayyad explains, this urban informality created a "new way of life" among inharmonious groups that ultimately failed to develop meaningful encounters with each other, resulting in a decline in modern impetus. All these aspects depicted a culture in crisis (AlSayyad 2004, 7–32). As Zakareya suggests, this crisis in culture occurs mainly when freedom of expression is strictly constrained, or when the bodies in charge of culture are ignorant or deliberately spread nonsense, or seek to bring the past to the present (Zakareya 2010, 21). This also happens with the measuring tools that enable people to assess, evaluate, and cultivate their cultural tree and habitus.

There is no denying that Egyptian society is often inclined toward conservative positions and attitudes. For both Muslims and Christians, this conservatism is based on traditional values and varies in extent as depicted in the 2008 film. In al-Minya, villagers seem to ascribe to a version of traditional conservatism that is very basic; while in Cairo, traditional conservatism varies from inclusionary to moderate to exclusionary in its relationship to others. Since antipluralism prevails in society, whether through populism or fundamentalism, and since Islamists have popular power and institutions, they can engage in recruiting others to their cause, not necessarily as members, but as masses that adopt political Islam and its set of habitus. Consequently, the exclusionary-oriented traditionalists turn into a type of fundamentalist. To counteract the Islamist tide, Zakaria suggests that "such values as rationality, criticism, logic and mental independence are not unique to Western civilization, but are found in Islamic civilization as well" (Sirry 2007, 342). He also calls for a secular and democratic civil society that is unconstrained by past interpretations of the sharia (Zakaria 1994). Surveillance, exclusion, and religious intolerance as depicted throughout the 2008 film are the core values of conservative traditionalism. They directly manifest the idea of the absolute denial of existence to groups of people, which is the ultimate form of fundamentalism (AlSayyad 2011, 6). Cairo of the 2008 film is indeed, then, a typical fundamentalist city.

The fast disappearance of Cairo's cosmopolitanism may be an indirect cause for this deterioration. And while Middle Eastern cities like Cairo were losing their cosmopolitan quality, globalization was replacing it as a modeling variable. "Globalization asserts trade and territorial extension toward the international integration of a standardized multiculturalism as

12.6. Hasan and Murqus facing sectarian clashes *(Hasan wa Murqus)*.

the 'one world view', while 'cosmopolitan principles in themselves do not presuppose commitment to a world state or to any other political architecture" (Kakabadse and Khan 2016, 1). But a globalized Cairo fractured the city and its people, further dividing them into an elite minority that is globally connected, and a large majority of religious masses isolated from global features. This has resulted in a condition under which many groups have succumbed to the excesses of the fundamentalist ideas that were floating around in popular culture at the end of the twentieth century. This may explain why in the 2008 film empathy seems to have totally disappeared and why the fundamentalists are gaining power by the day.

Concluding Remarks

The 1954 film depicts an inclusionary society that practiced coexistence and religious tolerance through various means including the Cairenes' perception of their religious differences as part of their culture and of diversity as an asset, not a liability. It is a society where different religious and ethnic groups were not segregated communities, but lived as majorities in their own quarters, where urban society, though divided into privileged and unprivileged, still seemed harmonious, and where citizenship and a sense of belonging existed and enhanced a connection to and a sense of place.

In the 2008 film, which is intended to address the growing sectarian violence in Egypt, the priest is made to leave Cairo when the masquerade is discovered because of extremists' threats to his life, as some accuse

him of apostasy. In the 1954 film, the three partners together run their pharmacy and business, considering their religious diversity part of their culture, and, thus, they need no masks. While, in the 2008 film, the two families become friends, it is only because each mistakenly thinks that the other is of their own faith, and they then immediately turn into enemies the moment they are unmasked. However, facing the same threat, not only do they save each other, but they also truly realize that they are destined to stay together. They boldly and fearlessly walk through the battling crowd, as if realizing that they have to retrieve the long-gone coexistence and religious tolerance realized in the 1954 film, and without disguise.

Through the masquerade, also, the conservative disposition of Egyptian society is cleverly depicted. In general, the masquerade reveals superficiality, ignorant fear of the other, mutual apathy, and aversion continuously cultivated by fundamentalists on both sides between and within citizens from both religions. The priest's son blames his father, asking, "Why have your hearts changed when your real names were revealed?" The masquerade reveals that segregation and escapism are the most dominant reactions toward these urban challenges.

The device of twin scenes in the 2008 film plays an instrumental role, particularly when the sheikh and the priest coincidently meet on their way to the mosque and the church. Instead of entering the church, the priest has to enter the mosque, opposite, and the sheikh has to enter the church. The priest finds himself discreetly and peacefully praying behind the imam, who is praying serenely as if their Muslim and Christian prayers complement each other, exactly as the sheikh's prayer and the priest's Christian prayer in the church equally complement each other. Another major twin scene at the end of the film captures parts of hate speech in both mosques and churches, showing how fundamentalists on both sides are amazingly similar, and typically cultivate violence and hatred, and how populists' views generate bloody confrontations. Here, the mosque and the church are portrayed in an aggressive scene contrary to their depiction in the 1954 film as a beautiful pairing in a panoramic scene.

Figurative analogies in the 2008 film accentuate the necessary unity between Muslims and Christians. These appear in several scenes, including the film poster featuring the sheikh and the priest in handcuffs as if they are true partners imprisoned under the same regressive conditions. A second example is when both families meet on their doorsteps, where the stair landing is a shared common space between their apartments. Two other important scenes are when the sheikh donates blood to the priest's son and when the families of the two young lovers gather around one table as if uniting two conflicting communities. One relevant final scene to illustrate this point is when the priest declares that "it seems that we are destined

to stay together." The choice of the name Hasan al-'Attar reminds us of one of the prominent al-Azhar scholars who contributed to modernizing Cairo in the nineteenth century, and probably shows that police officials lack such social knowledge and communication skills.

The 1954 film was meant to showcase coexistence between three religious communities with emerging challenging conditions. But, by 2008, Egyptian Jewry had totally disappeared and their contribution to Egyptian history soon faded into oblivion, depriving Egyptians of a part of their heritage while also depriving Egyptian Jewry of their right to have their lives and contributions recorded in Egyptian history. The 2008 film rightfully depicts Egyptian society's shift toward exclusionary attitudes propelled by the rise of fundamentalism and the growing power of Islamists in the media. In response, specific segments of Cairo's people have succumbed to intolerance and segregation, and ultimately to violence and terrorism.

Ultimately, cosmopolitan Cairo of 1954 has succumbed to the globalization of the twenty-first century. And while cosmopolitanism enabled Cairenes, as depicted in the 1954 film, to continue building a creative society, neoliberal globalization had turned the Cairo of the 2008 film into a follower society and had deepened its segregation. This shift from cosmopolitanism to globalization explains why in the 1954 film the cultural tree, a key driver of society that correlates to coexistence as explained earlier, comprised an inclusionary identity, empathy, a refined cultural product that reflects the presence of a cultural vision, and a link between modernity and authenticity. Unfortunately, all of these qualities had vanished by 2008 and were replaced by the exclusionary cultural tree that appears evident in the 2008 film.

The title of the 2008 film reminds us of the disappearance of the Egyptian Jewry, and its theme also points out the further marginalization of Egyptian Christians due to the growing sectarian division. Egyptian Christians represent around 10 percent of the Egyptian population. The question is what will happen to them as a minority and what will happen to Egyptian Muslims as a majority, as both are under the growing power of Islamists in a populist society that has renounced its traditional values of tolerance and coexistence. With segregation, discrimination, and emigration, not only are Cairo's Christians as well as Cairo's Muslims in danger, but Cairo itself is also at risk.

References

AlSayyad, N. 2004. "Urban Informality as a 'New' Way of Life." In *Urban Informality: Transnational Perspectives from the Middle East, Latin America, and South Asia*, edited by A. Roy and N. AlSayyad, 7–30. Lanham, MD: Lexington Books.

————. 2011. *The Fundamentalist City? Religiosity and the Remaking of Urban Space*. London: Routledge.

Amin, G. 2004. *Whatever Else Happened to the Egyptians? From the Revolution to the Age of Globalization*. Cairo and New York: The American University in Cairo Press.

Benien, J. 2005. *The Dispersion of Egyptian Jewry*. Cairo and New York: The American University in Cairo Press.

Berville, H. 2017. "'Populism Is a Form of Anti-pluralism': Review of J.-W. Müller, *Qu'est-ce que le populisme? Définir enfin la menace*." Translated by L Garnier. *Books and Ideas*, June 5, 2017, https://booksandideas.net/Populism-is-a-Form-of-Anti-Pluralism.html?lang=en

Caletrío, J. 2013. "Review of S. Graham and S. Marvin, *Splintering Urbanism*." *Mobile Lives Forum*, August 29, 2013, https://en.forum-viesmobiles.org/publication/2013/08/29/book-review-1136

Dinstein, Y. ed. 2019. *Israeli Yearbook on Human Rights*, Volume 49. Lieden, Boston: Brill | Nijhoff.

Garvin, A. 2016. *What Makes a Great City*. Washington, DC: Covelo; London: Islandpress.

Ghaleb, G. 2015. "Kessat al-Rihany was Badei with Hasan was Murqus was Kuhin: objected by al-Azhar wa al-Kenissah wa al-Hakhameya." *Al-Masry Al-Youm*.

Ghosh-Schellhom, M. 2018. *Transcultural Anglophone Studies: An Introduction*. Munster: LIT Verlag.

El Kadi, G. 2012. *Le Caire. Centre en mouvement: Cairo. Centre in movement. (Petit atlas urbain)* (Multilingual Edition). Paris: IRD Editions, Institut de recherche pour le développement.

Kakabadse, N.K., and N. Khan. 2016. "Editorial: Cosmopolitanism or Globalization." *Society and Business Review* 11, 3: 234–41.

Mahmoud, Z.N. 1990. *Bethur wa Jezour*. Cairo: Dar al-Sharouk.

Ma'touk, F. 2015. "al-Habitus al-arabi al-'anid wa-l-'atid." *Omran*, 12, 3:143.

Riley, D. 2017. "Bourdieu's Class Theory: The Academic as Revolutionary." *Catalyst* 1, 2: 107–36.

Rodenbeck, M. 1998. *Cairo: The City Victorious*. London: Picador.

Shafik, V. 2007. *Popular Egyptian Cinema: Gender, Class, and Nation*. Cairo and New York: The American University in Cairo Press.

Sirry, M. 2007. "Secularization in the Mind of Muslim Reformists: A Case Study of Nurcholish Masjid and Fouad Zakaria." *Journal of Indonesian Islam* 1, 2: 323–55.

Starr, A.D. 2004. "Sensing the City: Representations of Cairo's *Harat al-Yahud*." *Prooftexts* 26, 1–2: 138–62.

Svetelj, Tone. 2012. "Rereading Modernity – Charles Taylor on Its Genesis and Prospects." PhD diss. Boston College, MA.

UNESCO (2010). Historical Developments and Theoretical Approaches in Sociology, Volume 2. United Kingdom: Eolss Publishers Co. Ltd.

Zakaria, F. 1994. *al-Haqiqah wa al-Wahm fi al-Hāraka al-Islamiya al-Mo'assera*. Cairo: Dar al-Fekr lel Nashr wa al-Tawze'.

———. 2010. *Khetab ila al-Akl al-Arabi*. Cairo: al-Hayaa al-Masreya al-Amma lel kettab.

13

The City of a Thousand Minarets and a Million Satellite Dishes: The Dilemma of Islam and Modernity in Cinematic Cairo

Muhammad Emad Feteha

In January 2020, and during the Azhar International Conference on the Renewal of Islamic Thought, a rigorous debate took place between Mohamed Othman al-Khosht, the president of Cairo University, and Sheikh Ahmad al-Tayyeb, the grand imam of al-Azhar on the compatibility of Islamic thought with modern life. Al-Khosht argued for the necessity of renewing the foundations of Islamic sciences, suggesting that Muslims should learn from other cultures and that Islamic sciences must incorporate principles such as the plurality of the truth in order to be compatible with modernity. Sheikh al-Tayyeb found this call provocative, arguing that this is not a call for renewal, but rather a call for the abandonment of the Islamic tradition. The real problem in the Grand Imam's view is rather that the Islamic tradition is not being properly applied at present.

This debate came up nine years after the 2011 Egyptian Revolution, which brought to the fore the climax of the deep-rooted conflict between secularists and Islamists, a conflict that dates back to the early nineteenth century at the dawn of the modernization of Egypt. Throughout these two centuries, secularists and Islamists have been struggling over the role of Islam in modern Egypt and whether it should, or should not, extend to politics, ethics, law, and other areas. On the one hand, secularists believe that the role of Islam should be confined to an individual's personal belief or one's way of practicing spirituality. On the other hand, Islamists view Islam as the regulator of society and the governor of public life. Thus, secularists have been calling for the secularization of Islam in modern Egypt, while Islamists have been struggling for the Islamization of modern Egypt, and neither side has been able to achieve their goal and eliminate the other, nor have the two witnessed any remarkable fusion.

In this chapter, I will examine the changing role of Islam in Cairene society as represented cinematically during the republican era, namely

from 1952 till the present time. During this period, the secularist–Islamist struggle has passed through different stages in which the two sides have been alternatively predominant. Consequently, these stages would sometimes witness a decline and sometimes an expansion of the role of Islam in the life of the Cairenes, a fluctuation that has been represented in many Egyptian films. I will analyze these cinematic representations with special focus on three films that depict significant moments in the history of the struggle, namely, *al-Sheikh Hasan* (1954), *Lili* (2001), and *Mawlana (Our Sheikh)* (2016) (Figures 13.1–13.3). The protagonists of these three films are sheikhs (Muslim clerics), which allows us to closely view the status of Islam within cinematic Cairene society. Thus, I will capture the struggle over the role of Islam within the changing city through the eyes of the sheikhs. Following Nezar AlSayyad's approach to studying the cinematic city in his *Cinematic Urbanism*, by employing a trope as an analytical device, I will use the sheikh as a trope to analyze cinematic Cairo over half a century (AlSayyad 2006).

Sheikhs have played a central role in the life of Cairene society since the medieval age. Their main role has been to lead the five daily prayers in the congregational mosques and to give the Friday sermon. However, their role was not limited to mosques; they also guided people in their daily lives to morality and virtue, and people sought their advice not only in religious issues, but also social ones. Consequently, sheikhs enjoyed a wide scope of power and influence, and were closely intertwined with their communities. This has made rulers often try to make alliances with them in order to make use of their popularity and influence on the masses. Hence, some sheikhs were primary pillars in the systems of the Egyptian rulers, while others were revolutionaries and brought rulers down from their thrones; some were corrupted and benefited from their status, while others spent their lives guiding the people to righteousness.

As Cairo entered the modern age, the role of sheikhs in society became less prominent. Modernity limited the role of religion in society in different parts of the world, and to some extent also in Egypt. The abovementioned conflict between Islamists and secularists took place, and consequently the role of Islam in Cairene society has been in a dynamic state of transformation. Therefore, since Egypt entered the modern age, sheikhs have been struggling to cope with the modern system that has come to replace the Islamic-based system that governed Egypt in the medieval age, a struggle that is well reflected in the three films that this chapter analyzes. Thus, investigating cinematic Cairo through the protagonist sheikhs is actually an exploration of Cairo at its core; it reveals many aspects of Cairo, especially at a point in time when the role of Islam (which the sheikhs advocate) in Cairene society underwent dramatic transformation, which

subsequently had an influence on all facets of life in Cairo, including religiosity, the built environment, politics, economy, and many others.

But, before delving into the cinematic analysis, I will briefly present Talal Asad's study of the modernization process that Egypt underwent during the nineteenth and twentieth centuries and how it affected the role of Islam within Egyptian society. I argue that this transformation has created a gap between the sheikh and Cairene society, and has forced him to struggle to blend into the city in the modern age.

The Modernization of Islam in Egypt

In his *Formations of the Secular*, Talal Asad tries to offer an anthropology of secularism in addition to the history of secularism in Egypt. In his book, Asad argues that the concept of the secular should not be superficially reduced to mean the separation of religion and state. Rather, the secular cannot be understood in isolation from secularism, the doctrine from which it emerges, which arises from European intellectual development where it builds on the Renaissance doctrine of Humanism, the Enlightenment concept of nature, and Hegel's philosophy of history. Secularism conceives the world as "natural" and "social." Moreover, he argues that this concept of "the social" as we know today, on which the distinction between "the secular" and "the religious" is based, is essentially modern, as it did not exist prior to the nineteenth century (Asad 2003).

On the other hand, the premodern Islamic worldview did not acknowledge any separation between the social, the moral, or the legal, as all were encompassed by the sharia, the moral law of Islam. This led the orientalist Snouck Hurgronje to view *fiqh* (one of the disciplines of sharia) as an "incoherent mixture of religion, ethics, and politics" (Asad 2003, 242). According to Wael Hallaq, until the nineteenth century, the sharia regulated both society and government in the Islamic world, and was the reason behind maintaining a "well-ordered society" (Hallaq 2012, ix). It was not until modernization took place that the role of sharia started shrinking until it was restricted to the private sphere, namely the law of personal status (Asad 2003). That is why, for many Islamists, "modernization has been perceived as a form of neocolonialism, an evil that supplants religious and cultural identity" (Esposito 2000, 50).

The modernization of Egypt has witnessed a process of dismantling and recreating the sharia, a process that is carefully illustrated by Asad. It started during the reign of Muhammad 'Ali Pasha, who initiated reforms to the penal law following the European model. Then, in 1876, European control of the Egyptian economy forced the creation of the Mixed Courts by which European residents of Egypt were judged. The Mixed Courts adopted a European legal code and were administrated by European

judges. In 1883, one year after the British occupied Egypt, the sharia-based code that was used by national courts was replaced by the European code that was used in Mixed Courts. Thus, sharia was "deprived of jurisdiction over criminal and commercial cases and confined to administering family law and pious endowments *(awqaf)*" through what was called the Sharia Courts, which remained to be administrated by Islamic jurists. Hence, "law began to disentangle itself from the dictates of religion, becoming thereby both modern and more secular" (Asad 2003, 210–12). In 1955, the nationalist President Gamal Abd al-Nasser abolished the dual structure of the courts, putting an end to the Sharia Courts, and, since then, Egyptian law has been dominated by the European code.

Thus, Asad argues that, through the modernization of Egypt, the role of Islam was transformed from being the ideal that dictates the "way for individuals to discipline their life together [as a society]," to merely "a law whose authority resides in a supernatural realm" (Asad 2003, 250). He also argues that "the function of law is not merely to reflect social life but also to reconstruct it" (ibid). Thus, he argues that the replacement of sharia with secular law has reconstructed the social life of Egyptians.

In the following sections I will analyze the cinematic representation of Cairo in the last seventy years, and demonstrate if it verifies Asad's arguments or not.

Islam and Modernity in Egyptian Cinema

As mentioned above, the struggle of Islam and modernity has been extensively portrayed in the Egyptian cinema. One of the ways of depicting it has been through representing the sheikh in the modern city. The sheikh, the main representative of Islam in Egyptian society, is portrayed in Egyptian cinema in many different forms. For instance, in the early republican era, the sheikh is represented as a social and moral reformer who does his best to cure the corrupted society of the time and handle their abusive treatment of him and other good people, as in *al-Sheikh Hasan* and *Ja'aluni mujriman (They Made Me a Criminal)*, both released in 1954.

During Gamal Abd al-Nasser's nationalist era, the sheikh started to be depicted in an ironic manner, as in the 1961 *al-Safira 'Aziza*, in which the sheikh is played by a comedian and portrayed as a man who speaks *fusha* (classical Arabic) in a satirical way for comic effect, rather than modern colloquial Egyptian ('Assaf 2019). In the same period, portraying sheikhs in a sarcastic manner was practiced by the Egyptian poet and cartoonist Salah Jahin, who was also one of the most influential screenwriters of the 1960s and one of the greatest propagandists of Abd al-Nasser. In 1962, Jahin published a series of satirical cartoons in the newspaper mocking sheikh Muhammad al-Ghazali, an Azhari sheikh who was affiliated with

252 The City of a Thousand Minarets and a Million Satellite Dishes

the Muslim Brotherhood until the early 1950s, for being concerned with outdated topics such as how women dress and for being incapable of coping with the country's modernity and the great nationalist objectives of the leader Gamal Abd al-Nasser (Khurshid 2017). Jahin's practice was not the first of its kind. Rather, as Walter Armbrust shows, there had been an earlier satirical cartoon mocking an imaginary Sheikh Abu-l-'Uyun—"sheikh of the eyes"—, a cartoon character that appeared in an Egyptian magazine in the 1930s, satirizing the sheikh for his censorious traditionalism and his incongruity with the modern people of Egypt (Armbrust 2001). Thus, although depicting the sheikh as an outdated figure who belongs to the past and does not fit in with the modern conditions of Cairo had existed much earlier, it became most prevalent in the 1960s.

After the 1967 defeat in the Six Day War against Israel, Egyptian films reflected the anger of Egyptians against Abd al-Nasser's autocracy, and consequently depicted the different roles sheikhs played in Egyptian society in that period. For example, the sheikh was represented in *al-Zawja al-thaniya (The Second Wife)* (1967) as one who uses false interpretations of the Quran to facilitate the desires of the *'umda* (village mayor), and, in contrast, as an activist who inspires the villagers to rebel against tyranny in *Shay' min al-khawf (Some Sort of Fear)* (1969) (Muhammad 2018).

Starting from the 1980s onwards, after the assassination of President Anwar Sadat by a terrorist Islamist group in 1981, it became normal to portray Islamists negatively in Egyptian cinema. For example, through a review of the films of 'Adel Imam, one of the most popular actors of this period, one would find them full of anti-Islamist stereotypes. Islamists were portrayed in Imam's films as a swindler in *Karakun fi al-shari' (Prison Cell on the Street)* (1986); an unscrupulous employee in *al-Erhab wa-l-kebab (Terrorism and Kebab)* (1992); a terrorist in *al-Erhaby (The Terrorist)* (1994), *al-Sifara fil 'imara (The Embassy in the Building)* (2005), and *'Imarat Ya'qubyan (The Yacoubian Building)* (2006); a Machiavellian politician in *Tuyur al-dhalam (Birds of Darkness)* (1995); and a fickle university student in *Morgan Ahmad Morgan* (2005). Nevertheless, in his film *Hasan wa Murqus* (2008), Omar Sharif plays the leading role of a sheikh who is tolerant of Christians and confronts sectarian strife. Thus, the filmmakers of that period seem to imply a distinction between Islamists and the sheikhs. A good Islamist can exist, but only as a sheikh who does not involve religion in the "secular sphere" as other Islamists do. In other words, Islam is accepted as long as it respects the secularist limits.

'Adel Imam's *al-Erhaby (The Terrorist)* (1994) is often considered the best-known film whose central theme is the Islamist–secularist conflict. The film was written by the secularist writer Lenin al-Ramly and directed by Nadir Jalal. According to Walter Armbrust, *al-Erhaby* "constructs a

stark opposition between modern enlightenment, associated with material comforts that are fabulous by Egyptian standards, and Islamist backwardness linked to suffering and deprivation" (Armbrust 2002, 924). Armbrust adds that the film is heavily ideological and lacks any serious analytical approach to the phenomenon of Islamism, which makes it rather superficial. The representation of Islamists in the film is characterized by blatant reductionism. Islamists are represented as if they were all the same; they are all a product of ignorance, they are purely violent, and they oppose modernity, which is at odds with the far more complex reality in which there are—in addition to the examples represented in the film—Islamists who are well educated and nonviolent, besides Islamists who outdo secularists in defining the character of modernity (Armbrust 2002).

Another film that discusses the same topic is *al-Deif (The Guest)* (2019), written by the secularist activist, journalist, and, recently, screenwriter, Ibrahim 'Issa and directed by Hady al-Bagouri. The film follows *al-Erhaby* in being profoundly ideological and lacking analytical qualities, where it portrays the Islamist as a merely melodramatic villain. This makes it even more shallow than *al-Erhaby*, which at least presents some degree of sophistication in the character of the Islamist. Consequently, the film was harshly criticized for its poor screenplay, which is in fact a compendium of 'Issa's previously published writings reconfigured into a screenplay, that makes the film seem more of a lecture ('Afit 2020).

The Sheikh as a Moral Reformer

Al-Sheikh Hasan (1954) is a film whose real significance comes from its being a rare example of an Egyptian film created by an Islamist, Hussein Sidqy, who wrote, produced, and directed the film, in addition to playing the role of the protagonist, Sheikh Hasan. Sidqy was known for his religiosity, which was manifested in refusing to allow kisses in his films and building a mosque at his own expense, as well as many other pious acts. Sidqy was also a close friend of Sheikh al-Azhar 'Abd al-Halim Mahmud, who eventually convinced him to retire in 1961 due to the inevitable violations against religion in the film industry. Before his death in 1976, Sidqy ordered his children to burn all his films because they contained religious violations, with the exception of one film in which he played the role of the Prophet's Companion Khalid ibn al-Walid.

Al-Sheikh Hasan was first released in 1952 under the name *Laylat al-Qadr (The Holy Night of al-Qadr)*, but it was soon banned by Muhammad Naguib's presidential decree, most probably due to the controversial way it portrays Christians. Sidqy made some modifications to the film and it was released again in 1954 as *al-Sheikh Hasan* (AlQadi 2017). The film opens in a mosque with Sheikh Hasan standing on the minbar (pulpit)

giving a Friday sermon on the prohibition of hashish, cocaine, and opiates, and emphasizing that they are not different from wine which is explicitly prohibited in the Quran. This is in response to a common belief at that time that drugs were not prohibited since they were not explicitly mentioned in the Quran. The film shows the sheikh as deeply involved in the social life of the *hara*, where people keep consulting him about their family issues on his way home after prayers. For example, he agrees to the request of one of the *hara*'s inhabitants to visit him to give advice to his stubborn wife. He also convinces his neighbor not to force his daughter to marry a wealthy old man whom she does not love. But acceptance of the sheikh as a social adviser is not the case for the whole of the *hara* community. The film shows a group of the *hara* inhabitants who are addicted to smoking hashish, and among them is *muʿallim* ʿAllam, Sheikh Hasan's father (played by ʿAbd al-Warith ʿAsar). One day, Sheikh Hasan catches them smoking hashish on the rooftop of the family house. He advises them to stop smoking, but they do not listen, so he smashes their smoking paraphernalia and disperses their gathering, as he believes that he has a moral duty to prevent them from wrongdoing. As a result, Sheikh Hasan's father expels him from the house, and so he moves to live in a motel near the villa of Khawaga George.

Khawaga George (played by Stéphane Rosti) is a wealthy Christian foreigner *(khawaga)* who lives in Egypt and owns a chocolate factory. He lives in a modern, luxurious villa with his wife and two children. Sheikh Hasan becomes the Arabic language private tutor for his children, a part-time job that he does besides studying at Sharia College in order to make a living. Khawaga George's children are Joseph (played by Zaky al-Fayoumy) and Louisa (played by Layla Fawzy). At first, and unlike Joseph, Louisa does not like Sheikh Hasan for his traditional religious look, but after having a number of intellectual conversations with him, she starts to admire his rationality and wide knowledge.

After a while, Sheikh Hasan's mother dies and his father quits smoking hashish and invites him back to their home. Thus, Hassan returns to the *hara*. Moreover, Hasan's extended conversations with Louisa get them closer and make them fall in love, but they decide not to marry until he graduates. After Hasan graduates as a sharia lawyer, Louisa marries him and lives with him in the *hara* without the approval of her parents, who oppose the marriage because of Hasan's religion and financial status. Louisa and Hasan live happily for a short time, but when her mother's sorrow over the marriage makes her ill, Khawaga George prevents Louisa from visiting her mother except under one condition, that she gets divorced from Sheikh Hasan. Consequently, Louisa and Hasan agree to get divorced for a period of time so that she can see her mother and then they can remarry.

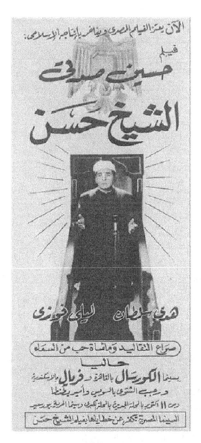

13.1. Poster for *al-Sheikh Hasan* (1954).

Thus, they divorce and she returns to live in the Khawaga's villa. Her father prevents her from seeing Hasan again. Later, Louisa, who is pregnant, suffers serious complications while giving birth to her daughter. Sheikh Hasan manages to persuade the Khawaga to forget their disputes in order to save Louisa's life. However, Louisa passes away, but before she dies, she confesses to her parents that she has secretly converted to Islam. In the end the Khawaga allows Hasan to take his daughter and raise her in the *hara*.

Al-Sheikh Hasan, which is described by its filmmaker in its poster as an "Islamist film production", manifests how Islamists viewed the role of the sheikh in Cairo of the 1950s. The sheikh is portrayed as a social reformer who does his best to prevent wrongdoing and to spread morality and tolerance within society.

Defeating the Sheikh

In contrast, the second film under discussion, *Lili* (2001), is a manifestation of a secularist concept of the sheikh's role in Cairo. *Lili* is a Clermont-Ferrand award-winning film directed by Marwan Hamed and produced by his father, Wahid Hamed, who has a long history of combating Islamists in cinema and TV drama. His works include a number of 'Adel Imam's films mentioned above, in addition to two parts of *al-Jama'a* TV series that are dedicated to criticizing the Muslim Brotherhood. *Lili* is based on Yusuf Idris's 1971 short story "Akana labud an tudi'i al-nur, ya Lili?" (Was It Necessary to Turn on the Lights, Lili?), which came out during the period that followed the 1967 defeat. Egyptian films reflected the despairing spirit of society in general, where escapism, drug taking, and rethinking big questions were among the features of the literature of this period. These themes were best seen in Naguib Mahfouz's quintessential novel which was made into the film *Tharthara fawq al-Nil* (*Adrift on the Nile*), which was also released in 1971. (The English title of the film was *Chitchat on the Nile*.)

Lili starts with a congregational prayer in the mosque of a *hara* in al-Batneyah, the most famous drug dealers' territory of the late 1960s and early 1970s. The prayer is continuously interrupted by the coughs

13.2. Poster for *Lili (2001)*.

of the worshipers who are almost swaying under the influence of hashish. During prostration, the sheikh leading the prayer passes away, leaving the congregation in a paralysis-like state with their faces stuck to the ground and asking all kinds of questions: "Has the imam died and left us in this position? Is he drugged? Assuming he is dead, until when will we keep prostrating?" All of which are symbolic questions that reflect the disorientation of the people and the lack of leadership at that time. They soon discover that the imam has indeed passed away, and, consequently, the mosque is assigned to Sheikh 'Abd al-'Al (played by Amr Wakid), a youthful, fresh graduate who has moved from the countryside to Cairo to be in charge of the mosque. His enthusiasm is soon doused when prayer time comes and he discovers that the inhabitants of the *hara* rarely come to the mosque and that he will perform the prayer with the mosque guard alone. He is puzzled at the paradox between the empty mosque and the crowded *hara*, and is even more puzzled when he discovers that people are lining up to buy hashish. The long line ends at *mu'allim* Hantita (played by Sami al-'Adl), a drug dealer and the man in control of the *hara*. He is portrayed as a man of great power, one who has connections with high-ranking officials and who is feared by everybody. When *mu'allim* Hantita first meets Sheikh 'Abd al-'Al, he offers him financial support, but only under the condition of not exceeding the limits or ever advising the people against smoking hashish. Thus, the sheikh realizes that the money he is offered is really a kind of bribe and he rejects it.

After a long month of waiting for the people to come to the mosque, he decides to reach out to them. With the intention of talking them into coming to the mosque, he heads to the *qahwa* or coffeehouse where people gather daily. However, he finds them all heavily smoking hashish and doped up. Someone asks him to sing to entertain them since they have heard his beautiful recitation of the *adhan* (call for prayer). He seizes this opportunity and sings a tearful supplication with his beautiful voice. The supplication catches the attention of everyone in the coffeehouse and its deep meaning temporarily awakens the people. However, this awakening is only short-lived: the supplication soon loses its meaning for and impact on the listeners, and the sheikh's daily chants have turned into a mere form of entertainment at their smoking sessions.

The *hara* is continuously a source of threat for the sheikh. Every time he walks through it he is exposed to sexual temptations. He is able to overcome these temptations until he meets Lili, whose charm he cannot resist. Lili is the *hara*'s most beautiful woman whom all the men dream of marrying, but she rejects them all. She approaches the sheikh by telling him that she is interested in broadening her religious knowledge and asks him to give her religion lessons. He suggests a book for her to read and leaves quickly. However, she keeps on chasing him, while the sheikh avoids her in order to stay focused on his mission of guiding the people of the *hara*. One day, he climbs the minaret to perform the *fajr adhan* (dawn call to prayer), as usual, but, just before he starts, the light of the room facing the minaret is turned on. The sheikh sees Lili in her full beauty awaiting him in her room, which is very close to the minaret. He keeps looking at her beautiful body until he misses the time of the *adhan*; he is never able to perform it again since Lili's seductive presence is always there. The sheikh feels guilty and vulnerable, and is obviously distracted from his social and religious mission; his only target now is surviving the seduction himself. However, Lili's charm continues to take hold of the sheikh's mind. One day, while he is praying, he finds himself unable to stop thinking about the door to her place, and in no time he is there, actually knocking at it. When she opens, he tells her that he agrees to give her the lessons she asked for. Shockingly, Lili simply slams the door in his face, having told him she no longer needs his lessons as she has already bought the book he recommended. In the film, this slamming of the door awakens the sheikh who, it turns out, has been daydreaming during the prayer, and did not go to Lili in the first place. However, the original story is different. In the short story, the sheikh actually falls prey to Lili's seduction and sadly confesses at the end that, "the devil triumphed" (Idris 2019, 25). The difference between the endings reflects the difference between the periods in which each of the two works was produced. During Abd al-Nasser's era, it was acceptable to depict the

sheikh as defeated by temptation, while, in the 2000s, such a depiction was no longer acceptable. Although it was normal to portray all kinds of Islamists negatively in the films of the 2000s, the cinematic portrayals of sheikhs in this period were usually respectful. This is because the Egyptian audience could easily accept severe criticism of Islamists' involvement in politics, for example, but they could not accept the same for sheikhs, whom Egyptian society still held in some reverence. This obliged filmmakers to be very careful when criticizing sheikhs, and it justifies Marwan Hamed's modification of the ending. Nevertheless, the film was banned and never released in Egyptian cinema despite the director's modification, most probably because of its controversial portrayal of the sheikh.

Reforming the Sheikh

The third film, *Mawlana (Our Sheikh)* (2016), is another secularist depiction of the role of the sheikh in Cairo, but this time in the aftermath of the 2011 Revolution. *Mawlana* is based on a novel published in 2012 by the aforementioned secularist writer Ibrahim 'Issa, and was written during the severe clash that took place between Islamists and secularists subsequent to

13.3. Poster for *Mawlana (Our Sheikh)* (2016).

the 2011 Revolution. During this clash, secularist intellectuals such as 'Issa accused Islamists of wrongly involving religion in politics, the sphere which secularists believe is essentially nonreligious. Many sheikhs were harshly criticized for using their wide influence over the masses for political goals. Thus, in both his novel and movie, 'Issa offers his views on the Egyptian scene and the relation between religion and politics at that time. In addition, he criticizes Islamic televangelism, a controversial phenomenon that has spread since the early 2000s with the emergence of satellite TV.

The film starts with Friday prayer in Sultan Hasan Mosque, attended by high officials and streamed on TV. The sermon should have been given by Sheikh Fathy (played by Ahmad Rateb), a famous sheikh from the Ministry of Awqaf. However, just before the sermon starts, Sheikh Fathy falls ill and Sheikh Hatem—often called Mawlana in the film—the official imam of the mosque (played by 'Amr Sa'd), gives the sermon instead. Although Sheikh Hatem is young and unknown, his charismatic performance captures the attention of the audience. Consequently, his popularity grows until he becomes Egypt's most famous televangelist within a very short period. His life rapidly transforms; he becomes a millionaire, starts a family, and buys a luxurious palace and a car. In line with his newfound wealth and status, he moves from the old part of Cairo to an elite area of the city.

However, Mawlana's enjoyment of his new lifestyle is constantly disturbed by his conscience: a clear difference can be seen between his discourse on his TV show and his private conversations. He never says anything against his own personal beliefs in his show, but the strict limits of speech that he is obliged to abide by make his discourse equivocal and prevent him from speaking critically about many issues. From his first appearances, he realizes that preaching on TV is totally different from doing so in mosques; the aim of the latter is to guide people, while the aim of the former is to generate revenue through advertisements. Thus, Mawlana is under an obligation to say only what pleases the mainstream and does not bother the sponsors, otherwise he will be substituted with a more obedient sheikh, and he will also lose all the benefits. While suffering this internal conflict, Sheikh Hatem's only child suddenly has an accident and his treatment requires a large amount of money. He is therefore obliged to continue presenting the program, despite his sense of guilt about it.

Mawlana's fame keeps growing until it gets him into the political sphere. He is assigned by the Egyptian president's son to convince his brother-in-law, Hasan (Ahmad Magdy), to revert back to Islam. Hasan is a rebellious young member of the presidential family who has decided to convert to Christianity. After Mawlana and Hasan talk it over, Mawlana realizes that Hasan's decision is based on superficial readings of religious texts with no sound intellectual justification and that his motive has been most likely to

simply rebel against the rules of his family. Moreover, the National Security Agency is constantly persecuting Mawlana's mentor, Sheikh Mokhtar (played by Ramzy El Adl), who is an ascetic spiritual leader, free from any of the worldly desires other sheikhs have, whose only concern is to worship God and to lead people along the path of righteousness. The background to these events is a corrupt political scene which creates a fertile soil for religious extremism at the expense of religious tolerance and moderation.

As a result of these policies, religious violence dominates. On the one hand, Hasan's shallow-mindedness leads him to adopt extremist ideas; thus he joins a terrorist group and bombs a house of worship, killing hundreds of peaceful worshipers. On the other, extremists assassinate Sheikh Mokhtar because of his being—as it happens, falsely—accused of promoting Shi'ism in Egypt. At the end of the film, Mawlana manages to overcome his own fear and rebels against the corrupted system. We see him breaking the imposed restrictions in an unequivocal broadcast. It is a speech that crosses all the imposed red lines in an attempt to save the country from sectarian strife. At the end of his speech, he smashes the microphone, a sign of his realization that televangelism cannot be the proper means for the preaching of Islam due to its intrinsic corruption caused by its capitalist nature.

Islam: From Social Leadership to Abandonment

Comparing the Egyptian *hara* as captured in the first two films, *al-Sheikh Hasan* and *Lili*, shows that major transformations took place in its structure between the mid-1950s and the early 1970s. First, both *hara*s were suffering from hashish addiction, portrayed as a great evil that threatens morality in both periods. However, this threat was not equal in both these periods. In the 1950s, we see hashish smokers exchanging it furtively and hiding on rooftops. On the other hand, by the 1970s, hashish has almost completely taken over the *hara*, and *Lili* shows people smoking it everywhere and dealers working in the open. Moreover, hashish smokers were a minority in the 1950s, while, by the early 1970s, a non-smoker is alien to the *hara*. It is as if, by this time, hashish has taken possession of the whole *hara*.

Hashish smoking provides, in fact, a useful approach to the city, as it reveals the transformation of religiosity and the status of Islam in Cairo between the two periods. Both films show that religious morality was substituted with the rule of law in modern Cairo. In both periods, what hashish smokers feared was the police, not God. This verifies Talal Asad's analysis of the modern nation-state, in which the "omnipotent God" was replaced by the "omnipotent lawgiver" (Asad 2003, 189). The transformation of people's religiosity corresponded with a transformation in the sheikh's status within the *hara*. In *al-Sheikh Hasan*, the *hara* inhabitants are continuously consulting the sheikh about religious and social issues, while,

in *Lili*, the sheikh is totally abandoned and has no disciples. This status is also reflected in the sheikh's struggle with hashish, where he has the power to destroy the smoking instruments in the first film, but, in *Lili*, the sheikh has no power to even publicly declare its prohibition.

Consequently, the mosque in the 1950s was portrayed as an important pillar of the *hara*, a vital space, full of people, which was continuously hosting gatherings both inside and outside of it. On the other hand, in the 1970s, despite its central location in the *hara* and the dominance of its minaret on its skyline, the mosque is shown as abandoned and rarely visited by people. This dichotomy between the mosque's central location and its marginal significance implies that, by then, the mosque had become an outdated institution, and that its location reflected only its centrality in the life of Egyptians in earlier periods. In both films, the sheikh lives in a humble apartment in the *hara*. However, in *Lili*, the sheikh needs money, which makes him liable to the temptation of bribery. In contrast, Sheikh Hasan, earlier, has an adequate governmental job as a shari'a lawyer; a job, however, that was abolished in 1955 and did not exist by the time of Sheikh 'Abd al-'Al of *Lili*. This shows that, as the role of Islam shrank in Cairo, sheikhs also lost much of their social and financial status.

Looking at the two films together suggests that Islam's role in Cairene society radically shrank during the rule of Nasser, and that the sheikh's status consequently transformed from one of social leadership to one of marginal existence and abandonment. Earlier, the sheikh was a reformer and a guide, but, later, the city seems to have frustrated his role with its modern conditions. Thus, the sheikh had to comply with the new status of Islam in Egypt and adapt his role to the modern Cairene society.

Modernizing Preaching and Reforming Islam
In contrast to the state of abandonment and misery that the sheikh had reached by the early 1970s, as depicted in *Lili*, *Mawlana* shows that the situation in the 2000s became radically different due to the modern reformation of the image of the sheikh. Preaching was modernized; it took place mainly on TV shows, which was more popular and effective than the traditional preaching in mosques. This modernization of preaching was far more than a mere updating of the method, but, rather, both the means and the ends of preaching were fundamentally changed.

First, the environment of the studio where the sheikh preached was much different from that of the mosque. As depicted in *al-Sheikh Hasan*, traditional Islamic sermons took place in mosques where males and females were segregated, a segregation that no longer existed in Mawlana's studio sermons, a secularist setting borrowed from entertainment shows (Wise 2003). Second, TV preaching separated the sheikh from the

audience by a number of mediators such as the sponsor, the director, the presenter, and many others who had control over the content and imposed strict restrictions on what he could say. This made his discourse rather equivocal because he would only have his power bestowed upon him by the sponsors of his TV show as long as he generated money, and he would lose this power whenever his discourse bothered them. Thus, the sheikh's social leadership became dependent on the satisfaction of the governmental authorities that own the media outlets.

The involvement of mediators was not the only thing that has distanced the sheikh from his audience, but also his new lifestyle has widened this gap between them. The sheikh's ability to generate money in the capitalist system that has dominated Cairo of the 2000s has transformed him into an upper-class figure. Consequently, the modernized sheikh left the *hara* in "Old Cairo" and moved to "Cairo of the Rich," or the so-called "New Cairo." In contrast to the humble apartments in which the two middle-class sheikhs lived in the earlier periods, Mawlana now lives in a luxurious palace in a city that lacks any organic interaction with people—a city composed of palaces and other structures that are private and gated. Even when he occasionally passes through the old city, he is separated from the public by bodyguards. Hence, in contrast to the sheikhs of the 1950s and 1970s who were in direct contact with their congregation during and after the sermons, Sheikh Hatem is no longer involved in the everyday life of the community. In other words, the sheikh has been transformed from a role model to a superstar who is distant from his fans.

The films also suggest a remarkable transformation in Cairene upper-class life. *Al-Sheikh Hasan* depicts upper-class Cairo in the 1950s as dominated by materialism and largely indifferent to religion. However, *Mawlana* shows that, by the 2000s, religiosity has become essential to the upper class.

In brief, *Mawlana* suggests that in the 2000s, televangelism replaced traditional mosque sermons in being the popular way of preaching. This has had many effects on the role of the sheikh in the city and on the nature of preaching. First, the mosque environment, which was governed by Islamic law and ethics, was replaced by the TV studio with its secular setting. Second, televangelism made the sheikh's discourse more easily controlled by the authorities and capitalist interests. Third, televangelism created a gap between the sheikh and his audience, where the sheikh's role became more of an on-screen performer rather than a real member of Cairene society.

Cairo: From Minarets to Satellite Dishes

The depiction of Cairo in the films between 1954 and 2016 shows that, after almost seventy years of modernization, the city of a thousand minarets has become the city of a million satellite dishes. This is to say that the

obvious modern transformation in the skyline of Cairo in which satellite dishes have replaced minarets as the main feature is far more than a mere physical transformation. Rather, I argue that it symbolizes the transformation the city has undergone through this span of time; the minarets and the satellite dishes each reflecting the dominating paradigm at two different points in the history of Cairo.

During the 1950s, the mosque was still the center of the *hara* (Figure 13.4), both spatially and socially similar to the medieval Islamic cities (AlSayyad and Tureli 2009). The centrality of the mosque in the *hara* shows that, despite the modernization that Egypt had undergone by that time, the role of Islam, and, consequently, of the sheikh, was still central to the social life of the Cairenes. By the early 1970s, a dichotomy existed between the central location of the mosque and its marginal role. At that time, as *Lili* suggests, the Cairenes were rebellious against their tradition. The centrality of the mosque at this period was merely a part of the obsolete plan of the city, which was no longer compatible with the Cairenes' real life. Consequently, the modernized city of the 2000s, or "New Cairo," shows no mosques at all (Figure 13.5). This does not necessarily mean that the new city lacks any mosques, but it rather reflects the marginalization of the mosque as an institution in modern Cairo, both spatially and socially.

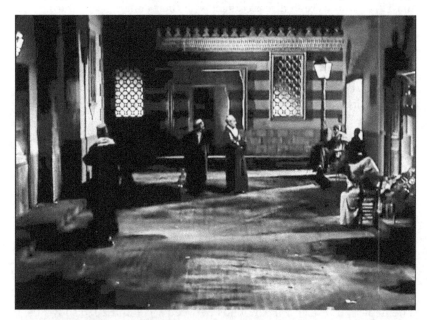

13.4. A midnight scene from *al-Sheikh Hasan* showing the spatial centrality of the mosque in the *hara* as well as the plaza in which the sheikh meets with the people after prayers.

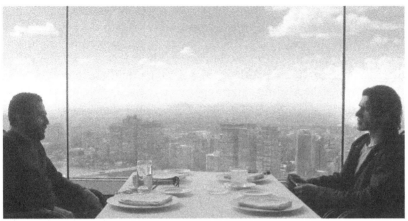

13.5. A scene from *Mawlana* showing Sheikh Hatem in a sky restaurant from which the view of modern Cairo in the background shows no minarets, in contrast to the old city.

The transformation of the city was paralleled by a transformation in the role of the sheikh in the Cairene society. In both the 1950s and early 1970s, the sheikh was mainly concerned with practicing one of the traditional moral tenets in Islam, which is *al-amr bi-l-ma'ruf wa-l-nahy 'an al-munkar*, or commanding right and forbidding wrong. This tenet obliges Muslims, especially sheikhs who should be role models for other Muslims, to promote virtues and prevent others from wrongdoing. In Islam, forbidding wrong should take place in three modes: first, forbidding wrong by the hand (using power); second, by the tongue (through teaching and advising); and third, by the heart (by silently rejecting wrongdoing) (Cook 2001). Although both sheikhs in the first two films were concerned with forbidding wrong in their *hara*s, the films show that in the 1950s the sheikh had the power to forbid wrong by hand and destroy the hashish smoking instruments, while in the 1970s he did not have even the power to forbid it by tongue and publicly declare its prohibition.

In the period following the one in which *Lili* is set, the Cairene community witnessed a revival of the role of Islam. This took place through the movement known as the "Islamic Revival" during the rule of President Anwar Sadat. Sadat began his presidency with declaring Islam as the religion of the state in the Egyptian constitution and allowing Islamists to participate in politics and social life following their persecution under Abd al-Nasser. Consequently, Islamism started to spread among the Cairenes, but it did not revert to how it had been in the 1950s. Rather, Islam was adapted to cope with the new conditions of modernity.

Patrick Haenni argues that this Islamic Revival has resulted in an adapted version of Islam that fits the neoliberal system of Egypt. One of

the main manifestations of this adapted Islam was the discourse of the Islamic televangelists. This discourse was centered upon the notion that it is a religious duty to achieve worldly goals, which Haenni calls the "Theology of Success" (Haenni 2015, 129). Subsequently, these reformations in the Islamic discourse made it more appealing to the upper class, which was reflected in the preoccupation of the Cairene upper class with Islam in the 2000s, in contrast to the upper-class attitude of the 1950s. It should come as no surprise that, despite this preoccupation with Islam, the "Cairo of the Rich" does not include any mosques as depicted in *Mawlana*; this is simply because the mosque is not central to this modernized version of Islamism.

The above analysis shows that the cinematic depiction of sheikhs' lives in Cairo through the seven decades from the 1950s to the 2010s verifies Talal Asad's claim that the secular reformations of Egyptian law in the nineteenth and twentieth centuries led to the reformation of the social and moral life of Egyptians. As seen in the films, religiosity has been secularized so as to fit into the modern conditions of Cairo, and the role of Islam in the social life of Cairenes had become significantly limited by the early 2000s in comparison to the 1950s. Consequently, the sheikhs had to secularize their discourse in order to fit into the modern, capitalist Cairo. However, the films show that, despite the reformation of their discourse, the sheikhs cannot totally blend into the modern conditions of Cairo; they are always struggling with various incompatibilities between Islam and modernity, which leaves them with only two choices, either to neglect Islam or to reject the system of the modern city.

Thus, Cairene films show that the city has been in a state of unrest in the struggle between Islamists and secularists to redefine the position of Islam in modern Cairo. Cairo is depicted as torn between Islamism and secularism. This undecidedness is brilliantly portrayed in the opening scene of *Mawlana* (Figure 13.6), in which an aerial view of the old city in 2016 is shown. The skyline of the city shows traditional minarets and modern satellite dishes, a skyline that perfectly manifests the struggle that the city has been witnessing between the traditionalist Islamists and the modernist secularists, or in other words, the dilemma of Islam and modernity in modern Cairo.

In the debate referred to at the beginning of this chapter, Sheikh al-Azhar ended his argument by saying, "Before the French colonialism, the Islamic world was ruled by the sharia, and this tradition was our source of empowerment." In response, the president of Cairo University stated that the cure for the current state is in the replacement of the epistemological foundations and methodologies of the Islamic tradition through more exposure to and acceptance of other cultures. Thus, it seems that the same conflict over how to incorporate the Islamic tradition into modern

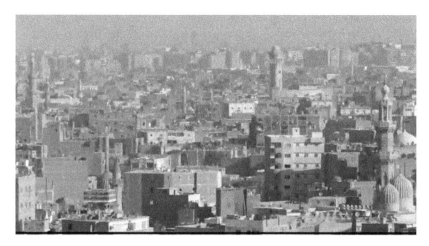

13.6. The opening scene of *Mawlana* showing an aerial view of Old Cairo in which one traditional minaret appears side-by-side with thousands of satellite dishes.

Cairo exists in both the cinematic city and the real city. In both, the sheikh confronts the boundaries modernity has placed on the role of religion in society. In both cases, the sheikh longs for the time when the city was governed by Islamic doctrines, a nostalgia for an imaginary reversion to history in and of itself. In other words, the sheikh desires to escape from the city of a million satellite dishes to that of a thousand minarets.

References

'Afit, F. 2020 "al-Dif: film am muhadara." *Arriyadiyah*, March 4, 2020, https://arriyadiyah.com/680777

AlQadi, K. 2017. "Rajul al-din fi al-sinima al-misriya: bayn al-mithaliya wa-l-khawf min al-Azhar." *Al-Quds al-'Araby*, June 9, 2017.

AlSayyad, N. 2006. *Cinematic Urbanism: A History of the Modern from Reel to Real*. London: Routledge.

AlSayyad, N., and I. Tureli. 2009. "Urban Geography: Islamic Urbanism." In *International Encyclopedia of Human Geography*, edited by R. Kitchen and N. Thrift, 598–606. Oxford: Elsevier.

Armbrust, W. 2001. "Colonizing Popular Culture or Creating Modernity? Architectural Metaphors and Egyptian Media." In *Middle Eastern Cities, 1900–1950*, edited by H.C.K. Nielsen and J. Skovgaard-Petersen, 20–43. Aarhus: Aarhus University Press.

———. 2002. "Islamists in the Egyptian Cinema." *American Anthropologist* 104, 3: 922–31.

Asad, T. 2003. *Formations of the Secular: Christianity, Islam, Modernity*. Redwood City, CA: Stanford University Press.

'Assaf, Z. 2019. "al-Adwar al-diniya fi al-sinima al-misriya bayn al-insaf wa-l-tajani." *Alrai*, May 21, 2019, http://alrai.com/article/10484889

Cook, M. 2001. *Commanding Right and Forbidding Wrong in Islamic Thought*. Cambridge: Cambridge University Press.

Esposito, J.L. 2000. "Political Islam and the West." *Joint Force Quarterly* 24: 49–55.

Haenni, P. 2015. *Islam al-suq*, translated by 'A. Sultani. Beirut: Namaa Center for Research and Studies.

Hallaq, W.B. 2012. *The Impossible State: Islam, Politics, and Modernity's Moral Predicament*. New York: Columbia University Press.

Idris, Y. 2019. *Bayt min lahm wa qisas ukhra*. London: Hindawi Foundation.

Khurshid, W. 2017. "Sira'at Salah Jahin ma' ashab al-'ma'im." *Aldostor*, April 23, 2017, https://www.dostor.org/1378427

Muhammad, D. 2018. "al-Sheikh fi mir'at al-sinima: mudalil yubih al-moharamat wa da'in ila al-istiqama wa-l-salah." *Elwatan news*, October 17, 2018, https://www.elwatannews.com/news/details/3731035

Wise, L. 2003. "'Words from the Heart': New Forms of Islamic Preaching in Egypt." MPhil diss., Oxford University.

14

Women's Right to the City: Cinematic Representation of Cairene Urban Poverty

Heba Safey Eldeen
Sherien Soliman

> The city is not a ready-made container for the practice of its residents, but a flexible entity that is made and remade through their practices. (Ghannam 2002: 23)

The study of women in Egyptian cinema has been one of many themes extensively debated. Evoking social and cultural discourse and shedding light on gender and family relations, this study of women in Egyptian cinema will map out changes in gender identity over the years. Over the past few decades, an overall process of modernization has taken place, whereby more contemporary and nuanced of women are now evolving in Egypt in both the real and the reel contexts as women's roles are becoming more interchangeable every day. Before film realism, women characters from the first half of the twentieth century were more likely to be depicted as stereotypically passive, emotional, powerless, and preoccupied with pleasing men, compared to the depictions of men as goal-oriented and problem-solving. Such cinematic images never reflected the reality of Egyptian women's lives, especially in less privileged urban or rural areas.

Over the span of almost seventy years, the Egyptian political regime has changed several times, from a parliamentary monarchy under foreign domination, to state capitalism with socialist overtones, and, finally, to a full market-led economy. With each change, the elites in power were reshuffled, triggering significant neoliberal upheaval and, in turn, bringing about different spatial organization. In this state of constant flux, the frequency of movement of people and activities, their changing places in time and space, has set the traditional patterns of urban segregation. This explains the sense of contradiction that observation of the conditions of this metropolis cannot fail to provoke: in all neighborhoods, relics of a

recent and distant past together with modern elements, as much social as specifically urban, rub shoulders, overlap, and interfere with each other. With the turn of the third millennium, Cairo became a metropolis that is constantly in movement, pushing against its limits further every day, and, as it grows, the movement—in fits and starts—of its ruling classes from the center to the periphery continues unabated. Each movement brings about a certain downgrading as it entails the progressive departure of dignitaries. In the domain of housing policies, the state totally disengaged itself from providing for the middle and poor classes and turned its attention to the production of luxury accommodation. Literature avows the pitting of old quarters against new ones, mediocrity against high life, degradation against social climbing, filth against cleanliness, order against anarchy, and so on. Consequently, the exodus from the center to the periphery has caused a readjustment involving large segments of the middle class who built and lived in the spontaneous informal areas. These displacements induced a requalification of these areas, and obliged a large sector of Cairenes to squat on state-owned land (El Kadi 2012, 17). The urban poor is evidently the most dominant feature of Cairo today. Living in the historic, old districts and informal areas of the city is associated with the smell of dust, sewage, and all sorts of dirt and chaos, and is equivalent to being at the bottom of the social ladder—the poorest, the least fortunate, and the most disadvantaged.

In the last few decades, attention to theories of space and urbanism across academia has generated broad interest in "cinematic urbanism." Much of this work provokes conversations between urban planners, geographers, and architects working on the city together with film scholars, creating a new discipline of "urban film studies." Cinema provides an urban archive or a memory bank that reflects changes in the urban landscape. At the same time, cinema serves to (re)produce the city; it produces multiple versions of even a single city by producing an imaginary urbanism through the construction of both fantasy urban spaces and ideas, and ideals of the city. Kracauer claims the city, and especially the street, as exemplary and essential cinematic space, attuned to the experience of contingency, flow, and indeterminacy linked to modernity (Kracauer, 2014).

A review of three selected films in this chapter highlights some of the gendered stereotypes as seen through the cinematic lens, in the hope of exploring some of the Cairene urban challenges. The analysis also explores differences in portrayals of women with regard to empowerment, and depicts patterns of cinematic representation of real Cairene women in different occupational roles, as well as their access to the built environment in the poor urban districts of Cairo.

The Urban Poor and the Right to the City

Urban poverty is assessed either as an absolute standard based on basic needs or the minimum amount of income needed to sustain a healthy and minimally comfortable life, or as a relative standard that is set based on the average standard of living in a nation (McDonald and McMillen 2008, 397). Either way, the general image of urban poverty is characterized by a deprived quality of life; hunger; and overcrowded housing, associated with a risk of forceful eviction—in addition to other features, such as the lack of safe, readily available water supplies; poor (or no) provision for sanitation, drainage, and solid waste collection; and many more inhuman living conditions that leave the urban poor in despair. In his *Cairo: The City Victorious*, Max Rodenbeck describes today's generation of Cairo's desperate urban poor as "this society where shame is felt to be more of a burden than guilt. Perhaps that is why a sharp line divides public from private behavior." He argues that such living conditions are the cause behind many of Cairo's urban poor's preference to suspend disbelief, to pay lip service to what they might personally feel is wrong, or untrue. He adds that "all kinds of mischief, meanwhile, go on with a wink and a shrug." Rodenbeck continues to describe a "we are as-if" society: "We speak of rules as if we intend to follow them, our government acts as if it were a democracy" (Rodenbeck 2007, 37).

In his comparison of the Low Life–High Life Cairo, Rodenbeck agrees with David Sims, claiming that at least two-thirds of Cairenes live in unzoned, unplanned popular quarters, exceeding 80 percent of the new urban fabric (Rodenbeck 2007, 49). The term "popular quarters" here covers a range of habitats, from country villages engulfed by the city, to the premodern parts of Cairo proper, to squatter communities on the city fringes that one day will become urban spaces as dense as the old quarters. Life in the popular quarters can be really hard. The absence of privacy, the confining of women and unmarried daughters in tiny apartments, and the lack of playgrounds for children are all unpleasant living conditions that create an obvious degree of intolerance between neighbors and provoke explosive quarrels between families. The causes are often petty: dirty water dripping on someone's washing line, arguments between children, neighbors who clutter communal stairs with their junk, and other such annoyances. Sewage may be leaky or nonexistent, electricity sporadic, and utilities equally absent or unreliable. Decades of breakneck growth have indeed uglified most of modern Cairo; small budgets, tremendous demand for housing, lax regulations, and a drain of architectural talent have combined to give the city a rough-hewn, unfinished look. In recent decades, dizzying population growth has combined with disregard of building codes to render many "formal" districts too dense to attract the middle class. Many middle-class families have moved out, and

the lower classes taken over. However, the popular quarters still boast a congenial intimacy that is rarely tainted by urban blights like crime and juvenile delinquency. Considering the degree of poverty in such quarters, the overall level of public safety is remarkable. Perhaps this is because most of the people still know their neighbors, care for their family reputations, and look on their small world as real. It is perhaps also a comfort to Cairo's urban poor that this laxity allows them to indulge more freely in minor illicit activities, including drugs. Weddings in popular quarters, for example, fill alleys with minicarnivals spotted with spontaneous revelry. Cairo is a city in progress, with the older quarters remaining the repository of a timeless Cairene identity. Realistically, the decay is sad, but, in compensation, these places are alive (Rodenbeck 2007, 117).

As explained by Michel de Certeau, in such societies as modern-day Cairo, there are still families with relatively high incomes, especially those with members who are skilled workers, and there are the unskilled workers with little income who can hardly sustain their families. In Cairo, many have had to take more than one job to meet the needs of their families. For Farha Ghannam, part of Cairo's low-income group's experience with globalization is structured by their economic resources and positions in social space. Their work in oil-producing countries has often been seen as the only hope for young men to secure an apartment, a necessary requirement for marriage, and various consumer goods which were rapidly becoming signs of social distinction: color TVs, VCR tape recorders, carpets, blenders, and so on. They also had to participate in saving associations (*gam'iyat*) to secure money (Ghannam 2002, 18).

Rodenbeck adds that the loss of morale has seeped into the pores of the city. It even shows in the physical appearance of the streets. Starting in the mid-1960s, there were built monuments to greed, corruption, and declining aesthetic sensibility. Today's city is no longer an intimate place where everyone who is anyone knows everyone else (Rodenbeck 2007; Sims 2011). Factually, Cairo is now a rough, impatient town; the battle of space, money, and self-respect is fierce. "A *mawlid* [religious festival] without the saint" is how the singer Ahmed 'Adaweya described the Cairo melee in a hit song about crowds in Cairo. It is difficult, dirty, and nerve-racking (Ibrahim 1992, 39).

Since the last quarter of the twentieth century, the urbanization of Cairo was facilitated by the sacrifices of the urban poor, particularly women. According to Samia ElSa'aty, Egyptian poor women suffer one or more or all of the following: deprivation, exclusion, loss of identity, limitations of financial resources and options, exposure to dangers, loss of access to resources and family decomposition, lack of or weak participation in decision-making, and lack of stability. ElSa'aty also asserts that most Egyptian poor women

experience health deterioration (equally among mothers and girls) as a result of poverty, coupled with their more active engagement in the labor force (16.7 percent of the total workforce) and a high rate of female unemployment often reaching 50 percent. The phenomenon of women as the breadwinners gives ground to the popular notion that a woman works "like a man," with a variety of economic roles in and outside of the house. By doing so, they either contribute on a small scale to the formal labor market, especially in governmental jobs that do not require skills, or contribute largely to the informal working sector, especially in minor trade activities, like selling vegetables and cheap household utensils. They also sell small, cheap desserts and food at school gates and stations, as well as at roundabouts and other traffic bottlenecks. Others buy goods on the black market which they sell door to door. Many work as cleaning women, and some do other minor jobs from their homes, such as sewing or crocheting. Supporting the family financially allows women to be decision-makers in the house. Divorced or widowed women receive a meager monthly governmental allowance if they have the required documents, which most do not, and so are pushed along with other poor families and individuals to the informal sector. In the absence of a husband, due to internal or external migration, death, sickness, or desertion for any other reason, women become both the pivot and the pillar of the family. The relationship between mother and children becomes much stronger, to the extent that sometimes she receives the wages of her working children (*Human Development Report of Women's Rights* 1996; ElSa'aty 2006, 77).

In retrospect, "the right to the city" is a term that was first coined in 1968 by the French Marxist philosopher and sociologist Henri Lefebvre (Lefebvre 1968). In the context of rapid urbanization, the civil rights movement backed a demand that people, not capital or the state, must have control over how cities are designed, shaped, and run. Housing for all is condition number one, followed by how the community is run and controlled. The work of Lefebvre has given rise to numerous arguments, such as over what "right" is meant. Is it people's right to reclaim, use, shape, and remake our urban surroundings? And is it everyone's common right, particularly those who are excluded or marginalized? Years later, David Harvey revisited the concept, and claimed that:

> the right to the city is far more than the individual liberty to access urban resources: it is a right to change ourselves by changing the city. It is, moreover, a common rather than an individual right since this transformation inevitably depends upon the exercise of a collective power to reshape the processes of urbanization. The freedom to make and remake our cities and ourselves is, I want to argue, one of the most precious yet most neglected of our human rights. (Harvey 2009)

Screening Cairo's Women in Poverty

According to Barry, the art of film is derived from the process of perception as well as the ability to create a reflection of reality through framing the content to create attitudes. He adds that "understanding can be brought to the still image, such as the meaning of close ups, camera angles, lighting and contexts" (Barry). This chapter is a study of today's Cairo from the very particular angle and specific view of the poor popular quarters of the city. It draws attention to women in the late twentieth century and the beginning of the new millennium in these places. Through three selected films, which span three decades of the regime of Hosni Mubarak, and beyond, we will reflect on the reality of urban poor women in Cairo. Being the cornerstone of their families, the glue of the community, and the gauge of its subsistence, it is crucial to study how the wheel of social change has much reshaped them through their representation in cinematic space. We investigate women's right to the city from three major viewpoints: first, the cinematic representation of women's roles within the overall social structure of the marginalized Cairene communities; second, the representation of urban poverty in the underprivileged districts of Cairo where women struggle for a decent living; and, third, the representation of gender power relations in the urban spaces of the city and women's right to them. These films are: *Yum mor, yum helw (Bitter Day, Sweet Day)* (1988), *Khaltit Fawziya (Fawzeya's Formula)* (2009), and *Yum li-l-sittat (A Day for Women)* (2016). The three films present different evolutionary narratives, where women protagonists tell their intimate stories, in contrast to a public, male-dominated world.

Yum mor, yum helw (Bitter Day, Sweet Day) (1988)

This film was written and directed by Khairy Beshara in 1988 and is considered a masterpiece among his works. The film is based on a true story that took place in the 'Assal neighborhood of Shubra, which is the area where the film was later shot. Aiming to secure her family after the death of her husband, 'Aisha (played by Faten Hamama) works as a tailor, a hairdresser, and any other small available freelance job. 'Aisha has five children. The eldest, Su'ad, helps her mother and refuses to marry the landlord to save the family; she falls for the milkman, runs away from the house after too much pressure from her mother, and ends up marrying a mute, caring tailor. The second daughter, Sana, works in a small factory and is in love with the mechanic 'Oraby, a thug who manipulates her and pressures 'Aisha to proceed with the marriage: he threatens to return to work in the Gulf if it does not take place. As a result, Sana and 'Oraby get married, and he lives with the family in their small apartment. The third daughter, Lamia, skips school and follows her mother's advice to work as a nurse; she

gives local drug addicts shots and brings a lot of money to the house. Lamia falls in love with her sister's husband, and attempts suicide through self immolation after he rapes her. The fourth daughter is sick and needs good nutrition. 'Aisha's youngest, Nour, is a ten-year-old boy whom 'Aisha forces to quit school to work in a garage, in a bakery, and at a mechanic's. After several humiliations, Nour escapes. At the end of the film, he returns home for the Eid feast, bringing happiness to his mother as the responsible man of the family. This comes together with the return of Su'ad with her and the tailor's baby, and the family rejoices after long trials.

14.1. Poster for *Yum mor, yum helw (Bitter Day, Sweet Day)* (1988).

Khaltit Fawziya (Fawzeya's Formula) (2009)

This film was written by Hana 'Ateya, and directed by Magdy Ahmed 'Aly in 2009. Fawzeya (played by Elham Shahin) lives on money from selling jam made with a special formula, always to the benefit of her ex-husbands and her marginalized community. Her true formula is a combination of tenderness, safety, compassion, laughter, and kindness in defeating poverty, loneliness, sorrow, and grief imposed upon her and upon her family and neighbors. The opening scene introduces her ex-husbands, and illustrates that she was both the one to propose to each and also the one to divorce them: 'Abdel 'Aziz, an alcoholic; Khalaf, a fireman; Tolba, a fish merchant, and Sayed, a plumber. Houda, a truck driver who becomes her fifth husband, does not appear until the middle of the film. She has four children, one from each of her ex-husbands; the oldest is physically handicapped and needs a wheelchair. Other characters in the film include Wedad, a former dancer, a cancer fighter who seeks empathy from anyone, gets a mobile phone to call the grocer, and buys a grave for herself and decorates it with plants and flowers; Fawzeya's own mother, who gets deceived and robbed by someone who promises to marry her; and Nousa, Fawzeya's friend who falls in love with her ex-husband the plumber and obtains Fawzeya's permission to marry him. However, the plumber gets hit by a stray bullet fired to celebrate their wedding day and they all take a truck to bury him. Knowing her story, Houda, the truck driver, gives Fawzeya flowers

14.2. Poster for *Khaltit Fawzeya (Fawzeya's Formula)* (2009).

Screening Cairo's Women in Poverty

to console her, whereupon she asks him to marry her. Upon their marriage, he is surprised to experience the fellowship of Fawzeya and her ex-husbands, who come for dinner every Thursday and stay together as one big family. Fawzeya cooks each one his favorite meal. The same happens in the holy month of Ramadan when the entire alley joins the iftar meal; and when it is time for the Eid (Bayram) feast, the entire community prays together, and the extended family and neighbors go out to celebrate and enjoy the day. Nousa gets married again, but, on her wedding day, Fawzeya's eldest son dies. The film ends with all the husbands building Fawzeya the bathroom she has always desired.

Yum li-l-sittat (A Day for Women) (2016)

This film was written by Hana 'Ateya and directed by Kamla Abou Zikry in 2016. The main protagonists of the film are 'Azza (played by Nahed El Seba'i), Layla (played by Nelly Karim), and Shameya (played by Elham Shahin). 'Azza is a developmentally handicapped orphan who takes care of her paralyzed grandmother. She is loved by a young mechanic (played by Ahmed Dawood), who treats her with empathy and brightens her miserable life. Layla is a silent griever who lost her husband and son in the famous accident and sinking of the ferry MV *Salem Express* in the early 1990s. Layla lives with her jobless father (played by Farouk el-Fishawy) and fanatic brother (played by Ahmed el-Fishawy), who always insults her and everyone in the alley. Responsible for the household, Layla runs a tiny, dark perfume shop in the alley. She is loved by a pool guard (played by Eyad Nassar), who discreetly sends her tender messages and tries to console her. Shameya is a lonesome model who is looked upon as a prostitute, though she is still a virgin, in love with her neighbor (played by Mahmoud Hemeida), who abandoned her a long time ago, married, and left to work in an oil-producing country. He comes back broken, and falls in love with her again. The fourth protagonist is a swimming pool guard and trainer (played by Hala Sedky).

The film starts, supposedly, in 2009 with a governmental truck driving around a poor neighborhood, with a microphone announcing the inauguration of a pool in the local abandoned youth club, with a special day for women. Everyone in the neighborhood listens to the voice in denial; women's faces are cold as ice, as if the news is not for them. Disputes about the value of the pool arise. Questions are raised as to its priority for the area, and if it had not been better for the government to distribute the money among the community, as needy as they are, or even build a school or a mosque instead. 'Azza tries to join the pool on the day it is filled and gets beaten back by the local children, but the pool guard comforts her with the news that the pool will be only for women on Sundays. The first Sunday,

'Azza, in her long-dreamed-of swimsuit, is the only woman to attend the pool. Eventually, Sunday becomes the happy day when all the women go to the pool, to laugh, play, entertain, dance, share their news and problems, and offer support to one another. Dismayed by the situation, the men sneak to the club lockers, steal the women's clothes, and throw them into the garbage. The women are stuck in the pool in panic, till the pool guard fetches their clothes. They go home late at night, walking slowly like a defeated army returning from battle. The revenge plan is set: the men's clothes disappear the next day when they are in the pool; they step in the alley in their swimsuits; and, upon a sign, dirty water and garbage are thrown onto them from every window and balcony. The days pass by and, gradually, the men accept the situation. Seasons change, the pool is closed for the winter, broken hearts get mended, and, soon, it is summer 2010, and the governmental truck with a microphone drives around the neighborhood announcing the opening of the pool, with a special day for women.

14.3. Poster for *Yum li-l-sittat (A Day for Women)* (2016).

We now move to analyze these three films in terms of the cinematic representation of women's roles, the representation of urban poverty in Cairo's popular districts in relation to the struggles of women, and women's access and right to the city in light of existing gender power relations.

"New Realism" and Beyond: The Changing Representation of Cairene Women

Realism has been a tendency in Egyptian cinema since the 1939 classic *al-'Azima (Resolve)* directed by Kamal Selim, and reached its high point with the films of Salah Abu Sayf in the 1950s. However, and as mentioned in other chapters of this book, a new school of cinematic realism appeared in the 1980s, pioneered by Atef al-Tayeb, Mohamed Khan, and Dawoud Abdel Sayed. Numerous local and national issues were covered in films throughout this period. One of these was urban deterioration and its reflection on the deprivation of the right to the city by its inhabitants. Not only has Egyptian cinema tackled the issue of women's right to the city, but it has also broadened it to include urban regeneration, urban

citizenship, and the masculinization of the city. Such themes are revealed in films including *Hina maysara (Whenever Possible)*, *Kalemni, shukran (Call Me, Thank You)*, *Dokan Shehata (Shehata's Shop)*, *Heya fawda (Chaos)*, *Welad Rezq (Rezq's Sons)*, *Nawwara*, *Ward masmoum (Poisoned Flowers)*, and many others. For the chapter at hand, the three films selected are argued to be therapeutic exercises that express the dissatisfaction, grief, empowerment, and solidarity of women in Egyptian society. The three selected films highlight the state of poor urban women and their changing roles over thirty years of Cairene contemporary history.

In her *Popular Egyptian Cinema: Gender, Class, and Nation*, Viola Shafik has classified women's studies into the following: feminism and femininity, effemination, sacrifices and arranged marriage, mothers, misery feminism, gateway to the repressed, inside the bourgeois home, gender spatiality, woman and the gaze, female bonding, women in action, feminism as a problem, and women directors. She affirms that there were some "feminist" films that advocated female education and professionalization, rejecting seclusion and ignorance while juxtaposing these binarisms to a nationalist framework in which female "liberation" was regarded as fundamentally operative in achieving national independence and economic progress. She mentions the role of Faten Hamama as a widow in *Yum mor, yum helw* as a "realist character combined with the determination to fight in the face of almost insurmountable obstacles with an appearance of delicate fragility. Presenting a self-confident woman in contrast to the more prevalent melodramatic mode before the new realism cinema of the eighties and onwards" (Shafik 2007, 116). In her classic study on melodrama, Laura Mulvey identifies some of the implications gender has on the representation of cinematic space, namely the way film associates gender with space, actions, and dominance (Mulvey 2004, 51). However, our three films do not support this seclusion or invisibility of women in public space. Instead, they exemplify a difference in gender roles. The open window, for example, is a common element in the three films, creating an in–out link with the neighborhood. The stairs, the roof, and the balcony are semicommunal indoor/outdoor spaces for all ages and genders in the neighborhood. The streets and public spaces are filled with women—whether shopping housewives, shop vendors, or workers of any type. The films also show that all lower-class women are witty, powerful, experienced, brave, hospitable, exhibit solidarity, and care about their neighbors. All the film protagonists have little or no formal education, are working or running small businesses, are economically independent, and are in charge of their families emotionally and financially. They mingle with men and support their communities. Such spatial cinematic associations have not only social, but also moral, implications for the changing role of women in society and their claim to their city.

The films also reveal other facts, such as male-dominated urbanism, female bonding, and motherhood struggles and sacrifices in less-privileged Cairo. Male-dominated urbanism in such districts appears in several scenes in the films. In *Yum*, for instance, the landlord who sits at the street corner watching the passersby bullies, harasses, or threatens 'Aisha and her family on every single trip they take. Another example from *Settat* shows the youngsters and the men openly denying women's right to use the pool, and from the same film shows the men and youngsters constantly bullying 'Azza and watching women in the pool with disdain.

Female bonding and motherhood are two more aspects examined by Shafik which she asserts have attained a positive depiction and centrality, hitherto unknown (Shafik 2007). In the three films, our protagonists struggle against oppressive circumstances and, despite differences in circumstance and personality, develop symbiotic relationships out of their common problems. Throughout the films, the stories outbalance the social victimization of the heroines through female solidarity that is reinterpreted in completely different ways. The films are confined to female protagonists in a truthful depiction of current lower-class Cairene conditions. Indeed, urban roles have been shifted, with the notion of masculinity now questioned by society. The notion of femininity is reconstructed to embody a variety of contradictory and opposing elements; even notions of power and powerlessness are simultaneously explored. Motherhood in these films is evidently positive, not passive as in earlier melodramatic films. This active–passive gender dichotomy draws attention to the real Cairo, a matter which requires us to further question women's rights to the city. Examples of women bonding are explicitly evident in the three films: 'Aisha's tendency to be part of every event and incident on the street in *Yum*, helping everyone, collecting the money for the monthly participatory savings associations (*gam'iyat*); Fawzeya and her friend's exchange of husband in *Khaltit*; and the women's plan of revenge in *Settat* are only a few. Concerning the above observations, several scholars affirm that, worldwide, women's lives in less-privileged areas now suffer numerous challenges like never before. As housing has become unaffordable, especially for single mothers or women who lack the financial support of a male partner, poorer women often end up in minuscule flats in high-rise, anonymous, brutalist buildings and feel less safe in public spaces and in transportation.

Cinematic Representation of Cairo's Urban Poverty

Based on the coverage of the three films, we can ask, how cinematic Cairo has presented the urban poor. Clearly, the representations are passionate and aspire to be as close to reality as possible. This might actually be a product of the wave of "New Realism" that took over Egyptian cinema at

the end of the twentieth century. Directors of the 1990s may have realized they were a generation that had been disempowered both personally and collectively, a generation that had come to know the impossibility of becoming what you want. It is perhaps their awareness of this dismal reality, at both a personal and a national level, that prompted them to produce what they wanted. The result is both a cinematic and a literary imaginary that portrays a radically different picture from the dominant national one, especially where the family is concerned. Atypically, the generation of the 1990s displayed, for the first time, gender equality, female writers, directors, and authors, and women-focused topics, with unconventional experimental content (Mehrez 2008, 213). The family became a relic of the past, represented through memories and old photography only fit to be packed in suitcases ready for departure. The individual protagonists, who have come to occupy the space of the family as a national icon, are at once disquieting and unsettling, and their relationship with the outside world is violent and nightmarish. Permeated with fear, loneliness, and anxiety, the total disorientation and alienation of these central characters becomes a shocking but candid response to the reality that surrounds them, whether familial or national (Mehrez 2008, 214). In his *Popular Culture in the Arab World*, Hammond adds that the collapse of the family, or *the* national icon, in reality announced not only the birth but also the untimely death of the individual. Egypt had its generation of the defeat (those of the New Realism wave), after whom came the "I've-got-nothing-left-to-lose generation." It is precisely this generation of urban and street-smart directors who opened up imaginaries that promised uncharted referential, technical, and aesthetic territories, thereby sealing the death of the family as a literary icon that represents the traditional Egyptian national imaginary (Hammond 2007, 87).

To illustrate this point, we can take Shubra district as an example, and as the setting in *Yum*, where a mixture of the middle-class and the poor cohabit differently in neoclassic stone buildings along relatively wide avenues, as compared to the small dwellings of a semirural settlement located in the suburbs or on the northern rural fringes. The effects of economic liberalization and massive emigration of Egyptian labor to the Gulf countries since the 1970s generated unprecedented social and urban adjustments and residential mobility. The vigorous construction boom engendered a dynamism characterized by strong speculative tendencies and soaring increases in the price of urban real estate, with repercussions for all sectors of the economy and society.

Yum was an important attempt to get closer to the reality of the Egyptian street and poor families at that time. Shubra is a nineteenth-century district that was founded by Muhammad 'Ali Pasha as a modern area on the outskirts

to the north of Cairo, where he built his summer palace. Once occupied by the elite, and later by upper-middle-class Cairenes, it transformed gradually into a popular district, becoming one of the most overpopulated districts in the last fifty years. Throughout the film, the apartment window is always open to the alley, acting as a connector between the indoor and the outdoor, where the alley and the street are extensions of the house. The social solidarity in the neighborhood is seen in the marriages, solace, and other practices in the alley. The little apartment itself is the main living space where all the activities take place: eating, studying, sleeping, meeting, sewing, and so on. Shooting most of the exterior shots in their true settings avows the urban deterioration of the district and its informal alteration. The film also captures the masculine dominance of the popular districts through the bakery owner who asks 'Aisha to marry him as a means to reduce her debts. There are also Nabil, the mechanic, who persists in wanting to marry Su'ad, the eldest daughter, which would save the family from poverty; and 'Oraby, who manipulates two of the other daughters, Sana (his wife) and Lamia (whom he rapes), and his control of the entire family. It is worth noting that some relate or compare the movie to the older *Bedaya wa nehaya* (*Beginning and Ending*), directed by Salah Abu Sayf in 1960, for its tragic story of a widowed mother's hellish struggle against poverty.

Regarding the cinematic representation of the historic city, and particularly the area where *Settat* is set, backing onto the rocky hills of Moqattam to the east, the old city holds the bulk of the most disadvantaged. Small shopkeepers and a few bourgeois others have remained there, notably in new buildings constructed along the streets that cut through the old city's obscure fabric. From its thousand-year history, several monuments still endure, the most prestigious of which have been well maintained across the ages, although most were abandoned to meet their fate. Despite the extreme deterioration of the buildings in this historic nucleus, it has held on to its diverse and dynamic low-quality artisanal and commercial activities. Mediocre informal high-rise buildings have been erected during the past few decades. At the same time, many late-nineteenth- and twentieth-century Cairo buildings, lacking maintenance, have collapsed or met a similar fate to the "ruins" of the old city.

Settat discusses the relationships of women to the social restrictions enforced upon them. The film depicts the situation of some marginalized women in lower-class Egyptian society, exposing their everyday and environmental behavior. Women in the movie are depicted as uneducated, ugly and fat, yet voluntarily supportive as a result of their tough lives. However, the pool is presented as an antidote for them to overcome the depression and frustration of their daily lives and past sorrows. For instance, the first time Layla touches the water she imagines her drowning son, and she passes

out. Regaining consciousness, she cries soberly. The weekly day at the pool helps the women change their perception of their gloomy lives. The film also accentuates social solidarity when it comes to a serious threat. This can be seen when two fights occur in the alley; one takes place when some naughty boys find some delicate red underwear in the lockers and wear it in the alley, and the other is when Layla's brother flies into a rage, accusing the alley of being unbelievers, and insults everyone and even beats his own father. The film as a whole is a call for contemplation, for love, and for life.

Though the location is not mentioned in the film, the exterior film shots are taken in Hattaba, in the Khalifa district, adjacent to the Citadel—which is one of the popular historic districts that have deteriorated over time due to the large number of informal developments in Cairo. Once again, the alley is an extension of the houses: people interact through windows and balconies. Markets and shops are meeting and gathering places; deteriorated urban pockets are playgrounds. The film is a live witness to the urban deterioration of historic districts, denied by Hosni Mubarak's regime, which is trying to dispel the frustration of Cairenes by throwing them a bone (the pool). However, other film scenes highlight the neglecting of fundamental human urban rights: alleys are flooded with drainage water, people have to cross them jumping from one leg to the other, like hopscotch, with piles of dirt everywhere. With Mubarak's photo on the walls of the streets, one of our protagonists, 'Azza, describes the other Egypt, whose people have lots of food to eat and more to throw away and bury in deep holes; it is another Egypt, where Barack Obama, "the king," is a Muslim from Aswan who performs pilgrimage every year. Layla, the other main protagonist in the film, switches the television on, with news of train crashes, fanatic debates, and semi-erotic video clips, yet, there he is—Mubarak—assuring the nation that he is there for each and every one of them. The film has several master scenes, the most outstanding of which is that of women taking their black veils off, throwing them to fly far and wide and settle freely everywhere. Moreover, the pool scenes, with the giggles, the caring, and the sharing, then the slipping on of the veils once again, and the return to their routine lives till next Sunday, are all very symbolic. Many other panoramic scenes of the area, with the skyline packed with the domes and minarets of the Islamic monuments, are also quite remarkable.

We see another dimension in the film *Khaltit*, which reveals the illegal but permitted expansion of the city in an attempt to absorb the overpopulation and which takes the form of squatters and informal vending. This trend appeared in the 1980s, spread widely in the 1990s, and became the dominant feature of the less controlled areas all around Cairo at the turn of the millennium, till today. Informal areas with less complex buildings involving minor social risks, were the alternative to spreading along the

river. There, as well, the scarcity of land and its exorbitant price on the one hand, and its inappropriate location on the other, allowed the undertaking of modest tertiary operations, comprising one- to two-story buildings intended primarily for shelter.

Khaltit has more than one noteworthy scene. The first is the children daring Fawzeya's eldest son to drink beer, then propelling him along in his wheel chair. He imagines himself flying lightly inside a rainbow, over the farmland and the houses, when he gets hit by a car. The second major scene is during the wedding party when Sayed is shot by accident and falls off the house roof. Another important scene is when the police demolish the public bath the community has built for themselves, claiming it has been constructed against the law. The final scene of note is the ending, when all Fawzeya's husbands—even the late Sayed, who appears in the mirror holding a red rose in his hand—participate in building her the bathroom. The master scene of the film is its panoramic opening, scanning the slums that have crawled along the agricultural areas around the Nile. The camera catches the eye of the viewer with panoramic shots of the poor red-brick houses, roofed with wooden logs, under the bridges along the River Nile and with women washing their clothes and utensils, or collecting berries from the trees. This is followed by contrasting scenes from the narrow alleys, revealing intimacy and empathy. The film uncovers the position of the government, allowing the informal urban sprawl, while prohibiting the people from the most basic human needs by demolishing the only bathroom the community built themselves. The film is a "shout out" by the informal inhabitants; it concludes that what they essentially miss are not only their basic needs, but also tenderness and love. They realize that they are segregated, excluded, and marginalized, so they collectively try to make the best of the ugliness they experience in all walks of life. Accepting their fate, and coping with it, they try to lead a better life of their own making. In contrast with *Yum*, *Khaltit* is a cheerful film that embraces both the challenges and opportunities in a community that practices social solidarity.

In all three films, the urban reality in the underprivileged districts is acutely represented. Either reel or real, these films express the physical and the behavioral aspects that are constantly defined and redefined according to the circumstances of the social and functional dynamics of the inhabitants.

Reflections on Women's Right to the Cinematic City

In the three selected films, perceptions of popular districts, local or *baladi* women are depicted as being the most representative of Cairene identity. As numerous writers and novelists describe them, the old alleys are the

real Cairo where one finds the authentic urban life, the attributes of which did not change over thousands of years. Even the neighborhoods located on the outskirts of Cairo are considered part of the urban landscape; they constitute a subculture which is based on attachment to local custom, family honor, solidarity, and the land (Campo, 90). The right of women to the city is a fundamental struggle that is rather modestly achieved in the films. In *Yum*, representing a popular district in Cairo during the 1980s, women claim possession of the alley *(hara)* on family occasions, like marriage, paying condolences, and so on. In *Khaltit*, which represents Cairo's informal areas around the turn of the millennium, women manage the area and the different households, controlling the local economy through their small microfinancial endeavors. They are more in number, mostly single or widows, and the few men are mostly absent because they work outside the area. In *Settat*, which represents Cairo's informal historic districts in the second decade of the twenty-first century, women are more resolved in their struggle to be present in public spaces; they have the courage to stand for their right to use the swimming pool, for example. The claims of women to the city build chronologically in the three films. Though the suffering of women is seemingly intensifying, their struggle to claim their urban rights in Cairo is also mounting.

Along a similar line, Ghannam raises questions about how modern discourses are articulated in the production of urban spaces and points out the position of women. She describes the diverse lifestyles manifested in urban activities, then categorizes these activities between men and women, and finally identifies a third activity group for both. The common occupations are those of petty traders, vendors, factory laborers, low-level governmental employees, or teachers. Men work as plumbers, metal and construction workers, shoemakers, craftsmen, mechanics, drivers, waiters, owners of small businesses (such as a barbershop or a blacksmith shop). Young women are usually factory workers, secretaries, and sales assistants in local shops, especially clothing; most stop working outside the home after marriage, but many become engaged in various economic activities around the housing unit. Ghannam asserts that in most poor districts, there are only a few cases of extreme religiosity and very little gender segregation in daily life (Ghannam 2002, 199).

According to Reeham Mourad, and also based on the three films, it can be argued that there are three categories of public spaces: safe zones, spaces out of social control, and spaces of harassment. Mourad argues that one can observe certain practiced power relations and forms of social control in these spaces. Sociability and vitality in streets and public spaces create zones of activities for women that are considered safe zones where women know each other, protect one another, and have strong social

relations and social connections. The result indicates there is a sense of street sociability, different in providing a sense of vitality and safety at the same time, creating a sense of surveillance that is present and clearly seen in the films. Furthermore, the films also reveal what can be termed as street politics, insinuating that women are not safe in spaces outside of social control—the regulation of public spaces at certain times and in certain locales throughout the day (Mourad 2016, 131). Evidently, there is a struggle over spaces. There are spaces and times in which women seemingly have greater rights and power, like the market, where they have more exposure to public life through trade and similar interactions. In *Cairo: Remaking the Modern*, Farha Ghannam describes the varying public spaces that are open or closed to women at differing times and occasions. She argues that the power relationships that reinforce gender inequalities regarding movement or access to spaces do not aim to control women's sexuality, but to control their access to knowledge (Ghannam 2002, 211). Reflecting on the films, we have seen several public spaces that illustrate the previously mentioned arguments by both Mourad and Ghannam. In *Yum*, there is the alley which is controlled by women, and there is the larger street, which resembles a plaza, for the numerous workshops and which is totally dominated by men. Women use the alley as an extension of the house, while men occupy the plaza and harass female passersby. In the two other films, the streets and public spaces are controlled interchangeably by men and women, according to the occasion. The struggle over spaces is highly significant in *Settat*.

Achieving women's rights to the city may start with them taking back the streets, actively and safely. Don Mitchell also offers a rich, geographically grounded exploration of struggles over public space and movements for social justice. The exploration of struggles is politically engaged, theoretically informed, and powerfully argued. Urban public spaces emerge not only as a site of brutal and often violent control, but also as a space of liberation and hope. Mitchell's work asserts that the right to public space is crucial to advancing the cause of justice. He thoughtfully argues that the struggle for rights actually produces a different public-space culture and thus insists that rights are to be taken seriously, as they are central to counteracting exclusionary practices and the pervasive power of the state (Mitchell 2003, 67).

The three films show how contemporary urban poor women respond to the underprivileged, inhuman urbanism in three different Cairene district types: the historic city, the nineteenth-century districts, and the informal areas. In satirical realism, our three films that span over a thirty-year period signify how the majority of lower-class urban poor women struggle for their fundamental rights to the city and a human quality of

life. Our analysis of the films relies on the notion of the right to urban life—or the right to the city as introduced by Lefebvre in 1968 and developed by Harvey since the 1980s. Social justice and liberation of public spaces are expressed in the three films chronologically and consecutively. It is observed how 'Aisha and her daughters in *Yum* are deprived of having even a little control over the public space beyond the alley, but *Khaltit*, twenty years later, avows more justice for women in public spaces. Ten years later, in *Settat*, women take their rights to the city more seriously, claiming both the alleys and public spaces, as well as the youth club and numerous shops. However, the films emphasize the need for a restructuring of the power relations that underline urban spaces, transferring control from the state to inhabitants.

Despite the fact that the films reveal that women's right to the city is truly contested, they emphasize a continuum of ongoing struggles regarding community perception and misconception of women and their rights regarding the issue. This argument evokes a question about sexism in Cairo's public spaces. As Doreen Massey argues, spaces and places may not be intrinsically gendered, but they reflect and affect the ways in which gender is constructed and understood. Since social relations are bearers of power in which spatial form is an important element in the constitution of such power relations, gender and space are produced through everyday practices in terms of such social relations (Massey 1994, 33).

Women and the Urban Poverty of Cinematic Cairo

The vulnerability of women to urban poverty, however, is not thoroughly appraised in Egypt. The few researchers who consider the gender dimension of poverty in their work relate it merely to economics. Our review of the three films affirms the discrimination that women face in terms of access to and control of resources, requiring us to raise the important question: Does urban poverty in Egypt have a woman's face? The films expose the socio-demographic profile, age, household composition, low educational levels, and employment status of the vulnerable women. They show that female-headed households have a lower individual income per earner and a higher per capita expenditure.

In the three films, *Yum, Khaltit,* and *Settat,* the position of women in the lower sectors of society, and their role as the cornerstones for supporting their families financially and emotionally are clearly emphasized. The role of women in cinematic Cairo with respect to social solidarity is also strongly stressed in the depiction of various community events. Lower-class women are always there—witty, powerful, experienced, brave, hospitable, and showing solidarity and concern for their neighbors. With little or no formal education, they work or run small businesses. They are economically

independent, contributing to or upholding the microeconomy in their neighborhoods. Such cinematic associations have not only social but also moral implications for the changing role of women in society as the cornerstone of the urban poor in Egypt. In both the reel space and, possibly, in the real setting, women try to defy the socio-physical barriers imposed upon them. Not only are they able to take over streets and spaces as extensions of their own modest dwellings through opening windows and balconies, but they are also able to dominate the markets and shops and transform deteriorated urban pockets into their working, meeting, and leisure places.

Based on our analysis of the three films, we can suggest that contentment among the urban poor women of Cairo is a product of a difficult struggle to find happiness in unlikely spaces and in unusual circumstances. In the three films, the main protagonists realize that they are segregated, excluded, and marginalized, as well as having to confront challenges for basic survival, yet they hold on with the support of other women in the community. They seek out one another to feel loved, cared for, and protected enough to survive the conditions in which they exist.

As women's roles have evolved, memories of the past, uses of space, desires of consumption, dreams of travel, and constructions of identity have emerged as new concerns for poor Cairene women. This suggests a fundamental change in their needs and visions. The public–private dichotomy which has defined Cairene women's access for decades is now contested and likely to make the issue of gender equality more prominent in Egyptian popular culture.

References:

ElSa'aty, S. 2006. *Women and Poverty: Between Reality and Enablement.* Cairo: General Egyptian Book Organization.

Fiorelli, L. 2016. "What Movies Show: Realism, Perception and Truth in Film." PhD diss., University of Pennsylvania, http://repository.upenn.edu/edissertations/1715

Ghannam, F. 2002. *Cairo: Remaking the Modern: Space, Relocation, and the Politics of Identity in a Global Cairo.* Oakland, CA: University of California Press.

Hammond, A. 2007. *Popular Culture in the Arab World: Arts, Politics, and the Media.* Cairo and New York: The American University in Cairo Press.

Harvey, D. 2009. *Social Justice and the City.* Athens, GA: University of Georgia Press.

Human Development Report of Women's Rights. 1996. Human Development Reports. Oxford: Oxford University Press.

Ibrahim, S. 1992. *Zaat: The Tale of One Woman's Life in Egypt during the Last Fifty Years.* Cairo: The American University in Cairo Press.

El Kadi, G. 2012. *Le Caire. Centre en mouvement: Cairo. Centre in movement. (Petit atlas urbain)* (Multilingual Edition). Paris: IRD Editions, Institut de recherche pour le développement.

Kracauer, S. 1997. *Theory of Film: The Redemption of Physical Reality*. Princeton, NJ: Princeton University Press.

El-Laithy, H. 2001. *The Gender Dimension of Poverty in Egypt*. Paper 0127. Cairo: Economic Research Forum Working Party (ERF).

Lefebvre, H. 1968. "The Right to the City." In *Philosophy of the City Handbook*, edited by S. Meagher and J. Biehl. Oxford: Routledge.

Massey, D. 1994. "Double Articulations: A Place in the World." In *Displacements: Cultural Identities in Question*, edited by A. Bammer. Bloomington, IN: Indiana University Press.

McDonald, J.F., and D.P. McMillen. 2008. *Urban Economics and Real Estate: Theory and Policy*. New York: John Wiley & Sons Inc.

Mehrez, S. 2008. "Where Have the Families Gone: Egyptian Literary Texts of the 1990s." In *Egypt's Culture Wars; Politics and Practice*, edited by S. Mehrez. Oxford: Routledge.

Mitchell, D. 2003. *The Right to the City: Social Justice and the Fight for Public Space*. New York: The Guilford Press.

Mourad, R. 2016. "Women, Class, Safety, and Social Relations in Local/ Sha'bi Communities in Cairo." Cairo: Unpublished Thesis.

Mulvey, L. 2004. "Looking at the Past from the Present: Rethinking Feminist Film Theory of the 1970s." *Signs: Journal of Women in Culture and Society* 30, 1: 1286–92.

Pojani, D. 2020. "Sexism and the City: How Urban Planning Has Failed Women." Modern Australian, April 18, 2018, https://www.modernaustralian.com/news/1145-sexism-and-the-city-how-urban-planning-has-failed-women

Rodenbeck, M. 2007. *Cairo: The City Victorious*. Cairo and New York: The American University in Cairo Press.

Shafik, V. 2007. *Popular Egyptian Cinema: Gender, Class, and Nation*. Cairo and New York: The American University in Cairo Press.

Sims, D. 2011. *Understanding Cairo: The Logic of a City Out of Control*. Cairo and New York: The American University in Cairo Press.

Wojcik, P.R. 2014. "The City in Film." In *Oxford Bibliographies in Cinema and Media Studies*, edited by K. Gabbard. New York: Oxford University Press, doi: 10.1093/OBO/9780199791286-0109. Oxford; https://www.oxfordbibliographies.com/view/document/obo-9780199791286/obo-9780199791286-0109.xml

CPSIA information can be obtained
at www.ICGtesting.com
Printed in the USA
JSHW062109010922
30098JS00001B/1/J

9 781649 031334